# Historical Dictionaries of Literature
## and the Arts
### Jon Woronoff, Series Editor

# Historical Dictionary of Rococo Art

Jennifer D. Milam

The Scarecrow Press, Inc.
Lanham • Toronto • Plymouth, UK
2011

Published by Scarecrow Press, Inc.
A wholly owned subsidiary of The Rowman & Littlefield Publishing Group, Inc.
4501 Forbes Boulevard, Suite 200, Lanham, Maryland 20706
http://www.scarecrowpress.com

Estover Road, Plymouth PL6 7PY, United Kingdom

British Library Cataloguing in Publication Information Available

**Library of Congress Cataloging-in-Publication Data**

Milam, Jennifer Dawn, 1968-
  Historical Dictionary of Rococo Art / Jennifer D. Milam.
     pages cm. — (Historical Dictionaries of Literature and the Arts)
  Includes bibliographical references.
  ISBN 978-0-8108-6183-1 (cloth : alk. paper) — ISBN 978-0-8108-7952-2 (ebook)
  1. Art, Rococo—Dictionaries. 2. Artists—Biography—Dictionaries. I. Title.
  N6425.R6M55 2011
  709.03'3203—dc22
                                                          2010049614

∞™ The paper used in this publication meets the minimum requirements of
American National Standard for Information Sciences—Permanence of Paper
for Printed Library Materials, ANSI/NISO Z39.48-1992.

Printed in the United States of America

In memory of Mary Vidal

# Contents

# Editor's Foreword

It is strange how what is new quickly becomes old, and in art, that applies a bit more than usual to Rococo. This was known in its time as the *gout moderne*. And, indeed, it was something new, coming after the incredibly long reign of Louis XIV, which lasted 72 years. This permitted a breath of fresh air, a relaxation of strict hierarchical relationships, a moment of gaiety and pleasure, and a chance for artists to break away from Baroque and Classicism. This occurred in all the arts but was noticed most in painting, where there were brighter colors, more fanciful brush strokes, different and sometimes almost scandalous or at least frivolous topics, and in architecture, where rigid straight lines became curves and asymmetry prevailed with much internal decoration. True, the academies were still there, but even they gradually mutated, and rich patrons made them less important anyway. What had not changed, or not that much, was that France was still the trend-setting nation and was copied around Europe as Rococo conquered or at least made incursions into Germany and Austria, Spain, Portugal and even Italy, and, thanks to the grand tour, Great Britain. Then things changed again; after the discovery of ancient Greek sites and more emphatically yet with the French Revolution and the collapse of the very society that nourished it, Rococo became passé or even worse. Still, during much of the 18th century, it inspired some extraordinary art, which is still admired, if a bit nostalgically today.

This *Historical Dictionary of Rococo Art* covers the core period of 1700–1789 extensively, but since no art movement emerges from nowhere or just disappears, it also reaches back to earlier times, which created the necessary preconditions and also follows on to later times, including the inevitable Rococo Revival. This can already be seen in the chronology, since, interestingly enough, most of the Rococo artists were actually once Classical or Baroque artists or later became Neoclassical ones. Moreover, in architecture, many older buildings were given a Rococo facelift or at least some features. This can already be seen in the introduction, which provides a broad overview. And the pattern carries on in the dictionary, where precursors and successors appear, but the emphasis is on the leading Rococo painters, sculptors, architects, decorators, garden designers, furniture makers, and others as well as their works, their patrons, their critics, and that new participant—the amateur.

Other entries show that although France retains pride of place, this was a pan-European trend, and Rococo flourished in many other countries, kingdoms, and even duchies. For those who want to learn more, the substantial bibliography is a good place to start.

The author of this latest addition to the art subseries is Jennifer Milam. She is a specialist in 18th century European art and especially French painting, basically the core of this book. She also has a keen interest in garden design, patronage, and aesthetic theory, peripheral but also significant. On reading the entries, it will soon become obvious that she has amassed considerable knowledge on all of the relevant topics. This is what she teaches at the University of Sydney, where she is an associate professor in the Department of Art History. And this is also what she researches and writes about, here and in numerous articles in learned journals. In addition, she has already published two books, *Fragonard's Playful Paintings*, which she wrote, and *Women, Art and the Politics of Identity in Eighteenth-Century Europe*, which she coedited. Not content to have turned out a very informative encyclopedia for us, she is now working on two other books, one of which will deal with the aesthetics of Rococo visual culture. For those who truly enjoy Rococo art because, at its best, it is still beautiful even if a bit old-fashioned, it will be a pleasure to have this source of reference handy or even to read the whole thing from A to Z.

Jon Woronoff
Series Editor

# Acknowledgments

Without the generous funding awarded to me through the receipt of a Thompson Fellowship at the University of Sydney, I would not have been able to write this book. I am indebted to Glenda Sluga, Geraldine Barnes, and Tim Fitzpatrick for their support of my application to this fellowship scheme. I thank Sally Grant and Andrew Schulz for their suggestions in relation to the Italian and Spanish entries respectively. I express my utmost gratitude to Georgina Cole, who read the entire manuscript prior to submission and provided invaluable recommendations for improvements. My greatest debt is owed to my family, who helped me see this project through to its completion. Chip Van Dyk, my husband, gave me the continual encouragement and time I needed to carry out the research and to write this volume, while our three children, Jakob, Nathaniel, and Wilhelmina, inspired my work with their unconditional love and understanding.

# Chronology

**1648 France:**   The Académie Royale de Peinture et de Sculpture is founded by Charles Le Brun and other artists, most of whom worked at court. The first of a series of civil wars, known as the Fronde, breaks out. The child king Louis XIV (who had been made king at age five in 1643) is eventually chased out of Paris with his mother, Anne of Austria; his brother; and his *premier ministre*, Cardinal Mazarin, who conspired to create negative memories of the capital, which scholars contend led to the establishment of his permanent court at Versailles, rather than the Louvre, in the 1680s.

**1661 France:**   The majority of Louis XIV begins. Cardinal Mazarin dies, and the title of *premier ministre* is abolished by the king. Louis XIV assumes sole responsibility for governing France from that point onward, establishing his personal authority as absolute monarch. Jean-Baptiste Colbert is appointed *conseiller du roi* and becomes the most important minister under Louis XIV with considerable executive power over the arts. André Le Nôtre begins work on the gardens of Versailles, which establish the French formal style as the dominant mode of garden design across Europe for the next century.

**1662 France:**   The Manufacture des Gobelins, a tapestry factory in the Faubourg Saint-Michel, is purchased by Jean-Baptiste Colbert on behalf of Louis XIV. The original factory for Flemish tapestry makers was established by Henri IV of France in 1602. Charles Le Brun serves as director and chief designer between 1663 and 1690, during which time the productions of the factory are extended beyond tapestries to include upholstered furniture.

**1665 France:**   Foundation of the Manufacture Royale de Glaces de Miroirs by Louis XIV as part of the market reforms of his new *contrôleur général des finances*, Jean-Baptiste Colbert. Informally known as the Compagnie du Noyer, the factory supplied the glass used in the Hall of Mirrors at Versailles. The importation of Venetian glass into France became illegal in 1672, when the production methods at the factory proved sound.

**1666 France:**   The Académie de France, a branch of the Académie Royale de Peinture et de Sculpture, is established in Rome for the training of young French artists.

**1670 England:** Richard Lassels's guidebook *The Voyage of Italy* is published posthumously first in Paris and then in London. He is the first writer to use the term "grand tour" when describing the benefits of travel for the young gentleman and the necessity of studying the arts of antiquity.

**1671 France:** Philippe de Champaigne delivers his lecture on Titian's *Virgin and Child with Saint John* at the Académie Royale de Peinture et de Sculpture, which begins the color/line debates.

**1673 France:** Roger de Piles publishes his *Dialogue sur le coloris* in defense of Venetian masters, continuing the color/line debates initiated in the *conférences* of the Académie Royale de Peinture et de Sculpture in 1671.

**1674 France:** Charles Le Brun transforms the *Prix Royal*, which originated in drawing competitions held at the Académie Royale de Peinture et de Sculpture from 1663. Renamed the *Prix de Rome* or *Grand prix*, subjects are henceforth to be taken from the Bible or ancient history, with a preliminary trial around the study of a male nude (known as an *académie*) used to narrow the competition. Winners were generally awarded scholarships to the Académie de France in Rome.

**1682 France:** Louis XIV moves from the Tuileries Palace into the Château de Versailles, establishing the main seat of his court and government outside of Paris. **Russia:** Peter I becomes czar of Russia. Under his rule as Peter the Great, he ushers in change with the intention of transforming Russia into the rival of Western European nations.

**1685 France:** The quarrel between the ancients and the moderns breaks out in literary circles, with debates continuing through 1694. This is a parallel development to the color/line debates raging within the Académie Royale de Peinture et de Sculpture since the early 1670s. Louis XIV revokes the edict of Nantes and many Huguenot artisans leave France, taking their skills with them.

**1690 England:** John Locke publishes *An Essay on Human Understanding*. Locke's epistemological and philosophical writings influence the development of Enlightenment thought throughout Europe and North America. **France:** Charles Le Brun dies. Pierre Mignard is appointed *premier peintre* and elevated to the post of director of the Académie Royale de Peinture et de Sculpture.

**1697 France:** The Comédie Italienne is expelled from Paris when its royal privilege is revoked; although, commedia dell'arte actors continue to perform in fairs and festivals, providing subject matter for early Rococo artists like Antoine Watteau. **Russia:** Peter the Great returns from his incognito tour

through Holland and Germany, which stimulated his desire to transform the arts and sciences in Russia, as well as Russian manners and court life, in emulation of Western models.

**1699 France:** Roger de Piles is appointed *conseiller honoraire* to the Académie Royale de Peinture et de Sculpture and publishes his *L'abrégé de la vie des peintres*, an account of the lives and styles of selected artists categorized according to schools. Jules Hardouin-Mansart, architect of the Galerie des Glaces at Versailles, is appointed *surintendant des bâtiments*, the position of chief architect for royal buildings. Louis XIV orders the refurbishment of the Ménagerie de Versailles for the duchesse de Bourgogne. The Académie Royale holds its first exhibition of works by academicians in the Grand Galerie at the Louvre, after a 25-year hiatus. The earliest surviving example of a teapot is produced in Paris, an example of the new forms of decorative arts objects being produced across Europe for the fashionable enjoyment of imported refreshments, such as tea and coffee.

**1700 Italy:** Giovanni Francesco Albani becomes Pope Clement XI. Papal policy aimed at the preservation and restoration of the remains of antiquity begins in earnest. **Spain:** King Charles II of Spain dies, ending the line of Spanish Habsburgs. The childless king had named Philip, Duke of Anjou and grandson of Louis XIV, heir to his throne. This provoked the War of Spanish Succession (lasting until 1713) and initiated the Bourbon line in Spain, leading to a shift in artistic tastes from Italian and Flemish models to those from France.

**1701 Germany/Prussia:** Elector Frederick III of Brandenburg crowns himself Frederick I, "king of Prussia." The Prussian kings develop Berlin as their capital.

**1703 Russia:** Peter the Great founds the city of Saint Petersburg on marshy wasteland beside the Gulf of Finland. An imperial capital of uniform aspect is created in less than two decades, with noblemen forced to erect houses according to standard designs issued by the Swiss architect Domenico Tresini, who also produced templates for utilitarian structures and tradesmen's quarters. Saint Petersburg is declared the Russian capital in 1712.

**1708 France:** Roger de Piles publishes *Cours de peinture par principes avec un balance de peintres*, a manual addressing the fundamental principles of painting and summarizing the artistic doctrine of the late 17th century.

**1709 England:** Richard Steele founds the periodical the *Tatler* in London, providing accounts of manners and mores, literary and antiquarian notes, and news and gossip from coffee houses. Joseph Addison and Jonathan Swift

both contribute essays on matters of taste in art, garden design, and literature. After the *Tatler* was discontinued in 1711, Steele and Addison published a similar daily journal, the *Spectator*, for nine months in 1712, followed by the *Guardian* in 1713. **France:** Dezallier d'Argenville publishes *La théorie et la pratique du jardinage*, which described the specific components and characteristics of the formal French garden. **Italy:** Ruins of an ancient Roman town are discovered at Herculaneum. Followed by excavations at Pompeii in 1748, these two archaeological finds fuel a renewed interest in antiquity and the development of Neoclassicism as a set of stylistic values. **Russia:** Peter the Great founds Peterhof as his summer residence. Construction of the gardens and palace begins in 1710.

**1710 Germany:** Elector Frederick Augustus of Saxony, who from 1697 ruled as Augustus the Strong, king of Poland, orders construction to begin on the Zwinger in Dresden (built 1711–28). Designed by the architect Matthäus Daniel Pöppelmann and ornamented by the sculptor Balthasar Permoser, the Zwinger was a uniquely festive and theatrical space conceived as a series of pavilions surrounding a courtyard in which court festivities would be held. In the same year, Augustus the Strong also establishes a porcelain factory at Meissen near Dresden, which becomes the first successful manufacturer of hard-paste porcelain in Europe.

**1711 England:** The portraitist Godfrey Kneller and others set up the first school of drawing and painting in London, the Academy in Great Queen Street. **France:** The *Oeuvre de Jean Bérain, receuillies par les soins du sieur Thuret* is published, widely disseminating Bérain's designs through Europe and influencing the development of Rococo forms, particularly in furniture and ceramics.

**1712 France:** Antoine Watteau is accepted into the Académie Royale de Peinture et de Sculpture, becoming a full member in 1717 with the submission of *Pilgrimage to the Island of Cythera* (Musée du Louvre, Paris). The minutes note that he was received as a painter of *fêtes galantes*, which indicates the Académie Royale's recognition of a new genre of painting.

**1714 Austria:** Johann Lukas von Hildebrandt designs the Belvedere Palace for Prince Eugene of Savoy in Vienna, with gardens laid out by Dominique Girard in the French formal style. **Italy:** Filippo Juvarra moves to Turin as architect to Victor Amadeus II, the Duke of Savoy and king of Sicily.

**1715 France:** Louis XV succeeds Louis XIV as king of France at the age of five. Philippe, duc d'Orléans acts as regent until 1723, during which time he moves the court of France back to Paris from Versailles. The regent

governed from the Palais Royal, appointing Gilles-Marie Oppenord as his chief architect and designer, while Louis XV lived in the Tuileries. Oppenord remodels the Palais Royal, designing further alterations until 1721.

**1719 England:** Watteau travels to London, where he completes paintings for Richard Mead, a well-known doctor and collector. He paints *The Italian Comedians* (c. 1719, National Gallery, Washington DC) for Mead, along with other works that appear to blur the lines between portraiture and scenes of everyday life. **Portugal:** Filippo Juvarra begins work on the monumental Baroque palace-convent complex at Mafra, commissioned by King John V.

**1720 England:** Louis Chéron and John Vanderbank move Godfrey Kneller's Academy of Painting and Drawing from Great Queen Street to Saint Martin's Lane. It is henceforth known as the Saint Martin's Lane Academy. **France:** Antoine Watteau paints *L'Enseigne de Gersaint* for his friend, the dealer Edme-François Gersaint. The painting is displayed at the front of Gersaint's shop *Au Grand Monarque* on the Pont Nôtre Dame, which had been in business since 1718. Rosalba Carriera visits Paris at the invitation of Pierre Crozat.

**1721 England:** William Hogarth publishes his moralizing print, the *South Sea Scheme*, which satirizes a recent financial scandal and brings a contemporary controversy into the subject matter of art. **France:** Watteau dies of tuberculosis. Charles-Louis de Secondat, Baron de Montesquieu, publishes the *Persian Letters*. Pierre Crozat commissions Gilles-Marie Oppenord to remodel the gallery of his *hôtel* on the Rue de Richelieu, where he was employed until 1730.

**1723 Italy:** Rosalba Carriera is invited to the Este court in Modena to paint portraits of the duke's daughters.

**1725 England:** Lord Burlington completes Chiswick House according to his own designs in the Palladian style. William Kent is involved in the interior decoration and the layout of the gardens.

**1726 England:** Philip Mercier introduces the conversation piece to English art with his *Party on a Terrace* (the Schultz Family, 1725, Tate Collections, London). **France:** Jean de Jullienne publishes *Figures des différents caractères*, containing engravings, mostly by François Boucher, after Antoine Watteau's works. The experience has a formative impact on the development of Boucher's style, while the project maintains Watteau's influence on the arts after his death. **Italy:** The Spanish Steps are completed. Designed by Francesco de Sanctis and the result of the patronage of Popes Clement XI and Innocent XIII, the system of staircase and landings were conceived as part of a program of urban enhancement in Rome.

**1728 England:** Batty Langley publishes *New Principles of Gardening*. **France:** Jean-Baptiste-Siméon Chardin is accepted into the Académie Royale de Peinture et de Sculpture as a painter of animals and fruits.

**1730 France:** Pierre Carlet de Chamblain de Marivaux publishes his play *Le jeu de l'amour et du hazard* as a work of literature in the "modern" style that parallels the innovations of Antoine Watteau. Gabriel Huquier begins publication of the *Livre d'ornements*, which contains a number of engravings after designs by Juste-Aurèle Meissonier and has considerable impact on the dissemination of Rococo forms. A new type of desk, the *secrétaire*, is invented in response to the needs of the personal letter writer.

**1731 France:** François Boucher returns to Paris after three years in Rome.

**1732 England:** William Hogarth publishes the six-print series of *A Harlot's Progress* and a new genre of novelistic prints with moralizing subjects emerges. Hubert Gravelot arrives in London and introduces French Rococo decorative influences into artistic circles, particularly that of Hogarth. **Italy:** Giambattista Tiepolo completes *The Education of the Virgin* at Santa Maria della Consolazione, Venice, his first large-scale altarpiece.

**1734 England:** William Hogarth revives the Saint Martin's Lane Academy, which had ceased to function in the previous decade. A nonhierarchical institution, the principal teachers were Hogarth, Hubert Gravelot, Francis Hayman, and Louis-François Roubiliac. It becomes a hub of Rococo stylistic activity and liberal artistic practices. **France:** François Boucher is received into the Académie Royale de Peinture et de Sculpture with *Rinaldo and Armida*. Voltaire publishes *Lettres philosophiques*. **Germany:** François de Cuvilliés designs the Amalienburg Hunting Pavilion in the gardens of Nymphenburg Palace outside of Munich. Completed in 1737 and built for the Bavarian Elector Carl-Albert, the interior of Amalienburg materialized Rococo ornamentation in three-dimensional form. **Spain:** The Palacio Real in Madrid is destroyed by fire. Filippo Juvarra is commissioned by Philip V to build a new palace in 1735 but dies soon after. The project is taken over by Juvarra's student, Giovanni Battista Sacchetti.

**1735 England:** The Engraver's Copyright Act is established to prohibit unauthorized copies for 14 years after production. **France:** Germain Boffrand begins his extension of the Hôtel de Soubise, including the oval Salon de la Princesse on the first floor of a two-story pavilion. The curving shape is enhanced by the formation of walls into arches to frame windows, doors, and mirrors, dissolving divisions and creating a continuous undulation. The room is considered a triumph of Rococo interior architecture. **Sweden:** Carl von Linné (Carolus Linnaeus) establishes the system of binomial classification in

*Systema naturae*, an important example of hierarchically organized systems of classification, which influenced other literary, artistic, and scientific areas of thought during the Enlightenment.

**1737 France:** The Salons begin biennially at the Palais du Louvre. Jean-Baptiste van Loo arrives in London. Jacques-François Blondel publishes *De la distribution des maisons de plaisance*. **Holland:** Jacob de Wit completes *Moses Choosing the Seventy Elders*, a decorative work for the Amsterdam Stadhuis.

**1738 England:** Louis-François Roubiliac's sculpted portrait of a living composer, George Frideric Handel, is erected in Vauxhall Gardens. **France:** A porcelain factory is founded at the Château de Vincennes, moving to Sèvres in 1756 and taking that name. Jean-François de Troy is appointed director of the Académie de France in Rome.

**1739 France:** François Boucher paints *Le déjeuner* (Musée du Louvre, Paris). Jacques de Vaucanson creates a "digesting" duck automaton.

**1740 Austria:** The Pragmatic Sanction of Charles VI allows Maria Theresa to assume rule of the Habsburg Empire. In addition to securing thrones for her children, she is a significant patron of the arts, following her father's example. **England:** Samuel Richardson's *Pamela, or Virtue Rewarded* is published, the first epistolary novel. **Germany:** Frederick II assumes the throne of Prussia, later to become known as Frederick the Great. He subsequently invades and captures Austrian Silesia, initiating the Austrian war of succession. A significant patron of art and architecture in the Rococo style, one of his first acts related to artistic production is to prohibit the importation of French snuffboxes with the aim of stimulating German production of these exquisite objects, which he collected with a passion. **Russia:** Elizabeth becomes Empress of Russia and establishes a lively court. Her principal architect is Bartolomeo Francesco Rastrelli, an Italian who trained in France and moved to Russia in 1716. Rastrelli creates for Elizabeth pavilions, palaces, and interiors in a monumental Rococo style.

**1742 France:** François Boucher paints *Diana Resting after Her Bath* (Musée du Louvre, Paris).

**1743 England:** William Hogarth paints the series *Marriage à-la-mode* (Tate Collections, London). **Germany:** Johann Balthasar Neumann begins work on Vierzehnheiligen, a pilgrimage church near Staffelstein in the Bavarian Rococo style. The highly innovative plan is composed of intersecting ovals around a central shrine.

**1744 Italy:** Giovanni Batista Tiepolo is at work on *The Meeting of Anthony and Cleopatra* and *The Banquet of Cleopatra*, frescoes for the Palazzo Labia in Venice.

**1745 France:** Madame de Pompadour becomes official mistress of Louis XV. She secures important ministerial posts related to the arts first for her uncle, Lenormand de Tournehem, and then for her brother, the marquis de Marigny. The family has substantial influence over royal commissions and the management of the Académie Royale de Peinture et de Sculpture. Eventually, the Rococo style will be associated as much with Pompadour as with the Regency period and Louis XV. Germain Boffrand publishes his *Livre d'architecture*. **Germany:** Construction begins on Frederick the Great's summer residence at Potsdam, outside of Berlin. Schloss Sanssouci is designed as an intimate retreat dedicated to the king's leisure pursuits in the arts, music, and philosophy as signs of his status as an enlightened absolute monarch. **Italy:** Giovanni Battista Piranesi leaves the Veneto to settle permanently in Rome. His captivating and imaginative views of Roman ruins entice gentlemen on the grand tour and become highly sought after mementos.

**1746 England:** Encouraged by the success of his view pictures with gentlemen on the grand tour, Canaletto moves to London where he is well received. His talents begin to be questioned in later years, and he departs for Venice in 1755.

**1747 England:** Garrick manages the Drury Lane Theatre until 1776 and encourages the development of "theatrical conversation pieces" with the idea of using art as a form of publicity for his productions. **France:** Étienne La Font de Saint-Yenne publishes *Réflexions sur quelques causes de l'état de la peinture en France*, with an attack on the "effeminacy" of modern painting.

**1748 Italy:** Excavations of Pompeii begin, reigniting the enthusiastic interest in antiquity first sparked by the discovery of Herculaneum in 1709.

**1750 France:** Jean-Francois Oeben begins to design and construct mechanical tables. **Germany:** Alexander Gottlieb Baumgarten begins to publish *Aesthetica acroamatica* (1750–58). This is the first use of the word "aesthetic" and the beginning of investigation into this philosophical idea.

**1751 France:** The first volume of the Encyclopédie appears, under the editorship of Denis Diderot and Jean Le Rond d'Alembert. **Germany:** Giambattista Tiepolo, assisted by his son Giandomenico, paints ceiling frescoes for the Kaisersaal in the Würzburg Residenz, which are finished in 1752. The playful use of foreshortening and trompe l'oeil techniques

combine with New World figures to produce works that bring together a Rococo emphasis on decorative qualities, impressions of Baroque grandeur, and an interest in exploration and discovery that is characteristic of the Enlightenment. In Munich, François de Cuvilliés designs the Residenztheater, completed in 1753. **Italy:** Pietro Longhi's painting *Rhinoceros* (National Gallery of Art, Washington DC) celebrates the arrival of an exotic animal in Venice and signals a wider interest in stimulating an acquired knowledge of other cultures through artful documentation. Giovanni Battista Piranesi's *Prisons* engravings are published. **Sweden:** Lovisa Ulrike becomes Queen of Sweden. A passionate patron of French art, she has agents at work in Paris buying contemporary paintings and drawings.

**1752 England:** William Halfpenny's *Chinese and Gothic Architecture Properly Ornamented* is published and influences the production of chinoiserie and gothic forms in garden architecture, building ornamentation, furniture, and the decorative arts. **France:** Jean-Honoré Fragonard wins the *Prix de Rome*. **Spain:** The Real Academia de Bellas Artes de San Fernando is founded in Madrid.

**1753 England:** William Hogarth publishes *The Analysis of Beauty*, asserting the beauty of the serpentine line. Partly derived from Rococo forms, the aesthetic application of his theory draws on current philosophical thought on the appeal of irregular lines to the eye and mind. **France:** On behalf of Louis XV, the marquis de Marigny commissions the Ports of France series from Joseph Vernet, which, when exhibited, are celebrated by Denis Diderot for their truthful depiction of nature. Diderot uses the example of Vernet's landscapes to draw attention to the lack of history painting of similar quality by contemporary French artists. Marc-Antoine Laugier publishes his *Essai sur l'architecture*.

**1754 England:** The Society of for the Encouragements of Arts, Manufactures and Commerce is founded by William Shipley and consolidated by royal acknowledgment in London. Thomas Chippendale publishes the *Gentleman and Cabinet-maker's Director*. Robert Adam goes on a grand tour, spending most of his time in Italy, where his study of ruins alters his approach to architectural design. He returns to London in 1757. **France:** Étienne Bonnot de Condillac publishes his *Traité des sensations*, and Denis Diderot publishes his *Pensées sur l'interprétation de la nature*. Jean-François Oeben is appointed *ébéniste du roi* and thereby exempted from guild restrictions. **Germany:** The Zimmermann brothers complete Die Wies, a pilgrimage church that stands as a paradigmatic example of the Bavarian Rococo. In Dresden, Johann Joachim Winckelmann publishes his treatise "Thoughts on the Imitation of Greek Works in Painting and Sculpture,"

which held up classical Greek art as the foremost model to imitate. Having formed a negative opinion of Baroque and Rococo art, Winckelmann's ideas and writings are instrumental in the development of Neoclassicism. **Russia:** Bartolomeo Rastrelli redesigns the Winter Palace in Saint Petersburg.

**1755 France:** Jean-Baptiste Greuze is accepted as a member of the Académie Royale de Peinture et de Sculpture. He takes many years to submit his reception piece, and despite the fact that it was a representation of a historical subject, he is received as a *peintre de genre*. François Boucher is appointed *inspecteur sur les ouvrages* at the Gobelins tapestry factory, following the death of Jean-Baptiste Oudry. At the Salon of 1755, Maurice-Quentin de La Tour exhibits a full-length pastel portrait of Madame de Pompadour. **Germany:** Johann Joachim Winckelmann continues his promotion of the ancient Greek model as the basis for art in his publication *Reflections on the Imitation of the Painting and Sculpture of the Greeks*. **Portugal:** Lisbon is destroyed by an earthquake.

**1757 England:** William Chambers publishes *Designs of Chinese Buildings, Furniture, Dresses, Machinery and Utensils*, which advertises Chambers's firsthand knowledge of Chinese architecture and decorative art as a stimulus for new designs appealing to Western tastes. The text is well received but then becomes the target of vehement attacks by writers and other artists. William Hogarth is appointed sergeant-painter to King George II. Edmund Burke publishes *An Enquiry into the Origin of Our Ideas of the Sublime and the Beautiful*. **France:** As the result of support from Madame de Pompadour, Étienne-Maurice Falconet is appointed director of the sculpture studios at the Sèvres porcelain factory. **Russia:** Ivan Shuvalov founds the Academy of Arts and houses it in his palace in Saint Petersburg. Catherine the Great renames it the Imperial Academy of Arts in 1764.

**1759 England:** Josiah Wedgwood founds a ceramic factory in London and capitalizes on the growing interest in antiquity. **France:** Denis Diderot begins writing criticism of the biennial Salons for Baron Melchior Grimm's *Correspondence littéraire*, a practice he continues until 1781. **Italy:** Pope Clement XIII includes Denis Diderot and Jean Le Rond d'Alembert's *Encyclopédie* and Helvétius's *De l'esprit* in the index of forbidden books. **Spain:** Charles III ascends to the throne of Spain. He opens the Fábrica del Buen Retiro porcelain factory (destroyed 1808).

**1760 England:** George II dies. George III becomes king of Great Britain. The first Society of Artists exhibition takes place in London. **France:** Bernard van Risamburgh begins production of the first porcelain tables for the *marchand mercier* Simon-Philippe Poirier.

**1761 England:**   Allan Ramsay is appointed sergeant-painter to George III. Thomas Gainsborough participates in the second Society of Artists exhibition in London. **France:** Jean-Honoré Fragonard returns to Paris after five years in Rome. Jean-Baptiste Greuze paints *The Village Betrothal* (Musée du Louvre, Paris) to the wide acclaim of critics at the Salons. Jean-Jacques Rousseau publishes his novel of sentiment, *Julie, ou la nouvelle Héloïse*, which includes a description of a garden designed through artful naturalness. **Italy:** Giovanni Battista Piranesi publishes *Della magnificenza ed architettura de' romani* in an attempt to refute the claim made by Johann Joachim Winckelman that Roman architecture was derived from Greek examples.

**1762 Italy:**   Pietro Bracci's *Oceanus* is installed in the central niche of the Fontana di Trevi, thereby completing the monumental fountain in Rome begun by Nicola Salvi in 1732. The Venetian philosopher, scholar, and art critic Francesco Algarotti publishes his treatise *Saggio sopra la pittura*. **Russia:** Death of Empress Elizabeth. Peter III becomes Emperor of Russia for several months until he is assassinated in a palace coup d'etat by his wife, Catherine II. Catherine the Great begins to rule. To differentiate her court from that of Elizabeth, she turns to Neoclassicism as a style in architecture and decoration. **Spain:** The German painter Anton Raphael Mengs, as well as Giambattista Tiepolo and his two sons, Giandomenico and Lorenzo, are all at work on frescoes at the Palacio Real. Mengs is appointed principal painter to Charles III in 1766. Giambattista Tiepolo dies in Spain in 1770. Giandomenico returns to Venice, but Lorenzo remains at work at the Spanish court.

**1764 England:**   Robert Adam publishes *Ruins of the Palace of the Emperor Diocletian at Spalatro in Dalmatia*. Hogarth dies. **Germany:** Johann Joachim Winckelmann publishes *History of the Art of Antiquity*. **Russia:** Catherine II founds the Hermitage museum in Saint Petersburg.

**1765 Austria:**   Joseph II of Austria becomes holy Roman emperor and ruler of the Habsburg Empire (d.1790). **France:** Jean-Honoré Fragonard is accepted into the Académie Royale de Peinture et de Sculpture with *Coroesus Sacrificing Himself to Save Callirhoë* (Musée du Louvre, Paris) with much critical attention and accolade. Jean-Baptiste Greuze exhibits *Girl Weeping over a Dead Bird* at the Salon. François Boucher is appointed *premier peintre du roi* and director of the Académie Royale, succeeding Carle van Loo.

**1766 England:**   The Swiss painter Angelica Kauffman arrives in London, where she lives until 1781. She is one of two women honored in 1768 with founding membership to the Royal Academy. **Germany:** Gotthold Ephraim Lessing publishes *Laocoön: or, the Limits of Painting and Poetry*.

**1767 France:**   Jean-Honoré Fragonard paints *The Happy Hazards of the Swing* (Wallace Collection, London).

**1768 England:**   The Royal Academy of Arts is established in England, with the painter Joshua Reynolds as president. Joseph Wright of Derby paints *Experiment on a Bird in the Air-Pump* (National Gallery of Art, London), one of several candle- and lamp-lit interiors depicting experimentation produced by the artist during the 1760s. **Poland:** King Stanislaus II appoints the Venetian Bernardo Bellotto as court painter. At the request of the king, Bellotto produces a series of views depicting Warsaw as testament to the capital city's development and standing under Stanislaus's rule. **Russia:** Catherine the Great invites the French sculptor Étienne-Maurice Falconet to Saint Petersburg to execute an equestrian monument to Peter the Great.

**1769 England:**   Sir Joshua Reynolds delivers the first of his discourses to the Royal Academy of Arts. He receives a knighthood from George III. **France:** Jean-Baptiste Greuze presents *Septimius Severus Reproaching Caracalla* to the Académie Royale de Peinture et de Sculpture as part of his unsuccessful bid to be received as a history painter.

**1770 England:**   Thomas Gainsborough exhibits *The Blue Boy* at the Royal Academy exhibition. **France:** François Boucher dies.

**1771 France:**   Jean-Honoré Fragonard paints four panels for Madame du Barry's gallery at Louveciennes, known as the *Progress of Love*. Completed in 1773, the series was rejected by Du Barry and replaced with works by Joseph-Marie Vien. Many art historians consider this episode to mark a shift in taste from Rococo to Neoclassicism.

**1772 England:**   Benjamin West is appointed historical painter to George III, the result of success he enjoyed after painting *The Death of General Wolfe* in 1770. **Germany:** Johann Wolfgang von Goethe writes an essay on German architecture, expressing his admiration for Gothic buildings.

**1773 England:**   Robert and James Adam begin to publish *The Works in Architecture of Robert and James Adam* (completed 1778).

**1774 France:**   Louis XVI becomes king of France. **Spain:** At the invitation of Anton Raphael Mengs, Francisco de Goya begins to supply tapestry cartoons to the Real Fábrica de Tapices y Alfombras de San Bárbara, completing a number of lighthearted genre scenes peopled with French- and Spanish-style figures.

**1776 England:** William Chambers begins work on Somerset House. **Germany:** Goethe begins work on designs for a pleasure park with Gothic and Classical follies at Weimar at the request of Duke Karl August of Saxe-Weimar. **American colonies** The American Declaration of Independence is signed by the congressional representatives of the thirteen states of the American colonies, and George Washington defeats the British at Trenton.

**1778 France:** Death of Jean-Jacques Rousseau. Hubert Robert is appointed *dessinateur des jardins du roi*.

**1779 France:** Influenced by a growing interest in revolutionary thought, democratic ideals, and the War of American Independence, the sculptor Jean-Antoine Houdon exhibits portrait busts of Voltaire, Jean-Jacques Rousseau, George Washington, and Benjamin Franklin.

**1780 Italy:** Giacomo Casanova publishes *Il duello*, the first of his autobiographies.

**1781 Enlgand:** Jean-Jacques de Loutherbourg's *Eidophusikon* is performed in London.

**1782 France:** Choderlos de Laclos publishes *Les liaisons dangereuses*. The Montgolfier brothers invent the hot-air balloon.

**1783 France:** The Treaty of Paris ends the American War of Independence; Britain recognizes the independence of the thirteen American colonies.

**1784 England:** Thomas Gainsborough secedes from the Royal Academy of Arts, refusing to exhibit at Somerset House. Sir Joshua Reynolds is appointed sergeant-painter to George III.

**1785 France:** Jacques-Louis David's *Oath of the Horatii* (Musée du Louvre, Paris) is exhibited at the Salon and received with public and critical acclaim. The Diamond Necklace Affair continues to damage Queen Marie-Antoinette's reputation.

**1786 Spain:** Francisco de Goya is appointed painter to Charles III. After the king's death in 1788, he becomes painter to Charles IV. **Sweden:** King Gustav III establishes the Swedish Academy.

**1787 France:** Élisabeth Vigée Le Brun exhibits her portrait, *Marie-Antoinette with Her Children* (Musée National de Château de Versailles, Paris), which attempts to present the queen as a "good mother"; although, the work was not received along these lines.

**1789 France:** Louis XVI summons the Estates-General in May. The National Assembly is formed and a new constitution established. The French Revolution begins with the storming of the Bastille on 14 July.

**1792 England:** Benjamin West becomes president of the Royal Academy following the death of Joshua Reynolds. **France:** The Reign of Terror begins shortly after the National Convention declares France a republic.

**1793 France:** Louis XVI is charged with high treason by the National Assembly and executed. The Louvre reopens as a national museum, called the Muséum Central des Arts, and the Académie Royale de Peinture et de Sculpture is abolished. Jacques-Louis David paints *The Death of Marat* (Musées Royaux des Beaux-Arts, Brussels).

**1796 France:** Artists working in the studio of Jacques-Louis David coin the word "rococo" as a derogatory term sometime between 1796 and 1797.

**1820s:** French art, architectural ornament, furniture, and other decorative objects seized during and after the Revolution of 1789 pour into the international art market, stimulating a taste for Rococo art and giving rise to the various revival styles between the 1820s and 1860s.

**1846 England:** John Weale publishes *Old English and French Ornament*, which reproduced Rococo designs for copying.

**1851 England:** One of the dominant commercial styles in the Great Exhibition in London is the Rococo Revival.

**1855 France:** Alphonse Giroux produces a Rococo-style *secrétaire* for Empress Eugénie, wife of Napoleon III and a prominent patron of the Rococo Revival. Franz Xaver Winterhalter paints *Empress Eugénie among Her Ladies-in-Waiting* (Château de Compiègne), a group portrait that intentionally evokes the elegance of Rococo painting.

**1863 France:** Charles Garnier's inspiration for the interior of the Paris Opéra is Rococo decoration, which becomes more flamboyant and excessive in this revival style.

**1881 France:** Passionate collectors of Rococo art, the Goncourts write the first comprehensive history of the era and style. Three volumes of *L'Art du XVIIIe siècle* are published between 1881 and 1884.

# Introduction

## DEFINING THE ROCOCO

The Rococo is generally defined as a style in art and architecture and as a period in the history of art. Chronologically, this period can be roughly located between 1700, during the final decades of the reign of Louis XIV, and the beginnings of the French Revolution in 1789. France is the point of origin of the Rococo, where it emerged as a mode of interior decoration. It developed as a playful and interactive contrast to the Baroque grandeur and Classical solemnity of the 17th century and flourished through its association with fashionable and aristocratic tastes at the French court and in Paris. Beyond France, its influence spread throughout continental Europe and to the Americas from the 18th century onward, enjoying periods of renewed interest, such as during the Rococo Revival of the mid-19th century.

Rococo art includes a diverse array of media, stylistic variations, and genres. Paradigmatic examples of the Rococo include Antoine Watteau's *fêtes galantes*, François Boucher's pastorals, and Jean-Honoré Fragonard's swinging women. As fantasies of aristocratic leisure, such paintings appear to embody the spirit of the age. These works share a stylistic affinity with garden sculptures by Étienne-Maurice Falconet and Jean-Baptiste Pigalle, which charm through their combination of wit and grace.

Equally representative works of the period include the society portraits of Thomas Gainsborough, the bourgeois dramas of Jean-Baptiste Greuze, and the "modern moral subjects" of William Hogarth. When these are considered in relation to the works of Watteau, Boucher, and Fragonard, it becomes increasingly difficult to determine a unifying set of formal and thematic characteristics. While stylistically incongruous, all these works engage with definitive aspects of the Rococo: innovation, novelty, and commitment to modern picture making. Similarly, Louis-François Roubiliac's naturalistic sculpted portraits, Jean-Baptiste-Siméon Chardin's painterly still lifes, and Francisco de Goya's satirical commentaries set within the Madrid fairs can be considered Rococo because of the way that they manipulate and play with received conventions. In architecture, it is equally difficult to come up with stylistic criteria encompassing the refined delicacy of the Hôtel de Soubise in

1

Paris, the heightened religious aestheticism of Bavarian pilgrimage churches, and the cosmopolitan exoticism of William Chambers's pagoda at Kew.

## Characteristics of an Ornamental Repertoire

While attempts to typify the Rococo style through overarching generalizations are invariably fraught with exceptions and continual reconfigurations, it is nevertheless possible to identify the dominant characteristics of an ornamental repertoire. The Rococo is distinguished by asymmetry, curving and sinuous line, a preponderance of natural motifs, and a serious interest in pleasure, play, and eroticism as themes in art and qualities of artistic expression. It was first and foremost a style of ornament that emerged in designs for the decoration of interiors, especially wood paneling, chimneypieces, moldings, stuccowork, and ceilings, which were painted, sculpted, or carved with highly inventive grotesques and arabesques. Decorative craftsmen excelled as the result of this new taste that revolted against 17th-century Classicism and the Baroque, threatening, to a certain extent, the authority of academic history painting, sculpture, and architecture. Architectonic forms were eroded by ornamentation. Mirrors and decorative stuccowork became the principal features of room interiors, displacing grand painting and sculptural reliefs that were traditionally the focal point on walls and ceilings but were increasingly relegated to over-doors and ceiling coves during the Rococo period. A shift of taste in subject matter accompanied this relegation, with a movement away from narratives conveying heroic virtues to themes of love and leisure.

Watteau was one of the first artists to translate arabesque forms and themes into figural painting. Subsequent generations of Rococo artists continued to explore the affective potential of decorative forms, specifically through sensual techniques that emphasized the materiality of art in service of eroticism. In general, Rococo figure painting is characterized by its use of painterly brushstrokes, softness of palette, and delicate color harmonies that aim to seduce the eye. Compositional space is often flattened out in Rococo painting, with complex figural poses creating surface patterns in cooperation with stage-like landscape or architectural settings. Rococo sculptors similarly began to experiment with unbalanced compositional arrangements and new materials, such as biscuit porcelain and terracotta, to enhance the tactile allure of their art works in tandem with sinuous lines.

As a style of interior decoration, the Rococo was initially confined to the intimate circles of wealthy and mostly aristocratic patrons who were able to pay for updated refurbishments of their urban townhouses and country estates. From interior walls and ceilings, however, Rococo ornamentation spread to the decorative arts, particularly in designs for silverware, porcelain,

and fabrics, as well as furniture. Suites of ornamental prints by Gilles-Marie Oppenord, Juste-Aurèle Meissonier, and Jacques de Lajoüe promulgated the Rococo as the style of civility to a wider audience composed of middle-class consumers. Expanding luxury markets increased the demand for Rococo objects, which were affordable to the bourgeoisie. Moreover, the production of ornamental prints contributed to the dissemination of the French Rococo throughout Europe, which varied the Rococo further as the artists and architects of other countries interpreted the style in accordance with local traditions.

## The Term *Rococo: Rocailles, baroque,* and the *goût moderne*

The etymology of *Rococo* as a stylistic label traces the term back to the French adjective *rocailles*, which was used to describe the rockwork decorating grottoes in gardens as early as 1715. The term *rocailles* was employed by artists and craftsmen in the 1730s and 1740s to designate the ornamental repertoire now considered to be distinctive features of the Rococo: asymmetrical cartouches, *contrecourbe* S-curves and C-curves, shells, batwings and palmettes, among other fantastic, exotic, and natural forms. *Rocaille* appears along with the related *coquillage* (shellwork) to designate these forms on ornamental prints.

Contemporary observations of the style as it appeared in architecture, painting, and sculpture were less specific, calling it "irregular" and "bizarre." Occasionally the term *baroque* was used, not to claim a continuity of style with Baroque art and architecture of the 17th century but to denigrate its asymmetry, lack of verisimilitude, and disregard for the rules of classical proportions. The French philosophe and art critic Denis Diderot, for example, attacked Rococo art using the adjective *baroque* to describe its forms, which he further qualified as "nuances of bizarre."

By the 1790s, *rocaille* was corrupted into *Rococo* as a form of studio slang in Paris. The term may have been conflated with *baroque* at the time through a derogatory and mnemonic play on the French transliteration of *barroco*, a word first used in Portugese to denote irregular pearls (*pérla barroca*) but also appearing in Spanish and Italian usage, and in German as *baroko* (closely related to *rokoko*). Partly because of this confusion of terminology, the Rococo was erroneously analyzed in the early 20th century as a continuation of the Baroque style and, at times, referred to as late Baroque. While art historians, such as Fiske Kimball and Anthony Blunt, subsequently argued that the stylistic designator *Rococo* should be restricted to works that share a discrete set of formal characteristics, current scholarship pursues the Rococo as a playful response to previous traditions and the rules of art.

In the study of French 18th-century art, the catch-all *Rococo* has recently given way to the more historically precise, yet equally vague, term *goût moderne*—a contemporary phrase used to refer to the modern taste of society in the first half of the 18th century, when the Rococo flourished. Even so, at that time, there was no theoretical exposition of the *goût moderne* in defense of its forms and themes. Hogarth's celebration of serpentine and sinuous lines as the ultimate formal expression of beauty came close, but it was not a theory he put into practice in his own art. The first extended characterizations of Rococo art were critiques by artists and writers largely antagonistic to its proliferation. Looking back over the century, these authors referred to the taste for such art as *le goût moderne*, *le goût nouveau*, or *le goût de ce siècle*. It is through the use of these words, however, that the Rococo comes into focus.

Contemporaries described Rococo art as "modern," "new," and "of the 18th century," implying by extension that it was anticlassical, outside of tradition, and not beholden to the past. This characterization accommodates stylistically heterogeneous works, such as Watteau's *fêtes galantes* and Hogarth's "modern moral pictures." While Watteau and Hogarth produced remarkably different paintings of contemporary life, they both created new genres of painting. In addition, their divergent practices responded equally to the fundamental qualities of the Rococo: its thirst for novelty, its boundless capacity for free invention, and its inclination toward abstraction. Indeed, the Rococo is best understood as an inventive rebellion against received artistic conventions and a refusal to be limited by the authority of the past.

## ORIGINS OF THE ROCOCO AT THE FRENCH COURT UNDER LOUIS XIV: AROUND 1700

The emergence of the Rococo in France can be contrasted with the prevailing style of art and architecture produced during the age of Louis XIV, which is marked by its ceremonial ostentation, glorification of monarchical power, and allusions to France as the rightful heir to classical antiquity. Grand Manner Classicism is the stylistic term sometimes used to designate this distinctive mix of Baroque pomp and classical restraint. According to the court memoirist, the duc de Saint-Simon, Louis XIV "liked splendor, magnificence and profusion in everything. He turned this taste into a poetic maxim, inspiring his entire court with it." The king personally motivated work in all the arts. Building projects provided a direct impetus for increased production in painting, sculpture, and garden design throughout Louis XIV's reign, although creative energies peaked between the king's triumphant return to Paris with his new Hapsburg bride in 1660 and the permanent installation of the court

at Versailles in 1682, with significant construction and embellishment of the main château continuing throughout the 1680s. Factory workshops were founded to produce tapestry and furniture, silks, ceramics, crystals, and other materials to decorate the royal châteaux. As a result, the decorative arts achieved unprecedented levels of craftsmanship, making it possible to assert, for the first time, the superiority of France within European luxury markets. Academies of the arts and sciences were also sponsored to better serve the glory of the king. These new institutions were established not only to support the arts but also to codify rules of practice and judgment. There was a general move toward transparency in matters of taste, within which the king became the ultimate arbiter of excellence and achievement. A direct correlation was struck between the products of French genius and the figure of Louis XIV.

While the general stylistic conformity of Louis XIV's reign served the purpose of establishing and maintaining a sense of tradition and monarchic authority for nearly 70 years, it also hindered innovation and variation. The development and refinement of the arts under Louis XIV began to stagnate from the late 1680s onward. Although major projects continued to stimulate artistic output, such as the building and decoration of Trianon and Marly, the king's preference for academic Classicism prevented stylistic experimentation. Nevertheless, the earliest articulation of Rococo forms began in his court. Fiske Kimball, in his influential book *The Creation of the Rococo* (1943), pinpoints the origins of the new style to a series of designs by Pierre Lepautre for chimneypieces produced for Marly in 1699. What distinguished these designs was the transference of arabesque ornamentation normally reserved for panel filling into the framing elements, which broke through the purity of geometric outline. This decorative destabilization of regular interior ornament represented an early challenge to the authority of architectural conventions.

## A New Decorative Idiom: Grotesques and Arabesques

The decorative tendencies associated with the Rococo—sinuous line, asymmetry, and the use of natural motifs—thus appeared around 1700 in the ornamentation of French interiors, specifically as part of the refurbishment of a number of royal châteaux, including Meudon, Marly, the Ménagerie at Versailles, Sceaux, Saint-Cloud, and La Muette. Ceiling decorations, wall panels, and chimneypieces at these and other palaces in the Île de France, as well as *hôtels particuliers* in Paris, were adorned with grotesques and arabesques, making new use of traditional decorative forms. In origin, grotesques were surface decorations found in partially excavated rooms of ancient Roman palaces. They were introduced at the French court during the Renaissance,

but lost favor in the time of Louis XIV, when Classicism dominated. Despite the ancient Roman genealogy, grotesques and arabesques contradicted the classical rules of proportion and geometric ordering. Grotesques arranged animal, vegetal, and architectural forms in intricate and irrational patterns. Arabesques borrowed from grotesques, blending figural and ornamental forms into delicate, airy, fragmented, and exotic designs. Within both genres, conventions of spatial illusion were ignored so that the experience of looking at grotesques and arabesques initiated aimless visual wanderings between patterning and representation. Grotesques and arabesques were enthusiastically revived in the 1690s by early Rococo artists both in architectural ornamentation and in costumes for the *ballet de cour*, masquerades that included the performance of courtiers. Both forms constituted an inherently aristocratic mode of decoration and were appreciated for their playful shifts between illusion and artifice.

Grotesques and arabesques were not the only ornamental designs that began to vie with the prevailing academic Classicism around 1700. Motifs from the theater, comic monkey imagery, and exotic borrowings from China were equally fashionable with aristocratic audiences. These subjects and forms opposed narrative legibility and didacticism, the cornerstones of 17th-century French art under Louis XIV, whose monarchical power was represented in painting by a combination of verisimilitude and the pursuit of higher truths. At the turn of the century, however, these values began to give way to an appreciation of wit and playful deception. In the interior, such a preference was taken to the extreme in the use of large mirrors rather than traditional paintings as panels above fireplaces and consoles. Similarly, the outward display of grandeur and magnificence expressed through the heavy ornamentation of Louis XIV's decorative schemes was rejected in favor of lighter, more delicate forms.

## The Impact of Costly Wars and a Decline in State Sponsorship

Scholars remain divided as to which historical and social circumstances gave rise to the new decorative approaches of the Rococo, although it is generally agreed that a series of costly wars impacted upon building and the arts in France from the late 1680s onward. Some innovation was forced through a change in financial circumstances at court. Silver furnishings belonging to the rich and fashionable were melted down at Versailles in 1689 and again in 1709 to fund ongoing military campaigns. Fine porcelain pieces were ordered in their place so that traditions of grand dining could continue, albeit with new stylistic accents. White and lightly colored porcelain imitated the chasing and molding of silver, but the overall impression was distinctly less

ornate and more graceful. The use of gold in decoration had been banned by royal decree in 1691, which encouraged a return to timber paneling. Large scale building projects gave way to less costly refurbishments and a trend for "little" châteaux and pleasure houses, in either the country or the expanding suburban areas around Paris. These economic and political constraints on elite consumption undoubtedly contributed to the development of the Rococo style, which is accordingly characterized by graceful refinements in decorative form, the use of porcelain as an artistic material, and smaller, more intimate interior spaces.

At the end of the century, state support for the arts in France was so curtailed that the office of *premier peintre*, once held by Charles Le Brun, was left vacant for some 20 years after the death of Le Brun's successor, Pierre Mignard, in 1695. As both of these painters had also led the Académie Royale de Peinture et de Sculpture, this left the artistic institution without significant direction and impetus. It was not, however, completely inactive. Theoretical disputes concerning the authority of the ancients over the moderns were revisited. In 1699, the amateur member, Roger de Piles published his *Abrégé de la vie des peintres*, reigniting the debate by favoring artistic license and celebrating the colorism of the Venetians and Peter Paul Rubens. This provided support for the leading academic painters, Charles de La Fosse and Antoine Coypel, who were increasingly colorist in approach, meaning that they used nuances of color and brushwork to materialize form, rather than hard lines to create the outlines of figures and compositional structure. While both Coypel and La Fosse received significant commissions from the crown for work at Versailles, Marly, and the Invalides in Paris, neither assumed the authority Le Brun enjoyed under the protection of Louis XIV's most powerful minister, Jean-Baptiste Colbert. Moreover, their personal styles in these major commissions largely conformed to the conventions of academic Classicism, albeit reinvigorated with a new decorative exuberance. Established stylistic tastes associated with Louis XIV's reign continued to dominate in official spaces in Paris and at court, but on the peripheries, interesting developments were taking place.

## Genesis of the Rococo: A Suitably "Youthful" Style

In the more intimate spaces of Versailles and other royal châteaux, particularly those dedicated to leisure and entertainment, the genesis of Rococo ornamentation occurred. New arrivals at court, such as the young duchesse de Bourgogne, gave cause for some significant creative departures from standard royal forms of decoration. Dubbed a "walking doll" by some courtiers, Marie-Adélaïde of Savoy came to France to marry the king's grandson at the

tender age of 11. She charmed Louis XIV, and many commented upon the lively spirit she brought to life at court. To please her, Louis XIV ordered the refurbishment of the Château de la Ménagerie in an appropriately "youthful" style. The result involved arabesques and grotesques by Claude III Audran and curvilinear sculptural forms incorporating shells in panel framing by Lassurance. It constituted a dramatic step away from the monumentality of the style of decorations at Versailles and toward the graceful delicacy and playfulness of the Rococo.

The redecoration of the Ménagerie did not, however, signal a wholesale shift in official taste, as it can be understood within the prevailing academic principle of *convenance*, which dictated the necessity of suiting form to purpose. In this case, the function of the place and the age of its intended oc-cupant required a lighthearted approach to decoration. Perhaps what is more important is that the fresh creative ideas for the decoration of the Ménagerie came from artists working within the administrative departments of the king's household, the Bâtiments du Roi and the Menus Plaisirs, which also produced novel decorative schemes of a similar type for the private apartments and châteaux of other members of the royal family. Alternative artistic programs that first articulated the visual vocabulary of forms and motifs associated with the Rococo thus developed from within the world of court culture and were not strictly opposed to the prevailing values and tastes of the highest-ranking nobles at Versailles.

Generalizations about the rise of the Rococo as a pursuit of sensual plea-sure and frivolity, therefore, too often pit it against what is described as the oppressive piety of the final years of Louis XIV's reign. A series of deaths within the royal family between 1711 and 1712, which left a boy of five (the future Louis XV) as the only legitimate heir to the throne in 1715, undoubt-edly dampened any celebratory mood. Nevertheless, the artistic changes that characterized the Regency were foreshadowed by the Sun King's retreat into intimacy and private entertainments at Trianon and Marly, as well as the youthfulness he embraced in doting on the duchesse de Bourgogne and seek-ing to please her through the rejuvenation of life at court.

## THE *STYLE RÉGENCE* AND THE
## RISE OF THE ROCOCO IN FRANCE: 1715–23

While emerging from the designs of artists working under Louis XIV, the initial phase of the Rococo in France is closely associated with the Regency period (1715–23). After the death of Louis XIV in 1715, while Louis XV was still in his minority, Philippe d'Orléans (the former king's nephew) was ap-

pointed regent of France. Shortly afterward, the new regent moved the court from Versailles back to its traditional location in Paris. This has been interpreted as a final — and futile — attempt on the part of members of the old noble families to reassert their authority in politics and culture, which had been eroded through the solidification of absolutism under Louis XIV. The Sun King's decision to move the court to Versailles in the early 1680s caused the balance of power to shift to the personal authority of the king as represented through his magnificent palace, which accommodated the nobility and served as both the seat of government and the center of social life. Paris, in contrast, remained a metropolis but ceased to be associated with the power and glory of king and court. At the beginning of the Regency, the outward signs of the aristocracy's renewed bid for power were visualized through private architectural projects and their ornamentation, which adopted the Rococo as an inventive alternative to the codified visual language of academic Classicism closely linked with monarchical authority under Louis XIV.

A wave of building hit Paris as early as 1700, fueled by financiers flush with profits made during the disastrous late wars of Louis XIV's reign. Luxurious residences began to appear in new fashionable neighborhoods, such as the Faubourg Saint-Germain. The nobility, however, did not return en masse until the regent established the seat of government at his family residence in Paris, the Palais Royal, with the boy-king Louis XV installed in the nearby Tuileries. Nobles of the sword and robe, as well as wealthy members of the bourgeoisie, built or refurbished residences to be close to the new center of power.

## The Regent as a Patron of Rococo Architecture and Interiors

Like Louis XIV before him, the regent set an example with his artistic patronage. The refurbishment of the Palais Royal, which had begun under his father in the last decade of the 17th century, was thoroughly revamped with an increased emphasis on architectural ornamentation. The regent's artistic advisors included a number of men with avant-garde tastes: Pierre Crozat, an enormously wealthy financier and patron of the arts, who hosted one of the most important gatherings of artists and amateurs in Paris during the first two decades of the 18th century; Roger de Piles, an amateur member of the Académie Royale and writer of theoretical treatises on the arts that championed artistic innovation and the seductive qualities of color; Antoine Coypel, a prominent academician and painter with colorist leanings and significant skills in the use of illusionistic painting techniques; and Oppenord, an architect who was more influenced by Italian Baroque decoration than the rational proportions of classical antiquity.

As early as 1701, Philippe d'Orléans had engaged Coypel to decorate the gallery commissioned by his father from Jules Hardouin-Mansart with scenes from Virgil's *Aeneid*. This was a novel choice, but conservative in some respects, as it drew its subjects from a classical epic. Nevertheless, Coypel took significant liberties with his source, omitting episodes and rearranging the sequence of events. The result was an innovative handling of a text from antiquity that abstracted the narrative program. Stylistically, the break with 17th-century French Classicism was equally evident. Areas of color, decoration, and illusionism seduced the eye, drawing the mind away from the subject matter to experience the pleasures of painted decoration. More than anything else, Coypel's paintings at the Palais Royal materialized the triumph of the "moderns" and *rubénisme*, or the colorist side of the color/line debates that began in 1670.

## Aesthetics: The Color/Line Debate

The color/line debates within the Académie Royale paralleled the "quarrel of the ancients and the moderns" that took place in the Académie Française, the institution concerned with the regulation of the French language and issues of judgment in philosophy and literature. Of central concern to those engaged in these arguments was the authority of the past. For both the "ancients" and the *poussinistes* (as the proponents of line were known), the model of classical antiquity, revived in the Renaissance and revisited in the middle of the 17th century by French artists, such as Nicolas Poussin, presented an ideal that could be equaled but not surpassed. The "moderns" and the *rubénisites* took issue with this position and argued for the merits of artistic freedom, claiming that contemporary innovation should not be subjugated to the stricture of rules. These arguments came to a head at the start of the regency, and the significance of the regent's personal support of artists, architects, and theorists within the moderns camp was of considerable influence in the successful promotion of art forms that challenged the authority of the past. As the example of Coypel's *Galerie d'Enée* indicates, this challenge was not an outright rejection of classical sources and inherited traditions but rather generative, creative play with the conventional forms and themes of representation.

In support of these new attitudes to artistic production, the Abbé Dubos, in his *Réflexions critique sur la poésie et la peinture* (1719), written in the early years of the regency, argued against the subjugation of artistic creativity to intellectual laws: "A work might be bad without transgressing the rules [of art], just as a work full of such transgressions is able to be excellent." Merely following rules did not ensure aesthetic value. Instead, the positive success

of art relied upon its appeal to sensation. The subjective reception of a work of art based upon the feelings and emotions that it aroused was, therefore, claimed to be as important as, or even more so than, its objective relationship to narrative traditions of representation and rules of judgment. This "modernist" issue had a formative effect on the types of artworks created by Rococo artists for their audiences, particularly in painting.

## Watteau and the *fête galante*

Rococo painting derives from arabesque forms of decoration. Around 1712, in the hands of Watteau, ornamental motifs and stylistic forms were transposed into figural painting. His *fêtes galantes*, which epitomize the Rococo as a style, are garden scenes of leisure and love, yet beyond this rather general description, their content remains vague, even mysterious. Elegant figures in 18th-century dress lounge in nebulous landscapes, striking languorous poses and engaging in conversation, music, and dance. Viewers cognizant of narrative techniques established during the Renaissance and codified by academic doctrine of the 17th century struggle to derive information from the parts of the painting where it is expected to be found—facial expressions are difficult to discern, and the backs of central figures are turned to the beholder. Emotions, therefore, cannot be read. Similarly, gestures lead to areas of the composition, or even outside of the frame, where no further information can be derived. Often what attracts the viewer's attention is the shimmering quality of fabrics and light, which stimulates an engagement with color and paint. In this way, Watteau manipulated the inherited narrative conventions of painting to produce images that encourage his viewers to prioritize the creative activity of art making over the narrative action of a depicted event or subject.

This insistence upon the viewer's acknowledgement of the creative act and the artfulness of an image, object, or building and its decoration is a defining characteristic of the Rococo. Considerably more important, however, is the engagement of Rococo painting with the manners and mores of its intended audiences—men and women of the 18th century varied by class, gender, and geographical contexts. In the case of Watteau, his paintings engage with elite codes of behavior related to the cult of *honnêteté*, an idealized way of life that defined noble deportment in France from the middle of the 17th century onward. More than simply representing leisure practices of elite society, Watteau's great innovation was his development of a style that embodied the values of his intended viewers, particularly the desirable notion of effortless and artful presentation of the self. By the time the French Rococo reached its height in the 1730s and 1740s, its forms and themes were seen as synonymous with an aristocratic way of life.

## TRIUMPH OF THE ROCOCO: 1723–50

As the Rococo continued to develop within the context of 18th-century interiors, it maintained a close association with elite forms of decoration. Genre scenes were increasingly popular with 18th-century collectors, and portraits continued to be in demand, but major commissions were linked to decorative projects with mythological subjects, which functioned as a sign of their patron's noble status (this included projects for non-nobles who were enormously wealthy and emulated the tastes and cultural habits of the ruling elite). Watteau's innovations with the *fête galante* were influential, but the majority of patrons and artists held on to the use of historical subject matter.

### Rococo History Painting and Decorative Schemes

Still perceived as the highest subject category within academic and court circles, history painting continued to be the preferred component of decorative schemes, primarily through its long-standing association with the decoration of princely dwellings. While noble patrons at the beginning of the 18th century resisted the allegorical transparency of history painting in the service of absolutism (a practice that had gained momentum during the reign of Louis XIV, when the mythological power of Apollo and the historical deeds of Alexander were used as thinly veiled references to the greatness of the king), they retained the perception of an alignment between history painting and elevated social status. Interior spaces in the urban residences of high-ranking or wealthy members of society dedicated to formal and informal socialization still required themes that reflected the eminence of the owner's position, even if such rooms were more intimate in scale and use when compared with the grand public salons found in 17th-century châteaux. When arabesque curves, spatial disjunctures, and color harmonies were fully assimilated into figural history painting in the hands of major Rococo artists, such as François Boucher, Carle van Loo, and Charles-Joseph Natoire, in the 1730s and 1740s, patrons were able to adopt the stylistic novelty of the Rococo while preserving the association between historical subject matter and high social rank. The Hôtel de Soubise is an example of this updated use of history painting within a trend-setting decorative scheme, which departed both formally and thematically from past traditions.

While Renaissance and Baroque art had previously emphasized the importance of narrative clarity and allegorical meaning through compositional choices that enhanced legibility, Rococo history painting maintained only a loose connection to narrative and allegory, with patrons and artists demonstrating a penchant for erotic emphasis in subjects taken from the loves of

the gods. Natoire's portrayal of the *Story of Psyche* in the Salon Ovale de la Princesse (begun 1732) at the Hôtel de Soubise exemplifies this predilection. The tale tells of the seduction of a beautiful maiden by Cupid, and Natoire included episodes that paralleled aristocratic rituals and behavior, such as the toilette. Subject choices appear to have been made based on their potential for an exploration of sensuality, love, and eroticism, rather than an elaboration of moral lessons, which was common practice in allegorical history painting from the 17th century. Moreover, in the Salon Ovale de la Princesse, history paintings are relegated to decorative spaces, in the coves between walls and ceilings, while mirrors are placed in the central panels. Entire decorative schemes revolved around the use of mirrors in Rococo interiors, whose reflective surfaces were intended to multiply and enhance the artful demeanor and dress of the inhabitants. The elegant men and women who occupied these spaces thus became the principal works of art. History painting simply served to reinforce their status as the heirs of princely culture in a "modern" age.

## Maturity: The *style Louis XV* and the Marquise de Pompadour

It is this coalescence of cultural heritage and modernity that marks the mature phase of the Rococo, which can be historically located within the period of Louis XV's personal rule. In France, this phase is so closely identified with the king, it is commonly referred to as the *style Louis XV*. Louis XV's commissions for his private spaces indicate a preference for the Rococo. He ordered the reconfiguration of the Petits Appartements at Versailles into smaller, more intimate rooms and repeatedly patronized the *fête galante* painters, Nicolas Lancret and Jean-Baptiste Pater, as well as the leading Rococo artists of the Académie Royale, Boucher, Van Loo, Natoire, and Jean-Baptiste Oudry. Due to his interest in the hunt, a new subcategory of genre painting developed around his passion for the sport. The king clearly did not favor heroic subject matter or academic Classicism in his private tastes. In building projects, however, which by definition had more public exposure, the royal taste for classical forms in architecture dominated and was no doubt intended as an expression of continuity between his reign and that of his great-grandfather, Louis XIV.

This form of active royal patronage, through large-scale architectural projects and official sponsorship of the academies and luxury manufactories, was encouraged from 1745 onward by Louis XV's official mistress, the marquise de Pompadour, and the members of her family who assumed positions of influence in the king's administration of the arts. Of bourgeois origins, Pompadour was under enormous pressure to fit in at court. For decades, wealthy members of the third estate had emulated the habits and customs

of the nobility. Pompadour's presentation at Versailles was the ultimate test of the bourgeoisie's ability to assimilate court culture. In her private commissions and collecting practices, Pompadour and her family pursued the Rococo. Pompadour was the most important patron of Boucher, Van Loo, and Étienne Maurice Falconet and was personally involved in the porcelain manufactory of Sèvres, helping to maintain the king's support for French porcelain production. Pompadour's favorite artists were recruited to supply artistic designs for functional and decorative items, which served to spread a taste for French Rococo art among collectors of luxury objects throughout Europe. Her support for Rococo artists and art forms was, in part, a reflection of the status to which she originally aspired and had ultimately risen. Publicly, this encouragement of the king's interest in the decorative arts was exerted in an effort to present Louis XV as heir to the golden age of French art under Louis XIV. It is for good reason that Pompadour has been called a "female Colbert," in reference to Louis XIV's influential minister who was *surintendant* of the Bâtiments and closely involved in the administration of the Académie Royale.

## THE ANTI-ROCOCO REACTION, SALON AUDIENCES, AND OFFICIAL ATTEMPTS AT REFORM: 1750–89

Although Pompadour was barred from holding administrative offices due to her gender, her relationship with the king allowed her uncle, Lenormand de Tournehem, and brother, the marquis de Marigny, to secure in sequence the directorship of the Bâtiments du Roi. Through this office, the family was able to shape the short-term future of the arts in France via their oversight of all public and private commissions extended by the crown and the institutional structures of the academies. Tournehem and Marigny's direction was largely aimed at reinvigorating the French school through the promotion of heroic subject matter and the principles of Classicism, although their efforts were curtailed by the lack of state funds available for significant commissions involving history painting. While the actual outcomes of Tournehem and Marigny's official encouragement of a return to academic history painting was minimal in terms of artistic achievements, their reformatory mandates coincided with the growing anti-Rococo sentiment of critics at the biennial exhibitions of works by members of the Académie Royale, known as the Salons.

Several high-ranking academicians were also in favor of reform, including Charles-Nicolas Cochin, who had accompanied Marigny as a young man on a grand tour of Italy and wrote a number of theoretical treatises on the art of

antiquity. Cochin published two satirical articles in the *Mercure de France* in 1754 and 1755 that launched a scathing attack on Rococo forms of decoration, principally by lampooning the most famous ornamentalists of the 1720s and 1730s: Oppenord, Meissonnier, and Nicolas Pineau. His rhetoric was directed at discrediting their art by associating it with the work of artisans, rather than educated academicians. For both Cochin and his patron, Marigny, the aim was to reestablish the cultural reputation and standing of the academic institution as a demonstration of the king's ultimate authority in matters related to the arts. They did not intend to discredit the work of high-ranking academicians, such as Boucher, who was attacked by critics at the Salons claiming to speak on behalf of the public.

## Art Critics and the Minor Genres

Art critics, who were neither patrons nor practitioners of art, began to denounce what they viewed as the diminished state of the arts in France from the late 1740s onward. Étienne La Font de Saint-Yenne and Diderot are the most well known, but there were many others who wrote extensively of the decline of French painting, in particular, into decoration and an overly artificial manner. One critic, writing at the Salon of 1757, complained that there was "too much of a mere application of method, above all in terms of color." Anti-Rococo critics called for a return to heroic subject matter and verisimilitude in art. When they could not find academic history painters who pursued these types of themes and forms, they turned to artists who worked in the minor genres, in whose works the critics claimed "nature" and "truth" could be seen. Diderot, for example, praised the still lifes of Chardin, the landscapes of Joseph Vernet, and the bourgeois dramas of Greuze.

While these artists produced scenes that were familiar to the public and based on a close study of nature, they did so in personal styles that were equally appealing to elite patrons and collectors. Chardin's painterly impastos, Vernet's inclusion of delightful details, and Greuze's handling of richly colorful hues signal their connection with the highly aestheticized formal vocabulary of the Rococo. Moreover, in their extension of that vocabulary into the treatment of subject matter that appeared modern in its links with the everyday world of more common 18th-century viewers, these artists pursued the creative possibilities of the Rococo originally laid out in the art of Watteau. What had changed, partially in response to the new audiences generated by the Salons, was the definition of modern life. Watteau's paintings were primarily concerned with the leisure pursuits of a ruling elite, but by the middle of the 18th century, the subject had widened to include the tastes and experiences of a socially diverse public.

## New Audiences, New Approaches

Salon audiences impacted upon the established systems of patronage and academic status in France in unanticipated ways that encouraged the independent creativity of the artist. Moreover, the market for luxury goods increased to such an extent during the second half of the 18th century that many artists were able to maintain thriving careers that did not include participation in the activities of the Académie Royale or the systems of royal patronage. Fragonard, one of the last great Rococo painters, followed this path. Despite an early career that involved training with Boucher, winning the *Prix de Rome*, and a Salon debut in 1765 that was celebrated by academicians and critics alike, Fragonard never sought full membership with the Académie Royale and stopped exhibiting at the Salons after 1767. Instead, he sold his works directly to private collectors and through dealers and was able to secure a number of important decorative commissions for wealthy patrons, including his cycle known as the *Progress of Love* (1771–73, Frick Collection, New York), painted for Louis XV's last official mistress, Madame du Barry. Art historians often consider the infamous rejection of this cycle and its replacement by another series of decorative panels that were more Neoclassical in style and theme, painted by Joseph-Marie Vien, as a marker signaling the end of the popularity of the Rococo among elite patrons in the 1770s.

The significance of the Rococo extended beyond its status as a fashionable trend in art. It was a modern approach to art making that contributed to the growing independence of artists from traditional patronage systems and institutional structures. Although the rejection of a major decorative commission would have had financial consequences for Fragonard, he was not beholden to the favor of individual patrons, or even the Bâtiments du Roi, for the continued benefit of his career. Similarly, Greuze, who had made a name for himself through widespread public acclaim of his bourgeois dramas, survived the insult he endured at the hands of academicians when he was received into the Académie Royale as a painter of genre, rather than history, which limited his ability to progress through academic hierarchies. While he refused to participate in the Salons as a result, Greuze sought out alternative venues, exhibited his works to the public in his studio, and sold actively on the open market.

The examples of Fragonard and Greuze indicate the extent to which Rococo artists liberated themselves from institutional structures in France. For the aspiring history painter, however, there remained only one path to official success, which was through the Académie Royale. From 1774, when Louis XVI assumed the throne, the Bâtiments du Roi was under the direction of the comte d'Angiviller, who was committed to enlightened reforms. Somewhat autocratic in his administrative approach, d'Angiviller put in place a number of initiatives

within the Académie that were designed to revive the French school, namely through the support of heroic history painting. While style was not dictated, it was clear that official favor was given to young artists who conformed to the growing preference for art following the models of antiquity and 17th-century Classicism. Jacques-Louis David was just one of the artists who made stylistic and thematic choices that were consistent with official tastes, which had shifted decidedly toward Neoclassicism. Pursuit of the Rococo continued in the 1770s and 1780s, but artists who followed this path did so independently of state-sponsored institutions. Even so, during the French Revolution, Rococo art was so closely aligned with the tastes of absolutism under Louis XV that it became untenable, whereas Neoclassicism was reconfigured as the art of a revolutionary era. Outside of France, however, additional political and social meanings were attached to the Rococo, which made it not only a visualization of absolutist authority in Central Europe and Spain but also a hallmark of artistic genius in Venice and an oppositional protest in Great Britain.

## BEYOND FRANCE: THE INTERNATIONAL ROCOCO

An international interest in contemporary French rocaille forms and arabesques immediately followed their appearance in the first decade of the 18th century. Many artists and patrons traveled throughout Europe, increasing the circulation of ideas and the dissemination of styles, which was aided further by the publication of ornamental prints in the 1730s and the expansion of trade in luxury markets. In some parts of Europe, the influence of the Rococo was confined to the decorative arts, where artisans incorporated the latest designs they knew from French prints into carved and chased objects. This was the case in the Netherlands, where wealthy merchants and burghers appreciated the superior craftsmanship of Rococo furniture and decorative objects. A similar taste for the Rococo is found in the Americas, where craftsmen learned its ornamental repertoire through prints and subsequently updated the forms they employed in wood-carved furniture and fine silverwork to express a sense of European refinement in the colonies. Throughout most of Europe, however, the Rococo was adopted as a style of architectural ornamentation that transformed local traditions in ecclesiastical and secular building projects, as well as in painting, sculpture, and garden design.

### Central and Northern Europe: The Rococo and Princely Absolutism

Among the best-known patrons who imported the latest French trends to Germany was the Elector Maximillian II Emanuel, a member of the Wittelsbach

family who spent an extended period of time in exile at the court of Louis XIV. Not only did he bring back a taste for the extravagances of Versailles, but also he arranged for his own court architect to train in Paris and brought French artists and gardeners to work at his residences and for other members of his family. This enthusiasm for the French Rococo in Southern Germany resulted in one of the most innovative realizations of Rococo architecture outside of France, the garden pavilion of Amalienburg, which materialized, in three-dimensional form, Rococo arabesques that had only been proposed as graphic designs within French ornamental prints. An example of the Bavarian Rococo, Amalienburg is just one of many architectural wonders produced in the region as the result of patronage by prince-bishops and electors, which extended to their private residences and to ecclesiastical projects that were under their control.

For the most part, princes ruled Central Europe (several of whom became kings), and court life centered on the residence. As in France, the Central European residence was the seat of court and government, as well as the ruler's principal home. It was governed equally by the dictates of custom and ceremony, becoming a theater for self-presentation. Palaces were rebuilt and modernized with the intention of visually expressing the political authority and cultural standing of the ruling family. German princes, in particular, were dazzled by the resplendent examples of Versailles, Marly, Meudon, Saint-Cloud, and Sceaux and adopted the model of French château architecture in order to emulate their grandeur. Although a famous Francophile himself, Frederick the Great of Prussia noted, with a degree of contempt for his fellow 18th-century rulers of Central Europe, "There is not one of them, down to the youngest son of a youngest son of an appendaged line, who does not preen himself on some resemblance to Louis XIV. He builds his Versailles; he has his mistresses; he maintains his standing armies." Significantly, the versions of Versailles that these rulers built appropriated the later Rococo forms and seamlessly incorporated them into the grandeur of their primary model. Although historically the Rococo is the style of the Regency and reign of Louis XV, to Central European rulers of the 18th century, it symbolized contemporary absolutism and perfectly embodied their princely aspirations.

The Bavarian Rococo and the Frederican Rococo (as the art produced under Frederick the Great is known) did not simply adopt the French Rococo without modification. It was adapted to their specific purposes and refashioned by centuries of highly developed workshop traditions and skills in engineering that enabled extraordinary decorative excesses in woodcarving, stuccowork, and fresco painting by collaborative teams of artists, as well as the architectural innovations of Balthasar Neumann, arguably the greatest Rococo architect in all of Europe. Working primarily in the service of the

Schönborn family, who, as prince-bishops, commissioned work on a number of churches and palaces in Southern Germany, Neumann transformed architectural traditions based on the classical orders to place greater emphasis on the molding of interior space. Walls and masses are often interpreted negatively, turning architecture into a shell for decoration. The Zimmermann and Asam brothers similarly transformed architectural elements through curvilinear moldings and stuccowork that eroded structure and complemented painting and sculpture to create an effect of opulent synergism.

Many of the artists and architects working in Southern Germany exploited the freedom of invention inherent to the Rococo and pushed architectural ornamentation to its limits, to a point where it verged on abstraction, divorced from any relationship to recognizable architectonic forms. In the specific context of the Bavarian Rococo church, however, this drive toward architectural and decorative innovation was stimulated by a desire to express the joy of religion and to communicate the presence of the divine in aesthetic beauty. It merged with the related purpose of demonstrating the secular magnificence of the ruler, which resulted in the elaboration of Rococo decoration on a grand scale. A prime example is the decorative scheme created at the Würzburg residence by Giambattista Tiepolo during the early 1750s in response to Neumann's architectural innovations. Working with his sons, Tiepolo produced allegorical history paintings that were fitted into existing spaces already determined by the placement of windows, and decorated with mirrors, stucco, and gilding. Although the themes were heroic in tone, the paintings were only one part of an all-encompassing decorative scheme that reduced the didactic impact of their content, thus running counter to Renaissance and Baroque traditions of allegorical representation. As with architecture, artistic conventions were made subservient to the aesthetic impression of the whole, which expressed monarchical grandeur through an excess of autonomous ornamentation.

In comparison with the rapid expansion of the Rococo through new building projects in Southern Germany and Prussia, the impetus for the development of a distinctly Austrian Rococo was stifled, to a considerable degree, by Empress Maria-Theresa's focus on interior decorative schemes. For reasons of economy or as an expression of continuity with her father's reign, Maria-Theresa mostly commissioned extensions and refurbishments of existing royal residences, which retained a stylistic emphasis on the Baroque. Austrian Rococo interiors were, nevertheless, exceptional in the relationship struck between furniture design and wall decoration, blending the two into a single visual element.

In Sweden, Rococo art was avidly commissioned and collected by members of the Swedish royal family and high-ranking noblemen. In their efforts,

these patrons were greatly assisted by the activities of Swedish grand tourists and diplomats, such as the comte de Tessin, who has been described as a cultural spy. While Tessin identified preeminent artists, like Giambattista Tiepolo, the Swedish court lacked the necessary resources to engage their services. Collectors did acquire a number of individual works, but commissions of large-scale decorative schemes by major Rococo painters were beyond their reach. As a result, some of the most significant holdings of French Rococo art are in the National Museum of Sweden, but the development of a Swedish Rococo was largely derivative.

Throughout the 18th century, the Russian imperial court pursued substantial building projects, attracting architects and artists from all parts of Europe. The French Rococo first appeared as a mode of interior decoration at Peterhof, introduced by the panel carvings of Nicolas Pineau. As part of the Petrine revolution, this novel form of ornamentation melded into Baroque palace architecture as a unified expression of imperial authority that increasingly looked toward the West for its cultural models. Further development of the style took place in Russian garden design, with intimate pleasure pavilions and playful follies given French names to reinforce the connection with Rococo forms. More spectacular was the Russian response to chinoiserie, with an extensive "Chinese" village constructed for Catherine the Great at Tsarskoye Selo. This extraordinary creation extended the fantasy of Rococo exoticism to implicate an imperialist ideology. Russia looked both east and west to extend its empire, and chinoiserie combined the cultural forms of both worlds. In the end, however, the Rococo was less capable of expressing the ambitions of Catherine the Great than Neoclassicism, which could situate the Russian empire culturally, geographically, and temporally as the modern heir to classical antiquity.

## Spain and Portugal: Vernacular Translations of a French Import

Reception of the Rococo in Spain was considerably different from elsewhere in Europe. It was simultaneously an expression of a shift of monarchical authority, from that of the Hapsburgs to the Bourbons, and a contemporary style that brought alternative formal and thematic options to the attention of Spanish patrons and artists alike. When Philip V, the grandson of Louis XIV, assumed the throne as the first Bourbon king of Spain in 1701, he imported the tastes he had developed at Versailles into the Spanish court, largely as a sign of a political and social alliance with France. For nearly two centuries, the Hapsburg kings of Spain had created a public image based on austerity and conservative cultural values, typified in architecture by El Escorial, and in painting by the sober portraits of Philip IV by Diego Velázquez.

By contrast, the house of Bourbon forged its identity through expressions of grandeur and magnificence in building projects, such as La Granja de San Ildefonso, and alternative modes of court portraiture in direct opposition to the visual conventions of the Hapsburgs. The new monarchs also expressed their discontent with the quality of paintings by local artists. Queen María Luisa of Savoy claimed in 1712 that she could send no royal portraits to Versailles until a French painter was found to work at the Spanish court. As a result, French artists began to flood into Madrid, bringing with them not only the traditions of Grand Manner portraiture but also knowledge of the latest stylistic and thematic developments taking place in Paris at the time, informed as they were by the Rococo.

As at the princely courts of Central Europe, the Rococo in Spain was not seen in opposition to the Grand Manner style of Louis XIV but as an updated extension of those tastes. Consequently, the Rococo flourished primarily in the decorative arts in Spain, particularly in furnishings for the royal palaces. While history paintings, allegorical frescoes, and palatial architecture remained largely conservative in their late-Baroque and Classical idioms of grandeur and magnificence, tapestry cartoons presented artists such as Francisco de Goya and Francisco Bayeu with the opportunity to conceptualize subjects of their own that illustrated contemporary life in Madrid. Intended for the decoration of private royal spaces, it is these works that provide the evidence of a Spanish Rococo.

Although influenced by *fête galante* imagery and subjects first developed in France, Goya introduced distinctly Spanish motifs by representing members of the lower classes in Madrid and their pastimes. Moreover, he recast the timelessness of the generic pastoral image in a specific Spanish location enacted by figures in contemporary guise, often with satirical overtones. While Goya's tapestry cartoons were bold and startlingly modern in their critical reconceptualization of inherited conventions, they also appealed to conservative court tastes through their links to the pastoral nostalgia of the French Rococo.

In Portugal, the Roman Baroque tastes of King John V continued to dominate in art and architecture during the first half of the 18th century. The Rococo style was known through the presence of French artists, such as Jean Ranc, who moved from the Spanish to the Portuguese court in order to work for John V. Still, the king did not encourage its further development as a major style at his court. John V's preference for Chippendale-style furniture was his only real concession to Rococo forms. Despite the lack of interest exhibited by the crown, Rococo themes of leisure and love percolated through the craft of Portuguese polychrome glazed tiles, or azulejos, which were a central feature of garden designs. Portuguese azulejos represent a uniquely regional response to the Rococo.

## Peripatetic Italian Artists and the Venetian Rococo

In many parts of Italy, the Baroque endured without interruption until the rise of Neoclassicism, the epicenter of which was Rome. Venice was the exception. Tiepolo was one of many Venetian artists who were consistently employed at foreign courts in Central Europe and Spain. They attracted the attention of English patrons as well. Venetian artists were sought out for their superior skills as colorists and in fresco techniques. While Venice was a prime destination on the grand tour, a journey undertaken by young noblemen to augment their education, opportunities for artists were limited in the city, in part owing to the political and economic deterioration of the Venetian republic during the 18th century. View paintings (*vedute*) and portraits were in demand, especially among English grand tourists, as were representations of the customs of Venice. Such tastes encouraged Venetian artists to focus on the qualities of modern life and the unique scenery of the city and its surrounds, leading to innovations in form and theme that rivaled those of their French contemporaries. Moreover, the fame of the most talented Venetian painters led to invitations to travel to other cities and courts throughout Europe. Rosalba Carriera, Canaletto, Francesco Guardi, Antonio Pellegrini, and the Tiepolos had largely itinerant careers, which enhanced their reputations and extended their networks of acquaintances to an international mix of artists, connoisseurs, collectors, and dealers. It also increased the international exchange of ideas and working methods. Rosalba's stay in Paris as the guest of Pierre Crozat, for example, stimulated new modes of informal portraiture and the increased use of pastels by French Rococo artists. The cosmopolitanism of a specifically Venetian decorative idiom is owed to the circulation of these artists, who were celebrated for their nonacademic styles, the lightness of their touch, and their use of luminous, fresh colors that appealed to broadly international Rococo sensibilities, disconnected from their French origins.

## A Cosmopolitan Style: The English Rococo

The Rococo's ability to be simultaneously old-fashioned and avant-garde is one of the paradoxes of art history. In the 18th century, it was regarded as a style that originated in French decorative traditions, yet it was often reclaimed as a cosmopolitan style that arose from the cross-pollination of international circles of artists and patrons outside of France. This is perhaps most true of the Rococo in England. The military and commercial treaty negotiated in 1711 between France and England made it easier for French artists to travel to England and work for English patrons. Watteau arrived in London around this time to capitalize on the interest English collectors had taken in his work,

but he was by no means the first French artist to make the journey. A number of French engravers and decorative artists immigrated to England in the late 17th century as a result of the expulsion of the Huguenots from France. Many of these refugees were excellent craftsmen, with skills in metalwork, engraving, and carving that outstripped the lackluster local competition. These artists maintained high standards of craftsmanship and workshop traditions in England, which served to train their descendants and kept abreast of new stylistic developments in France. While a taste for Rococo painting was evident in England from 1720 onward, stimulated by the circulation of engravings after Watteau's art and the development of the conversation piece by his principal follower, Philip Mercier, it was the next generation of Huguenot émigrés who ushered in the novel forms of the *genre pittoresque* during the mid-1730s. The influx of engravers, sculptors, and decorative painters from France, Italy, and Central Europe in the early 18th century was, however, less the result of religious persecution than a response to the increased opportunities created by an expansion of patronage in England. Patrons, such as Frederick, the Prince of Wales, Lord Chesterfield, and Charles Montagu, sought stylistic alternatives to the conventional Palladianism that dominated English architecture and interiors. For these men, the Rococo was primarily an expression of their receptiveness to pan-European tastes that countered the provincialism and staleness of English artistic traditions.

Foreign-born artists pursued careers in England through narrow circles of contacts among patrons, largely circumscribed by political and social ties. While this situation presented some opportunities for the exchange of working methods and ideas, it was at the Saint Martin's Lane Academy, founded in 1735 and "principally promoted" by William Hogarth, that the cosmopolitan character of the English Rococo took shape. The Academy in Saint Martin's Lane brought together a number of like-minded artists of different nationalities to teach drawing. These artists were motivated by a common interest in the progress of the arts in England, which included an openness to forms, subjects, techniques, and tastes imported from continental Europe. Many of these artists congregated at Old Slaughter's Coffee House, which was described by George Vertue in 1739 as "a rendezvous of persons of all languages and Nations, Gentry, artists and others." While life drawing was undoubtedly the major focus of the academy's activities, the French engraver Hubert-François Gravelot was listed as the principal teacher of "design" and promoted an ornamental approach to figure and composition that was Rococo in character. Nevertheless, the Rococo, as it existed within the Saint Martin's Lane Academy, was never exclusively a matter of style. It was also connected to the desire to raise the standards of artistic production in England in order to compete with imports and to expose young artists and architects to alternative

models that would inspire creativity and invention in contemporary art to rival the achievements of the past.

As a classical metaphysician, the Earl of Shaftesbury was not a proponent of Rococo tastes, preferring the Platonic and Aristotelian theories of beauty and art. His ideas, expressed in *Characteristics of Men, Manners, Opinions, Times* (1711), about the relationship between contemporary art and the formulas of the past indicate the mood of many British artists and writers concerned with matters of aesthetics and modern experience during the first decades of the 18th century: "To copy what has gone before can be of no use . . . . To work originally, and in a manner create each time anew, must be a matter of pressing weight, and fitted to the strength and capacity of none but the choicest workmen." This statement helps us to situate the ambitions of Hogarth as an artist in relation to the English Rococo, even though his populist "modern moral subjects" appear to be diametrically opposed to the elitist decorative pleasures of the French Rococo. Hogarth went further than Shaftsbury in rejecting "the blind veneration that is generally paid to antiquity" to argue instead for art that was "appealing to the eye, and common observation." Hogarth's aesthetics, articulated in his *Analysis of Beauty* (1753), was based on the direct experience of objects in nature, namely the sinuous lines of a living, beautiful woman, whose features and appeal he describes in terms of intricacies, variety, and curiosity, which keep "the eye and mind in constant play" with "imaginary pursuits." It would be difficult to conjure up a more provocative description of the aesthetic impulses of the Rococo.

Like many of the other artists in the Saint Martin's Lane Academy during its formative years, Hogarth was initially motivated by the threat of imported artworks from continental Europe. In the 1730s, collectors preferred ancient and foreign art over local contemporary output, and dealers encouraged this taste through their expanding trade practices. By supporting a cosmopolitan academy, the thinking was that future generations of English artists would be trained through direct exposure to the skills and methods of foreign artists and the English school would thereby prosper. The situation had changed by 1750, following the outbreak of war once again between France and England in 1745, which led to increased anti-French sentiment. Many French-born artists who had flourishing careers in London, such as Gravelot, left England at this time. A backlash against the Rococo as a French import increased, and nationalistic rhetoric accompanied criticism of the style in painting, architectural ornamentation, and garden design. Nevertheless, the spirit of the Rococo and its challenge to the authority of antiquity remained. In the early 1750s, there was mounting support for the foundation of a state-sponsored academy of the arts in England, and the artists of Saint Martin's Lane were divided over whether or not instruction should begin with copying casts of canoni-

cal sculptures and teaching the rules of art treatises or by drawing from the live model and an emphasis on direct experience. Hogarth presented a strong case for the latter in *The Analysis of Beauty*, specifically through recourse to a Rococo aesthetic, which he redefined in relation to "common observation." The Rococo in England thus evolved from its French formal and thematic origins into a thoroughly modern approach to artistic training and aesthetic judgment theorized by Hogarth. His treatise is more than a rationalization of Rococo forms. It signals a shared subversiveness that served to unite works of considerable stylistic and thematic diversity under the rubric of "Rococo art."

## THE SCOPE OF THIS DICTIONARY

In this book, the Rococo is considered broadly as connected to the cultures and aesthetic ideas of 18th-century Europe. As the Rococo was centered in France, the majority of the entries address French artists, architects, patrons, institutions, critics, and terminology, although significant attention is also given to major figures connected with the Bavarian, Frederican, Spanish, Venetian, and English Rococo. In nations where the Rococo had less significant impact or coexisted as a minor movement alongside the Baroque and Neoclassicism, such as in Austria, Poland, Portugal, Russia, and Sweden, country entries bring together general information about the production, collection, and reception of Rococo art.

There are a number of major 18th-century artists and architects who are not included, such as Anton Raphael Mengs and Antonio Canova, because it is felt that their works are more properly considered in connection to the rise of Neoclassicism and can, therefore, be found in the *Historical Dictionary of Neoclassical Art*. Other artists whom readers may be surprised to find in a book dedicated to Rococo art, such as Francisco de Goya and Jacques Louis David, are included because of their strong connections with Rococo tastes early in their careers. Similarly, artists and architects who worked primarily in the 17th century are commonly associated with the Baroque, which is covered by entries in the *Historical Dictionary of Renaissance Art*.

# A

**ABSOLUTISM.** The consolidation of monarchical power during the 17th century led to the increased unification of the state and the decreased influence of the nobility across Europe. It was largely based on the divine right of kings, a philosophical and religious principle that allowed the monarch to claim that his authority was derived directly from God and that he was not subject to the will of the people, the church, or the nobility. Absolute rulers used their **patronage** of the arts and **architecture** as a visual manifestation of their power and magnificence. **Louis XIV** is the archetypical absolute monarch, and his example was emulated throughout Europe, with great rulers and minor nobles alike building and furbishing residences modeled after **Versailles**. *See also* AUGUSTUS III; AUSTRIA; BOURBONS; COLBERT, JEAN-BAPTISTE; FRANCE; FREDERICK THE GREAT; LOUIS XV; LOUIS XVI; RUSSIA; SPAIN.

**ACADÉMIE DE SAINT-LUC, PARIS.** The Communauté des Maîtres Peintres et Sculpteurs de Paris, or guild of artists and artisans, was officially renamed the Académie de Saint-Luc in 1723, although it had been known by this name from the middle of the 17th century, when Simon Vouet became its first president. It held exhibitions in **Paris** between 1751 and 1774, providing an important alternative venue to the official **Salons** of the **Académie Royale de Peinture et de Sculpture**, especially for **women** artists. During the 18th century, the Académie de Saint-Luc was involved in a number of lawsuits through which the directors attempted to enforce their legal entitlement to the restricted manufacture of decorative arts and other luxury objects for the benefit of its members. This rival institution to that of the Académie Royale was abolished by royal decree in 1776, along with all corporations.

**ACADÉMIE ROYALE D'ARCHITECTURE.** The architect François Blondel and Louis XIV's minister **Jean-Baptiste Colbert** established **France**'s official academy of **architecture** in 1671, with Blondel installed as its first director. As with the other academies instituted in this period, it was intended to develop the theory and practice of architecture in France and

to search for objective standards of beauty. Blondel's *Cours d'architecture* (1675) is based on lectures he gave at the academy in which the antique is held up as the preeminent model for French architectural design and the pursuit of ideal proportions in the orders is argued to be paramount to the success of a building. The debates between the ancients and moderns took place in this academy as well, with arguments stemming from the polarized teachings of Blondel and the "modern" **Charles Perrault**, the latter championing empiricism and custom in opposition to the rationalist doctrine of the ancients. *See also* CLASSICISM; QUARREL OF THE ANCIENTS AND THE MODERNS.

**ACADÉMIE ROYALE DE PEINTURE ET DE SCULPTURE.** Established through an official petition to **Louis XIV** in 1648 and modeled on Italian academies constituted in the previous century, the founding members of this academy intended to advance the plastic arts and the status of painters and sculptors in **France** through a rather loose program of art education based around theoretical lectures and courses in life drawing. In 1663, it was brought under the protection of **Jean-Baptiste Colbert**, who sought to use academic institutions as instruments of the state with the purpose of glorifying the king.

The first chancellor of the Académie Royale, Charles Le Brun, instituted a series of *conférences* based on **paintings** in the royal collection. It was during these lectures in 1671 that the **color**/line debate broke out, which coincided with the larger intellectual struggle between the ancients and the moderns. For most of the 17th century, line dominated academic teaching through its emphasis on drawing. By the 1690s, however, the theories of **Roger de Piles** celebrated color in painting for its unique ability to appeal to the imagination. De Piles' ideas were of central importance to the next generation of artists, many of whom, such as **Antoine Watteau**, chose to work outside the official academic structures.

The institutional structure of the Académie Royale contributed to the perception of a hierarchy of genres. Only those members received as history painters or sculptors (who took historical, mythological, or biblical stories for their subjects) could become professors, and the higher offices were filled from the professoriate. The *premier peintre du roi* was always chosen from the academic rank of history painters, a position held by leading Rococo artists, including **Antoine Coypel** (who served the regent, **Philippe II, duc d'Orléans**, in this capacity from 1715 to 1722); **Charles-Antoine Coypel** (from 1747 to 1752); **Carle van Loo** (from 1752 to 1765); **François Boucher** (from 1765 to 1770); and Jean-Baptiste Pierre (from 1770). These regulations and privileges instilled the preeminence of historical subject matter above all the other categories, including **portraiture**, landscape, and still life.

A number of leading Rococo artists were admitted not as history painters but as painters of *fêtes galantes* (a category created for Watteau); animals and fruits (**Jean-Baptiste-Siméon Chardin**), and **genre** (**Jean-Baptiste Greuze**). Moreover, the talents of **women** artists were encouraged toward the "lesser" genres and the number of female members was limited to four at any one time. As women were barred from academic drawing classes that provided foundational training for the treatment of historical subject matter through a focus on the nude, artists such as **Élisabeth Vigée Le Brun, Adélaïde Labille-Guiard**, and **Anne Vallayer-Coster** had little choice but to specialize in portraiture and still-life painting as genres deemed appropriate to their sex.

During the 18th century, the Académie Royale sponsored art prizes for its students, such as the *Prix de Rome*, and mounted regular exhibitions of works by its members, known as the **Salons**. These events gave increased access to contemporary paintings and sculptures and prompted the development of the new and powerful voice of the art critic, who was neither a practicing artist nor an experienced collector but claimed to judge art on behalf of the public. Outside of the official Salons of the Académie Royale, there were few venues in which to exhibit works of art, particularly after the dissolution of the guild-based **Académie de Saint-Luc** in 1776. For the next five years, artists who were not members of the Académie Royale had no venue to display their works until the establishment of the Salon de la Correspondance in 1781. *See also* AESTHETICS; COYPEL, ANTOINE; DIDEROT, DENIS; LA FONT DE SAINT-YENNE, ÉTIENNE; QUARREL OF THE ANCIENTS AND THE MODERNS; SCULPTURE.

**ACCADEMIA DI SAN LUCA, ROME.** Established by papal decree in 1577, this association of artists inaugurated an educational program that attempted to bring together the theory and practice of **painting**. During the 1630s, the Roman academy hosted a series of theoretical debates between Pietro da Cortona and Andrea Sacchi over the proper disposition of history paintings, which prefigure the **color**/line debates in the French **Académie Royale de Peinture et de Sculpture** later in the century. The guild and the academy were effectively amalgamated in **Rome**, and an elite group of academicians (usually history painters) presided over the broader confraternity of artisans, which included craftsmen as varied as embroiders and **stuccoists**. The academy and company thereby controlled artistic production in Rome from the 16th century onward.

During the 17th century, the academy increased its power and prestige by excluding foreign artists and artisans from the privileges enjoyed by academicians, such as the exclusive right to provide expert appraisals. Painters specializing in minor genres were admitted in the 18th century, as were a few

**women**, such as **Rosalba Carriera** and **Élisabeth Vigée Le Brun**. While there was no official style of the Accademia di San Luca, stylistic leanings during different periods are indicated by the choice of *principe*. In 1744, for example, at a time when the French Rococo enjoyed its greatest influence, **Jean-François de Troy** was elected to take up the post. Similarly, when tastes shifted toward **Neoclassicism**, Anton Raphael Mengs was chosen by his peers in 1771.

**ADAM, ROBERT (1728–92).** The Adam brothers, which included Robert and his two younger siblings, James and William, formed a prominent London-based architectural and design partnership in the second half of the 18th century. Robert Adam's synthesis of diverse Classical sources, with a strong emphasis on ornament, resulted in an elegant and distinctive style. He trained with his father, William Adam, and older brother, John in Edinburgh, before leaving on a **grand tour** in 1754. In these early years, working in the family business in Scotland, his sketches show an interest in Rococo decorative details and **chinoiserie**, elements of which he introduced into his father's more Palladian designs. In **Italy**, his friendships with artists who delighted in the depiction of ruins, such as **Charles-Louis Clérisseau** and **Giovanni Battista Piranesi**, and exposure to the monuments of antiquity altered his approach.

On his return to London in 1758, his career advanced rapidly, and he was appointed architect of the king's works in the early 1760s. At this time, he set up a practice with his brothers, taking on a number of remodeling and **interior decoration** projects that secured their reputation. The rooms he created with his brother James at Syon and Osterley Park exhibit a unique brand of ornamented **Classicism** intended to delight the eye through variety and restraint. Adam designs are typically dominated by a unification of decoration and **architecture**, based on Roman sources, with **grotesques** and painted ornament becoming increasingly complex, delicate, flat, and refined. *See also* ENGLAND AND THE ENGLISH ROCOCO; WARE, ISAAC.

**ADDISON, JOSEPH (1672–1719).** An English poet, essayist, and politician, Addison is best known as cofounder of the *Spectator* (1711–14), a daily paper that he started with his friend Richard Steele and later published in book form. He also helped establish the Kit-Cat Club for the promotion of ideas among Whig supporters and was a regular contributor to Steele's *Tatler* (1709–11). Addison's **aesthetic** theories were laid out in his essays on English **gardens**, literature, art, and the "Pleasures of the Imagination," in which he claimed that the moderns "excel" over the ancients. In these writings, he argued for judgment in the arts to be derived according to the "Sense and Taste of Mankind," rather than from the arts themselves. As influential as his writings on matters of taste, his *Remarks upon Several Parts of Italy*

(1705), written when he returned from the **grand tour**, proclaimed **Italy** to be the "great school of Musick and Painting." In this contribution to aesthetics, he redirected the arc of influence away from **England**'s great contemporary rival, **France**, and claimed a place for the English as definitive connoisseurs of the arts, past and present.

**AESTHETICS.** As a separate area of philosophical inquiry, aesthetics can be traced back to the writings of Alexander Baumgarten who, in 1735, derived the word from the Greek *aisthetika* (matters of perception) to describe the analysis of sensuous responses to art and nature. Many European philosophers during the **Enlightenment** shared Baumgarten's interests in sensation and were similarly engaged in the philosophy of art and the critical analysis of beauty. In **Great Britain**, Francis Hutcheson, **William Hogarth**, Edmund Burke, and Antony Ashley Cooper, the third Earl of Shaftsbury, treated responses to art and nature in their philosophical writings. Aesthetic judgment received its most extended analysis in Immanuel Kant's *Critique of Judgement* (1790), in which he argued that the aesthetic experience of beauty was subjective, yet potentially universal. *See also* ADDISON, JOSEPH; AGUCCHI, GIOVANNI BATTISTA; ALEMBERT, JEAN LE ROND D'; BASTIDE, JEAN-FRANÇOIS DE; ENGLAND AND THE ENGLISH ROCOCO; PILES, ROGER DE; DIDEROT, DENIS; LA FONT DE SAINT-YENNE, ÉTIENNE.

**AGUCCHI, GIOVANNI BATTISTA (1570–1632).** Author of *Trattato della pittura*, written between 1607 and 1615, the Bolognese papal diplomat was also a man of letters with an interest in art theory, mathematics, and astronomy. Within the *Trattato*, Agucchi puts forward one of the first classicist arguments concerning ideal beauty in the 17th century, which would stimulate the later **color**/line debates in **Italy** and **France**. His *idea della bellezza* celebrates the **sculpture** of antiquity and the works of Raphael, Annibale Carracci, and Domenichino, in which beauty is created through a process of selecting and improving the raw material of nature. *See also* AESTHETICS; CLASSICISM.

**À LA GRECQUE.** Excavations at Pompeii and Herculaneum during the middle of the 18th century and the subsequent publication of discoveries in folios of engravings led to a fashionable interest in Greek history during the 1760s in **France**. **Friederich Melchior, Baron von Grimm**, wrote in 1763 that "all of Paris is *à la grecque*." Horace Walpole disparaged this fad for the antique among the French, which he found to be years behind English tastes. In France, à la grecque describes a style in which classical elements are blended with Rococo forms in a manner that is nonspecific and somewhat

arbitrary and which responded to a fashionable taste in the 1770s that was known as the *goût grec*. *See also* CLASSICISM; INTERIOR DECORATION; ITALY.

**ALBA, DOÑA MARÍA TERESA CAYETANA DE SILVA Y ÁLVAREZ DE TOLEDO, DUQUESA DE (1762–1802).** The Duchess of Alba's **patronage** of **Francisco de Goya** played a significant role in the development of the arts in **Spain** during the **Enlightenment**, particularly for Spanish **women**. She married into a prominent family of Spanish politicians in 1775. At the time, the Alba collection was one of the finest in Europe, the culmination of a series of dynastic marriages from the early 16th century onward, that brought together a number of significant art collections and libraries. The collections owned by doña Cayetana and her husband, the duke consort, don José Alvarez de Toledo y Gonzaga (1756–96), included works by Spanish and Italian masters, including Diego de Velázquez, Raphael, and Correggio. The Albas became active patrons of Goya, with the duchess continuing her support following the death of her husband. The duchess and the artist became quite close when Goya stayed at the Alba estate in Sanlúcar de Barrameda between 1796 and 1797. It was during this time that he completed the striking *Duchess of Alba* (1795, New York, Hispanic Society of America), which depicts the duchess in confident pose and black *maja* dress set within a fairly barren landscape. In this **portrait**, the tilted perspective and flat treatment of the background contrasts with the decorative detail of the duchess's Spanish dress and the volumetric treatment of her body to create a heightened sense of individuality, which for many art historians constitutes a thoroughly modern portrait of a female sitter.

**ALCÁZAR, MADRID, SPAIN.** *See* PALACIO REAL DE MADRID.

**ALEMBERT, JEAN LE ROND D' (1717–83).** Elected to the Academy of Sciences at the age of 24 and made a member of the French Academy in 1755, d'Alembert wrote extensively on mathematics, science, philosophy, and the arts. He also coedited the *Encyclopédie ou dictionnaire raisonné des sciences, des arts et des métiers* (first edition 1751) with **Denis Diderot**. His **aesthetic** writings of the 1750s take a rationalist and universalist perspective on issues of creativity, the formation of "good taste," and the role of the artist within society. As is typical of many philosophes, much of d'Alembert's writings are contradictory, which signals the transitional nature of his age. Most significant for the arts is d'Alembert's attempts to reconcile liberal concepts of artistic genius with the logic and rules of **Neoclassicism**. *See also* ENLIGHTENMENT; FRANCE.

**ALGAROTTI, FRANCESCO (1712–64).** The well-educated son of a wealthy Venetian merchant, Algarotti traveled extensively throughout Europe, cultivating relationships with scholars, antiquarians, collectors, artists, philosophers, and rulers. He wrote theoretical treatises on subjects ranging from optics to opera, with several essays addressing **painting** and **architecture**. Algarotti acted as agent for **Augustus III** of Poland from 1743 onward, not only acquiring new paintings but also restructuring the collection according to school and chronology in a manner that anticipates modern museological practices. Algarotti was an important **patron** of **Giambattista Tiepolo** and purchased works from the artist for his own collection and on behalf of the king. The sophistication of his taste in matters of art is attested to by his large collection of drawings by contemporary artists, which was still something of a rarity, and his emphasis on the importance of drawing and the study of the antique in his writings on art. *See also* AESTHETICS; VENICE.

**AMALIENBURG PAVILION, SCHLOSS NYMPHENBURG, MUNICH.** Built between 1734 and 1739 by **François de Cuvilliés** for Elector Charles Albert, this garden retreat introduced the French Rococo style of the *petite maison* into Bavaria. A small, single-story building, the exterior is marked by its lack of decoration and simple alternations between convex and concave forms, a design principle of complement and contrast that is continued on the interior, which is ornate and sumptuous by comparison. The floor plan is dominated at its center by the spectacular Spiegelsaal, a curved mirrored room richly decorated with **boiseries** that erase distinctions between wall bays and ceiling borders through their organic growth up and around the surfaces. For the first time in Bavaria, corners were rounded and **asymmetrical** possibilities were explored. French architectural influence is also apparent in the connection of this central hall to other rooms on either side, which together form *appartements en enfilade*. In addition to smaller salons, there is a large kitchen space decorated entirely with tiles from floor to ceiling, providing cool and comfortable surfaces for indoor picnic parties. Conceived as an updated hunting lodge and dedicated to Diana, goddess of the hunt, through a sculpted overdoor at its principal entrance, the emphasis throughout the pavilion is on artful informality within outdoor spaces, a characteristic Rococo theme that connects the noble visitors to the natural world. *See also* ARCHITECTURE; BAVARIAN ROCOCO; GERMANY; INTERIOR DECORATION; NYMPHENBURG.

*AMATEURS.* A term used in **France** during the 18th century to describe the most sophisticated of collectors, an *amateur* was an art lover who was able to prescribe subjects and recommend improvements to a work of art. Later in

the 18th century, this kind of intrusive behavior on the part of **patrons** was increasingly criticized by artists and writers of the **Enlightenment**, such as **Denis Diderot**. Many *amateurs* were honorary members of the **Académie Royale de Peinture et de Sculpture**, and sale catalogs of the period often refer to the collection of *un grand amateur*.

**AMERICAN ROCOCO.** Largely confined to the decorative arts in the third decade of the 18th century, Rococo detailing can be found on silver objects produced for the American colonies. Such objects were easily transported and brought examples of recent European styles and high culture into American households during these years. Later in the 19th century, affluent **patrons** and consumers revived an interest in the Rococo style, employing it as a sign of aristocratic cultural heritage to distinguish their tastes from those of the middle classes, which were in turn viewed as parochial and bourgeois. *See also* ROCOCO REVIVAL.

**ANET, CHÂTEAU D'.** Situated 75 kilometers west of Paris, this 16th-century château was originally designed by Philibert de L'Orme for Diane de Poitiers, mistress of Henri II. From the 1690s onward, its new owner, the duc de Vendôme, began to enlarge and refurbish the château. It is known that **Claude III Audran** created designs for several apartments in the early 18th century, returning with **Christophe Huet** to work for its subsequent owner, the duchesse du Maine, in the 1730s. The Salon Doré at Anet features in contemporary guidebooks, which described the interiors as "in the **grotesque** genre." Although the decorations do not survive, Audran's original drawings, held at the Nationalmuseum in Stockholm, indicate the highly inventive and innovative nature of his Rococo schemes. Classical gods mingle with monkeys, zephyrs, birds, men, and dragonflies, which are all set within delicate **ornamental** surrounds. *See also* ARCHITECTURE; FRANCE; INTERIOR DECORATION.

**ANGIVILLER, CHARLES-CLAUDE DE FLAHAUT, COMTE DE LA BILLARDERIE D'** (1730–1809). A close political ally of Anne-Robert-Jacques Turgot, **Louis XVI**'s new *comptroller-général*, d'Angiviller became the new *directeur des bâtiments du roi* from 1774. He was one of several advisors to the young king committed to enlightened reform. His administration of the arts is characterized by its investment in a patriotic and educational deployment of the arts. His program of **patronage** was designed to promote history **painting** and to mobilize the careers of young artists in the service of the nation through the exhibition of their works at the **Salons**. D'Angiviller's first major series of commissions in 1777 signaled a new direction for aca-

demic painting, one that drew on ancient and French national history for its subject matter, with strong moral and pedagogical purposes. His management of the **Académie Royale de Peinture et de Sculpture** was considered to be highly autocratic, particularly by the revolutionary artist **Jacques-Louis David**. *See also* BÂTIMENTS DU ROI; ENLIGHTENMENT; FRANCE; LENORMAND DE TOURNEHEM, CHARLES-FRANÇOIS; MARIGNY, MARQUIS DE.

**ANTIN, ANTOINE-LOUIS DE PARDAILLAN DE GONDRIN, MARQUIS, LATER DUC D' (1665–1736).** The duc d'Antin became the *directeur des bâtiments du roi* in 1708, receiving the bequest and income of the office as part of his marriage contract to Marie Victoire-Sophie de Noailles. The most significant act of his administration was the competitive exhibition, or *concours*, he announced in 1727. The top 12 history painters participated, with the size of the works stipulated but the subject matter left open. The paintings hung on public display in the Louvre's Galerie d'Apollon for two months. While the contest was officially judged by d'Antin, public opinion held considerable sway and resulted in the award of more than one prize. This is one of the earliest examples of the public's impact on the judgment of matters of artistic taste, and it prefigures the growing importance of this body for the **Salons**, which were instituted with regularity after 1737. *See also* ACADÉMIE ROYALE DE PEINTURE ET DE SCULPTURE; BÂTIMENTS DU ROI; FRANCE.

**ARABESQUES.** Developed around 1775 as a form of painted salon decoration that merged aspects of ancient **grotesques** with more naturalistic **ornament**, arabesques tend to incorporate foliage and grotesque figures into scrollwork and strapwork. **Charles-Louis Clérisseau** used arabesques in decorative **panels** completed for a salon at the Hôtel Grimod de la Reynière in **Paris**. His contemporaries referred to the motifs through the terms *goût arabesque et étrusque* and *genre arabesque*. This blended terminology stems from the idea that arabesques were a modern borrowing from the ancients. Rooms completed by Rousseau de La Rottière at Fontainebleau for **Marie-Antoinette** in 1787, such as the Cabinet Turc, demonstrate the fashionability of the style at court. *See also* BANDWORK; *GENRE PITTORESQUE*; INTERIOR DECORATION; PALMETTES AND PALMS.

**ARANJUEZ, SPAIN.** This royal palace is located in the province of Madrid, nearly 50 kilometers south of the city and situated between the rivers Tagus and Jarama. The site was used as a royal residence as far back as the 14th century, although the present palace was begun two centuries later during the reign of Philip II. The original designs were largely the work of Juan Bautista

de Toledo and Juan de Herrera, both of whom also worked on **El Escorial**. The palace and its **gardens** were not completed until the 18th century, under **Philip V** and Ferdinand VI, then later expanded and embellished by **Charles III**. Primarily used as a spring and summer retreat, the extensive gardens are a combination of Spanish Hapsburg and **Bourbon** tastes.

Philip II's gardens at Aranjuez were praised in the literature and music of the period, noted for their beautiful plantings, fountains, and statuary, the result of Flemish gardening techniques and Italian landscaping designs. The delights and surprises of its musical fountains and waterworks, as well as the use of numerous statues depicting mythological gods, predate those of **Versailles**. Yet the Bourbon kings also made their mark upon the gardens by employing French and Spanish gardeners. Between 1732 and 1733, Étienne Boutelou laid out the Jardín del Parterre in the French formal style. Later, during the second half of the 18th century, under Charles III, the Jardín del Príncipe was designed in the informal style by Juan de Villanueva. The sumptuous Gabinete de la Porcelana (1763–65) was also created for Charles III and decorated in the Japanese style with plaques made at the Fábrica del Buen Retiro under the direction of the Neapolitan artisan Giuseppe Gricci, who had previously worked in the king's **porcelain** factory at Capodimonte. *See also* SPAIN.

**ARCADIA.** A symbol of pastoral simplicity, Arcadia refers to a utopian landscape in which man lives in harmony with nature uncorrupted by civilization. While the mythology of this idyllic place dates back to antiquity, most famously as the setting of the Roman poet Virgil's *Eclogues*, during the 17th and 18th centuries, Arcadia was most often imagined as an idyllic place peopled by shepherds who occupy their time with philosophical thought, music, and love. While the 17th-century French painter Nicolas Poussin treated the contemplative potential of Arcadia in his two versions of *Et in Arcadia ego* (c. 1627, Chatsworth House, Devonshire, and 1637–39, Musée du Louvre, Paris), 18th-century artists and **patrons** favored the lighter side of Arcadia as a paradise of simple pleasures. This idea of Arcadia inspired the fantasy settings of *fêtes galantes* and *fêtes champêtres* in Rococo art. In the imagined shepherds of Arcadia, the European nobility found an uncomplicated version of itself, tied to the land as it was in feudal times and occupied with more agreeable pastimes than those governed by the highly cultivated formalities of life at court. *See also* PAINTING.

**ARCHITECTURE.** Rococo architectural form largely emerged in opposition to the authority of previous traditions: the unadulterated forms of antiquity, the theatrical heaviness of the Italian Baroque, the Grand Manner of

French **Classicism**, and the austerity of Palladianism in **England**. However, a comprehensive rejection of those traditions was never fully attempted or perhaps even contemplated by the architects and **patrons** who embraced Rococo designs. Instead, the Rococo played with the past. It offered a novel stylistic vocabulary to patrons bored with repetition in building designs and freedom of invention to architects constrained by the dictates of the classical orders. Ultimately, however, the Rococo's challenge to the authority of past traditions was short lived and almost exclusively contained within interior and garden spaces. Although there are buildings that can be classified as wholly Rococo, such as the **Amalienburg** Pavilion in Southern **Germany**, most Rococo buildings tend to exist as garden structures within larger palatial complexes that are informed by the Italian Baroque and French Classicism. Even in the ecclesiastical architecture of Southern Germany, where the **Bavarian Rococo** flourished as a coherent architectural style, it embraced the vitality and ecstatic spirit of the Roman Baroque, extending rather than rejecting it as a stylistic mode. **Balthasar Neumann**'s extraordinary creations at **Würzburg** and **Vierzehnheiligen** demonstrate how this most ingenious of Rococo architects adapted his innovative spatial experiments to fit conventional floor plans and facades. Nevertheless, by effectively suggesting that there are no architectural rules to be followed within their revolutionary interiors, Rococo architects presented a scenario in which the definition of architectural frameworks became redundant within the overall decorative scheme. It was perhaps this challenge to the authority of architecture itself that led to the Rococo's ultimate demise.

The Rococo was initiated in French architecture at the end of **Louis XIV**'s reign by **ornamentalists**, such as **Claude III Audran**, Pierre Lepautre, and **François-Antoine Vassé**, working under the direction of the **Bâtiments du Roi** and the king's *premier architecte*, Jules Hardouin-Mansart. The style began as a form of **interior decoration**, linked to architecture through painted and sculpted **paneling** that was enriched with airy **arabesques**, sinuous S curves and delicate **boiseries**. The move from decorative ornamentation into architectural structures occurred slightly later, in the hands of **Gilles-Marie Oppenord**, **Robert de Cotte**, **Jean Courtonne**, and **Germain Boffrand**, specifically in their designs for Parisian *hôtels particuliers* and palaces. Oppenord studied in **Italy** at the Académie de France in **Rome** during the last decade of the 17th century. Instead of concentrating on the classical orders, he explored the undulating forms and architectural details of the Baroque. When he returned to **Paris**, Oppenord was excluded from official commissions by Hardouin-Mansart. He nevertheless developed a substantial reputation working for high-ranking members of the aristocracy, including **Philippe II, duc d'Orléans**, who became regent in 1715 and promoted

Oppenord to the position of his *premier architecte*. In this position, Oppenord oversaw the rebuilding and refurbishment of the **Palais Royal** (1722–29), the primary residence of the Orléans family, to which the seat of government was transferred from **Versailles** at the start of the Regency. In this major architectural project of the early Rococo period, Oppenord created the *lanternon*, originally designed as an elliptical salon, two stories in height, jutting out of the line of the wall with one end extending on a bracket over the Rue de Richelieu. The design was contrary to all academic rules, as were the arched shapes that Oppenord created for the tops of windows.

A similar shift to the use of curvilinear forms in floor plan and architectural detail was initiated at the **Hôtel de Soubise** by Boffrand. Originally hired to replace **Pierre-Alexis Delamair**, who had proposed a central enfilade scheme that was considered outmoded by the patrons, Boffrand altered axial movement by placing the enfilade scheme to the side. He further emphasized **asymmetry** in his overall design by building a two-story oval pavilion on one end of the garden facade. These novel approaches to the shaping of space are fundamental components of French Rococo architecture, which is characterized by curvilinear forms, the reorganization of circulation, and a preference for smaller, more intimate rooms separated from the public areas of a residence. In both the Palais Royal and the Hôtel de Soubise, the oval salons formed corners hinging the public *cabinets* to the private *appartements* at right angles, simultaneously joining and separating the two types of spaces and allowing for a progressive retreat into privacy.

Both the Palais Royal and the Hôtel de Soubise were constructed during the building boom that occurred in Paris in the third and fourth decades of the 18th century, during which the *hôtel particulier* became the dominant architectural type and a prime site of Rococo ornamentation. Decorative paneling included non-narrative arabesques and boiseries, while figural **paintings** and **sculptures** began to be relegated to overdoors, reducing the significance of thematic and narrative readings of scenes. Individual components of both architecture and decoration were made subservient to the overall aesthetic effect of a room, which was often unified either through the delicate harmonies of pastel **color** schemes or a coherent use of gold and white. **Mirrors** were also an essential feature of interiors and contributed to the dazzling impact of the **dress** and demeanor of a room's inhabitants.

The interior layout of these private townhouses tended to be directed by contemporary ideas of comfort and convenience, rather than ceremony and tradition. These demands came from patrons and were met by architects, creating a new attitude toward spatial organization that is key to an understanding of Rococo architecture in **France**. Moreover, the period preference for privacy and retreat was not limited to the *hôtel particulier*. It was extended to

royal palace architecture when **Louis XV** returned his court to Versailles in 1722. The king commissioned his *premier architecte* **Ange-Jacques Gabriel** to redesign the Petits Appartements into smaller, more intimate spaces. Yet while elite interiors underwent dramatic transformations in terms of layout and ornamentation, the exteriors of buildings were either left unaltered or designed to be formally consistent with French Classicism, which preserved a connection to the past.

Outside of France, the Rococo was absorbed and transformed by local traditions and patronage. In Southern Germany and Central Europe, teams of architects, sculptors, and painters worked together to create cohesive spaces. Bavarian Rococo buildings and interiors are the result of close collaboration between architects and artists, so much so that it is impossible to speak of the ecclesiastical architecture of **Johann Michael Fischer, Dominikus Zimmermann,** and Neumann without consideration of the sculptural **ornamentation** and woodcarvings of Johann Michael Feuchtmayer, Joachim Dietrich, **Johan Baptist Zimmerman,** and the **Asam brothers.** Moreover, the patrons, who were most often kings, electors, and prince-bishops, took an active interest in architectural projects, exerting considerable control over the architects who worked for them. Some of these patrons, such as Maximilian II Emanuel, had spent periods in exile at the French court, observing the development of the Rococo and bringing their own architects to train in Paris so that the latest French styles could be employed upon their return to their family estates. **Joseph Effner** and **François de Cuvilliés** were both supported by their patrons in this way. Cuvilliés, in particular, is credited with introducing French Rococo forms into German architecture during the 1720s and 1730s at **Brühl** and **Nymphenburg.** Yet the design of his most celebrated Rococo building, **Amalienburg,** is far from a slavish imitation of French examples and had no equivalent in France. Cuvilliés successfully translated the Rococo fantasies of French ornamental prints into full-scale architectural forms seamlessly wedded to organic **stuccowork.** Perhaps most importantly, he exploited the carving skills of German craftsmanship to produce architecture in which traditional architectural forms are displaced by ornamentation that approaches aesthetic autonomy.

**Frederican Rococo** architecture is similar in many respects, as it too was the result of decorative teams working under the supervision of their patron. Architects were trained in a variety of media, namely sculptural ornamentation, and, therefore, moved easily between architecture and decoration. At **Schloss Sanssouci, Frederick the Great** was personally involved in the design of his Rococo garden palace. **Georg Wenzeslaus von Knobelsdorff** executed plans according to the king's sketches and collaborated closely with **Johann August Nahl** and the **Hoppenhaupt brothers** to ensure

adherence to his artistic directives. The king's personal involvement produced a highly original design, which drew on the prevailing architectural criteria of the Rococo in the scale of the building, the intimacy of its rooms, and the use of full-length arched windows on the garden facade. At the same time, Sanssouci referenced antiquity and the recent architectural achievements of Central European kings, namely Augustus the Strong's **Zwinger** in Dresden. It, therefore, refused subservience to French models, expressing, rather, the personal authority of Frederick the Great, not through architectural grandeur and spectacle but through the king's creative play with architecture as an exercise of his power. This idea of architecture as plaything, connected with leisure pursuits and pleasure, is an underlying characteristic of the European Rococo.

In **England**, the Rococo coexisted with Neo-Palladianism, which was the dominant style of public buildings and large country houses. It has been seen as a decorative response to the monotony of Palladian-inspired interiors that had become predictable and old-fashioned by the start of the 18th century. Like its continental counterpart, the English Rococo is largely a matter of interior decoration, particularly for smaller, more intimate rooms that were part of a period shift to privacy and social retreat. What England lacked in comparison with France and **Germany** were integrated teams of highly skilled craftsmen, particularly wood-carvers and ornamental panel painters, with the technical competence to work together under the creative direction of an experienced architect. Instead, the English Rococo interior relied upon inventive **plasterwork** on ceilings and wall features. The architects who introduced Rococo styling into their Neo-Palladian interiors include William Kent and **Isaac Ware**. The established conventions of exterior architecture were never threatened by these interior developments. Where the English Rococo did flourish as exterior architecture was in **garden design**, the most significant being **William Chambers**'s creations at **Kew** for **Frederick, the Prince of Wales**, and Princess Augusta, which involved a cosmopolitan mix of building types borrowed from different times, places, and cultures. Chambers's pagoda is an enduring monument to Rococo **chinoiserie**. Similarly, the gardens at Lord Burlington's **Chiswick Villa** included an artful scattering of eclectic buildings and features within a complex pattern of winding, twisting paths. In some buildings, such as at Painswick in Gloucestershire, Rococo interiors and garden structures incorporated **Gothic** form and ornamentation. Many smaller Rococo gardens were recorded by **Thomas Robins the Elder**, but have otherwise disappeared.

While the Rococo provided a new vocabulary of architectural form in 18th-century interiors and garden buildings, it resists definition as an autonomous architectural style. Little architectural theory supported its development as a

formal approach to building, nor its challenge to the prevailing forms of Classicism. Indeed, during the Rococo's brief ascendency, theoretical debates in France began to articulate the need for a "rational" architecture, which forged a path for **Neoclassicism**. **Jacques-François Blondel** wrote extensively on the varied architectural styles of contemporary Paris and lamented their eclecticism. He promoted a return to the architectural principles of French Classicism and the reduction of excessive decoration. Such views had their roots in the **quarrel of the ancients and the moderns** that took place during the 1670s at the **Académie Royale d'Architecture** and questioned the authority of classical forms as unalterable absolutes. The perspective of the "ancients" was developed and refined over the course of the 18th century, culminating in the rational system of architecture expounded in the abbé Laugier's *Essai sur l'architecture* (1752), which called for the rigorous clarification of architectural elements, such as the post and lintel, coupled with the virtual elimination of ornament. On the "modern" side of the debate, however, it was held that ancient architecture evolved out of building needs and was, therefore, subject to continual modification. While relatively short-lived and restricted in its impact, Rococo architectural form can be understood in relation to this "modern" conception of the past as open to change and adaptation in response to the tastes and needs of contemporary inhabitants. *See also* ADAM, ROBERT; DOORS; LEDOUX, CLAUDE-NICOLAS; POLAND; PORTUGAL; RUSSIA; SWEDEN.

**ARIOSTO, LUDOVICO (1474–1533).** The most famous work by this 16th-century Italian poet who served the Este family in Ferrara is his epic romance *Orlando furioso*, which brings together themes of chivalry, love, war, and fidelity. Ariosto's poem includes many *ekphrases*, or dramatic descriptions of works of art, which made it of interest to art lovers, and it became a source of inspiration to artists from the 16th century onward. In the Rococo period, **Jean-Honoré Fragonard** prepared around 150 oversized drawings of the first 16 cantos for an edition that was never published. The wonderfully free handling of Fragonard's drawings indicates the artist's imaginative response to the text, which closely adheres to the general plot of the story yet without a strong emphasis on narrative. *See also* ITALY.

**ARMS AND ARMOR.** The style of firearm decoration associated with the prestige and power of **Louis XIV** dominated European production in the 17th and 18th centuries. Emigrant gun makers, pattern books, and gift giving disseminated this French fashion to other countries. Around 1650, a number of influential pattern books were produced in **Paris**, often by artists who also worked as painters and engravers. **Jean Bérain I** produced one such album in

1659 with plates illustrating **ornamentation** for metal parts and relief carvings. The emphasis was on **grotesques**, blending together human and natural forms on curving and flat surfaces. In the 1680s and 1690s, the engravers Claude and Jacques Simonin produced rival plates illustrating designs from Laurent Le Languedoc's workshop, which gave new prominence to convex surfaces and curved profiles, with three-dimensional interplay between elaborate ornamental side panels and the wood they were laid into. In the 1720s, Simonin and Bérain revival styles were augmented with the addition of strapwork and recessed panels intended for gilding. During the 1740s, designers such as Gilles de Marteau enhanced the proportion of pure ornamentation through the increased application of nonfunctioning parts.

**ARSENAL, PARIS.** In addition to its purpose for military stores, the Arsenal of Paris was also the residence of the *grand maître de l'artillerie*. It was established by François I and built by Philibert de L'Orme under the supervision of the duc de Sully during the 16th century. The duc de Maine, **Louis XIV**'s legitimated son, expanded the lodgings from 1712 onward, appointing **Germain Boffrand** as architect. Boffrand built the river wing and designed the Pavilion de la duchesse de Maine. His drawings for the decoration of a salon present a scheme that connects with the style of Louis XIV, no doubt as part of the campaign to claim successional rights to the throne. The duc de Maine's military role is alluded to through the deployment of the gods Bellona and Mars amid **trophies** and various other symbols of war, while his rights as heir to the French throne are reinforced by a frieze peopled with mythological figures, visually laying claim to a genealogy that stretches back to antiquity. *See also* ARCHITECTURE; PARIS.

**ARTOIS, CHARLES-PHILIPPE DE FRANCE, COMTE D' (1757– 1836).** Grandson of **Louis XV** and the younger brother of **Louis XVI**, the comte d'Artois spent heavily on horseracing, gambling, and the arts. His building of the small Château de **Bagatelle**, complete with landscape **gardens** in the Bois de Boulogne on the outskirts of **Paris**, was the result of a wager with **Marie-Antoinette**, the expense and speed of construction causing yet another royal scandal for the crown. **François-Joseph Bélanger** was responsible for its design. Bélanger also redecorated d'Artois' lodgings at **Versailles**, the Hôtel du Temple, and the Château du Maisons. Not simply a **patron** of building, d'Artois was also an avid collector of contemporary French art. **Paintings** by **Jean-Baptiste Greuze, Jean-Honoré Fragonard, Hubert Robert**, Louis-Jean-François Lagrenée, **Élisabeth Vigée Le Brun**, François-Guillaume Ménageot, Vincent, and **Jacques-Louis David** all featured in his collection, some commissioned directly from the artists, while

others were bought on his behalf at sales by the picture agent Jean-Baptiste-Pierre Le Brun, the husband of Vigée Le Brun. Favoring erotic figure scenes and landscape pictures to decorate many of his rooms, he also commissioned large-scale mythological paintings, most likely for a private gallery at the Hôtel du Temple, his residence in Paris. D'Artois went into exile during the Revolution, returning and later ruling **France** as Charles X between 1824 and 1830.

**ASAM BROTHERS.** The sons of Hans Georg Asam (1649–1711), a Bavarian painter, Cosmas Damian (1686–1739) and Egid Quirin (1692–1750), are best known for their collaborative, decorative schemes based on the principles of the *Gesamtkunstwerk* (total work of art) in which **architecture, painting,** and **sculpture** are combined to represent an idea or theme. Their reputation as renderers of superb illusionism secured them several commissions in Southern German churches, and they worked primarily for ecclesiastical **patrons.** Cosmas Damian trained as a fresco and altarpiece painter, while his brother, Egid Quirin, specialized in sculpture and **stuccowork,** but both brothers worked as architects. One of their most successful collaborations was at the Benedictine Monastery of Weltenburg an der Donau (built between 1716 and 1735), where they employed an artistic scheme based around the theological concept of the Church Triumphant (which is the subject of the ceiling fresco signed by Cosmas Damian in 1721) and the religious work of the Benedictines. The high altar, in particular, achieves a perfect unity between architecture, painting, sculpture, and ornament, an artistic aim that is often linked to the Baroque and the work of **Gian Lorenzo Bernini.** Yet their use of **color** and stucco is invariably Rococo. Most unique of the Asam brothers' projects is their construction and decoration of Saint Johann Nepomuk, their private church in Munich, built between adjoining houses bought by Egid Quirin in 1729. Here, the brothers brought all four arts together to honor and celebrate the glory of the church. Theatrical effects and brilliant **color** draw the eyes from darker spaces below and up to the light-flooded ceilings covered with illusionistic frescoes. *See also* BAVARIAN ROCOCO; GERMANY.

**ASYMMETRY (*CONTRASTE*).** Asymmetry of form, known in French as *contraste*, was a fundamental characteristic of Rococo **ornamentation** around 1730. It began to figure in architectural designs by **Juste-Aurèle Meissonier, Nicolas Pineau,** and **Jacques-François Blondel,** among others, who employed asymmetrical **cartouches, trophies,** and shells, as well as frames interrupted by broken or disjointed scrolls. At the time, Rococo asymmetry was considered part of the *goût moderne* or the **genre pittoresque.** *See also* PAINTING; INTERIOR DECORATION; ROCAILLE.

**AUBERT, JEAN (ACTIVE 1702–41).** Aubert was a French **architect** and interior designer. Little is known of his early training beyond the fact that he was the son of a master carpenter in the employ of the Service des **Bâtiments du Roi**. It may have been through his father that he gained work as a draftsman under Jules Hardouin-Mansart, where contemporary sources place him between 1702 and 1708. His career grew far beyond these humble beginnings as Aubert became the favorite architect of the Bourbon-Condé family. For Louis-Henri de Bourbon, Prince de Condé, he built the magnificent stables at **Chantilly**, which were designed in 1719 and executed between 1721 and 1735. He also designed interiors for the Petit Château at Chantilly (1718–22) and oversaw their execution by craftsmen who also completed the **boiseries**. Aubert maintained several workshops, and the style of wood **paneling** executed under his control involves both geometric structure and organic **ornamentation** that breaks down order in a characteristically Rococo way through a combination of curvilinear line and floral detailing. He also designed and built the Hôtel Peyrenc de Moras at 77 Rue de Varenne in **Paris**, which became known as the Hôtel Biron when sold to the maréchal de Biron in 1753 and now houses the Musée Rodin. Built for Abraham Peyrenc de Moras, originally a wigmaker who made a fortune in financial speculation, the house was completed in 1730 and features a masterful use of **rocaille** architectural ornamentation on its exterior and interiors. *See also HÔTEL PARTICULIER.*

**AUBRY, ÉTIENNE (1745–81).** Aubry was a French painter from Versailles who trained in Paris under Jacques-Augustin Silvestre and **Joseph-Marie Vien**. He was received into the **Académie Royale de Peinture et de Sculpture** as a portrait painter in 1775 but is best known today for his scenes of daily life, such as *The Nurse's Farewell* (Clark Art Institute, Williamstown, Massachusetts), which was exhibited at the Salon of 1777 and celebrated by the critics. The **comte d'Angiviller** and other prominent collectors of contemporary French **painting** bought Aubry's works. *See also* FRANCE; GENRE; SALONS.

**AUDRAN, CLAUDE III (1658–1734).** A French decorative artist from a family of painters and engravers based in Lyon and Paris, Audran trained with his uncles, the most famous of whom was Claude Audran II (1639–84). As a specialist in painted ornament, Audran was sought after by noble **patrons** for his **grotesque, arabesque,** and *singerie* designs. He completed elaborate **ornamental** schemes at **Versailles, Anet**, La Muette, Sceaux, Meudon, and Marly, although most of these are lost and known today only through drawings. The style of his decorations is most closely associated with the Regency period, although his early works predate the death of **Louis XIV**. In the last

decades of Louis XIV's reign, Audran received substantial payments from the **Bâtiments du Roi**, which demonstrates the king's taste for his designs in certain applications, such as at the **Ménagerie de Versailles**. His innovative ornamental designs were highly influential on early Rococo artists. He collaborated with **Nicolas Lancret**, and several future academicians trained in his workshop, including **Antoine Watteau, François Desportes, Jean-Baptiste Oudry**, and **Christophe Huet**. *See also* FRANCE; INTERIOR DECORATION; PAINTING.

**AUGUSTUS III, KING OF POLAND AND FREDERICK-AUGUSTUS II, ELECTOR OF SAXONY (1696–1763).** From the House of Wettin, Augustus III came from a long line of German rulers, **patrons**, and art collectors, which included his father, Augustus the Strong, who commissioned the **Zwinger** and supported the establishment of the **Meissen porcelain** factory. His father's patronage of the visual arts provided a strong example of the use of royal and civic building projects and large-scale collecting practices as signs of absolute power and authority. Augustus III developed the French Rococo style in Saxony and **Poland** through numerous building projects, several of which were continuations of those begun by his father. He completed the Japanisches Palais in Dresden, designed by Mattahäus Daniel Pöppelmann, Zacharias Longuelune, Johann Christophe Knöffel, and Jean de Bodt, and commissioned numerous Meissen productions to decorate it. His patronage of church **architecture**, such as the Roman Catholic Hofkirche in Dresden, is noteworthy for its extensive use of Rococo decoration. He employed an international circle of artists at his court, including Louis de Silvestre, **Bernardo Bellotto**, Anton Raphael Mengs, Adám Mányoki, Johann Alexander Thiele, Ismael Israel Mengs, Marcello Bacciarelli, and Johann Samuel Mock, preferring the genres of portraiture, landscape, and *vedute*. *See also* ABSOLUTISM.

**AUSTRIA.** While the Austrian High Baroque has been celebrated for the notable ecclesiastical and secular **architecture** of Johann Bernard Fisher von Erlach and Johann Lukas von Hildebrandt, less attention has been given to the Austrian or Viennese Rococo, which developed primarily in interior design and the decorative arts. Hildebrandt's work at the **Upper Belvedere** (1721–22) signaled the emergence of an Austrian interest in Rococo architectural forms, in which an emphasis on **ornamentation** erodes the articulation of mass. The taste for the Rococo was further developed at the court of Maria Theresa, Holy Roman Empress between 1745 and 1780. Maria Theresa's emphasis on economical conversions and extensions, however, partially impeded its efflorescence in major architectural projects. The empress sought a

new degree of comfort and intimacy for the royal family, and it is mainly in the refurbishment of court interiors that the Austrian Rococo prospered. She had 16 children, including **Marie-Antoinette**, who became Queen of **France** as wife to **Louis XVI.**

At Schloss Schönbrunn, in particular, a Rococo court style can be observed in the **interior decoration** of the Chinesisches Kabinett, the Vieux-Laque-Zimmer, and the Millionenzimmer, which Maria Theresa used as her conference room. Exotic tastes for lacquer panels, vases, bottles, and boxes brought from East Asia are blended with Viennese enamel chandeliers, intarsia floors, and wood **paneling**. More unusual features include the 260 Indian miniatures that the empress acquired from Constantinople. These Oriental **genre** scenes were framed by gilt **cartouches** set into rosewood paneling imported from Guyana and the Antilles. Some scholars have described these objects as the visual exploits of colonial despotism. Considered more positively, the **aesthetic** merger of East and West in Austrian decoration expresses the growing cosmopolitanism of **Enlightenment** culture, which was the result of expanded European trade routes and **grand tour** travel itineraries that stimulated interest in non-European art forms. The furnishings of the Millionenzimmer were designed to form an invisible unity with wall decorations, in which **rocaille** and foliage motifs dominate in a **color** scheme of brown and gold, typical of the Austrian Rococo.

Maria Theresa sponsored the production of Rococo luxury objects. On her authority, the Wiener Porzellanmanufaktur was converted to state ownership and renamed the Kaiserliche Porzellanmanufaktur in 1744. Established in Vienna in 1718, it was the second manufactory in Europe to successfully produce hard-paste **porcelain** (**Meissen** was the first). The most significant Rococo objects produced by the factory were the single figures and groups modeled by Johann Joseph Niedermayer from the 1740s to the 1780s. Typical characters were taken from the **commedia dell'arte**, mythology, and pastoral subjects, such as shepherds and shepherdesses. *See also* ABSOLUTISM; CHARLES VI.

# B

**BACHAUMONT, LOUIS PETIT DE (1690–1771).** A French *amateur* and critic who wrote extensively about the arts, Bachaumont was influential in the 1748 reorganization of the **Académie Royale de Peinture et de Sculpture** under **Lenormand de Tournehem**. He was an important arbiter of taste, advisor to art administrators and collectors, and friend to prominent artists, such as **Charles-Antoine Coypel, Jean-François de Troy, François Boucher,** and Jean-Baptiste Pierre. He also advised the young anti-Rococo art critic **Étienne La Font de Saint-Yenne.** As a young man, he frequented the weekly *réunions* of artists and *amateurs* at the home of **Pierre Crozat,** later launching with Madame Doublet (a relative of Crozat) a literary and artistic salon known as the Parish. His largely sensationist theories of **aesthetic** judgment are put forward in his 1751 treatise, *Essai sur la peinture, la sculpture et l'architecture.* In addition to the numerous memoranda he wrote, in which he provided advice on the choice of architects, artists, and artisans for domestic interiors, as well as suggestions in relation to urban projects, he kept copious records relating to the art market, public exhibitions, private collections, and the Académie Royale. Published after his death, his *Mémoires secrets pour servir à l'histoire de la république des lettres en France depuis 1762* documents social, artistic, and literary life in **Paris** during the second half of the 18th century. *See also* BÂTIMENTS DU ROI; PATRONS AND PATRONAGE.

**BACHELIER, JEAN-JACQUES (1724–1806).** Although Bachelier was received by the **Académie Royale de Peinture et de Sculpture** as a painter of flowers in 1752, he was admitted to the category of history painters in 1763. An example of his work in this genre is *The Tragic Death of Milo of Cortona* (c. 1761, National Gallery of Ireland, Dublin), in which his skills as a still-life and animal painter combine with his study of classical art. He studied with Jean-Baptiste Pierre in the 1740s, and many viewed him as a successor to **Jean-Baptiste Oudry.** Bachelier received many royal commissions not only for decorative **panels,** which included allegorical themes acted out by putti for the Hôtel des Affaires Étrangères at **Versailles** (c. 1763), but

also **portraits** of **Madame de Pompadour**'s dogs and extraordinary trompe l'oeil depictions of antler trophies from the royal hunt. Bachelier was artistic director of the Manufacture de Vincennes from 1752, and *directeur* of the Manufacture de **Sèvres** from 1756 to 1793. **Porcelain** produced under his directorship features brilliant coloring, gold **arabesque** and acanthus **ornamentation**, and pastoral motifs, such bouquets of flowers and **children** at play. *See also* FRANCE; PAINTING.

**BAGATELLE.** An elaborate *petite maison*, this small château, complete with landscape gardens laid out in the English style, was completed in just 64 days to win a wager between the **comte d'Artois** and his sister-in-law, **Marie-Antoinette**. Designed in 1777 by the comte's royal architect, **François-Joseph Bélanger**, the pavilion is square in plan and extended on the garden facade by a circular salon flanked by two **boudoirs**. The comte's position as *grand maître de l'artillerie* is alluded to through the **interior decoration**, although the theme of his conquests as a lover receives equal billing in the military tent designed for his bedroom and the display of paintings with mildly erotic themes by contemporary French artists. *See also* ARCHITECTURE; FRANCE; GARDEN DESIGN.

**BANDWORK.** This descriptive term is used in relation to painted and modeled **ornament** in which flat bars or bands are interwoven and crossed over each other to form delicate patterns. Bandwork was a significant feature in the development of **arabesque** forms when combined with acanthus foliage. Early examples of such uses of bandwork can be found in the decorative repertory of Pierre Lepautre, **Jacques Boyceau**, and Charles Le Brun. On certain painted wall and ceiling panels at Vaux-le-Vicomte and the Galerie d'Apollon of the Louvre, Le Brun employed interlacing bands with scrolls that metamorphose into acanthus leaves. Le Brun's novel use of bandwork influenced **Jean Bérain**, who engraved plates of ornaments found in the Galerie d'Apollon. Bérain further developed this patterned use of bandwork in his designs for private buildings in the 1680s and 1690s. In **ceilings** at the Hôtel de Mailly, Bérain used bandwork and contrasting **color** to reinforce a sense of patterning that dominates over vegetal elements. Bandwork is commonly found in decorative panels, **stuccowork**, and garden **parterres** of the period. *See also* GARDEN DESIGN; INTERIOR DECORATION; PANELING.

**BARRY, JAMES (1741–1806).** The Irish painter James Barry was a resolute supporter of history **painting** as an expression of personal and national character. He trained briefly with a landscape painter in his native Cork prior to

moving to Dublin and entering the Society of Arts' drawing school in 1763. There he attracted the attention of Edmund Burke, who introduced him to **Joshua Reynolds** and James Stuart in London. Already devoted to historical subject matter, his interest in the achievements of the ancients was excited by his work for the archeologist James "Athenian" Stuart on the volumes of *The Antiquities of Athens*. By 1765, Barry was en route to **Italy** to continue his studies, again financed by Burke. Remaining until 1771, mostly in **Rome**, he immersed himself in the art of the ancient world and Italian old masters.

Barry was elected to the Royal Academy of Arts two years after his return to London and rose through the ranks to become a professor of painting in 1782. His most ambitious history paintings date from this period, including his *Progress of Human Culture*, six large murals on canvas, the longest of which is 12.8 meters. This series, painted for the Great Room of the Society of Arts, blends together more than 125 **portraits** with allegorical and historical subjects to make a statement about **Great Britain** as heir to the development of classical civilization under the patronage of enlightened institutions, such as the Society of Arts. A high-minded achievement in the "grand style" that took seven years to complete, the artistic handling is of mixed quality. Still, it demonstrates the extent to which Barry was fully versed in and committed to the heroic language of gesture and expression.

Barry's technical skill as a painter is visible in the few Grand Manner portraits that he painted on commission, such as *Hugh Smithson, 1st Duke of Northumberland* (c. 1784–86, Syon House, London). In these more conventional paintings, which were in high demand among his patrons, Barry confirmed that he was capable of rivaling his more successful peers, such as Reynolds, but that he chose to pursue a more noble aim for his art. Barry wrote several treatises, all with the aim of educating the public through the promotion of history painting as a genre worthy of significant **patronage** in Britain. Eventually, his extreme views regarding the necessity of high classical principles in art led to his expulsion from the Royal Academy in 1799. *See also* CLASSICISM; ENGLAND AND THE ENGLISH ROCOCO; NEOCLASSICISM.

**BARRY, MARIE-JEANNE BÉCU, COMTESSE DU (1746–93).** The illegitimate daughter of a dressmaker, Du Barry became the last official mistress of **Louis XV** in 1769. Following the example of her more famous predecessor, **Madame de Pompadour**, she used **patronage** and collecting as a demonstration of her position. To signal her authority, she commissioned a grand portrait of herself as a Muse (Musée National du Château de Versailles, Paris) from François-Hubert Drouais, which was displayed at the **Salon** of 1771 and caused a scandal due to its reputed lack of decency. Dressed in transparent

drapery in the style of the antique, she was portrayed as goddess of the arts on a monumental scale. A fashionable and beautiful woman, her taste influenced trends in **Paris** and at court, although she was a controversial figure because of her low birth. Du Barry attempted to differentiate her style from that of Pompadour by supporting artists who were not associated with the school of **François Boucher**, like **Claude-Joseph Vernet** and **Jean-Baptiste Greuze**.

The king gave her the Château de **Louveciennes**, which **Ange-Jacques Gabriel** was commissioned to restore. By 1770, however, she had hired **Claude-Nicolas Ledoux** to build the Pavillon du Barry on the grounds of Louveciennes in the latest **Neoclassical** style. She also commissioned **Jean-Honoré Fragonard** to provide a decorative cycle for the interior. Known as the *Progress of Love* (1771–73, Frick Collection, New York), the cycle was rejected and replaced with works by **Joseph-Marie Vien** (Musée du Louvre, Paris and Préfecture, Chambéry), which were less Rococo and more Neoclassical in style. The exact reasons for the rejection are unknown, but it is interpreted as a pivotal moment in the history of art that signals the demise of taste for the Rococo in official circles. *See also* FRANCE.

**BASTIDE, JEAN-FRANÇOIS DE (1724–98).** A French author and son of a provincial magistrate, Bastide wrote novels and pieces for the theater. He was also a critic and journalist, publishing *Le Nouveau spectateur* in the late 1750s. His minor **aesthetic** writings, *L'homme du monde éclairé par les arts* (1774, coauthored with **Jacques-François Blondel**) and *La petite maison* (1753), blend didactic critiques of art and **architecture** into fictional narratives. The latter text explores the affective impact of the arts by describing the possibility of seduction through architecture and **interior decoration**. Bastide's ideas correspond with the sensationist ideas explored by **Enlightenment** philosophers. *See also* FRANCE.

**BATH.** Dating back to the Roman invasion of **England** in the first century AD, Bath, situated on the River Avon, became a fashionable spa resort at the beginning of the 18th century. A series of purpose-built rooms and buildings were constructed from 1706 onward to accommodate both the social activities of taking the waters, gaming, and dancing, and the ever-increasing influx of visitors who required lodging during the spring and summer seasons. Bath is both a significant example of town planning and evidence of the general shift in **architectural** taste away from Palladianism and toward **Neoclassicism** in England during the 18th century. The uniformity of style for which Bath is known is largely the result of an ambitious project initiated by John Wood (1704–54), the son of a local builder. Queen Square is testament to Wood's entrepreneurial skills and vision of Bath as a classical city. Unable

to secure the backing of Bath's landowners or corporation, Wood devised a speculative development plan whereby he leased a number of contiguous plots that he then subleased to others. These sub-lessees were legally bound to build according to the designs and elevations that Wood supplied, which emphasized regular proportions and an absence of decorative detail. His austere classical designs had the benefit of cheap building costs. At the same time, they achieved Wood's ambition for a unified facade of townhouses that conveyed "the appearance of a palace."

**Painting** also thrived at Bath during the 18th century, as middle-class tourists, country gentry, and aristocrats all desired fashionable **portraits** painted during their visits. William Hoare, a pastel painter who specialized in swiftly executed and affordable works, may have started the trend in the late 1730s. **Thomas Gainsborough** also found a ready market of sitters at Bath and an opportunity to perfect his elegant style of portraiture, which suited Bath's elite society. Numerous artists put works on display in rooms within their homes that they opened to the public. Studio visits became a fashionable pastime during the season in Bath. This more personal experience of viewing art by the public presents an alternative historical model to the development of public exhibition spaces in the cities of London and **Paris** during the 18th century. Similar to the facades of Queen Square, such visits gave the impression of exclusivity and a sense of belonging to elite society, even if one was simply a tourist passing through. *See also* PATRONS AND PATRONAGE; ROBINS, THOMAS, THE ELDER.

**BÂTIMENTS DU ROI.** One of three administrative departments within the king's household (Maison du Roi), the Bâtiments exerted an enormous influence on the production of art and **architecture**, as well as on the training of artists and architects, not only through **patronage** but also through oversight of the academies, their schools, and the royal manufactories of luxury goods. It commissioned and managed all land, gardens, and permanent architectural structures belonging to the king, as well as all decorative works permanently attached to those spaces. This included **paneling**, **sculpture**, **painting**, prints, **mirrors**, and **tapestries**, as they were (or could be) attached to the walls, as well as the royal nursery. Additional aspects of royal arts administration were covered by the two other departments, with which the Bâtiments worked closely: the **Garde Meuble de la Couronne** transported, installed, stored, and cared for moveable interior decorative furnishings, like silver, **porcelain**, draperies, and **furniture**, while the **Menus Plaisirs** oversaw the ephemera produced for court entertainments, festivities, and ceremonies.

Of the three, the Bâtiments was the most bureaucratic, with the largest staff (including draftsmen, copyists, and keepers of pictures) and greatest

expenditure on building projects. The *surintendant et ordonnateur général des bâtiments* was a purchasable office, appointed by the king, and was most often held by a bureaucrat rather than a high-ranking courtier (the exception was the **duc d'Antin**, the son of Madame de Montespan, who held the post between 1708 and 1736). **Jean-Baptiste Colbert** became *surintendant* in 1664, while he was also *intendant des finances* and *vice-protecteur* of the **Académie Royale de Peinture et de Sculpture**. By simultaneously occupying these three positions until his death in 1683, he transformed royal arts patronage into a machine of the state. While Colbert's aim was to establish the symbolic presence of the king in **Paris** through the completion of the east facade of the Louvre and other urban projects, **Louis XIV** had more interest in creating a symbol of his power and magnificence at **Versailles**, where he intended to house both his court and his seat of government. Thus, from the 1680s onward, the Bâtiments were primarily occupied with building projects at the royal châteaux of Versailles and Marly.

In addition to architectural commissions, there was considerable work carried out on the **gardens**, as well as the need to decorate the interiors. The success of these projects was largely due to the administrative skills of Jules Hardouin-Mansart, who occupied the post of *surintendant* between 1699 and 1708. As *premier architecte du roi*, Hardouin-Mansart had the professional experience required to best serve the king as he took on more building projects in the name of his immortal glory.

Numerous fiscal crises during the early reign of **Louis XV** caused **Philibert Orry**, *directeur général des bâtiments* from 1737 to 1745, to curtail state patronage, although it was during this period that biennial **Salons** were instituted, exhibiting works produced by members of the Académie Royale de Peinture et de Sculpture. The next great period of activity was under the administrations of **Lenormand de Tournehem** (1745–51) and the **marquis de Marigny** (1751–73), **Madame de Pompadour**'s uncle by marriage and brother, respectively. It is likely that, as official mistress of the king, Pompadour used her influence to secure these positions for her family. Under Tournehem, a sweep of reforms were put in place with the aim of reestablishing the authority of the king as a great patron of the arts, partly through the undertaking of civic projects by the Bâtiments. These included the completion of the Place Louis XV, new work on the Cour Carrée of the Louvre, the creation of the École Militaire and the École des Élèves Protégés, renewed involvement in the luxury manufactories, the academies, and their schools, and significant commissions in painting and architecture, such as the church of St. Geneviève by **Jacques-Germain Soufflot** and the series of the "ports of France" by **Claude-Joseph Vernet**. Moreover, there was a close alliance between Pompadour and her favorite painter, **François Boucher**, who was

not only first painter to the king but also the highest ranking member of the Académie Royale, working closely with the Bâtiments. Once again, as with the time of Colbert and Louis XIV, the Bâtiments took up a central role in directing the artistic activities of **France**, influencing all matters of taste.

Under **Louis XVI**, the **comte d'Angiviller** was appointed to the post of *directeur général des bâtiments* (1774–90). His administration was characterized by its emphasis on centralized authority and hierarchy, which was a difficult position to maintain as exhibitions brought works of art increasingly into the public sphere. Moreover, the independent voice of the critic often conflicted with the official judgments of the Académie Royale and the Bâtiments. Nevertheless, d'Angiviller made significant purchases on behalf of the king, encouraged a return to heroic history painting in the Neoclassical style, commissioned the "great men of France" sculptural series, and engineered the debuts of several young artists. The Bâtiments clearly played a part in the shift of styles through the influence it exerted as surrogate patron for the king and protector of the academies and luxury manufactories. Thus, the rise and fall of different styles can be associated with specific arts administrations: from the **Classicism** and Grand Manner associated with Colbert and Hardouin-Mansart, to the height of Rococo forms under Tournehem and Marigny, and through the rise of **Neoclassicism** during the tenure of d'Angiviller and the reign of Louis XVI.

**BATONI, POMPEO (1708–87).** A favorite painter of Englishmen on the **grand tour**, Batoni was the most famous and successful painter in 18th-century **Rome**. His father was a goldsmith in Lucca, where Pompeo initially learned a detailed form of drawing while working in the family trade. By 1727, Batoni had moved to Rome with the ambition of becoming a history painter. He made numerous copies of ancient sculptures, while at the same time studying the paintings of Raphael, Annibale Carracci, Nicolas Poussin, Guercino, Domenichino, and Guido Reni. The highly polished surface textures of many of Batoni's paintings, as well as his refined use of **color**, is due to his study of the early Roman Baroque style. In the 1740s, Batoni primarily worked on historical and mythological subjects, finishing only a handful of **portraits** during these years. His most important commission was for an altarpiece in Saint Peter's, *The Fall of Simon Magus* (1746–55, Santa Maria degli Angeli, Rome), a work that was quickly rejected, perhaps an indication of the extent to which the popularity of large-scale Baroque history painting had declined. The enormous painting demonstrates Batoni's close study of the numerous altarpieces completed for Saint Peter's during the 17th century, particularly in its use of dramatic movement, compressed space, exaggerated foreshortening, and competing diagonal, vertical, and curvilinear lines.

While the disappointment of the rejection no doubt contributed to Batoni's increased production as a portraitist, he did not entirely turn away from historical subjects. He regularly received commissions for mythological paintings from the great noble houses of Europe in the 1760s and 1770s, including works for **Frederick the Great**, the Empress Maria Theresa, and Catherine the Great. His *Continence of Scipio* (1771–72, Hermitage Museum, Saint Petersburg) evidences the stylistic shift of his later years toward a more delicate and painterly form of **Classicism**. In this work, Batoni's palette is lighter, gestures are more rhythmic, and drapery falls in a highly decorative manner.

Batoni's reputation today rests on his numerous **portraits**, which were commissioned first by English- and Irishmen on the grand tour but became highly sought after by the nobility of continental Europe. His *Portrait of Emperor Jospeph II with His Brother Peter Leopold of Tuscany* (1769, Kunsthistorishes Museum, Vienna) earned Batoni considerable praise and was one of the most famous portraits of its day. The subtle exchange of gesture and glance between the two sitters results from a carefully structured composition that moves the beholder's eye around the canvas in a manner that is most closely associated with the Rococo style. Batoni's ability to move freely between the styles of Bolognese Classicism, French Rococo, and Roman **Neoclassicism** undoubtedly contributed to his success as an artist during the 18th century.

Although he is often credited with the invention of the grand tour portrait, Batoni perfected a format already practiced in Rome. *Thomas Coke, 1st Earl of Leicester* (1774, Holkham Hall, Norfolk) is a paradigmatic example. Set within an interior that opens to the landscape beyond, the sitter's location in the city of the ancients is established through the specific inclusions of classical **architecture** and **sculpture**, which combine with a vague allusion to the Roman *campagna* in the background. While objects and settings (Batoni's sitters are displayed with a variety of ancient sculptures, maps, drawings, elaborate furnishings, and famous buildings) supply a clear indication of the sitter's character as a learned and cultured man, Batoni's ability to capture nonchalance through pose and elegance in the handling of **dress** conveys equally important elements of aristocratic status. Moreover, the manner of painting, which relies upon rapid execution, ease of brushwork, and mastery of **color** and hue, reinforces the nobility of both the individual and the artwork. *See also* KAUFFMAN, ANGELICA.

**BAVARIAN ROCOCO.** Many scholars believe that the Rococo reached the zenith of its stylistic potential in **Germany**, more specifically in Bavarian churches, such as **Dominikus Zimmermann**'s pilgrimage churches at Stein-

hausen (1729–33) and Die Wies (1745–54) and **Johann Michael Fischer**'s Zwiefalten (1744–65). While Italian architects, painters, sculptors, and stuccoists had been regular imports to the courts of northern Europe, the influence of French tastes was equally felt at the end of the 17th century. It became increasingly common for German princes to send artists and architects from their courts to train in **Paris** and to return informed by the latest stylistic trends. One of the earliest examples of this conflation of influences can be seen at **Nymphenburg** outside Munich, where the collaborations of the Zimmermanns and **François de Cuvilliés** produced some of the earliest secular examples of the Bavarian Rococo. Ecclesiastic spaces extended the playful decoration of palace **architecture** into the spiritual realm as a celebration of counter-reformatory zeal. Effectively, Bavarian Rococo architects treated space as a canvas for **ornamentation**, often with an elaborate ornamental **stucco** zone intervening between architecture and fresco. *See also* AMALIENBURG PAVILION; BRÜHL, SCHLOSS, AUGUSTUSBURG AND FALKENLUST; INTERIOR DECORATION; VIERZEHNHEILIGEN.

**BAYEU Y SUBÍAS, FRANCISCO (1734–95).** The Bayeu y Subías family of artists included three brothers, of which Francisco was most successful. A painter and **tapestry** designer, Francisco Bayeu entered the **Real Academia de Bellas Artes de San Fernando** in 1758, where he studied with **Antonio González Velázquez**. He was at court from 1763, working under the direction of Anton Raphael Mengs in a style that conformed to the ideals of academic **Neoclassicism** established in **Spain** by the German artist. Francisco held several court and academic posts throughout his life, including *pintor de cámara* (1767), *director de pintura* at the Real Academia (1788), and director general (1795). Despite his early attachment to Mengs, Francisco Bayeu also explored the stylistic flourishes associated with the work of **Giambattista Tiepolo**, which he would have known through the Italian artist's frescoes in the **Palacio Real** in Madrid. His combination of the stark academic qualities, for which 17th-century Spanish painting is known, with the lightness of French Rococo **color** and line can be seen in the scenes he completed at Palace of **Aranjuez**, many of which resemble the early court works of **Francisco de Goya**, his more famous brother-in-law. After the death of Mengs, Francisco Bayeu was the leading Spanish artist working at court and in Madrid, although Goya soon eclipsed his favor in court circles. Bayeu had two younger brothers, Raymón (1746–93) and Frey Manuel (1740–1809), who were also artists. Manuel Bayeu specialized in religious paintings influenced by the Italian Baroque style, while Raymón's paintings, prints, and tapestry designs were more Neoclassical and in step with academic teachings.

**BEAUVAIS, MANUFACTORY OF TAPESTRIES.** Located in the northwestern French city of the same name, with a weaving tradition dating back to the middle ages, this **tapestry** factory was founded in 1664 as part of the mercantile policies of **Jean-Baptiste Colbert**. The venture, which began as a private enterprise with royal subsidies, was intended to supplant the import of Flemish verdure tapestries by the nobility and wealthy Parisians. In addition to more conventional Grand Manner themes, such as the *Conquests of Louis the Great*, Beauvais produced highly innovative designs at the end of the 17th century that included **grotesques, arabesques**, and **chinoiseries**. Many of these were after paintings by Jean-Baptiste Monnoyer, undoubtedly inspired by **Jean Bérain**'s engravings. One of these series, *The Grotesques*, survives as an important example of early Rococo decoration, in which figures mix within delicate architectural frames decorated with floral motifs. The painter **Jean-Baptiste Oudry** became actively involved in production from the 1720s onward, first employed as a painter and then becoming director of the factory in 1734. He closely supervised the workmanship and developed a closer visual relationship between the original painted cartoons and final tapestries. Oudry's talents as a painter of **ornamental panels** and animals merged in his approach to subjects, such as the fables of La Fontaine. He also employed other well-known artists, including **François Boucher**, to produce designs for the factory. Tapestries produced in the middle decades of the 18th century at Beauvais are characterized by their lighthearted subject matter: narratives derived from modern literature and theater, mythological loves of the gods, *fêtes*, and pastorals. The works produced under Oudry's supervision forged close connections between painted cartoons and final tapestries, particularly in terms of composition and **color**. *See also* FRANCE; GOBELINS; REAL FÁBRICA DE TAPICES Y ALFOMBRAS DE SAN BÁRBARA, MADRID.

**BÉLANGER, FRANÇOIS-JOSEPH (1744–1818).** Best known as the architect and landscape designer who built **Bagatelle** for the **comte d'Artois**, Bélanger also made drawings for **interior decoration, furniture**, and court festivals. In the late 1760s, early on in his career, he worked for the crown as *dessinateur du roi* at the Hôtel des **Menus Plaisirs**. At this time, he also received many independent commissions from the wealthy admirers of his mistress, the actress Sophie Arnould. In the 1780s, he was more actively involved in the urban development of public works and submitted projects for the reconstruction of the Paris Opéra as well as reports for flood-control on the Seine. As a landscape architect, Bélanger worked on many of the most spectacular French picturesque **gardens** of the late 18th century. In addition to those of Bagatelle, he assisted the prince de Ligne at Beloeil, worked for

the duc de Laborde at Méréville (before being replaced by **Hubert Robert**), and created the Folie Saint-James in Neuilly-sur-Seine for the financier Claude Baudard de Saint-James. In addition to the serpentine paths that meander through these gardens in the *jardin-anglais* style, numerous *fabriques* in the form of classical grottoes and temples decorate the landscape and provide destinations for the amusement of visitors. *See also* ARCHITECTURE; FRANCE.

**BELLA, STEFANO DELLA (1610–64).** The son of a minor Florentine sculptor, Stefano della Bella was a prolific draftsman and etcher working in Florence, **Rome**, and **Paris**. He studied etching with Remigio Cantagallina, who also trained Jacques Callot. His prints and drawings provide some of the most insightful and vivid records of urban and rural life in **Italy** and **France**, and many of his drawings were made in the open air and at public events. His minute style is characterized by a free-hand technique, rapid handling, use of fine lines, and varied strokes that suggest a wide variety of textures. He traveled to Paris in 1639 as part of the ambassadorial entourage of Alessandro del Nero and remained in **France** until 1650, when the political unrest of the Fronde forced him to return to Italy. In Paris, he worked for **Pierre-Jean Mariette**, as well as obtaining court commissions from the king's chief ministers, cardinals Richelieu and Mazarin. He recorded military sieges by the royal army and also made *The Game of Mythology* (1644), a set of instructional playing cards for the boy king, **Louis XIV**. The latter were reprinted in 1692 as a pleasing pedagogical game for salon society.

Della Bella's **ornamental** etchings were published in five suites in Paris during the mid-1640s and remained influential among decorative artists into the 18th century. They include the *Raccolta di varii capricii* (1646) and his *Nouvelles inventions de cartouches* (1647). These highly original prints teem with naturalistic foliage mixed with fantastic creatures, half animal and half human. A 1734 review in the *Mercure de France* of a new suite of ornamental engravings by **Juste-Aurèle Meissonier** notes the debt of the new *genre pittoresque* to the manner of della Bella.

**BELLEVUE, CHÂTEAU DE.** Bellevue was built for **Madame de Pompadour** between 1749 and 1750, after the land was gifted to her by **Louis XV**. It was intended to function as an intimate retreat for the lovers and their close friends, a purpose that is reflected in the simple block-like **architecture** of the central building. Domestic services were relegated to peripheral buildings set around a courtyard to the rear, providing inhabitants with greater privacy when in residence. This emphasis on intimacy and a genuine preference for relatively small-scale structures is typical of Rococo domestic architecture,

and Bellevue is one of the first châteaux associated with the king to adopt this approach. When his sexual relationship with Pompadour ended, Louis XV repurchased the property in 1757 and expanded the main building by adding two wings, commissioning **Ange-Jacques Gabriel** to design the alterations. After Louis XV's death in 1774, Bellevue became the property of his three unmarried daughters, Madame Adélaïde, Madame Victoire, and Madame Sophie. Avid **patrons** and collectors, their improvements were largely focused on the interiors and **gardens**. They created a new *jardin anglais orné* nearby, an example of the increased Anglomania in French aristocratic circles at the time. *See also* FRANCE; INTERIOR DECORATION.

**BELLOTTO, BERNARDO (1722–80).** Like his uncle, Canaletto (Giovanni Antonio Canale), with whom he worked first as an assistant in **Venice**, and later painting side-by-side along the canals of the Veneto, Bernardo Bellotto was known for his *vedute*, or view pictures. The closeness of the two artists' output is demonstrated by Bellotto's *View at the Entrance of the Grand Canal* (Fitzwilliam Museum, Cambridge), which closely follows Canaletto's views of the Grand Canal from the 1730s but with a slightly looser handling of brush. Bellotto's style of **painting** became increasingly distinct from that of his uncle after he left **Italy** in 1747 to work as an itinerant court artist between Dresden (1747–58; 1761–67), Vienna (1758–61), Munich (1761), and Warsaw (1767–80), completing numerous *vedute* for rulers who desired views of their palaces and other architectural expressions of their monarchical authority. In Dresden, at the invitation and urging of Frederick-Augustus II, Elector of Saxony (and **Augustus III, King of Poland**), Bellotto developed his ability to capture majestic **architecture** at the same time that he blended such buildings into their topographical environment. *The Moat of the Zwinger* (1749–53, Gemäldegalerie, Dresden) is an early example of his success with this type of image, which promotes the architectural achievements of the ruler. Using extreme diagonal lines to accentuate the sweep of the moat, formal drama is then naturalized by a palette of local **color** and fine attention to the less significant architectural details of the surrounding town. Bellotto's intricate painterly handling and manipulation of composition results in view pictures that balance a taste for Rococo delicacy and intimate expression of detail with the grandeur of Baroque building projects. *See also* GUARDI, FRANCESCO.

**BÉRAIN, JEAN, I (1640–1711).** Bérain was a French designer of ornament, decorative objects, costumes, festival ephemera, and garden **parterres**. By 1670, he was employed by the crown as an engraver. His talents as a decorative artist led to his appointment as *dessinateur de la chambre et du cabinet du roi* in 1674, a position that required him to produce all manner of scenery

and costuming for theatrical performances, masques, amusements, and *fêtes*. It is not his work for the crown, however, for which Bérain is best known. Working for high-ranking members of the aristocracy, he produced richly inventive **arabesque** designs, particularly for **ceilings** and **chimneypieces**, which are considered to be important precursors to the Rococo. Known through published books of engravings, they inspired younger decorative artists, such as **Claude III Audran** and **André-Charles Boulle**. His drawings for ceiling and panel decorations at the Hôtel de Mailly in **Paris** are marked by the rich variety of his designs, some of which are purely **ornamental** in their elaborate conflation of **bandwork** and foliage, while others mix together fantastic flora and fauna with antique herms and medallions. Bérain's work exemplifies the important links between official art produced for **Louis XIV** and the tastes of satellite courts established in and around Paris. *See also* PANELING.

**44 BERKELEY SQUARE.** In 1764, Horace Walpole described the staircase built by William Kent for Lady Isabella Finch at 44 Berkeley Square "as beautiful a piece of scenery, and considering the space, of art, as can be imaged." The staircase combines a Rococo sense of unexpected **asymmetry** and sweeping curves. A single flight up to a half-landing divides in two, leading to the first floor where it changes once again to a single flight up to the second floor. This movement between centrality and division is complemented by the curving lines of the handrail on the wrought-iron balustrade, which features S-shaped scrollwork. Kent also completed designs for the Saloon (RIBA Library Drawings and Archives Collections), which date from the mid- to late-1740s. In the Saloon, Kent put architectural form in the service of **ornamentation**, particularly in the **ceiling**, which features decorative interconnecting **stuccowork** that creates compartments to hold brightly colored paintings. *See also* ARCHITECTURE; CHESTERFIELD HOUSE; ENGLAND AND THE ENGLISH ROCOCO.

**BERNINI, GIAN LORENZO (1598–1680).** While Gian Lorenzo Bernini is the quintessential Italian Baroque architect and artist, his style and works were influential in the development of the Rococo in **France**. Bernini, along with several other architects, was invited to provide designs for the eastern facade of the Louvre in **Paris**. While his designs were eventually rejected, Bernini was brought to the court of France to develop them in more detail. The undulating curves of the facade of his second design (Musée du Louvre, Paris) are Baroque in movement and grandeur, but the serpentine curve of line at the center of the design anticipates the curves that are so often found in **painting** and **furniture** from the Rococo period, as well as the playfully

curving facades of Rococo garden structures, such as **Amalienburg** in the gardens of Schloss **Nymphenburg** on the outskirts of Munich. Indeed, it is the **Bavarian Rococo** that is heir to Bernini's innovations, combining the creativity and exuberance of his architectural forms with proliferating **rocaille** ornamentation. *See also* ITALY; SCULPTURE.

**BLONDEL, JACQUES-FRANÇOIS (1705–74).** Jacques-François Blondel was the most important French teacher of **architecture** during the 18th century. He wrote extensively about the theory and practice of his profession and opened the first private school of architecture in **France**, the École des Arts. His teachings differed considerably from those of the **Académie Royale d'Architecture**, most radically in his insistence that his students observe contemporary and 17th-century buildings in and around **Paris**. Blondel took a rational approach to architectural design and expressed distaste for excessive decoration. While he documented the full range of styles of architecture current in mid-18th-century **France** (**chinoiserie**, *turquerie*, **gothic**, and **rocaille**), he also lamented the lack of direction evident in the eclecticism of contemporary tastes. He promoted an appreciation of 17th-century **Classicism**, namely the designs of Claude Perrault, François Mansart, and Louis Le Vau. Blondel was invited by **Denis Diderot** and **Jean Le Rond d'Alembert** to contribute his ideas on architecture to the *Encyclopédie*, a request that suggests the appeal of his theories within **Enlightenment** circles.

**BOFFRAND, GERMAIN (1667–1754).** The son of Jean Boffrand, a minor architect and sculptor, and nephew to the court poet Philippe Quinault, who made important introductions for him, Germain was the most important architect working in the Grand Style between Jules Hardoin-Marsart and **Ange-Jacques Gabriel**. He is celebrated for the Salon de la Princesse at the **Hôtel de Soubise**, which stands at the height of French Rococo **architecture** and interior design. Boffrand trained as a boy in the studio of François Girardon before working as a draftsman in the **Bâtiments du Roi** from 1685 until around 1700. In addition to building a number of *hôtels particuliers* and expanding the **Arsenal** (1712) in **Paris**, Boffrand was also *premier architecte* to Leopold, Duke of Lorraine, for whom he designed several buildings in and around Nancy, most importantly the Château de **Lunéville** (1708–22), inspired by the example of **Versailles**. He was involved in speculative building projects, which aided the development of the faubourgs Saint-Germain and Saint-Honoré during the second decade of the 18th century, although much of this ended with the collapse caused by John Law's financial scheme. Boffrand's most influential achievement was his design of a two-story pavilion for the Hôtel de Soubise (1735–40), which houses two oval salons. The

highly celebrated Salon de la Princesse is formed by eight arches that frame windows, **doors**, and **mirrors**. Between the arches are **boiseries** crowned by painted canvases set within freely curved, ornate frames. The room undulates in a characteristically Rococo fashion, with all division between walls and ceiling dissolved.

**BOISERIES.** Rococo wood **paneling** is often referred to by the French term *boiseries*. **Ornamentation** of rococo boiseries typically included **arabesque** designs made out of shallow relief carvings, which were painted in soft pastel **colors** or gilded.

**BONAVIA, GIACOMO (SANTIAGO) (1705–59).** Bonavia was a painter and architect from Piacenza, brought to **Spain** in 1728 by marchese Annibale Scotti to assist with ongoing royal building projects. Initially, he worked with French military engineers at the royal palace of **Aranjuez**, most likely with the idea that he would bring to the project a style that embodied the decorative qualities valued in the northern Italian courts. He was appointed director of royal decoration in 1735. While his architectural designs respond to the heavy and **ornamental** Baroque designs of **Filippo Juvarra** and Guarino Guarini, his **paintings** are more Rococo in their soft coloring and theatrical character. Emphasizing illusion and no doubt drawing from his experiences as a stage designer for the theater at El Buen Retiro, Bonavia excelled at trompe l'oeil fresco paintings that provide fictive extensions of real spaces into **architectural** settings for mythological figures. In this regard, his achievements at Aranjuez parallel those of **Giambattista Tiepolo** at the **Würzburg Residenz**.

**BONNIER DE LA MOSSON, JOSEPH (1702–44).** Upon his father's death, Joseph Bonnier de La Mosson inherited a treasury post, the family château in Montpellier, and a fashionable *hôtel* in **Paris**. He was an avid collector of natural and artificial curiosities and commissioned **Jean Courtonne** to design a physical sciences cabinet for their display in his Parisian *hôtel*. Courtonne's drawings (1739–40, Fondation Jacques Doucet, Paris) record the manner of display, which achieves a balance between scientific and **aesthetic** concerns, with the objects artfully arranged, rather than rationally categorized. Bonnier de La Mosson also commissioned for this space several overdoors by **Jacques de Lajoüe** that extend the scientific fantasy (1734, Sir Alfred Beit Foundation, Russborough). These painted perspectives are **asymmetrical** in composition and weave together actual features of the collection and its display with fantastic vistas that move the imagination beyond the confines of the Hôtel Bonnier de La Mosson. As an example of a late *Wunderkammer*, Bonnier de La Mosson's cabinet demonstrates the lingering

microcosmic interests of the Baroque collector brought into agreement with the refined aesthetic tastes of the time of **Louis XV**. *See also* PATRONS AND PATRONAGE.

**BOUCHARDON, EDME (1698–1762).** Edme Bouchardon won the *Prix de Rome* for **sculpture** in 1721, having trained with his father, Jean-Baptiste and Guillaume **Coustou** the Elder. He traveled to **Rome** two years later, where he was popular within papal circles and among French and English expatriates, and received numerous private commissions. His portrait busts were particularly in demand, and his sitters included the new pope, Clement XII. Bouchardon's study of classical sources is evident in his bust of the antiquary *Philip, Baron von Stosch* (1727, Skulpgal, Berlin), although he was also influenced by the work of Baroque sculptors like **Gian Lorenzo Bernini** and Alessandro Algardi. Bouchardon returned to **Paris** in 1733 and was soon after accepted into the **Académie Royale de Peinture et de Sculpture**. He was received as a full member in 1745 with the submission of his *Crucified Christ* (Musée du Louvre, Paris) and quickly rose to the rank of professor. Bouchardon exhibited at the **Salons** from 1737 onward but joined a group of prominent academicians who refused to display in 1749 and 1751, protesting against the art criticism of writers such as **Étienne La Font de Saint-Yenne**, which they believed to be unprofessional, inflammatory, and highly damaging to their careers.

It was during this time that Bouchardon painted his most famous surviving work, *Cupid Cutting a Bow out of Hercules' Club*. This had been ordered for the crown by **Philibert Orry** in 1740 to adorn the Salon d'Hercule at **Versailles**, and it took the artist 10 years to complete the commission. The subject is quintessentially Rococo in that it puts a symbol of physical strength and heroism into the service of love. Cupid's twisting, somewhat contorted pose reveals the influence of Mannerist painting, but the face is treated with Bouchardon's signature naturalism. The work was not well-received, with critics suggesting that a street urchin had come to Versailles.

In 1749, Bouchardon received a commission from the city of Paris for an equestrian monument of **Louis XV**, destined for the new Place Louis XV (now the Place de la Concorde) and destroyed during the Revolution in 1792. He made over 300 drawings for this work, and it remained unfinished at his death in 1762. The monument was completed by **Jean-Baptiste Pigalle** and inaugurated in 1763. A reduction of the original in the Musée du Louvre shows Bouchardon's ability to blend classical sources with naturalistic forms. He drew inspiration from the equestrian statue of Marcus Aurelius, which he knew from his years in Rome, yet he modified the pose so that Louis XV sits astride the horse with considerable grace and ease. The king is portrayed as a

Roman emperor, with the hard lines of his drapery complementing the visible strength of muscles in his neck and arms and contrasting with the delicate naturalism of the horse.

**BOUCHER, FRANÇOIS (1703–70).** François Boucher is the artist most closely associated with the Rococo style. He was a favorite artist of **Madame de Pompadour**, to whom he gave amateur art lessons, and historically, his works have been attached to the art produced during the period she was official mistress to **Louis XV**. Boucher, however, had a much longer career, and he was both successful and active before the time of Pompadour. His art was popular with private collectors and **patrons**, and with a few notable exceptions, most critics praised his works in the press. Boucher was a prolific artist who moved with ease between diverse idioms, media, and subject categories. He produced etchings, **paintings**, drawings, tapestry cartoons, designs for **porcelain** and the stage, book illustrations and frontispieces, and fans. By his own account, which may be exaggerated, he completed over 10,000 drawings and 1,000 paintings. Boucher worked across genres, executing mythological and religious compositions, landscapes, pastorals, scenes of everyday life, **portraits**, hunts, and animal pictures. His drawings demonstrate his facility working with chalks, pastels, pen, and ink, as well as brush and ink with washes. He directed a large workshop and held influential official posts, which effectively reinforced the dominance of his style, although his most powerful positions as *premier peintre du roi* and director of the **Académie Royale de Peinture et de Sculpture** were only granted in 1765, toward the end of his life.

Boucher's earliest training as an artist was probably with his father, Nicolas Bouché (1672–1743), who was a painter and member of the **Académie de Saint-Luc**, rather than the Académie Royale. He also worked in the studio of **François Lemoyne**, which allowed him to compete for the *Prix de Rome*, although he was not a student at the Académie Royale at the time. Boucher won the competition in 1723, but he did not receive a funded place at the Académie de France in **Rome**. Consequently, he remained in **Paris** between 1723 and 1728, training as an engraver with the publisher Jean-François de Cars (1661–1730). It was during this time that he made a series of etchings after **Antoine Watteau**'s drawings for a publication by Jean de Julienne, *Figures de différents caractères* (1726–28). The process of copying and enhancing the works of Watteau in etched form influenced the development of Boucher's style in these early years. It is during this period that Boucher became an accomplished draftsman, assimilating Watteau's *trois crayons* **technique** (red, white, and black chalk used for the same drawing).

Boucher's work as a printmaker and painter provided him with the funds to travel to **Italy**, which he did in 1728 with François, **Carle**, and

**Louis-Michel van Loo**. In Rome, he lodged at the Académie de France, but it is unclear how involved he was in the activities of that institution. He certainly did not follow the usual training practices of young artists at the academy, who were urged to make copies after antique **sculpture** and Renaissance masters, like Michelangelo and Raphael. Boucher's drawings from this period instead show that he studied the works of Italian Baroque artists, like Pietro da Cortona and **Gian Lorenzo Bernini**, known for their illusionism and heightened appeal to emotion. It is likely that he was already painting highly original mythological scenes while in Rome, such as *Hercules and Omphale* (c. 1730, Pushkin Museum, Moscow), which takes a sensual approach to historical subject matter and emphasizes themes of love and eroticism.

Upon Boucher's return to Paris in 1731, he continued to work as an engraver, making etchings after Watteau's decorative paintings at the Château de La Muette, and was accepted into the Académie Royale. For the next few years, he began to work more actively as a painter, completing large-scale religious and mythological paintings, as well as the first of his "enfants de Boucher," which depict **children**, putti, and cupids engaged in playful activities. Boucher became a full member of the Académie Royale in 1734 with his reception piece *Rinaldo and Armida* (Musée du Louvre, Paris). He subsequently received royal commissions to paint works for **Versailles**. The first commission was for emblematic virtues in the form of putti for the Chambre de la Reine in 1735 and, between 1736 and 1738, two exotic hunt pictures for the dining room of **Louis XV**'s Petits Appartements at Versailles. During the late 1730s, Boucher produced cabinet pictures in a variety of modes to attract private collectors, including scenes of everyday life, such as *Family Taking Breakfast* (1739, Musée du Louvre, Paris).

Boucher's most successful years as an artist were between 1740 and 1765. His cabinet pictures, such as *Diana after the Bath* (Salon of 1742, Musée du Louvre, Paris) and *La marchande de modes* (1746, Nationalmuseum, Stockholm), were well received at the **Salons** and sought after by private collectors throughout Europe. The latter work was ordered by **Count Carl Gustav Tessin**, the former Swedish ambassador in Paris, for Princess Lovisa Ulrica of **Sweden**. He also worked extensively for Madame de Pompadour during this period, executing her **portrait** on several occasions, completing a *Nativity* (1750, Musée des Beaux-Arts, Lyon) for her chapel at the **Château de Bellevue** and two large-scale decorative works, *The Rising of the Sun* and *The Setting of the Sun* (1753, Wallace Collection, London), which were the crowning achievements of his career.

It was during this period of royal favor and professional prosperity that Boucher became the focus of attacks by critics associated with the anti-

Rococo reaction. As early as 1747, **Étienne La Font de Saint-Yenne** and others criticized Boucher's use of **color** and approach to subject matter in *The Rape of Europe* (Musée du Louvre, Paris), which he entered in a competition between leading academic painters. Better known are the scathing Salon reviews by **Denis Diderot** in the *Correspondance littéraire et artistique* between 1759 and 1781, which claimed that Boucher's "degradation of taste, color, composition, characters, expression, and drawing have kept pace with moral depravity." While Diderot's words were only marginally influential during his lifetime, they have had a lasting impact on the historical reception of Boucher's art.

**BOUDOIR.** Part of a lady's private suite of rooms, the boudoir was adjacent to the bedchamber and used to entertain intimate friends. As in the *cabinet*, of which it was the female equivalent, **paintings** often adorned the walls. Anti-Rococo critics disparaged artists, such as **François Boucher** and **Jean-Honoré Fragonard**, by describing them as "boudoir painters," insulting not only the decorative style of the work but also their popularity with female **patrons**. *See also* ARCHITECTURE; FRANCE; INTERIOR DECORATION; WOMEN.

**BOULLE, ANDRÉ-CHARLES (1642–1732).** The most influential cabinetmaker under **Louis XIV**, Boulle and his workshops produced marquetry floors, wainscoting with decorative details, cabinets, commodes, bookcases, armoires, clock cases, and other pieces of **furniture** for the crown, the nobility, and wealthy financiers. Some of his most celebrated pieces, such as a pair of commodes made for the king's bedchamber at Trianon in 1708–9, became models for workshop replicas, and variants were reproduced into the 19th century. Sale catalogs from the second half of the 18th century attest to a strong revival of interest in Boulle luxury furniture during the time of **Louis XVI**, as part of a turn away from the more delicate style associated with **Louis XV**. Boulle is best known for his marquetry furniture, often in ebony with gilt-bronze mounts and inlaid with wood, metal, and tortoiseshell. The fittings and inlay often drew upon **arabesques**, acanthus leaves, and elaborate naturalistic floral forms. His workshops also produced clocks with sculpted figures set on conch shells that were largely asymmetrical in composition, incorporating elements of an early **rocaille** vocabulary into decorative objects. The terms *boulle-work* and *buhl-work* were used in the 18th century to refer to the marquetry technique (invented in 10th-century Italy) that Boulle mastered with such virtuosity, regardless of whether or not the objects were actually produced by the Boulle workshops. *See also* FRANCE; INTERIOR DECORATION.

**BOURBONS.** The French Rococo is most closely associated with the reign of **Louis XV**, the fourth Bourbon king of France. Henri IV of Navarre claimed the throne of **France** through his marriage to Marguerite, daughter of the Valois king, Henry II, thereby becoming the first Bourbon king of France in the late 16th century and ending the Valois line. His descendants ruled France for the next three centuries, their reign occasionally interrupted by revolutions. His second wife, Marie de' Medici, aimed to have her children on all the thrones of Europe and to this effect, secured important marriages for her offspring. **Louis XIV** was the most magnificent Bourbon king, and the name is most clearly associated with his reign. By the 18th century, Bourbons were on the thrones of France, **Spain**, Naples and Sicily, and Parma. This contributed to the spread of the Rococo across Europe, as stylistic and thematic affinities visually represented political and social ties between different members of the ruling families. As the first Bourbon king of Spain, **Philip V** not only imported avant-garde artistic tastes from the court of **Versailles**, where the Rococo was emerging, but also French artists and artisans, who in turn influenced local artistic traditions. The Bourbons were a branch of the Capetian dynasty and direct descendants of Hugh Capet (c. 940–996). During the Revolution of 1789, **Louis XVI** and **Marie-Antoinette** were referred to as "Louis and Antoinette Capet." *See also* ABSOLUTISM; CHARLES III; ITALY.

**BOYCEAU, JACQUES (1552–1634).** Jacques Boyceau was one of the first garden designers and theorists to articulate the rules of the French formal garden. He stressed the need for order, symmetry, and visual harmony and the containment of decorative elements within **parterres**. His designs for parterres incorporate **bandwork** and acanthus foliage in a manner that anticipates Rococo **arabesques**. Appointed *intendant des jardins du roi* under Louis XIII, Boyceau laid out the first gardens of **Versailles** and is thought to have been responsible for the gardens of Luxembourg Palace. His parterres were realized at **Fontainebleau**, Saint-Germain-en-Laye, the Louvre, and the Tuileries. Boyceau's theories were published in his *Traité du jardinage* (1638), one of the first texts to treat **garden design** as an intellectual pursuit. *See also* FRANCE.

**BRÜHL, SCHLOSS, AUGUSTUSBURG AND FALKENLUST (1729–40).** **Louis XIV**'s troops destroyed the medieval Schloss Brühl, located west of the Rhine, between Bonn and Cologne, in 1689. It was owned by the Bavarian branch of the Wittelsbach dynasty, who were electors and archbishops of Cologne during the 17th and 18th centuries. The Bavarian Wittelsbachs were avid **patrons** and collectors, with Francophilic taste in the arts. This

was largely the result of Elector Joseph Clemens's (1671–1723) exposure to the court of **Versailles** during a period of exile from the Holy Roman Empire for his support of the French in the War of the Spanish Succession (1701–13). Upon his return to Cologne, he brought the French Rococo style to the Rhineland. When Elector Joseph Clemens decided to rebuild Brühl in 1715, he commissioned plans from the French court architect **Robert de Cotte**, who worked closely with Jules Hardouin-Mansart at Versailles. The building project was taken up by his nephew and successor, Elector Clemens Augustus, who first employed a local architect, Johann Conrad Schlaun, to complete the exteriors. A visit to Versailles in 1725 influenced the taste and patronage of Clemens Augustus, who began to model his artistic activities after the court of **Louis XV**.

His first project upon his return was Falkenlust (1729–40), a hunting pavilion connected to the main Schloss by a long allée, similar in scale to the Petit Trianon and in decoration to the Trianon de Porcelain in the gardens of Versailles. Designed by **François de Cuvilliés**, a French-trained architect attached to the Bavarian court, this intimate two-storied block employs a witty use of **porcelain** tiles depicting the hunt to decorate many of the walls, as well as white **ornamental stuccowork** and gilt framing elements and accents. This coherent scheme of blue, white, and yellow not only reinforced the delicate restraint of the latest Rococo forms but also referred to the family colors of the Wittelsbachs, signaling that the space accommodated pleasurable pursuits and political functions. The gardens were also redesigned in the French style at this time by Dominique Girard, who trained with André Le Nôtre. Cuvilliés brought Rococo forms into the interior of the main palace, renamed Augustusburg, by designing smooth, white surfaces covered with stuccowork and ornamental panels eroding divisions between walls and **ceilings**. *See also* BAVARIAN ROCOCO; GERMANY.

# C

**CANALE, GIOVANNI ANTONIO, CALLED CANALETTO (1697–1767).** The nickname Canaletto (the little canal) may stem from the years when Giovanni Antonio worked with his father, Bernardo Canale, a theatrical scene painter. In 1719, they were in **Rome** together, where Canaletto became influenced by Roman topographical **painting** and prints. He was back in **Venice** during the early 1720s, when he made his first *vedute*, or view pictures. These works brought the attention of two men who would change the course of his career: Owen McSwiney, an Irishman who acted as an agent for the Duke of Richmond, and **Joseph Smith**, an English connoisseur, collector, and art dealer. Both men encouraged Canaletto in his production of small topographical views of Venice, which were enormously popular with Englishmen on the **grand tour** as mementos of their time abroad. While McSwiney once described these works as paintings of "things which fall immediately under his eye," Canaletto's scenes were carefully composed from a variety of viewpoints that would not have appeared to a stationary viewer. Buildings were added in and turned around, rooflines changed, curves of the Grand Canal reshaped, and multiple perspectives merged. His attention to minute details and delicate handling of brushstrokes created a heightened sense of visual reality that was delightfully deceptive.

Canaletto was also known for his capriccios, architectural scenes of ruins or buildings derived entirely from the artist's imagination and rendered as drawings, paintings, and etchings. In 1746, he went to **England**, where he enjoyed initial success painting views of London. Demand for his paintings decreased, however, and he was back in Venice by 1755. Canaletto was elected a member of the Venetian Academy in 1763, after an earlier unsuccessful attempt, possibly due to the fact that he specialized in an inferior genre. He completed over 1,500 paintings and drawings over the course of his career. *See also* GUARDI, FRANCESCO.

**CARNICERO, ANTONIO (1748–1814).** Originally from Salamanca, Carnicero moved with his father, who was also a painter, to Madrid in 1749. He won numerous academic prizes and scholarships, eventually earning the

protection of Manuel Godoy, Principe de la Paz. Carnicero was an accomplished portraitist and received commissions from members of court, including Godoy, whom he painted several times. The 1796 **portrait** of Godoy in the Museo Romántico de Madrid poses the sitter within a carefully ordered composition and exhibits Carnicero's characteristic emphasis on line and finish. While the centrality of pose and symmetry of features betrays his adherence to academic rules of pictorial construction, the contrasting diagonals established through the ornamentation of the sitter's dress suggest a loosening of academic conventions to enhance the status of the sitter. Carnicero also painted **genre** scenes and *vedute* peopled by *majos* and *majas* who converse, dance, smoke, and drink. In these paintings, members of court often intermingle with lower-class figures, such as in *Ascent of the Balloon in the Presence of Charles IV and His Court* (c. 1783, Museo de Bellas Artes, Bilbao). The lightness of palette, elongation of figures, rhythmic treatment of gesture and pose, and painterly treatment of landscape backgrounds in these works are a significant departure from Carnicero's portrait style and reveal the extent to which a taste for Rococo genre paintings existed alongside long-standing academic traditions within Spanish **painting**. *See also* SPAIN.

**CARRIERA, ROSALBA (1675–1757).** Known for her pastel **portraits** and miniatures in tempera on ivory, Rosalba Carriera was the most celebrated **woman** artist of the early 18th century. She was well-educated, receiving, with her two sisters, lessons in French, history, literature, and music. Carriera's works were highly sought after and admired across Europe, and her popularity resulted in her admission to several academies, including those in **Rome**, Bologna, and **Paris**. The details of her early training are vague. Sources note that she studied with Giuseppe Diamantini, a painter and printmaker from Fossombrone working in **Venice**, although **Pierre-Jean Mariette** states in his *Abécédario* that she started painting **snuffboxes** under the guidance of the French painter, Jean Steve. By 1700, she was already an accomplished miniaturist and working in pastels.

Carriera became associated with **Giovanni Antonio Pellegrini** when the Venetian painter married her sister in 1704. Both artists pursued a light, airy, and painterly style that influenced the international development of the Rococo. While Pellegrini pursued large-scale decorative commissions, Carriera specialized in portraiture and miniature paintings, which were considered suitable genres for her sex. She spent a year in Paris from April 1720 at the invitation of the *amateur* **Pierre Crozat**, whom she may have met through Mariette. There she came into contact with members of Crozat's circle, which included the artists Hyacinthe Rigaud, Nicolas de Largillière, **Jean-François de Troy**, and **Antoine Watteau**. In addition to the fashionable **portraits** she

completed in Paris and at court, Carriera was invited to make a portrait of the young **Louis XV** in pastel and in miniature, which significantly enhanced her reputation.

For the remainder of her career, she continued to expand her international clientele and worked for the Este court in Modena, **Joseph Smith**, the British consul in Venice (who was also an art dealer), the imperial family in Vienna, and Frederick Augustus II, Elector of Saxony. Carriera was a cosmopolitan artist of the Rococo period whose style is defined by a delicacy of touch, harmonies of **color**, and gracefulness in expression and gesture. *See also* AUSTRIA; PAINTING; PATRONS AND PATRONAGE.

**CARTOUCHE.** A cartouche is an **ornamental** panel that resembles a tablet, shield, or sheet of paper scrolled, rolled, and cut in various shapes. Cartouches often hold inscriptions or coats of arms but also remain blank in many Rococo decorations. The use of the cartouche in **architecture** dates back to the Renaissance, but it became a dramatic focus in 17th- and 18th-century exteriors, interiors, **furniture**, and prints. A central feature of pediments (sometimes broken) above doorframes, windows, **chimneypieces**, and cabinetry, the Rococo cartouche is often **asymmetrical** in form and flanked by elaborate scrollwork, shellwork, foliage, animals, or figures, emphasizing its ornamental purpose. In the 1740s and 1750s, ornamental designers produced suites of engravings that added to the extensive vocabulary of possibilities, such as Babel's *Cartouches pittoresques*, Peyrotte's *Cartouches rocaille*, and **François de Cuvilliés**'s *Livre de cartouches à divers usages*. *See also* DOORS.

**CASERTA (1752–74).** In the early 1750s, King Charles VII of Naples turned his attention to two significant projects in Caserta, which followed the tastes and interests of the other **Bourbon** rulers and princes: a magnificent palace in the manner of **Versailles** and a majolica factory that paralleled the **porcelain** production houses of France. Luigi Vanvitell was commissioned to design the Palazzo Reale di Caserta, constructed according to a simple block plan surrounding four interior courtyards. The resulting palace is a combination of classical proportions and Baroque scale, with an imposing exterior unbroken by **ornamentation**. In contrast to the geometric monotony of the facade, highly decorative **ceiling** paintings, colorful marble, and abundant ornamental **stuccowork** adorn the interior, characterized and combined according to Rococo stylistic principles. Martin Biancour laid out the **gardens** according to the conventions of French formal designs, although an English-style garden was added to one side in the 1780s under Ferdinand IV. Charles VII's majolica factory, the Real Fabbrica di Caserta, was open between 1753 and

1756. In those three years, it mostly produced plaques and tableware in the Rococo style, with the mark of a **Bourbon** lily in relief. *See also* ITALY; MEISSEN PORCELAIN; SÈVRES PORCELAIN.

**CASTILLO, JOSÉ DEL (1737–93).** At the age of 14, this aspiring artist from Madrid received a scholarship from the prime minister of Ferdinand VI to travel to **Rome**, where he studied with the Italian Rococo painter, **Corrado Giaquinto**. He later returned to Madrid with Giaquinto, whom he assisted with several projects. Castillo also participated in competitions at the newly formed **Real Academia de Bellas Artes de San Fernando**, before returning to Rome in 1757 for another seven years. Back in Madrid, in 1765, he joined the **Real Fábrica de Tapices de San Bárbara**, where he worked under Anton Raphael Mengs, although he did not easily adopt the rigid form of **Classicism** practiced in official academic circles. His talents as a Rococo painter were suited to the scenes of everyday life that were popular at the time and the production of **tapestry** cartoons. His *Painter's Workshop* (1780, Teatro Real, Madrid) demonstrates the blending of a compositional structure that is rooted in the geometric rationality of academic Classicism, while the pastel colors, painterly handling of dress and landscape background, delicate features, and curvilinear lines of poses and drapery share stylistic affinities with the lighter Italian Rococo style. *See also* PAINTING; SPAIN.

**CAYLUS, ANNE-CLAUDE-PHILIPPE DE TUBIÈRES DE GRIMOARD DE PESTELS DE LEVIS, COMTE DE (1692–1765).** From an old noble family, the comte de Caylus was a prominent collector with a taste for antiquities, as well as an amateur artist trained in engraving by **Charles-Antoine Coypel** and in drawing by **Antoine Watteau**. His interest in art was sparked while traveling in **Italy** and the Middle East as a young man in military service, through which he gained first-hand knowledge of the monuments of antiquity, which was rare at the time. In **Paris**, he frequented the weekly gatherings of artists and connoisseurs held by **Pierre Crozat** during the 1720s, where he further developed his understanding of Old Master drawings and **paintings**, and was introduced to theoretical debates about art. He became an *amateur honoraire* of the **Académie Royale de Peinture et de Sculpture** in 1731, although it was not until the late 1740s, under the regime of **Lenormand de Tournehem**, that he actively participated in institutional reform. To foster skills in drawing among young artists, he established a prize for the drawing of expressions, known as the *Prix Caylus*. He also revived the Académie Royale's *conférences*, with regular lectures on the history and theory of art intended to produce more learned painters. He hoped that a more programmatic approach to the education of young artists would reinvigorate

the French school and encourage the production of history painting as the most significant genre. Caylus' emphasis on the promotion of drawing as a foundation of art making owes a great deal to his espousal of the Greek ideal. *See also* CLASSICISM; COLOR; NEOCLASSICISM.

**CEILINGS.** The painted decoration of vaulted ceilings was not common practice in **France** until the 17th century. Charles Le Brun's designs for ceilings at the Hôtel Lambert, the Château de Vaux-le-Vicomte, the Palais du Louvre, and the Château de **Versailles** are among the first great works of this type, which set **paintings** within a richly sculpted framework employing a stylistic vocabulary of heavy plastic and geometric forms that create a sense of ordered clarity. In contrast to this style of compartmentalized ceiling decoration, **Antoine Coypel** initiated the use of *quadratura* techniques at the Chapel of Versailles and the Grand Galerie of the **Palais Royal** around 1700, stimulating the enjoyment of heightened illusionism in paintings that appear to open up the ceilings to the heavens. Such an emphasis on verticality is a shift away from academic **Classicism** in France, and it combines with a colorist approach to the definition of form in order to appeal directly to the senses. **Giambattista Tiepolo** also revived the Italian Baroque use of this technique in his approach to ceiling painting, although he manipulated the geometric structure inherent to the **architectural** framework of *quadratura* to serve as a point of contrast with the more **ornamental** aspects of his designs. It is the resulting emphasis on artifice over illusion that subtly distinguishes the Rococo from the Baroque in decorative ceiling paintings. *See also* STUCCO AND STUCCOWORK.

**CHAMBERS, SIR WILLIAM (1723–96).** Born to a Scottish merchant family that settled in **Sweden**, Chambers was educated in **England** with the intention of entering into a mercantile career. He made three trips to the Far East in the employ of the Swedish East India Company between 1640 and 1648, thus gaining exposure to exotic cultural forms that would serve him well when he changed careers to pursue **architecture**. In 1749, he enrolled in **Jacques-François Blondel**'s École des Arts in **Paris**, traveling to **Italy** a year later. He remained in **Rome** for five years, associating with French artists and *amateurs* at the Académie de France, and making important contacts with Englishmen on the **grand tour**.

When he moved to England in 1755, the style he had developed in Rome, which has been described as Franco-Italian **Neoclassicism**, was unpopular with an English clientele that preferred a localized version of Palladianism. Chambers, however, quickly established himself through publications that demonstrated his stylistic versatility: *Designs of Villas, Temples, Gates,*

*Doors, and Chimney Pieces* (1757) and *Designs for Chinese Buildings* (1763). One, a pattern book that demonstrated his classical skills reformed according to English tastes, and the other, an advertisement of his unique knowledge of the exotic, these books announced Chambers's eclecticism, which was made physically evident in the Rococo garden he designed for the Princess and **Frederick Prince of Wales** at **Kew** (finished in 1762). The pagoda at Kew remains an iconic example of 18th-century **chinoiserie**, and it is in the area of landscape architecture that Chambers's Rococo inclinations are most evident. His *Dissertation on Oriental Gardening* (1772) was controversial in England but influential in continental Europe as it contributed to a growing taste for the *jardin anglo-chinois*, not only in **France** but also in **Germany**, **Russia**, and Sweden.

Chambers was a tutor in architecture to King George III during his childhood. Enjoying royal favor once George ascended to the throne, Chambers was appointed joint architect to the Office of Works, a position from which he influenced all architectural projects pertaining to the crown. Advancing to comptroller in 1769, he was given even more control over government building. Chambers also designed several villas in the 1760s that show his Neoclassical refinement of Palladian models, an example of which is at Duddingston House, Midlothian (1763), built for James Hamilton, eighth Earl of Abercorn. He also designed townhouses for private **patrons** in London with unified interiors, such as at Melbourne House, Piccadilly (1771, interior destroyed in 1803), where he completed the decorative wall **furniture**, including details down to silver urns and candelabras. Somerset House (begun 1776) is Chambers's most significant public building, which brings together his leanings toward an **ornamental** manner first learned in France, particularly in the interiors, and architectural precepts that he laid out in his *Treatise on Civil Architecture* (1759). Chambers was the consummate establishment architect and presented an example of the characteristics that defined the modern profession. The internationalism of his influence is attested to by the partial translation of his writings into Russian by Catherine the Great and his elevation to Knight of the Polar Star by Gustav III of Sweden. *See also* ADAM, ROBERT; CLÉRISSEAU, CHARLES-LOUIS; FREDERICK, PRINCE OF WALES; GARDEN DESIGN.

**CHANTILLY, CHÂTEAU DE.** During the 18th century, the Château de Chantilly in the Oise, some 40 kilometers north of **Paris**, was owned by the Condé family. The Renaissance château had already been updated in the style of **Louis XIV** under the Grand Condé, who commissioned work from François Mansart and André Le Nôtre. His heirs continued this practice of remodeling parts of the château and grounds in the latest styles. Louis-Henri

de Bourbon, Prince de Condé (1692–1740) commissioned a design from **Jean Aubert** for stables (designed 1719, built 1721–35). As service-oriented outbuildings, the stables employ a restrained form of the classical orders. Yet the richly sculpted architrave over the main doorway and the horizontal channeling of the rusticated wall surfaces signal a more decorative approach to construction that communicates both the status of the **patron** and the stylistic innovations of the architect. Around the same period, **Christophe Huet** was employed to complete two schemes of decorative panels for two cabinets known as the Grande **Singerie** and the Petite Singerie (1735). These interiors include inventive **arabesques** surrounding vignettes of monkeys engaged in the activities of courtiers. In 1773, Louis-Joseph de Bourbon, Prince de Condé (1736–1818) converted the French formal **gardens** east of the Grand Parterre into a *jardin anglais*, which included an early example of a fictive village, or *hameau*, comprised of several small, rustic buildings with elegant interiors. *See also* ARCHITECTURE; BOURBONS; HAMEAU DE LA REINE.

**CHARDIN, JEAN-BAPTISTE-SIMÉON (1699–1779).** A French painter of modern life, Chardin is linked with the Rococo for his choice of subjects. Stylistically, he is hard to group with painters like **Antoine Watteau, François Boucher**, and **Jean-Honoré Fragonard**, except that he shared their ability to create subtle **color** harmonies, to find **ornamental** lines in natural forms, and to merge naturalism with painterly flourishes of his brush. Chardin specialized in still lifes and **genre** scenes, and while his involvement in the **Académie Royale de Peinture et de Sculpture** indicates his ambitions as an academician, he clearly developed subjects that would suit public rather than official tastes. He studied with the history painters Pierre-Jacques Cazes and **Noël-Nicolas Coypel** for short periods around 1720 but never developed the requisite skills in academic drawing to become a painter in this genre. His earliest known work is *The Surgeon's Shopsign* (c. 1724, location unknown), a four-and-a-half meter signboard painted for a surgeon's premises that depicts a street scene with an injured duelist. This **painting**, which is known through a 19th-century etching after a sketch by **Jules de Goncourt**, recalled Watteau's more famous *Gersaint's Shopsign* (1720, Schloss Charlottenburg, Berlin) of a few years earlier and caused a similar sensation within artistic circles.

Through this work and others that he exhibited at the annual open-air *Exposition de la jeunesse* at the Place Dauphine in the mid to late 1720s, Chardin's talents became known to critics and academicians alike. Many of his still lifes from this period were inspired by 17th-century Dutch and Flemish examples, which were popular with Parisian collectors. He was first accepted into the

**Académie de Saint-Luc** in 1724, and four years later, became a member of the more prestigious Académie Royale as a "painter of animals and fruits." One of Chardin's *morceaux de réception* for the Académie Royale, *The Ray-fish* (1728, Musée du Louvre, Paris), was reportedly confused with an original Flemish still life by high-ranking academicians, and it was this blunder that led to his immediate admission into the Académie Royale on 25 September 1728. Unusually, Chardin was both accepted and received on the same day. Chardin continued to paint original still lifes in the late 1720s and early 1730s, such as *The Copper Urn* (c. 1734, Musée du Louvre, Paris). In these works, simple objects are placed against blank backgrounds that set off their different shapes and volumes, which Chardin emphasized through variation in paint textures. The result is still-life painting that is primarily concerned with the purity of form, rather than symbolic meaning.

In the 1730s and 1740s, Chardin concentrated on figure painting in domestic settings: servants at work, ladies at leisure, and scenes of **childhood** were all part of his repertoire. *The Governess* (c. 1739, National Gallery, Ottawa) and *The Morning Toilet* (c. 1741, Nationalmuseum, Stockholm), both bourgeois interior scenes, established Chardin's reputation with prominent collectors in Europe, critics, and the public. An oft-quoted pamphlet to the Salon of 1739 remarks on both the accessibility of Chardin's subject matter and the naturalness of his scene in *The Morning Toilet* that rendered the work appealing to a wider audience: "It is always the bourgeoisie that he puts into play . . . . we observe here a deep understanding of nature, first in his figures and the easy accurate movements of their bodies, and secondly the workings of their inner lives." Engravings after Chardin's genre scenes were popular, and most had moralizing verses attached to them. It is unclear, however, whether Chardin had any involvement in the choice of verses, and, therefore, they cannot be read as the intended meanings of the artist. Nevertheless, they provide an indication of some of the interpretations that circulated at the time.

Of equal importance, however, is that critics found complex **aesthetic** significance within Chardin's works, which similarly indicates the appeal of his paintings to connoisseurs and avid collectors of contemporary art. **Denis Diderot**, for example, described Chardin's late still lifes, the genre that dominated his practice after 1750, as works of a "great magician": "your silent arrangements! How eloquently they speak of the artist! How much they have to tell about the imitation of nature, the science of color and harmony!" For many contemporary viewers, Chardin's paintings referred less to a genre or subject matter than to the process of art making itself.

Despite the fact the Chardin was not a history painter, he held the influential office of treasurer in the Académie Royale and was responsible for hanging arrangements at the **Salons** for many years. Although he received few official

or royal commissions, he painted allegorical overdoors for the Château de Choisy, *Attributes of the Arts* and *Attributes of Music* (both 1746, Musée du Louvre, Paris), and the **Château de Bellevue**. In the 1770s, Chardin worked increasingly in pastel, with which he composed penetrating self-portraits and a **portrait** of his wife (Musée du Louvre, Paris). His turn to pastel portraiture may have been the result of problems he experienced with his eyes, which were irritated by the fumes of oil paint. His approach to drawing was that of a Rococo painter. Rather than line, Chardin used **color** and texture to build up form and to establish harmonies that both pleased the eye and engaged the viewer in the experience of art. *See also* PARIS.

**CHARLES III OF SPAIN (1716–88).** A **Bourbon** king of **Spain** from 1759 to 1788, Charles III was the eldest son of **Philip V of Spain** and Princess Elisabeth of Parma. Heir to the duchy of Parma, he became Charles I at the death of his uncle, Antonio Farnese, in 1731. As Duke of Parma, he conquered Naples and Sicily in 1734 and was simultaneously crowned Charles VII of Naples and Charles V of Sicily. He acceded to the Spanish throne in 1759, abdicating the thrones of Naples and Sicily, which passed to his son Ferdinand. Charles III pursued the policies of an enlightened monarch and the cosmopolitan **patronage** typical of the Spanish Bourbons. His first major artistic project in Madrid was the rebuilding of the **Alcázar**, which had already commenced. He replaced the architect in charge with the Neapolitan Francesco Sabatini (1721–97) and brought Anton Raphael Mengs and **Giambattista Tiepolo** to Spain to paint **ceiling** frescoes for the palace. Tiepolo's Rococo form of decoration had some impact on young artists working at court, but most were trained under Mengs, who advocated strict academic principles rooted in **Classicism**. **Francisco de Goya** began working at the court of Charles III in 1774, and it is tempting to see, in the route of his training, a cosmopolitanism that would have appealed to the king: Goya was trained in Saragossa with a Neapolitan-trained painter before traveling to **Rome** and Parma to continue his study of art. Whether or not this influenced the king in his choice of Goya as an artist, it is clear that Goya painted in a Rococo style during his early years at court, which appealed to the tastes of Charles III. *See also* ABSOLUTISM; ENLIGHTENMENT.

**CHARLES VI (1685–1740).** A Hapsburg **patron** of the arts with mercantilist policies, Charles was involved in numerous and costly wars, including the War of Spanish Succession and conflicts with the Turks. He became Holy Roman Emperor (1711–40) at the death of his brother Joseph I. Toward the end of his life, he secured approval of the pragmatic sanction that made his daughter, Maria Theresa (mother of **Marie-Antoinette**), heir to the Hapsburg

lands. His approach to patronage focused on the visual expression of his personal virtues combined with an ideal of **Austrian** glory and resulted in the first truly Kaiserstil (or imperial style). Remarkably cosmopolitan in their blending of styles from **Italy**, **France**, and the **Netherlands**, the projects completed during the reign of Charles VI communicate an ideal of universal harmony and a claim to power.

**CHESTERFIELD HOUSE, LONDON (1747–52, DESTROYED 1934).** Designed by **Isaac Ware** for the fourth Earl of Chesterfield, the Palladian exterior of Chesterfield House in South Audley Street, Mayfair, contained a large number of rooms in the French Rococo style. Jean Mariette's *L'architecture françoise* (1738) and **François de Cuvilliés's** *Livre des plafonds irreguliers* (1738) provided inspiration for **ornamental** decoration in the rooms, including the hall, ballroom, saloon and drawing room. Ware maintained in his *Complete Book of Architecture* (1756) that he completed the designs *à la française* according to the fanciful dictates of his **patron**, critiquing the continental practice of creating mazes of "unmeaning ornament." Despite this apology for the Rococo interiors at Chesterfield House, the delicate and inventive **boiseries** produced by French craftsmen that adorned the panels, cornices, and ceiling of the drawing room (which is known through photographs and a partial reconstruction in modified proportions at the Bowes Museum, Barnard Castle) were harmonized into a unified scheme of **interior decoration** that closely followed authentic French models. *See also* ARCHITECTURE; ENGLAND AND THE ENGLISH ROCOCO.

**CHILDREN AND CHILDHOOD.** Rococo artists such as **Antoine Watteau**, **Charles-Antoine Coypel**, **Carle van Loo**, and **François Boucher** frequently portrayed children in adult roles and as personifications of the arts and sciences. Whether intended as serious or farcical representations, these images do not focus on the state of childhood, which became a subject that interested philosophers, writers, and artists during the **Enlightenment**, particularly after the publication of pedagogical treatises by John Locke and Jean-Jacques Rousseau. Children increasingly became the subjects of **portraits** from the late 17th century onward, with the visual language of representation shifting away from signs of aristocratic lineage and toward those that indicated the imaginative play of childhood. **Nicolas Lancret** and **Jean-Baptiste-Siméon Chardin** painted numerous pictures of children, some as portraits but others as **genre** scenes that show a distinct interest in the life of the child. In their paintings, they often depicted play as an appropriate occupation of childhood. Chardin's *Soap Bubbles* and *House of Cards* (c. 1735–40, National Gallery of Art, Washington DC) can be read as reinterpre-

tations of *vanitas* emblems in scenes of everyday life, yet the focus brought to the child through representation is equally in keeping with Enlightenment writings that attend to pedagogy and childhood. *See also* PAINTING.

**CHIMNEYPIECES.** In northern European countries, from the later middle ages onward, the chimneypiece was the principal feature of wall decoration and the focus of a room. In **France** at the time of **Louis XIV**, marble was most often used for the mantel, and the overmantel became the central feature of the wall treatment. Some of the earliest examples of decorative elements that became standard features of Rococo designs are found in chimneypieces, namely in prints that record designs by **Jean Bérain** and Pierre Lepautre used in the redecoration of the Château de Marly and the Château de **Versailles** in 1699. These designs for new chimneypieces, which were published in several different suites of plates, with titles like *Desseins de cheminées* and *Livres de cheminées*, suggest the significance of this feature within **interior decoration** and quickly created a trend for new ornamentation that was followed by the great ladies of court. Both Bérain and Lepautre employed **arabesques**, but Lepautre allowed relief ornamentation to invade from the frame into the filling of the overmantel at the top, bottom, and middle. The vitality of form was evident and became a space of Rococo decorative experimentation, only to be eclipsed in importance by **mirrors** after the second decade of the 18th century. By the 1720s, designs for chimneys treated mantel and overmantel as fragments. Such an approach to design tended to ignore the traditional role of the hearth as the central focal point of both decoration and the room. *See also* DOORS; PANELING.

**CHINOISERIE.** As a genre of European ornament, chinoiserie flourished during the 17th and 18th centuries. The decorative vocabulary of this Western mode of exoticism gave free range to the artist's creative imagination. Loosely based on a highly generalized knowledge of the "Orient" and a European fantasy of Cathay, the forms were pure invention and often eclectic in combination. It is not unusual to find figures that resemble Chinese, Turkish, and Indian people mixed together in a single composition, at times with monkeys. The delight in chinoiserie at court stimulated its appearance in all the arts, including textiles, interiors, **furniture**, decorative objects, and garden architecture, with the most fantastic examples appearing in prints. Jean-Baptiste Pillement's *Album of Chinese Cartouches* and **Jacques de Lajoüe**'s colored designs for silks demonstrate the tendency to mix figures in nonspecific Eastern clothing and exaggerated Chinese architecture with equally eccentric treatments of foliage, birds, and fruits. Garden follies from the second half of the century, such as the pagodas at Chanteloup and **Kew**

Gardens, respectively show the extent to which the craze for chinoiserie could be adapted to include **Neoclassical** detailing and to adhere more closely to actual Chinese models. *See also* CHAMBERS, SIR WILLIAM; GARDEN DESIGN; HALFPENNY, WILLIAM; INTERIOR DECORATION; RUSSIA; SANSSOUCI, SCHLOSS, POTSDAM.

**CHIPPENDALE, THOMAS (1718–79).** Few details are known about Chippendale's early training. His father was a joiner in York, and it is likely that Thomas received drawing lessons in either York or London. He established his first cabinetmaking business in the early 1750s in Saint Martin's Lane. It was during these years that he completed the *Gentleman and Cabinet-Maker's Director* (first edition 1754, with revised editions in 1755 and 1762). This pattern book influenced the development of **English Rococo furniture** and stimulated its spread in the American colonies and Europe. French editions of the *Director* were owned by Catherine the Great and **Louis XVI**. The *Director* includes French designs in the styles of **Louis XV**, more traditional English designs that are defined by deep carving, examples that involve Chinese latticework and lacquer, and others with **Gothic** detailing. In addition to furniture, Chippendale designed wallpaper, **chimneypieces**, silverware, and carpets. He also created entire furnishing programs for grand interiors, collaborating at times with **Robert Adam** and **William Chambers**. At his death, his son Thomas Chippendale (1749–1822) carried on the business. *See also* PORTUGAL.

**CHISWICK VILLA (1723–29).** Testament to Lord Burlington's infatuation with an ancient Roman-Palladian architectural style, Chiswick Villa in Middlesex, near London, features a staccato form of **interior decoration** in which richly carved sculptural details are set against plain walls and isolated from one another. William Kent used S- and C-curve scrolls throughout the interiors with Rococo inventiveness, moving figural representation into abstraction. Sculpted details include merboys with S-scroll tails that spout C scrolls or Green Men with mouths that grow into C-scroll acanthus leaves extending into S scrolls. As a whole, however, Chiswick Villa displays the cosmopolitan character of the **English Rococo** in its blending of influences that stem from ancient Rome, 17th-century England, and 18th-century **France** and **Italy**.

**CHODOWIECKI, DANIEL NIKOLAUS (1726–1801).** The son of a Polish grain merchant who was also an amateur painter, Daniel Chodowiecki described himself as a self-trained artist, although he did have formal instruction in enamel **painting** and attended life-drawing classes in Berlin. While he

painted at court and became a member of the Berlin Kunstakademie in 1764, he is best known for his prolific output as a printmaker. Chodowiecki popularized scenes of everyday life in Berlin, depicting middle-class subjects and scenes from popular literature in prints and paintings. His **genre** scenes translate French Rococo depictions of the leisure classes by artists like **Antoine Watteau** and **Jean-Honoré Fragonard** into a bourgeois idiom that found favor with a German market. His *Party in the Tiergarten* (c. 1765, Museum der Bildenden Künste, Leipzig), for example, features middle-class figures in a public garden of Berlin. While the leisure activities and garden setting recall French prototypes, the quality of dress and less-refined gestures and poses combined with a less-exclusive location to express a significant departure that shares stylistic traits found in other examples of English and Central European Rococo genre scenes. *See also* GENRE; PAINTING; POLAND.

**CLASSICISM.** In the 18th century, there was a renewed enthusiasm for antiquity. Although scholars and artists in the Renaissance and 17th century had taken a distinct interest in the classical past, the fascination of 18th-century men and women for the antique was more historically specific. Numerous publications appeared that provided increasingly detailed historical and visual information, such as Bernard de Montfaucon's *Antiquité expliquée* (1716), Lord Burlington's edition of Palladio's manuscript drawings of Roman baths (1730), and **Giovanni Battista Piranesi**'s engraved series, *Antichitá romane* and *Varie vedute* (1748). Archeological excavations began at Herculaneum in 1738, with findings published by **Charles-Nicolas Cochin** in his *Observations sur les antiquités de la ville d'Herculaneum* (1754), and further excavations began at Pompeii in 1748. New details about Greek **architecture** and **sculpture** also had an impact on matters of taste through publications like David Leroy's *Ruines des plus beaux monuments de la Grèce* (1758) and Johann Winckelmann's *Geschichte der Kunst*, which asserted the specific superiority of Greek art, as opposed to a more generalized appreciation of the authority of the "ancients."

In **Paris**, during the 1760s, this resulted in the highly fashionable style **à la grecque,** which did not overtake the Rococo but often merged and blended with its refinement, lightness, and sensibilities of **color**. In **England**, a taste for Classicism did not wane between the 17th and 18th centuries. Palladianism in architecture remained strong from the time of Inigo Jones onward, and by the 18th century, classical interiors prevailed as well. **Robert Adam**'s interiors of the late 1750s and 1760s embraced a taste for Roman domestic ornament that included the classical **arabesque**. In this way, Classicism was not antithetical to the Rococo style, but constituted a significant departure from it that subjugated free **ornamental** invention to a more studied

absorption of details from the classical past. This taste prepared the way for a more rigorous treatment of classical form in **painting**, sculpture, and architecture, known as **Neoclassicism**, which developed from the 1780s onward. *See also* AESTHETICS; ITALY.

**CLÉRISSEAU, CHARLES-LOUIS (1721–1820).** A French painter, architect, and archaeologist, Clérisseau was a significant figure in the development of the **Neoclassical** style. He trained initially at the **Académie Royale d'Architecture** with the Rococo architect **Germain Boffrand** and won the *Grand prix* in 1746. He was admitted to the **Académie Royale de Peinture et de Sculpture** as a painter of **architecture** in 1769. While Clérisseau was in **Rome** between 1749 and 1764, he became part of a community of international artists, writers, and **patrons** who were interested in the antique, including the Cardinal Albani, Johann Winckelmann, and **Giovanni Battista Piranesi**. His views of Roman monuments and topographical drawings were popular with Englishmen on the **grand tour**. **William Chambers** and the **Adam brothers** sought out Clérisseau for instruction in drawing during the 1750s. As an architect, Clérisseau produced works that were an extension of his imaginary views: a ruined garden at Sala, classical scenes with grotesque decorations for the café in the Villa Albani, and a monastic cell complete with a hermit that was designed to look like an ancient ruin. Elements of fantasy and whimsy temper the potential severity of **Classicism** in Clérisseau's work. He worked in London with the Adam brothers before being brought to Saint Petersburg by Catherine the Great to design a Roman house and museum at Tsarkoe Selo. In **France**, Clérisseau worked for **Laurent Grimod de La Reynière**, designing two salons during the 1770s that employ the classical **arabesque** in decoration. *See also* ITALY; PAINTING; RUSSIA.

**CLERMONT, ANDIEN DE (active 1716–83).** Little is known about Clermont's training but that he arrived in **England** around 1716 and was patronized by the English court between 1730 and 1754. Clermont specialized in exotic forms of painted Rococo decoration: *singeries*, **chinoiseries**, and *turqueries*. At Kirtlington Park in Oxfordshire, he created the fanciful Monkey Room (1744–45), which includes monkey men and monkey ladies engaged in the chase. Clermont also decorated rooms and **ceilings** at Wilton House, Langley Hall, and Wentworth Castle. *See also* INTERIOR DECORATION.

**COCHIN, CHARLES-NICOLAS (1715–92).** Born into a family of engravers, Cochin held numerous official positions within the **Académie Royale de Peinture et de Sculpture** and at the French court of **Louis XV**, which was somewhat unusual for a printmaker and illustrator. He trained with Jean

Restout and, by 1741, was accepted by the Académie Royale, becoming a full member in 1751. Cochin accompanied the future **marquis de Marigny** on his journey to **Italy** (1749–51). From that point onward, he enjoyed the protection and favor of Marigny, who became *directeur des bâtiments* in 1751. Cochin thus became one of the most prominent administrators of the arts in **France** during the 18th century and exerted enormous influence over artists, **patrons**, and critics. His writings on art include his *Observations sur les antiquités de la ville d'Herculanus* (1754), *Voyage d'Italie* (1758), and *Lettres à un jeune artiste peintre* (c. 1774). Many of his drawings record ceremonial events at court, such as weddings and funerals, and works like the *Masked Ball Given by the King* (1745, Musée du Louvre, Paris) provide a visual history of life at **Versailles** during the time of Louis XV. *See also* À LA GRECQUE; CLASSICISM.

**COLBERT, JEAN-BAPTISTE (1619–83).** The most powerful statesman under **Louis XIV**, Colbert was appointed *conseiller du roi* in 1661 and subsequently held significant posts that allowed him to exert enormous influence over the arts through the centralization of expenditure and policy. He became *surintendant et ordonnateur général des bâtiments, arts et manufactures* in 1664 and *contrôleur général des finances* the following year. From that point onward, he reshaped the practice of commissioning works of art for the royal household and the sponsorship of the **Académie Royale de Peinture et de Sculpture** into instruments of state **patronage**. Under the leadership of Charles Le Brun, Colbert required all artists who worked for the crown to be members of the Académie Royale and encouraged the establishment of *conférences* in an attempt to develop a set of standards and practices for artistic excellence. To exert more control over public building practices in **Paris**, he founded the **Académie Royale d'Architecture** in 1671. These policies and initiatives had a long-term impact on the state control of the arts in **France**, which was interrupted, but not eliminated, by the Revolution of 1789.

**COLOR.** Rococo color is characterized by a lightness of palette. Pastel pinks, greens, and blues are common. Rococo artists were primarily colorists—rather than an emphasis on drawing and line, they manipulated the properties of paint and harmonies of color to create form. Much of the interest in the artistic potential of color in the early 18th century grew out of the color/line debates of the late 17th century. As part of the *conférences* initiated by **Jean-Baptiste Colbert** and Charles Le Brun, a controversy broke out in the **Académie Royale de Peinture et de Sculpture** over the suitable artistic models to follow. On one side were artists who became known as *poussinistes* for championing the model of Nicolas Poussin. *Poussinistes* maintained that

*disegno* (or drawing) was the most important aspect of a painting because line appealed to the intellect. On the other side were *rubénistes*, or artists who favored works by Peter Paul Rubens, arguing that it was color that made **painting** unique among the arts in its direct appeal to the emotions. The art theorist, **Roger de Piles**, was among those who celebrated Rubens's use of color as an alternative model for art, whereas Le Brun, as leader of the Académie Royale with its pedagogical foundation in the teaching of drawing, was firmly aligned with the camp that supported *disegno*. Closely linked to the **querelle des Anciens et des Modernes** in philosophy and literature, which set the unsurpassable model of Greco-Roman antiquity against modern innovation, the arguments between the *poussinistes* and *rubenistes* mark a turning point in French art, away from the linear treatment of form found in academic **Classicism** and toward the color harmonies and painterliness of Rococo art that dominated the 18th century until the emergence of **Neoclassicism**. *See also* AESTHETICS.

**COMMEDIA DELL'ARTE OR *COMÉDIE ITALIENNE*.** The "Italian theater" frequently provided subject matter for early Rococo painters, including **Antoine Watteau**, for whom it was a favorite subject with significant creative possibilities. Based around the comic antics of stock players, the performances became highly gestural and acrobatic during the 18th century. This was partly the result of the revocation of its royal privilege in 1697, which pushed these troupes of Italian players into the fairs and festivals that took place around **Paris**. As the Comédie Française held the exclusive privilege of performing in French, actors trained in the commedia dell'arte (as the Italian theater is more commonly known) began to perform in pantomime to avoid prosecution. **Claude Gillot**, Watteau's teacher, drew these performers in his *Comedians and Acrobats* (Nationalmuseum, Stockholm), and **Claude III Audran**, with whom Watteau also worked on occasion, included acrobats in his decorative designs for **ceilings** and **paneling** (Nationalmuseum, Stockholm). Both artists attest to the fashionable interest in these subjects by wealthy **patrons**. Watteau himself blended references to the commedia dell'arte into his *fêtes galantes* by including the figure of Pierrot/ Gilles among the graceful men and women engaged in other leisure pursuits, thereby suggesting a parallel between the gestural performances of the troupes of actors and the artful presentation of the body in elite society. *See also* FOIRE DE SAINT-GERMAIN AND FOIRE DE SAINT-LAURENT; GOLDONI, CARLO; ITALY.

**COMPIÈGNE, CHÂTEAU DE (1751–86).** **Anges-Jacques Gabriel** supplied designs for the remodeling of the royal Château de Compiègne in the

Oise, north of **Paris**, for **Louis XV**. His trapezoidal plan was **Neoclassical** in character, although communication with the gardens at an oblique angle counters the continuous horizontals and plain style of the *cour d'honneur*. The extensive gardens planned by Gabriel from 1755 (ploughed up after 1789) included a series of five terraces with *parterres de broderie*. The most Rococo element of Compiègne is the Hermitage **Madame de Pompadour** had built between 1753 and 1754, with wainscots carved by **Jacques Verberckt**, who also completed panels following Gabriel's designs for apartments in the main château. *See also* GARDEN DESIGN; PARTERRES.

**CONVERSATION PIECES.** The term "conversation piece" is specifically used to describe small-scale group **portraits** in which figures are informally posed, often engaged in leisure activities or conversation in their homes or gardens. Although not exclusive to British art, this was a popular mode of portraiture in **England** from around 1720. The earliest artists working in this genre were **Philip Mercier** and **Francis Hayman**. Mercier's *Viscount Tyrconnel and His Family* (1725, National Trust, Belton House) is a typical scene, in which the sitters are grouped around a swing in a garden setting with the family estate in the background. Conversation pieces were not exclusively posed portraits but also incorporated groups composed from the artist's imagination, also known as **"fancy pictures."**

*COQUILLAGE. See* ROCAILLE.

**COTTE, ROBERT DE (1656–1735).** The principal collaborator of Jules Hardouin-Mansart and also his brother-in-law, Robert de Cotte worked for the Service des **Bâtiments du Roi** from 1685 onward, the same year that he became a member of the **Académie Royale d'Architecture**. He made the requisite trip to **Italy** somewhat late in his career, for six months in 1689, possibly as a reaction to comments from people like **Pierre-Jean Mariette**, who questioned his abilities as a draftsman and training as an architect. He succeeded Mansart as both director of the Academy (1699) and *premier architecte du roi* (1708), and completed work at the Place Louis XIV (Place Vendôme) and chapel of **Versailles**. Like his brother-in-law, he demonstrated a remarkable capacity to oversee numerous projects simultaneously and to manage teams of architects, sculptors, and draftsmen.

De Cotte was also able to synthesize styles, not only those of pure French **Classicism** in the manner of François Mansart and of the great French 17th-century architects working in Classicism on a Baroque scale, such as Louis Le Vau, but also the Palladian-villa type, which he deployed with characteristic restraint in Parisian *hôtels particuliers*. His designs for private residences, in

particular, closely follow the rules of *bienséance* (decorum), using the status and needs of the patron to determine the appropriate architectural elements. Examples of this approach include the Hôtels du Lude (1710, destroyed), d'Estrées (1711–13), and du Maine (1716, destroyed). Outside of the capital city in **France**, he completed proposals for the Place Bellecour in Lyon and designed the Episcopal palaces of Verdun and Strasbourg. The latter were based on the *hôtel particulier* type but, following the principles of *bienséance*, included both distinct ceremonial spaces and emblematic details that signaled the high social and religious status of the bishops that they housed.

De Cotte was the leading architect in Europe at the beginning of the French Regency period (1715–23) and was actively sought out for consultation by German princes who desired residences that would emulate Versailles. In addition to supplying plans for Schleissheim for the elector of Bavaria, he was consulted on the palaces of Poppelsdorf, **Brühl**, Godesberg, Bonn, Clemensruhe, and **Würzburg**, the latter of which brought him into contact with the most significant Bavarian architect of the Rococo period, **Balthasar Neumann**. **Philip V of Spain** also solicited designs from de Cotte for Buen Retiro.

While de Cotte's influence on the development of Rococo ornamentation has been questioned due to the lack of specific drawings that can be solely attributed to him, it is clear that he oversaw the execution of numerous interiors and decorative pieces with scrollwork, **rocaille** detailing, and **chinoiserie** elements. He may not have been part of the avant-garde, but considering his executive position and widespread reputation, de Cotte played a significant role in disseminating the Rococo style across Europe. *See also* ARCHITECTURE; BAVARIAN ROCOCO; STYLE RÉGENCE.

**COURTONNE, JEAN (1671–1739).** The architect of a number of townhouses in **Paris** during the second and third decades of the 18th century, Jean Courtonne is described as late as 1722 as a "master mason and entrepreneur of buildings." There is some dispute over the level of control he exerted over designs for the Hôtel de Noirmoutiers on the Rue de Grenelle, where the **patron** himself appears to have provided details for the decorations, proportions, and plan of the building. Regardless of such active intervention from his patrons, which was customary at the time, Courtonne derived highly inventive solutions that negotiated between the conventions of **architecture** and the expression of aristocratic status. His novel designs for the plan of the Hôtel de Matignon along the Rue de Varenne around 1720 involved discontinuity between the axes of the court and garden facades and a circular path through the building. This incorporation of **asymmetrical** design principles may have been the result of a desire on the part of his patron, the Prince of

Tigny and a *maréchal de France*, to give further emphasis to both the court and garden facades, thereby effecting a more palatial impression in an *hôtel particulier*. In 1728, Courtonne became a member of the **Académie Royale d'Architecture**, and shortly after, he published his *Traité de la perspective pratique* (1725), in which he proposed, against tradition, that the exterior of a building should be derived from the forms of the interior, a theoretical directive that can be seen in practice at the Hôtel de Matignon.

**COUSTOU BROTHERS.** The Coustou family of sculptors from Lyon included Nicolas Coustou (1658–1733) and Guillaume I (1677–1746), both of whom worked under the direction of **Robert de Cotte** at **Versailles** and Marly. Nicolas and Guillaume moved to **Paris** to train with their uncle, **Antoine Coysevox**, who was a leading sculptor at the court of **Louis XIV**. In turn, each of the Coustou brothers won the *Prix de Rome*, although only Nicholas was awarded a place in the Académie de France. Guillaume, however, went to **Rome** at his own expense and worked for Pierre Legros, a French expatriate sculptor in the Baroque manner. After their return to **France**, the Coustou brothers rose through the ranks of the **Académie Royale de Peinture et de Sculpture** and held positions of increasing authority. Like their uncle, they were kept busy at court on commissions received from the **Bâtiments du Roi**. The three often worked in collaboration, together completing the sculpted ensemble *Vow to Louis XIII* for the choir of Nôtre-Dame Cathedral in Paris.

Nicolas trained a number of young sculptors who pursued careers in Denmark, **Spain**, and **England**, the most famous of which was **Louis-François Roubilliac**, who played a significant role in the development of the Rococo style in London. Nicolas's style, which is characterized by the graceful animation of Rococo **sculpture**, was thus influential beyond the borders of France. Guillaume was also active as a teacher. His students included his son Guillaume (1716–77), his nephew Claude Francin, and **Edme Bouchardon**. Guillaume's masterpieces of 18th-century monumental sculpture are the pair of *Horse Tamers* (1739–45, Musée du Louvre, Paris) he produced for Marly-le-Roi. These well-known works demonstrate the extent to which Guillaume was able to maintain the grandeur associated with the style of Louis XIV, while at the same time exploring new stylistic possibilities found in **asymmetrical** systems of form and balance.

**COYPEL, ANTOINE (1661–1722).** Son of the French painter Nöel Coypel (1628–1707), Antoine was brought up in **Rome**, where his father was the director of the Académie de France. Back in **France** by 1676, Antoine became part of a generation of artists working in a transitional style that adhered to

many aspects of 17th-century French **Classicism** while, at the same time, exploring the use of **color**. His theoretical tracts published in 1721 confirm his support for an eclectic approach that combined elements from both sides of the color/line debate. Nevertheless, his art responded to the emotional potential of color. Perhaps through his friendship with **Roger de Piles**, Coypel became painter to **Philippe II, duc d'Orléans**, for whom he decorated the Grande Galerie in the **Palais Royal** with a scheme from the story of Aeneas (1702–3, destroyed, but known through a sketch held at the Musée des Beaux-Arts, Angers). Following the success of this work, he decorated the vault of the Chapel Royal at **Versailles** (1709, in situ). Both decorative schemes demonstrate the extent to which Coypel was influenced by the illusionism of the Italian Baroque, although the **ornamental** trompe l'oeil effects on the side vaults temper the vertical thrust of the central vault and ceiling, resulting in a more controlled exuberance than that of Roman models. As a draftsman, Coypel experimented with the *trois crayons* technique, which is often associated with Rococo artists. He became director of the **Académie Royale de Peinture et de Sculpture** in 1714 and *premier peintre du roi* in 1715. *See also* COYPEL, CHARLES-ANTOINE; COYPEL, NOËL-NICO-LAS; STYLE RÉGENCE.

**COYPEL, CHARLES-ANTOINE (1694–1752).** Charles-Antoine spent his childhood in the **Palais Royal**, where his father **Antoine Coypel** was painter to **Philippe II, duc d'Orléans**. Accustomed to court life at an early age, he enjoyed royal **patronage** throughout his career, which culminated in his appointment to *premier peintre du roi* in 1747. He was the favorite painter of Queen Marie Leczinska, whom he painted in several **portraits**, and was part of prominent social circles of men interested in the arts, such as the **comte de Caylus** and **Pierre Crozat**. Charles-Antoine was accepted into the **Académie Royale de Peinture et de Sculpture** as a history painter at the age of 21. He participated in numerous initiatives aimed at stimulating the production of history painting, such as the *concours* (competition) of 1727 and the establishment of the École des Élèves Protégés, which was an elite school for the most talented young artists and part of a series of reforms instituted within the Académie Royale by **Lenormand de Tounehem**. For most of his career, Charles-Antoine's style was quite similar to that of his uncle, **Noël-Nicolas Coypel**, which has been described as a translation of Rococo **ornamentation** into figural form. As early as 1737, however, he began to place further emphasis on dramatic expression and gesture, which his *Fury of Achilles* (1737, The Hermitage, Saint Petersburg) combines with a compositional shift back to the center. Charles-Antoine Coypel was also active as a playwright, illustrator, and **genre** painter, interests that were brought into dialogue with

one another in works like *Children's Games* (1728, private collection) where partially clad toddlers act out a toilette. *See also* CHILDREN AND CHILDHOOD; PAINTING; PARIS.

**COYPEL, NOËL-NICOLAS (1690–1734).** Half-brother of **Antoine Coypel**, Noël-Nicolas was likewise trained by his father, Noël Coypel, who held high-ranking official posts within the **Académie Royale de Peinture et de Sculpture**. He is best known for his mythological **paintings**, although he also painted religious subjects and fashionable **women** at court. In 1727, he participated in the *concours* (competition) organized by the **duc d'Antin**, *directeur des bâtiments*, to encourage the production of history paintings by leading artists within the Académie Royale. First prize was shared by **Jean-François de Troy** and **François Lemoyne**, although many critics preferred Noël-Nicolas' *Rape of Europa* (1727, Philadelphia Museum of Art, Philadelphia). The result was a controversy that led the comte de Morville, a secretary of state, to purchase the work at a price equivalent to the *concours* purse of 1,500 livres. In Noël-Nicolas' handling of theme, composition, and palette, *The Rape of Europe* is a paradigmatic example of Rococo mythological painting. The work is composed out of pale blues, pinks, and greens. Bodies establish spatial structure, rather than presiding architectural or landscape elements, and the entire composition is ordered by contrasting diagonals that are organized according to **asymmetrical** design principles. In this way, his paintings anticipate the major mythological works of **François Boucher**. Noël-Nicolas would have, no doubt, played a more significant role in the development of Rococo mythological painting if he had not died so young. He was made professor at the Académie Royale in 1733, shortly before his death. *See also* COLOR; FRANCE.

**COYSEVOX, ANTOINE (1640–1720).** Originally from Lyon, Antoine Coysevox was the son of a joiner who went to **Paris** in 1657. He became *sculpteur du roi* in 1666 and was appointed professor first at the Lyon Académie in 1677 and then a year later at the **Académie Royale de Peinture et de Sculpture**. Coysevox enjoyed a successful career at the court of **Louis XIV**, working for the **Bâtiments du Roi** on official commissions, as well as for high-ranking private **patrons**. He was particularly sought for his sculpted **portraits**, which included vivid portrayals of the king, princes of blood, important ministers, and other artists. Coysevox's terracotta bust of Charles Le Brun (1676, Wallace Collection, London), for example, demonstrates his ability to combine psychological penetration with vitality of form. The lifelike quality of Le Brun's face is complemented by the energetic treatment of drapery and locks, which create interest and movement through contrasting

line and variations of texture. Such busts demonstrate Coysevox's absorption of Classical and Baroque stylistic models, most notably the influence of the antique and **Gian Lorenzo Bernini**. He trained his nephews, Nicolas and Guillaume **Coustou**, with whom he often collaborated. Coysevox completed numerous garden **sculptures** for **Versailles** and Marly, working with his nephews in planning the sculptural work for the park of the latter château. Completed late in his career, *The Duchess de Bourgogne as Diana* (1710, Musée National du Château de Versailles, Paris) demonstrates the extent to which he modified his style with the times. The whimsical treatment of the subject matter, graceful pose, and seemingly weightless movement of the figure adapt classical themes and Grand Manner decorum to the lighthearted spirit of the Rococo.

**CRESPI, GIUSEPPE MARIA (1665–1747).** Also known as *lo Spagnuolo* (the Spaniard), Crespi was one of the first Italian artists to explore the subject matter of everyday life as a central preoccupation of his career. Crespi studied the works of the first Bolognese school, particularly the Carracci and Venetian art. No doubt, it is through these works that he became interested in the potential of **genre** imagery. In the early 1700s, Crespi opened his own school and successfully attracted the **patronage** of Grand Prince Ferdinando de Medici, and it was in his court that he began to paint scenes of contemporary fairs around Florence, such as *The Village Fair* (1709, Pinacoteca di Brera, Milan). Around 1716, according to his biographer Zanotti, Crespi produced a cycle of satirical paintings that narrated the rise and fall of an opera singer, supposedly commissioned by an Englishman. Although the series is lost, replicas of some of the paintings exist, including *The Courted Singer* (c. 1716, Galleria degli Uffizi, Florence), which suggests an important precedent to **William Hogarth**'s "modern moral subjects" of the 1730s and 1740s. Stylistically, the earth-tone colors and use of chiaroscuro are closely connected with 17th-century Bolognese art, and the features of figures are decidedly coarse in comparison with the refinement of figures in French painting from the same period. Nevertheless, the scene demonstrates a close affinity with Rococo painting in its various stylistic forms as it developed outside **France**, in **England** and northern **Italy**. *See also* LONGHI, PIETRO.

**CROZAT, PIERRE (1665–1740).** One of the wealthiest financiers in 18th-century **France**, Pierre Crozat amassed a collection of drawings that numbered close to 19,000 at his death and fostered an appreciation of the medium. He bought his drawings on his travels to **Italy**, by acquiring entire collections through sales in **Paris**, and by sending agents abroad to buy on his behalf. **Antoine Watteau** and Charles de La Fosse both studied Crozat's

Old Master drawings while they were living and working in his house. Crozat played host to artists and connoisseurs alike at his *hôtel particulier* on the rue de Richelieu (1704) and country house in Montmorency (1708), which provided a social setting for discussions of art and music among a group of like-minded individuals, regardless of rank. **Rosalba Carriera** and **Giovanni Antonio Pellegrini** stayed with Crozat during their visits to Paris in the early 1720s. During this period, he embarked upon a publishing project supported by the regent, **Philippe II, duc d'Orléans**, and encouraged by **Pierre-Jean Mariette** and the **comte de Caylus**, which is known as the Recueil Crozat and was designed to reproduce the most significant Italian paintings and drawings in France. Two volumes with engravings by various artists, etchings by Caylus after the drawings, and commentary by Mariette were published in 1729 and 1742. At Crozat's death, his nephew inherited his properties and paintings, while proceeds from the sale of his collections of drawings and engraved gems went to the poor. *See also* PATRONS AND PATRONAGE.

**CUVILLIÉS, FRANÇOIS DE, I (1695–1768).** François de Cuvilliés introduced French Rococo forms into Southern **Germany** during the late 1720s. Of Flemish origin, Cuvilliés worked primarily for the Wittelsbach family of electors in Munich and Cologne. He entered the service of Maximillian II Emanuel, Elector of Bavaria, as a court dwarf at age 11. The elector was personally responsible for Cuvilliés's early education and sponsored his training as an engineer and architect. Between 1720 and 1724, Cuvilliés studied in **Paris** at the elector's expense, where he was exposed to the **rocaille** decorations of **Nicolas Pineau**. Upon his return to Munich, he worked under the chief court architect, **Joseph Effner**, who had also trained in France. His close collaboration with teams of **stuccoists** and wood-carvers, such as **Johann Baptist Zimmermann** and Joachim Dietrich, was an important factor in the success of his most significant works: the hunting lodges of Falkenlust at **Schloss Brühl** (1729–40) and **Amalienburg** at Schloss **Nymphenburg** (1734–39), which were modeled on similar pavilions in the gardens of **Versailles** and Sceaux. Together, architect and ornamental sculptors created unified decorative interiors with a strong emphasis on the plasticity of ornamental forms, particularly in the **ceiling** coves.

Cuvilliés extended his reputation and influence by producing 75 series of ornament and **furniture** designs, engraved and published in Munich between 1738 and 1756. For this enterprise, he appropriated ideas from the printed designs of other French Rococo designers like **Jacques de Lajoüe** and **Juste-Aurèle Meissonier**. However, he departed from French practices by replacing painted wall panels with elaborate **grotesques** and natural motifs sculpted in gilt or silvered wood and gesso. This highly inventive approach to

wall decoration demonstrates Cuvilliés's independence from French models by adapting Rococo **ornamentation** to the traditional strengths of German artistic craftsmanship. The circular Mirror Room of Amalienburg is Cuvilliés's masterpiece. Silvered gesso ornamentation, sculpted into natural and animal forms and mixed with **trophies** that reinforce the themes of hunting and pleasure, are set off against a smooth background of pale blue and frame large **mirrors**, flowing upward into undulating coves that support further sculpted ornamentation of cupids, vases, foliage, and birds. The entire space shimmers with light and movement. *See also* BAVARIAN ROCOCO; INTERIOR DECORATION.

# D

**DAVID, JACQUES-LOUIS (1748–1825).** An active revolutionary and the most prominent **Neoclassical** painter of his generation, David began his career admiring the work of **François Boucher** and other Rococo artists. As a young man, he trained in both the studio of **Joseph-Marie Vien** and the official school of the **Académie Royale de Peinture et de Sculpture**. He won second prize in the *Prix de Rome* competition of 1770 with his *Combat of Mars and Minerva* (Musée du Louvre, Paris), a decidedly unheroic painting that employs a light palette, loose brushwork, an **asymmetrical** compositional structure, billowing clouds, and animated drapery. Although extraordinarily disappointed by his failure to achieve first prize, he did go to **Rome** to continue his academic training. Not yet a proponent of classical forms, he claimed the antique had little to offer because it lacked movement. His exploration of weighty history subjects did not begin until his return to **Paris** in the 1780s. David's works from this period, such as the *Oath of the Horatii* (1784, Musée du Louvre, Paris), exhibit not only the choice of solemn subject matter but also a shift in technique to subdued **color**, tight brushwork, strict linear perspective, and legible gestures. He carefully orchestrated the display of his works at the **Salons** to carry favor with the public, rather than academic officials. David influenced the next several generations of French artists, many of whom trained with him as pupils. It was in his studio that the term "Rococo" was first used to describe the art created at the time of the **marquise de Pompadour**. *See also* PAINTING.

**DECOUPAGE.** From the French *découper*, meaning "to cut" or "cutting out," the technique of decoupage involves cutting shapes from paper, assembling them into a design, and pasting them to a surface. Subjects included flowers, garlands, birds, butterflies, putti, and musical instruments. Decoupage was a popular form of amateur art making throughout Europe during the 18th century. **Madame de Pompadour** created images by cutting up prints by **François Boucher**, and **Marie-Antoinette** continued the trend at the court of **Louis XVI**. The hand-colored, botanical decoupages created by Mrs. Mary

Delany in **England** when she was in her 70s are remarkable examples that blur the line between amateur and professional pursuits.

**DELAMAIR, PIERRE-ALEXIS (c. 1676–1745).** The French architect Delamair is best known for his design of the **Hôtel de Soubise**, which he completed in 1705 for the Prince and Princesse de Soubise on the recommendation of their son, Cardinal de Rohan, for whom he also built the Hôtel de Rohan across the adjoining garden. Delamair produced designs for the exteriors, courtyards and garden, staircases, and interiors, although the architectural layout and decoration of the *appartements* was transferred to **Germain Boffrand**, who was perceived to be more up-to-date in his style and use of **asymmetrical** enfilade schemes. Delamair, however, produced a highly original design for the exterior of the Hôtel de Soubise, particularly in the sweeping curves of the colonnade that screens the *cour d'honneur* from the street. *See also* ARCHITECTURE; *HÔTEL PARTICULIER*; PARIS.

**DESMARÉES, GEORGES (1697–1776).** Born in **Sweden** to an artistic family of French and Netherlandish descent, Desmarées became a leading painter in the style of the **Bavarian Rococo**. He is best known for his large formal **portraits,** such as *Elector Max III Joseph of Bavaria with His Intendant Count Seeau* (1755, Residenz Museum, Munich), which reveals the stylistic influence of French Rococo portraits by Hyacinthe Rigaud and Nicolas de Largillière. Desmarées initially trained in the painting school of his uncle, Martin van Mytens II, but then traveled to Amsterdam, Nuremburg, and **Venice** before settling in Bavaria. While Desmarées's biography is distinctly international, his mature style is representative of the Francophilic tastes of the Bavarian electors and prince-bishops.

**DESPORTES, ALEXANDRE-FRANÇOIS (1661–1743).** A superbly accomplished animal painter working in **Paris** and at court, Desportes embraced the imagery of the hunt. Such subjects were popular during the reign of **Louis XV,** in part because the king was an avid hunter and favored **paintings** related to the sport. Desportes learned to draw directly from nature and in the Flemish manner of animal and still-life painting from Nicasius Bernaerts, his first teacher, who had trained with Frans Snyders. He later studied at the **Académie Royale de Peinture et de Sculpture**, where he learned academic drawing practices. Desportes had difficulty establishing himself as an independent artist in the late 1680s and early 1690s, but he worked actively as an assistant to many decorative painters. Although his works of this type are untraced, it is known through contemporary sources that he collaborated with **Claude III Audran** and completed decorative animal scenes at the **Mé-**

nagerie de Versailles, the Château d'Anet and Clichy, and in private *hôtels particuliers* in Paris. Desportes was invited to the Sobieski court in Poland, where he stayed between 1695 and 1696, painting portraits of King Sobieski and his circle, after which time he was recalled to France.

Desportes' reception piece for the Académie Royale, *Self-Portrait as a Hunter* (Musée du Louvre, Paris), earned him membership as an animal painter in 1699 and established his primary areas of training and specialization. He became official painter of the hunt and animals to Louis XIV in 1700, a position he retained under Louis XV. Paintings like *Chienne blanche devant un buisson de sureau* (1714, Musée de la Chasse et de la Nature, Paris) demonstrate the extent to which Desportes was able to incorporate rocaille visual language into Flemish still-life traditions. While the realism of the flora and fauna reveals Desportes' close study of nature, the lightness of palette and reverberation of curvilinear line clearly caters to the decorative tastes of 18th-century French collectors. *See also* OUDRY, JEAN-BAPTISTE.

**DIDEROT, DENIS (1713–84).** An important writer and thinker during the Enlightenment, Diderot was a wit, philosophe, and cosmopolite. In addition to his novels, dramatic pieces, and philosophical tracts, Diderot was editor of the *Encyclopédie ou dictionnaire raisonné des sciences, des arts et des métiers* (first edition 1751). He was also an art critic, and although not the first, his criticism and aesthetic writings are considered to be an early example of the independent review. In the late 1750s, his friend Friedrich Melchior, Baron von Grimm, suggested that he contribute writings on the biennial Salons in Paris organized by the Académie Royale de Peinture et de Sculpture to the *Correspondance littéraire*. This bimonthly newsletter circulated to an international list of subscribers, which included Frederick the Great of Prussia and Catherine the Great of Russia. Although its sale was prohibited in France, literary and artistic circles in Paris were well aware of Diderot's reviews. *See also* ALEMBERT, JEAN LE ROND D'; CHARDIN, JEAN-BAPTISTE-SIMÉON; GREUZE, JEAN-BAPTISTE.

**DOORS.** Interior double doors to rooms became standard in France after 1657, when Charles Le Brun developed designs for door casings as composite units wherein the doorway and overdoor were subsumed under an outer architrave rising to the ceiling. Such doors typically included carved ornamentation in the wood paneling. In a typical French interior at the time of Louis XIV, double doors *en enfilade* were balanced by false doors in square rooms with symmetrical wall membering, and doorways extended by overdoors to the same height of windows rising from floor to cornice. By the 1730s, however, French interiors had made significant departures from this format to

emphasize **asymmetry** and to erode divisions between architectural structure and ornamentation. Doors are shifted in enfilade schemes that sit on one side or are incorporated into curving rooms that diminish their visual significance within larger design schemes involving windows, **mirrors**, and paneling, both of which can be seen in the interiors designed by **Germain Boffrand** at the **Hôtel de Soubise**. **Nicolas Pineau**, also produced designs for the Hôtel de Rouillé (c. 1732, Musée des Arts Décoratifs, Paris, building destroyed) that removed conventional architraves from doorways. Instead, Pineau employed a thin outer frame and attenuated moldings. Door panels were reduced to two, which placed further emphasis on height, and new curvatures were introduced into the ornamentation to break down the conventional rectangular structure. In **England**, Rococo ornamentation combined with the imposing architectural features of Palladian door casings. At Claydon House, Buckinghamshire, the doorway of the Chinese Room features "columns" of foliage, scrollwork, and Chinese heads, on top of which sits the alcove composed of a fantastical **chinoiserie** garden structure reaching to the height of the cornice.

Doors feature prominently in Rococo **genre** scenes, particularly those with mildly erotic plots or that emphasize issues of privacy and intimacy. In **Jean-Honoré Fragonard**'s *Stolen Kiss* (late 1780s, Hermitage Museum, Saint Petersburg), one partially open door allows young lovers to meet and kiss, escaping the attention of their chaperones, who are glimpsed through another open door playing cards in the next room. The use of doors in scenes such as this underscores the separation of interior spaces that permitted seclusion and removal from the watchful eyes of others. A parallel emphasis on intimate rooms and privacy is provided through the inclusion of doors in images such as **Nicolas Lancret**'s *Morning* (1741, National Gallery, London) or **Jean-Baptiste-Siméon Chardin**'s *Lady Sealing a Letter* (1733, Schloss Charlottenburg, Berlin). *See also* ARCHITECTURE; INTERIOR DECORATION.

**DRESS.** The court of **Louis XIV** established modes of dress that were refined through variations of fabric, cut, and levels of informality throughout the 18th century. Fashion trends were set in **France**, and the courts of Europe tended to emulate French tastes with few exceptions. Men's costume was determined by the suit and composed of coat, waistcoat, and breeches, while **women**'s dress showed greater diversity and capacity for rapid change. The sack dress, or *robe à la française*, was the most typical gown and featured an open robe. It evolved from an informal negligee, and early Rococo artists, like **Antoine Watteau**, were attracted to the graceful lines created by the loose pleats of early versions. English women preferred the mantua, which was also an open gown, but had a tight fitting waist and was fitted at the back.

Rococo dress is characterized by a lightening of **color**, cut, and materials, as well as increased imagination in the **ornamentation** that broke up the surface of the dress or regularity of the suit. It was no longer assumed in men's dress, for example, that all elements of the suit had to be of the same piece. Similarly, the use of frills, ribbons, and flounces increased in the decoration of women's gowns, and dressmakers went to great lengths to cover the surface of dresses with ornaments such as jewels, feathers, ribbons, and garlands of artificial flowers. For men and women in the 18th century, fashionable elegance required the artful presentation of the self, and through fashionability, the noble body was transformed into a work of art.

**DUBOS, JEAN-BAPTISTE, ABBÉ (1670–1742).** Dubos was initially a diplomat, serving the regent, **Philippe II, duc d'Orléans**, in this capacity. Upon receipt of a generous pension, he was able to devote himself to intellectual pursuits, which principally included a work related to **aesthetics**, *Réflexions critiques sur la poésie et sur la peinture* (1719). In this work, Dubos put forward theories of representation, reception, and artistic genius (*génie*) and attempted to explain national differences in art-making according to varying environmental conditions. His contention that one of the primary functions of the arts was the prevention of ennui demonstrates a perception of the value of distraction in court culture. Dubos' contribution to the history of ideas was recognized by his peers when he was received into the Académie Française in 1720. *See also* FRANCE.

# E

**EFFNER, JOSEPH (1687–1745).** The architect and garden designer Joseph Effner is an important figure in the development of the **Bavarian Rococo**. He trained in **Paris**, having been brought to **France** in 1706 by the Elector Maximillian II Emanuel who was living there in exile. Effner was from a family of gardeners, and it was the intention of his **patron** that he should learn the techniques of French **garden design** directly from the source. Either because of his own interests or to better serve those of his patron, Effner began to study **architecture** under **Germain Boffrand**, later assisting the master with his refurbishment of the Château de Saint-Cloud, which Maximillian II Emanuel had bought in 1713. At this time, the elector was also planning the redecoration of his Bavarian residences in the French style. Effner returned to Munich with his patron in 1715. Serving as court architect, he began to carry out the elector's plans, altering and extending the castles at Dachau, Fürstenried, **Nymphenburg**, and Schleissheim near Munich.

At Schloss Nymphenburg, Effner collaborated with Dominique Gerard, who had studied with André Le Nôtre, to lay out gardens in the French formal style for the first time in German-speaking lands. Effner was responsible for the design of three Rococo follies in the gardens: Pagodenburg (1716–19), an example of early **chinoiserie** architecture with lacquered interiors; Badenburg (1718–21), a bathhouse with tile and **stucco ornamentation**; and Magdalenenklause (1725–28), a hermitage with classical and Gothic detailing, built as a ruined cell. Effner also collaborated with **Johann Baptist Zimmermann** at the Preysing Palais (1723–29), a townhouse in Munich in which stucco ornamentation dominates the structural framework and takes over the function of articulation. Effner became chief court architect from 1724, and through his work for the elector, was responsible for importing a French style of **architecture** and garden design to Bavaria. *See also* AMALIENBURG PAVILION; CUVILLIÉS, FRANÇOIS DE, I; GERMANY.

**EISEN, FRANÇOIS (1695–1778).** Of Flemish origin, François Eisen is best known for his scenes of everyday life, the most delightful of which is his mildly erotic version of *The Swing* (1770, Bourg-en-Bress, Musée de Brou).

He moved to **Paris** around 1745, where his son Charles had already established himself as a successful draftsman and illustrator. Eisen responded to a market demand for subjects made popular by artists like **François Boucher** and **Jean-Honoré Fragonard**: games, waffle sellers, and *sultanes*. It is most likely that he created these cabinet pictures for dealers, who were increasingly active in the creation of contemporary art for wealthy bourgeois **patrons**. *See also* GENRE; PAINTING.

**EL ESCORIAL, SPAIN.** This enormous monument of the Spanish Habsburgs was expanded under the Spanish **Bourbons** in the 1770s and 1780s. As **Charles III of Spain** spent more time hunting at El Escorial, additional buildings were required to house the court. The architect in charge was Juan de Villanueva (1739–1811). Among the new buildings and extensions that Villanueva designed were the Casitas de Abajo y Arriba (1773), which are largely **Neoclassical** in style, but the intimacy of scale is indebted to garden pavilions of the Rococo period in France. Some architectural elements of the Casitas de Abajo derive from Rococo ancestry, such as the concave curved roofline and the plasticity of the facades. Between 1774 and 1792, **Francisco de Goya** produced numerous **tapestry** cartoons for the royal palace of El Escorial under Charles III and Charles IV. Among these are his most Rococo works, including a series of light-hearted scenes with figures playing on swings and seesaws in brilliant colors that satisfied Charles IV's commission of 1790, which specified "rural and humorous" subjects for the decoration of his secretariat. Such refurbishments brought late examples of the Rococo style and French Bourbon tastes to the very center of Spanish Habsburg cultural heritage. *See also* SPAIN.

**ENGLAND AND THE ENGLISH ROCOCO.** The English Rococo is most closely associated with **Frederick, Prince of Wales**, its most prominent **patron**, and the artists of the **Saint Martin's Lane Academy**. It was initially imported from **France** by visiting French artists and flourished during the second quarter of the 18th century. **Antoine Watteau** traveled to London in 1710, and although little is known about the work he produced there, it had a significant influence on the development of English art and design. A number of his **paintings** were engraved by a group of French-born printmakers, and through these engravings, Watteau's style and subjects became known in England and English taste influenced by the *fête galante*, the new genre he is credited with inventing. Watteau's closest follower in England was **Philip Mercier**, who became court painter to Frederick and adapted the *fête galante* to English portraiture traditions, creating the **conversation piece** as a result. Mercier was the son of a Huguenot, as was the Rococo sculptor **Louis-**

**François Roubiliac**, and the influx of these French refugees to England as a result of religious intolerance in their home country considerably improved the standards of craftsmanship in the visual arts during the first half of the 18th century. They brought with them superior training in the decorative arts and knowledge of the latest French ornamental forms, and their influence was particularly felt among goldsmiths and silver chasers, many of whom also worked as engravers of **trade cards** and adopted a wide variety of Rococo designs. Other French Rococo artists, such as **Hubert-François Gravelot** moved to London for economic reasons during a period when English tastes for French fashions prospered.

For many English artists and patrons, the importation of the French Rococo was seen as a modern alternative to local traditions in art and **architecture**. **William Hogarth** and **Francis Hayman** were among the first English artists to respond to contemporary French art. Both artists were involved in the revival of the Saint Martin's Lane Academy, where Gravelot and Roubiliac also taught and **Thomas Gainsborough** most likely studied. While some of Hogarth's **portraits** suggest the stylistic influence of French Rococo masters, his **genre** scenes, particularly his "modern moral subjects," are distinctly different from their French counterparts in that they provide a social critique of life in contemporary London. Nonetheless, Hogarth's **aesthetic** writings read as a manifesto celebrating the beauty of sinuous forms.

Far from being a purely provincial style, the English Rococo stimulated the development of craftsmanship, new genre categories, and an openness to stylistic innovation. Perhaps more than any other English artist at the time, Gainsborough embraced the painterly characteristics of the Rococo, specifically in the flourishes of his brushwork and his creation of visually pleasing **color** harmonies. As with Hogarth, his approach was distinctly different from those of his French contemporaries, although there are valid comparisons to be made with **Jean-Honoré Fragonard**. Both artists demonstrated a remarkable facility in painting and pursued innovations in subject matter that blurred the boundaries of genre categories, as part of an expression of creative genius.

Rococo stylistic exuberance and blending of artistic conventions was also applied to **architecture** and **interior decoration**. The dominance of Neo-Palladian building styles and decorative schemes during this period was challenged by the introduction of Rococo forms, which interrupted its classical austerity, particularly in the interior. Behind the restrained Palladian facade of **Chesterfield House** in London, for example, Rococo forms proliferated in the delicate gilded boiseries of the Drawing Room. However, it is in country houses and gardens that Rococo **ornamentation** thrived, often coexisting with the **Gothic**.

While French artists and ornamentalists initially shaped the English Rococo, other foreign decorative painters had a strong impact on its

development. The Venetian decorative painter **Giovanni Antonio Pellegrini** was employed by members of the Whig nobility to decorate their country seats and London townhouses. **Francesco Zuccarelli, Canaletto**, and **Angelica Kaufmann** also enjoyed thriving careers in London, painting picturesque landscapes, English *vedute*, and history paintings respectively. These foreign artists increased the cosmopolitan outlook of English art, yet around 1750, a Rococo reaction set in, which was framed in patriotic terms. The style was attacked as contributing to the "vain, luxurious and selfish effeminacy" of the aristocracy and gentry who emulated the French. Many Rococo artists and craftsmen joined the Anti-Gallican Society, which aimed to extend British commerce and discourage the importation of French goods. *See also* ADAM, ROBERT; BATH; 44 BERKELEY SQUARE; CHAMBERS, SIR WILLIAM; CHIPPENDALE, THOMAS; CHISWICK VILLA; CLERMONT, ANDIEN DE; GARDEN DESIGN; GARRICK, DAVID; HALFPENNY, WILLIAM; LANGLEY, BATTY; REYNOLDS, SIR JOSHUA; ROBINS, THOMAS, THE ELDER; WARE, ISAAC.

**ENLIGHTENMENT.** The term "Enlightenment" refers to a period in Western philosophical history that affirmed the power of reason and advocated a series of religious, economic, and state reforms. It coincided with the lead up to revolutions in America and **France**, as well as with the development of **Neoclassicism**. Enlightenment writers, such as **Denis Diderot**, Jean-Jacques Rousseau, and Immanuel Kant, among others, were concerned with matters of taste and judgment in the arts. The Enlightenment can be associated with the anti-Rococo reaction in the visual arts, largely through Diderot's **Salon** criticism. There is, however, no Enlightenment style, although some paintings by particular artists have been connected with the writings of specific philosophers (**Jean-Baptiste-Siméon Chardin**'s paintings of **children** at play, for example, have been connected with John Locke's writings about pedagogy). A close connection between the Enlightenment and Neoclassical **architecture** can be observed in the philosophy and designs of Thomas Jefferson, although he is the exception, rather than the rule. *See also* AESTHETICS; ALEMBERT, JEAN LE ROND D'; LA FONT DE SAINT-YENNE, ÉTIENNE.

*ESPAGNOLETTE.* An *espagnolette* was a decorative motif consisting of a female head wearing a large, stiff collar around the neck, under the chin. Popularized by **Antoine Watteau** and **Claude III Audran** at the beginning of the century, it relates to the Spanish ruff donned in masquerade, which is represented as a type of fictive costuming worn by figures in later **paintings**, such as **Jean-Honoré Fragonard**'s *Progress of Love* (1771–73, The Frick Collection, New York).

# F

**FALCONET, ÉTIENNE MAURICE (1716–91).** Falconet was one of the most famous French sculptors of the 18th century, although he was slow in receiving official commissions from the **Bâtiments du Roi** and was justifiably disappointed by the accusations of plagiarism that accompanied the rejection of his initial reception piece, *Milo of Cortona* (plaster model exhibited Salon of 1745, Musée du Louvre, Paris), submitted to the **Académie Royale de Peinture et Sculpture**. The dynamic struggle between man and beast in this piece demonstrates the direct influence of the French Baroque sculptor Pierre Puget, as well Falconet's admiration for the compositional vitality of **paintings** by Peter Paul Rubens. Indeed, Falconet's study of Rubens indicates that the ideas of the **color**/line debates impacted upon the medium of **sculpture** as well as painting.

Falconet trained for 10 years in the studio of **Jean-Baptiste Lemoyne** and never traveled to Italy. He was the favorite sculptor of **Madame de Pompadour**, who was responsible for his appointment as director of the sculpture studios in the Manufacture Royale de Porcelaine at **Sèvres**. In this position, he was responsible for the design of small-scale pieces in *biscuit de Sèvres* that became enormously popular on the open market. Many of these were reproductions of marble figures made on commission for elite collectors and exhibited to the wider public at the **Salons**. Falconet's *Silencing Cupid* (1757, Musée du Louvre, Paris), commissioned by Pompadour, epitomizes Rococo sculpture in its wit, charm, and solicitation of the viewer's involvement in an amorous conspiracy through open pose and quiet gestures. It was exhibited in the Salon of 1757, the same year that Falconet took up his new position at Sèvres. *Silencing Cupid* was reproduced many times and was repeatedly used as a motif in Rococo paintings and engravings. It appeared most famously in **Jean Honoré Fragonard**'s *Happy Hazards of the Swing* (1767, Frick Collection, New York) where it not only functioned as a charming visual commentary on the main scene but also made a clever reference to the **aesthetic** achievements of contemporary French artists.

In addition to Pompadour, Falconet's prominent **patrons** included **La Live de Jully** and Catherine the Great, who invited him to work at her court

following the recommendation of **Denis Diderot**. Falconet stayed in **Russia** between 1766 and 1778, where he designed the monumental bronze equestrian statue of *Peter the Great* (unveiled in 1782, Saint Petersburg), one of the most significant sculptural projects of the Rococo period. The work displays a decisive break with classical traditions in its avoidance of allegorical trappings and represents an updated and naturalistic image of an ideal hero. The following year, Falconet suffered a paralytic stroke, and this, coupled with his increasing blindness, forced him to give up sculpting and to concentrate instead on the organization of his collected writings until his death in 1791. He maintained an extended correspondence with Diderot and Catherine the Great on matters related to the arts and wrote, at Diderot's request, the article on sculpture for the *Encyclopédie*. In his writings, Falconet espoused the superiority of the moderns over the ancients and defended the artist's creative autonomy and **aesthetic** authority over the rising voice of the untrained art critic. *See also* FRANCE; PIGALLE, JEAN-BAPTISTE; PORCELAIN; QUARREL OF THE ANCIENTS AND THE MODERNS.

**FANCY PICTURES.** The term "fancy" was used in English art to refer to compositions that blurred the boundaries between scenes of everyday life and **portraiture**. A typical fancy picture represents a child or young woman with sentimental or mildly erotic overtones. Lower class figures are often posed as if for a portrait or in a landscape, as in **Joshua Reynolds**'s *Children with Cabbage Net* (1775, Lard Faringdon, Buscot Park, Berkshire) and **Thomas Gainsborough**'s *Girl with Pigs* (1782, Castle Howard, Yorkshire). **Philip Mercier**, **Francis Hayman**, and **William Hogarth** were early-18th-century artists who explored the thematic and pictorial possibilities of fancy pictures. Closely related to **conversation pieces** (which were popular in the first half of the 18th century), it can be difficult to tell if fancy pictures are portraits of actual individuals or drawn entirely from the artist's imagination. *See also* ENGLAND AND THE ENGLISH ROCOCO; GENRE.

**FAVART, CHARLES-SIMON (1710–92) AND MARIE-JUSTINE-BENOÎTE (1727–72).** The French playwright Charles-Simon Favart produced successful comic operas and plays for the Théâtre de la Foire and the seasonal Opéra Comique in **Paris**, of which he became the director. In 1745, he married Marie-Justine-Benoîte Duronceray, who performed in many of his plays and was a successful actress, singer, and dancer in her own right. The Favarts were friends with **François Boucher**, who provided stage designs and costumes for their productions at the Théâtre de la Foire in the early 1740s. Boucher's involvement with the Favarts coincided with his own revival of painted pastorals in the late 1730s, which were innovative in their

depiction of country figures clothed in a combination of naturalistic and stage costuming. Madame Favart was known to perform in highly original peasant costumes, wearing wooden shoes and linen dresses that left her arms bare, rather than court dress. Such parallels suggest an open exchange of ideas between theater and **painting** in the 1740s, a period during which pastoral imagery was revived and adapted to Rococo forms. Boucher designed two frontispieces with Madame Favart in the title roles of "Le Caprice Amoureux ou Ninette à la Cour" and "La Bohémienne," which were both engraved by Jacques-Philippe Le Bas in 1754 and 1755 respectively.

**FÉLIBIEN, ANDRÉ (1619–95).** A member of the minor provincial nobility, Félibien was appointed by **Jean-Baptiste Colbert** to the post of historiographer of the **Bâtiments du Roi** in 1666. He was well educated and knew many of the founding members of the **Académie Royale de Peinture et de Sculpture**. Among his publications concerned with the arts are the *Conférences de l'Académie royale de peinture et de sculpture pendant l'année 1667* (1668) and his 10-volume *Entretiens sur les vies et les ouvrages des plus excellens peintres anciens et modernes* (1666–88), which was translated into English, German, and Italian during the 18th century. The latter is a history of European **painting**, which includes a definition of "the classical doctrine" in the section devoted to Nicolas Poussin. Although not as famous, the *conférences* were equally important in recording the lectures at the Académie Royale that commenced the **color**/line debates in the last quarter of the 17th century. At times, these *conférences* were re-read at the Académie Royale in an attempt to spark further debate when there was an apparent lack of interest in current lectures. *See also* FRANCE.

*FÊTES GALANTES, FÊTES CHAMPÊTRES,* AND *FÊTES VENITI-ENNES.* These categories of **painting** were used in the 18th century to describe subjects in which variously costumed figures pursue activities of leisure, love, and sociability in landscape settings, either in gardens or the countryside. As subject categories, they blur the boundaries between scenes of everyday life and theatrical fantasy. The term *fête galante* is most closely associated with the art of **Antoine Watteau,** as he was admitted into the **Académie Royale de Peinture et de Sculpture** specifically as a painter of this specialized genre. Watteau is credited with inventing this category, which is typified by his *morceau de réception, The Pilgrimage to the Island of Cythera* (1717, Musée du Louvre, Paris). The *fête galante* is a variation on the earlier *fête champêtre*, popular in 16th-century Venetian art. In Rococo art, *fêtes champêtres* are visually quite similar to *fêtes galantes*, yet they tend to take place in the countryside, rather than a garden or park, and some of the figures

wear more rustic versions of court **dress**. Watteau's continued innovation in this genre can be seen in his *Fêtes venitiennes* (1718–19, National Galleries of Scotland, Edinburgh), which includes figures in Venetian dress. The term *venitiennes* is connected with an opera-ballet performed at the Académie Royale de Musique in 1710, suggesting further allusions to the cognate arts of theater, music, and performance. *See also* GENRE; FRANCE; LANCRET, NICOLAS; PATER, JEAN-BAPTISTE.

**FEUCHTMAYER, JOSEPH ANTON (1696–1770).** From a large, extended family of artists, Joseph Anton Feuchtmayer trained as a sculptor and **stuccoist**. His cousins Franz Xaver Feuchtmayer (1705–64) and Johann Michael Feuchtmayer (1709–72) worked as a decorative team throughout southern **Germany**, most famously alongside **Johann Michael Fischer** at Diessen. Joseph Anton moved with his father to Mimmenhausen, near Salem, and for most of his life, he worked at the monastery of Salem, becoming head of the **sculpture** workshop in 1730. Many of his works are now destroyed, but his interior stucco decorations at the pilgrimage church of Unsere Liebe Frau in Birnau (1746–53) are in situ and demonstrate his highly original contribution to the **Bavarian Rococo**. Flowing forms and subtle gradations of **color** fill the interior with light and movement. In addition to the confessionals, stalls, and reliefs, Feuchtmayer completed stations and life-size figures of saints that reveal the influence of Late Gothic limewood sculpture in combination with contemporary **rocaille** formal vocabularies. His *Pietá*, for example, sets a naturalistic and emotive scene of the Virgin holding Christ's contorted body within a highly ornate gilt frame composed of scrolling acanthus foliage and shell-work. *See also* ARCHITECTURE; ZIMMERMANN BROTHERS.

**FISCHER, JOHANN MICHAEL (1692–1766).** Originally from the Upper Palatinate, where he trained as a mason with his father, Fischer settled in Munich in 1723. He fulfilled commissions for members of the Wittelsbach family, eventually becoming court architect, but he is better known for his ecclesiastical **architecture**. The inscription marking his grave records 32 churches, 23 monasteries, and numerous secular works. Many of these buildings are late Baroque in their architectonic conception, although they exhibit Rococo stylistic principles in their articulation of curvilinear movement within rectilinear spaces. Indeed, Fischer supplied the structural framework for the rich decorative interiors created by Rococo **stuccoists** and fresco painters, which effectively obscure the elements of construction. At Osterhofen, in the 1720s, he collaborated with the **Asam brothers**, and while at Diessen, during the 1730s, he worked with a decorative team that included **Giambattista Tiepolo**, **François de Cuvilliés**, Joachim Dietrich, and the Feuchtmayer brothers, Franz Sarer and Johann Michael (the cousins of **Joseph Anton Feuchtmayer**). The

interior at Diessen is one of the most successful examples of Rococo Gesamt-kunstwerk (a German word referring to architecture in which fresco-painting and stucco-decoration play an integral part). The extent to which Fischer's architecture can be labeled Rococo, as opposed to late Baroque, has been debated because of his tectonic treatment of supporting elements underneath the effective illusionism of decorative work overhead, which visually transported worshippers up into heaven. What is significant in Fischer's buildings, however, is the uniformity achieved between architecture and decoration, which consequently refuses a purely structural reading of vaults and other supporting elements. *See also* BAVARIAN ROCOCO; GERMANY.

**FOIRE DE SAINT-GERMAIN AND FOIRE DE SAINT-LAURENT.** The fairs of **Paris** were annual events lasting for several months. They were places of pleasure, entertainment, and boutique commerce, largely free to operate outside of guild restrictions. Fairs were an important public space during the 17th and 18th centuries in which a wider audience could view paintings, although they were mostly of lesser quality. Picture dealers and artists could be found at the Foire de Saint-Germain. Most importantly, the fairs provided Rococo artists with popular imagery of contemporary life, which they incorporated into their **paintings** and decorative work. *See also* COMMEDIA DELL'ARTE OR *COMÉDIE ITALIENNE*; GILLOT, CLAUDE; WATTEAU, ANTOINE.

**FONTAINEBLEAU.** The palace of Fontainebleau is most closely associated with the Valois kings of France and more specifically François I. Parts of the palace were remodeled by the architect **Ange-Jacques Gabriel** under **Louis XV**, who frequented the château to hunt in the adjoining forest. Traditionally, the court moved to Fontainebleau during the summer months, which resulted in the need for upkeep and redecoration. The most magnificent refurbishments in the Rococo style were the painted interiors of the council chamber and king's bedchamber, with **ceilings** by **François Boucher** (1753), **paneling** by Jean-Baptiste Pierre, and monochromes by **Carle van Loo. Louis XVI** made further alterations during the mid-1780s in the fashionable style **à la grecque**, such as in the gaming room of the queen's *appartements* designed by Jean Rousseau de La Rothière. *See also* FRANCE.

**FRAGONARD, JEAN-HONORÉ (1732–1806).** A painter and draftsman of extraordinary talent and skill, Fragonard is the last major artist associated with the French Rococo. He worked across a number of genres, initially painting religious, mythological, and allegorical scenes, as well as pastorals, before turning to landscapes, **portraits**, and scenes of everyday life, many of which provide novel perspectives on what were becoming conventional subjects.

His fantasy figures and urban pastorals, examples of which include *The Abbé de Saint-Non* (1769, Musée du Louvre, Paris) and *The Fête at Saint Cloud* (c. 1775–80, Banque de France, Paris), move beyond existing definitions of portraiture and the *fête galante* to test the boundaries of subject categories and to explore the nature of art-making in modern **Paris**. *The Bathers* (1765, Musée du Louvre, Paris), one of his most representative works of mildly erotic subjects, appears to epitomize an 18th-century taste for **boudoir paintings**, yet at the same time, it engages with deeper philosophical and **aesthetic** concerns of the age that questioned the relationship between art and nature. His paintings are characterized by exuberant brushwork, and his drawings exhibit a similar facility in the handling of chalk, washes, and pen and ink.

Fragonard was also able to change style at will to suit different subjects and the tastes of his intended audiences, moving easily between a painterly Rococo manner and the highly polished finishes that are more closely connected with **Neoclassicism**. Among his most innovative achievements was *The Bolt*, an erotic **genre** scene that was created as a pendant to *The Adoration of the Shepherds* (both c. 1777, Musée du Louvre, Paris). Commissioned by the marquis de Veri, a prominent collector of contemporary French painting, the choice of subject and style was left up to Fragonard. This unconventional pairing across genre categories challenged the *amateur* to look beyond superficial links of subject matter to engage with the **aesthetics** of art, largely independent of theme. In this, the works break with tradition and look forward to modernism.

As a young artist, Fragonard did all the things expected of one who hoped to pursue an official career within the **Académie Royale de Peinture et de Sculpture** and at court. He trained in the studios of successful academicians, at first with **Jean-Baptiste-Siméon Chardin**, before entering the studio of **François Boucher** in the late 1740s. The influence of the latter artist is evident in his early decorative panels, such as *The Shepherdess*, *The Harvester*, *Woman Gathering Grapes*, and *The Gardener* (c. 1750, Detroit Institute of Arts, Detroit), although the free handling of paint and exploitation of contrasts between natural and artificial **color** signal Fragonard's relative independence from the manner of Boucher at the initial stages of his career. In 1752, Fragonard won the *Grand prix de peinture* (also known as the *Prix de Rome*) with *Jeroboam Sacrificing to the Idols* (École Nationale Supérieure des Beaux-Arts, Paris), a significant achievement for a 20-year-old who had not trained at the Académie Royale. He then entered the newly formed École Royale des Élèves Protégés to gain further technical and theoretical training under **Carle van Loo**, the school's current director, before leaving for the Académie de France in **Rome** at the end of 1756.

According to one of Fragonard's early biographers, Boucher cautioned his former pupil not to take the works of Raphael or Michelangelo too "seriously" or he would "be lost." Despite this warning, Fragonard reportedly experienced a crisis of confidence when he saw the works of these Italian Renaissance masters, fearing he would not be able to rival them. Rather than try, he turned his attention to works by 17th- and 18th-century Italian artists, including Pietro da Cortona and **Giambattista Tiepolo**. Fragonard was capable of quickly absorbing the designs of other artists and transforming them with his unique stylistic approach, such that we find him reusing certain figural poses from Cortona's compositions long after he left Rome. For example, Fragonard's reworking of Cortona's figures in a set of overdoors acquired by the **comtesse du Barry** (c. 1752–53, Musée de Toulon, Musée Fragonard in Grasse, and National Gallery of Ireland in Dublin) subsumes all traces of Baroque grandeur within the delicate visual delights of Rococo decoration. As with many Rococo artists, Fragonard's relationship to tradition was largely formal and rarely derivative.

Of more enduring influence from the time spent in **Italy** were the drawings made *en plein air* in the parks and gardens surrounding Rome. Fragonard and his fellow pensioners were encouraged in this practice by the director of the Académie de France, **Charles-Joseph Natoire**, who himself drew at Tivoli between 1759 and 1760. During this time, Fragonard met **Hubert Robert** and his protector, the Abbé de Saint-Non. Fragonard's and Robert's Tivoli views are remarkably close in style and subject, indicating that they often drew side-by-side. Together, Fragonard and Robert developed a taste for the picturesque, which would inform their personal approaches to the depiction of nature, gardens, and ruins for the remainder of their careers.

Fragonard was accepted as a provisional member of the Académie Royale after he returned to Paris with his portrayal of *Coresus and Callirhoë* (1765, Musée du Louvre, Paris), a highly dramatic and theatrical history painting depicting themes of heroic sacrifice, love, and suicide. The work was exhibited in the **Salon** that same year and was celebrated by critics such as **Denis Diderot**, who referred to Fragonard as the future of the French school. It signaled a return to serious history painting by a junior member of the Académie Royale and was dutifully bought by the **marquis de Marigny** for the king's collection, although payment was not made to the artist until many years later. Despite the fact that this triumph put Fragonard on track to enjoy a successful career as an academic history painter, at the next Salon, he exhibited his *Swarm of Putti* (Musée du Louvre, Paris), most likely a design for a ceiling decoration, which Diderot called "insipid" and described as a "giant omelette of babies . . . painted like cotton wool."

Although there is no documentary evidence explaining why Fragonard stopped exhibiting at the Salons after 1767 or why he failed to submit his reception piece to the Académie Royale to gain full membership, it is likely that he saw no advantage in the traditional career path of the academic artist. Instead, he worked actively for private **patrons**, collectors, and dealers. This caused critics such as **Louis Petit de Bachaumont** to remark on Fragonard's "thirst for profit" and his dubious satisfaction in "distinguishing himself . . . in boudoirs and dressing rooms." Fragonard's most famous painting, *The Happy Hazards of the Swing* (1767, Wallace Collection, London), appears to confirm this assessment, although its extraordinary appeal resists such critical condemnation. Painted for a gentleman of court who ordered a provocative picture of his mistress on a swing, the work exhibits a masterful handling of painterly brushwork and **color** harmonies. It plays with visual forms and creates witty puns through thinly veiled emblematic motifs, such as the swing itself, which refers to the fickleness of love and the sexual act. Yet, perhaps most importantly, the vertiginous visual experience created by the serpentine lines and varied impastos parallels the sensation of swinging. In a similar way to **Antoine Watteau**, Fragonard translated the theme of his work into visual form.

Fragonard's career reached its peak in the 1770s, a period during which fashionable tastes began to shift toward the *goût grec* and a return to history painting and **Classicism** was gaining momentum within the official structures of the Académie Royale. The infamous rejection of the cycle Fragonard painted for the garden pavilion of **Madame du Barry**, known as the *Progress of Love* (1771–73, Frick Collection, New York), is often discussed as marking the end of a preference for Rococo art. Soon after the four canvases were installed in the new residence of **Louis XV**'s mistress, they were taken down and returned to the artist. A replacement series was produced by **Joseph-Marie Vien** depicting "Greek" lovers in a more polished style. Despite this rejection, the cycle is Fragonard's masterpiece, epitomizing the amorous themes and formal characteristics of the late Rococo. Tied to the pleasures and pursuits of elite society, the paintings picture a world that exists midway between fantasy and reality.

Fragonard continued to paint large-scale decorative cycles and easel paintings throughout the 1780s, many of which explore the tensions between artifice and nature, such as *The Island of Love* (also known as *The Fête at Rambouillet*, c. 1770, Museu Calouste Gulbenkian, Lisbon). He worked closely with his sister-in-law, **Marguerite Gérard**, who was his pupil and collaborator. His son, Alexandre-Évariste, also became an artist and trained with **Jacques-Louis David** after the Revolution. Fragonard escaped prosecution and exile after 1789, moving with his family to their native Grasse for



several years. Upon his return to Paris, he assumed a new position as an arts administrator, largely through the support of David. *See also* FALCONET, ÉTIENNE-MAURICE.

**FRANCE.** The Rococo style was centered on France. It originated in French court culture around 1700 and spread quickly through Parisian society during the first decades of the 18th century. **Louis XIV** had utilized the arts to express his personal grandeur and the glory of his reign. In the name of the king, the success of crown-sponsored academies and manufactories of luxury goods combined with the magnificence of **Versailles** to cement French cultural hegemony. More so than the Grand Manner **Classicism** of Versailles, which had stylistic links to **Italy** through its blending of Baroque and classical forms, the Rococo emerged as a uniquely French style. Emanating from court but strongly connected to the urbanity of **Paris**, the Rococo simultaneously reflected and reinforced the authority of the French in matters of artistic taste.

While Paris never lost its status as the official capital of France, it was only after the death of Louis XIV, when the regent, **Philippe II, duc d'Orléans**, moved his court and government back to the capital from Versailles, that the city became the preeminent European center of commerce, society, and artistic life. The rise of the Rococo is commonly linked with this return of the French nobility to Paris, so much so that its first phase of stylistic development is often referred to as the *style régence*. **Louis XV** returned his court to Versailles, but Paris continued to thrive in parallel. Both were major centers of Rococo culture when the style reached its height of popularity during the 1730s and 1740s. Similarly, when the anti-Rococo reaction began around 1750, the official institutions of the crown and Paris-based art critics equally encouraged a shift toward classical tastes. For the next two decades, the Rococo existed alongside the newly fashionable *goût grec*, until **Neoclassicism** became the dominant style in France during the 1780s.

Crown **patronage** diminished during the first half of the 18th century. Louis XV had little interest in commissioning monumental **architecture**, which stimulated further production in all the arts through the need for **interior decoration** and furnishings. Moreover, the royal treasury was restricted in its expenditure on the arts due to the financial drain of wars fought at the end of Louis XIV's reign. Private patronage, by contrast, increased significantly during this period, particularly among *fermiers généraux* (tax farmers) and financiers who married into nobility. Lavish spending on the arts was a way for the wealthy arrivistes to legitimize their pretensions to aristocratic status. The most sophisticated of this new class of patrons and collectors were known as *amateurs*: men like **Pierre Crozat**, **La Live de Jully**, and **Grimod de La Reynière** not only decorated their Parisian *hôtels particuliers*

and country residences with Rococo interiors but also were friends with leading Rococo artists and focused at least part of their collecting practices on contemporary French art.

Louis XV's mistress, the **marquise de Pompadour**, came from this uppermost tier of the third estate. Through her position as official royal favorite from 1745, her uncle and brother, **Lenormand de Tournehem** and the **marquis de Marigny**, sequentially assumed the position of director of the **Bâtiments du Roi**, through which the family exerted enormous influence over the **Académie Royale de Peinture et de Sculpture** and state patronage. In their official roles, Pompadour's family developed initiatives designed to introduce a new solemnity into the administration of the arts, many of which were executed by **Charles-Nicolas Cochin**, a prominent critic of the Rococo style. Privately, however, Pompadour's family was well known for its patronage of leading Rococo painters and sculptors, such as **François Boucher, Carle van Loo, Jean-Baptiste Pigalle**, and **Étienne-Maurice Falconet**. Pompadour commissioned châteaux that were furnished in a Rococo style and encouraged the production of Rococo **porcelain** and small-scale **sculpture** at **Sèvres**. The family's personal tastes conformed to those of the luxury-loving French elite that had embraced the Rococo from the first decades of the 18th century onward and continued to support the style alongside newly fashionable modes of Classicism until the Revolution in 1789.

The French Rococo thrived in **interior decoration** and the decorative arts. These areas of artistic production were more liberated from academic principles than architecture, sculpture, and history **painting**. During the Regency period, more relaxed arrangements of interiors became fashionable, with a preference for smaller salons and *cabinets*. Designs by **Gilles-Marie Oppenord, François-Antoine Vassé**, and **Nicolas Pineau** emphasized **ornamentation** through the decorative use of **boiseries** with **asymmetrical** patterns. **Robert de Cotte** and **Germain de Boffrand** were in demand as architects of *hôtels particuliers*, although the exteriors of their buildings rarely displayed the sensuous curves and atectonic qualities for which the Rococo is known. The interiors of their buildings, however, were another matter, the most inventive example of which is the Salon Ovale of the **Hôtel de Soubise**. In interiors such as this, history painting lost its position of authority on the wall and **ceiling** and was relegated instead to overdoors and replaced with ornamental **panels** and **mirrors**. The talents of young painters, including up-and-coming academicians, were redirected toward these types of decorative schemes. **Nicolas Lancret, Jean-Baptiste Oudry**, Boucher, Van Loo, **Jean-François de Troy**, and **Jean-Honoré Fragonard** became leading practitioners of painted decorative schemes, while at the same time producing easel paintings for private patrons, dealers, and collectors.

Despite this emphasis on decoration, the authority of the **Académie Royale de Peinture et de Sculpture** remained strong. The **color**/line debates of the late 17th century had placed history painting on top, which was reinforced by the hierarchical structure of the Académie Royale. Rococo artists were in no way immune to the influence of this institutional support of historical subject matter. Nevertheless, they were able to redirect its focus toward mythological themes of love and eroticism. "Lesser" genres also advanced rapidly, even within the Académie Royale. **Antoine Watteau**, for example, was admitted as a painter of *fêtes galantes* in 1717, an episode that simultaneously maintained the authority of history painting and signaled an openness to the creation of new genres within its ranks. Many leading painters of the Rococo period were admitted as painters of still life (**Jean-Baptiste-Siméon Chardin**), genre subjects (**Jean-Baptiste Greuze**), and **portraiture** (**Élisabeth Vigée Le Brun**). In part, this was due to the increasing ability of artists to fashion careers by working for private patrons, collectors, and art dealers. As a result, artists enjoyed the freedom to experiment with subject matter and techniques that ignored academic rules in the pursuit of informality, intimacy, and creativity.

Many connoisseurs looked to collect drawings as an expression of these very artistic values, which further stimulated an appreciation of the *trois crayons* and pastel techniques practiced by **Antoine Coypel**, Watteau, **Rosalba Carriera**, and **Maurice-Quentin de La Tour**, among others. Printmaking also proved lucrative for Rococo artists, not only for **ornamentalists** like **Juste-Aurèle Meissonier** and **Jacques de Lajoüe** but also for prominent painters, such as Boucher, Chardin, and Fragonard. Prints, perhaps more than any other medium, contributed to the spread and development of the Rococo, reaching international and middle class audiences through their circulation.

The **Salons** of the Académie Royale also brought attention to the Rococo but with largely negative effects. Critics, such as **La Font de Saint-Yenne** and **Denis Diderot**, lamented the lack of serious history painting and the emphasis on decoration. Their writings were well known both within and outside of France. One of the first truly public events in Europe, the Salons attracted audiences from all walks of life, many of whom had no point of reference from which to understand either the Rococo's stylistic links to interior decoration or its focus on themes taken from mythology and elite sociability. Some artists, such as Chardin and Greuze, forged new types of pictures that attempted to negotiate the need for paintings of wider appeal. Their technical virtuosity and **color** harmonies appealed to the sophisticated tastes of patrons and collectors, while at the same time their subjects, which appeared to be taken from the daily life of the bourgeoisie, were immediately accessible to wider audiences. Such works met with public acclaim but did not secure for their creators recognition as history painters within official structures.

The resurrection of serious history painting required direct patronage of the crown, which it received under **Louis XVI** and his new *directeur général des bâtiments*, the **comte d'Angiviller**. As with the Rococo, however, **Neoclassicism** could be configured with decorative purpose. A paradigm of French Neoclassicism, **Jacques-Louis David**'s *Oath of the Horatii*, was commissioned on behalf of the king as a model for the **Gobelins tapestry** manufactory. Nevertheless, David reportedly stated that while he began by making a painting for the king, he ended up making one for himself. This comment suggests that artists were no longer reliant upon royal patronage. Public acclaim at the Salons and celebration by the unofficial voices of art critics brought fame that resulted in further private commissions and sales through art dealers, representing a movement toward the creative independence of modern artists. While the Salons are rightly credited as a major factor in this change in circumstance, the private patronage and collecting that gave rise to the Rococo and the resulting emphasis on an appreciation of **aesthetics** over subject matter was also a significant market force that redirected the arts toward a "modern" outlook in France. *See also* ABSOLUTISM.

**FREDERICAN ROCOCO.** *See* FREDERICK THE GREAT, KING OF PRUSSIA (1712–86).

**FREDERICK, PRINCE OF WALES (1707–51).** Frederick played a leading role in creating a taste for Rococo art in **England** and was an avid **patron** of the arts. The eldest son of George II and Caroline of Ansbach, Frederick was born and raised in Hanover. He moved to England in 1728, when his father ascended to the throne, but maintained an uneasy relationship with his parents. Some art historians have proposed that Frederick's patronage of the English Rococo was intended as a political promotion of an "oppositional" style, but his eclectic tastes argue against this as an exclusive motive. Frederick began purchasing works of art as an adolescent and formed a magnificent collection of 17th-century **paintings** and drawings, including works by Anthony van Dyck, Peter Paul Rubens, and Nicolas Poussin. Frederick also commissioned paintings from contemporary Italian and French artists, such as **Philip Mercier**'s *Music Party: Frederick Prince of Wales and His Sisters* (c. 1733, Windsor Castle, Windsor). The choice of a **conversation piece** situates Frederick as a patron of modern art, yet the breadth of the prince's aesthetic interests are indicated by his selection of the Neo-Palladian William Kent to remodel Carlton House and the White House at Kew and to design an ornate state barge (1732, National Maritime Museum, Greenwich). Moreover, his initiation of exotic plantings at **Kew**, which led to **William Cham-**

bers's **ornamental** garden layout after the prince's death, suggests that his tastes were more cosmopolitan than oppositional. Nevertheless, his patronage of such artists as Mercier and the French engraver Joseph Goupy established royal support for the Rococo style in England. *See also* GARDEN DESIGN.

**FREDERICK THE GREAT, KING OF PRUSSIA (1712–86).** Frederick II Von Hohenzollern, known as Frederick the Great, ruled as king of Prussia from 1740 to 1786. His tastes as a **patron** were distinctly French, and the buildings, **interiors**, and art collections created under his direction have become known as the Frederican Rococo. Before ascending the throne, he began purchasing works by **Antoine Watteau** and **Nicolas Lancret**, including *Gersaint's Shopsign* (1720) and the *Pilgrimage to the Island of Cythera* (1717, both Schloss Charlottenburg, Berlin). Frederick favored **Georg Wenzeslaus von Knobelsdorff** and **Antoine Pesne** as leading architect and painter at his court. In addition to remodeling the interiors of several existing family residences and adding a new wing to Schloss Charlottenburg, Frederick turned his attention to **Schloss Sanssouci** (French for "without a care"), built in 1745–47 by Knobelsdorff partly to the king's plans. It is an intimate, single-story building at the top of a terraced vineyard with a central elliptical chamber that projects onto the garden. The interiors host all forms of Rococo **ornamentation**. In 1746, Knobelsdorff began work on the **gardens**, which included a Chinese teahouse built by Johann Gottfried Büring (1754). In the years that followed, Frederick was inspired by **William Chambers** to build in a more accurate Far Eastern style, which led to the construction of a Chinese pagoda built by Carl von Gontard called the Dragon House (1770–72). Frederick aspired to be a philosopher-king, which resulted in a version of enlightened **absolutism**. He carried out a 50-year correspondence with Voltaire, whom he entertained as a guest at Sanssouci in 1750. *See also* ARCHITECTURE; CHINOISERIE; ENLIGHTENMENT; GERMANY.

**FURNITURE.** Furniture production during the 18th century was of a high quality and involved considerable invention as artisans rivaled one another to interest connoisseurs and meet the demands of a wealthy clientele. Rococo tastes were quickly assimilated into designs for furniture pieces with detailed lacquer-work and marquetry in a range of tones and materials, generally with bronze decoration. Ingenious devices and locks were introduced into desks and cabinets, such as rolling tops and hidden drawers. Even more diversity can be found in pieces created for private spaces, which were delicate in form and small in size, such as the *cabaret* tables with fine, curved legs and **porcelain** tops created by Roger van der Cruze (1728–98) in the middle of

the century. New imports of luxury goods and popular habits created demand for unique items, such as gaming tables that seated different numbers of players and special-purpose food cupboards, chests, and cabinets for the storing of shells, ribbons, spices, and other luxury goods or collections. *See also* CHIPPENDALE, THOMAS; RIESENER, JEAN-HENRI; RISAMBURGH, BERNARD VAN.

# G

**GABINETE DE LA PORCELANA.** *See* ARANJUEZ, SPAIN.

**GABRIEL, ANGE-JACQUES (1698–1782).** The fifth member of the Gabriel family to work as an architect in **France**, Ange-Jacques is the best known and the most closely associated with the taste of **Louis XV**. Ange-Jacques worked with his father **Jacques V Gabriel**, completing many projects the elder Gabriel began and eventually succeeding him as *premier architecte du roi* and director of the **Académie Royale d'Architecture**, overseeing all royal building projects between 1742 and 1775. During this period, the interiors of royal châteaux were transformed according to "modern" tastes and preferences for privacy and comfort. Royal apartments at **Versailles, Fontainebleau,** Choisy, and **Compiègne** were reorganized along these lines, and new monumental schemes were introduced that had a substantial impact on the appearance and layout of their spaces. Two of the most significant include the demolition of the Ambassadors' Staircase at Versailles and the Galerie d'Ulysse at Fontainebleau to make way for new upgrades and enlargements. More delightful and playful, in a Rococo sense, are the theaters and garden pavilions created to entertain the king, his official mistresses, and the court.

The Royal Opera House (1753–70) is Gabriel's masterpiece and combines the grandeur of the court tradition with the movement and visual enchantment of the Rococo style: a sweeping half-oval curve contains the boxes, which are backed by **mirrors** to enhance the light and sparkle of chandeliers, gilding, and painted decoration. In addition to these theatrical accomplishments, Ange-Jacques satisfied Louis XV's and the **marquise de Pompadour**'s desire for retreats from the formalities of court life with hermitages in the **gardens** of Fontainebleau, Versailles, Compiègne, and Choisy, the most substantial and spectacular of which is the Petit Trianon (1754), a simple classical block that suggests informality and simplicity through its lack of **ornamentation** on the exterior and the elegant curves of the interior, such as those used in the Grand Staircase. The **comtesse du Barry** hired Ange-Jacques to restore the Château de **Louveciennes**, a gift from the king in 1769; however,

in 1770, she commissioned a garden pavilion in the latest **Neoclassical** style from **Claude-Nicolas Ledoux**, perhaps to distinguish her taste from that of her predecessor, Madame de Pompadour, through its direct contrast with Gabriel's Petit Trianon. Having served his king, Louis XV, Ange-Jacques Gabriel stepped down as *premier architecte* at the age of 77 in the first year of **Louis XVI**'s reign but maintained his position as director of the Académie until his death in 1782. *See also* ARCHITECTURE.

**GABRIEL, JACQUES V (1667–1742).** From a family of French architects, Jacques V trained in the office of Jules Hardouin-Mansart alongside **Robert de Cotte**, with whom he traveled to **Italy** between 1689 and 1690. He was admitted to the **Académie Royale d'Architecture** in 1699 and was thereafter appointed to several official posts, eventually succeeding Hardouin-Mansart and de Cotte as *premier architecte du roi* in 1734 and director of the Académie in 1735. Jacques V received commissions for private *hôtels* in the first two decades of the 18th century and for public projects in the provinces, but it was for **Louis XV** that he received major court commissions, including designs for additions, alterations, and redecorations at La Muette, **Compiègne**, **Fontainebleau**, and the Petits Appartements at **Versailles**. While the specific contribution of Jacques V Gabriel to the development of Rococo interiors is difficult to determine, his position as principal and then first architect during a period of transitional tastes signals his importance in leading French architectural style away from the academic **Classicism** of the late 17th century and toward the decorative delicacy and spatial intimacy associated with **architecture** during the time of Louis XV. His son, **Ange-Jacques Gabriel**, completed many of the projects he initiated.

**GAINSBOROUGH, THOMAS (1727–88).** Known for his landscapes, **portraits**, and **genre** scenes, Gainsborough was one of the most significant and talented English painters of the 18th century. He moved from his birthplace in Sussex to London around 1740, where he trained with the French artist **Hubert Gravelot** and is believed to have assisted **Francis Hayman** on the supper-box pictures for **Vauxhall Gardens**. It is also likely that he studied at the **Saint Martin's Lane Academy** established by **William Hogarth**, with which Gravelot and Hayman were also involved. Such associations place Gainsborough's early career firmly within the development of the **English Rococo**. Although still very young, this exposure to painterly flourishes and the decorative potential of form influenced his approach to painting for the rest of his career.

Gainsborough found it difficult to establish himself as an independent artist in London, so he returned to the country, moving to Ipswich in 1748,

where he painted **portraits** for middle-class **patrons**. His most celebrated work from this period is *Mr. and Mrs. Andrews* (1748–50, National Gallery, London), a genteel portrait set within a landscape that pictures the family farmlands. In 1759, Gainsborough moved to **Bath**, a fashionable spa resort, which offered profitable opportunities for skilled portrait painters. *Mary, Countess of Howe* (1764, Kenwood House, London) is a prime example of his masterful achievements during this period. The full-length portrait, set against a landscape background, reveals Gainsborough's study of Anthony van Dyck's compositional arrangements and Peter Paul Rubens's brushwork and blending of **color**, particularly in the handling of **dress**. Rococo influences are also clearly present in the graceful play of line and delicate color harmonies. These stylistic features are also found in *Mrs. Philip Thicknesse* (1760, Cincinnati Art Museum, Cincinnati). The Rococo innovations of this portrait can be seen in the placement of the sitter in a confident, yet graceful, serpentine pose. While contemporaries admired the beauty of this work, some considered it too "bold" for a society portrait. Gainsborough was often frustrated by the need to please his **patrons** through an adherence to convention.

Gainsborough began to exhibit in London at the Society of Artists while still living in Bath. He became a founding member of the Royal Academy of Arts in 1768 but did not regularly exhibit there because he was not pleased with how his **paintings** were hung. He settled permanently in London in 1774, where he received commissions from aristocratic **patrons** that culminated with a series of portraits for the royal family. His preference, however, was to paint landscapes, which did not sell well. Nevertheless, his preoccupation with landscape produced highly original results when blended with portraits and **"fancy pictures,"** as in *The Morning Walk* (1785, National Gallery, London) and the Cottage Door series (two of the finest examples are in the Cincinnati Art Museum, Cincinnati, and the Huntington Art Collections, San Marino), which present a nostalgic and artificial view of poverty and country life that appealed to an audience of wealthy urban viewers.

**GARDE MEUBLE DE LA COURONNE.** The Garde Meuble de la Couronne was one of three branches of the Maison du Roi charged with the transport, installation, storage, and care of the French king's **furniture** and moveable interior furnishings, such as silver, **porcelain**, and draperies. It was created as an independent service by **Jean-Baptiste Colbert** in 1663. The Hôtel du Garde Meuble (now Hôtel de la Marine) was the headquarters of the service in **Paris**. For almost a century it was located in a building abutting the Cour Carrée of the Palais du Louvre, but this was demolished as part of the **marquis de Marigny**'s project to complete the Louvre in 1758. **Ange-Jacques Gabriel** designed a new building for the service in 1772 at the Place

Louis XV (now Place de la Concorde). A product of **Enlightenment** ideas about the organization, care, and display of collections, this building held offices, storerooms, conservators' workshops, and exhibition rooms that were open to the public. Although the venture was short lived due to the looting of the collections during the French Revolution, it contributed to the conception of the modern museum.

**GARDEN DESIGN.** As with **interior decoration, painting**, and **ornamentation**, the spirit of the Rococo influenced garden design in many parts of Europe. While it does not possess a set of definable forms, the Rococo garden is primarily distinguished by its stylistic eclecticism, intentional invocation of fantasy, and its orchestration of amusing entertainments for visitors. For the 18th-century **patrons**, *amateurs*, and landscape architects who were responsible for the design of Rococo gardens, the character of these spaces was largely derived from creative play with forms and moods. In many ways, Rococo gardens are the ultimate expression of artistic license in the period. They assert the right of garden designers (whether **patrons** or artists) to deviate from convention in their use of forms and features inherited not only from the past but also from different cultures. Rather than developing its own formal vocabulary, the Rococo garden put old forms to new uses. Consequently, the Rococo garden can be identified, in part, by its subversion of the rules of the French formal style that dominated palace garden design throughout continental Europe in the late 17th and early 18th centuries.

Established by practitioners such as André Le Nôtre in the 1670s but theorized as early as 1630 by **Jacques Boyceau**, the French formal garden is predicated upon the geometric reordering of nature on a grand scale. It stressed symmetry and visual harmony and is exemplified by Le Nôtre's work at **Versailles** for **Louis XIV**. While curvilinear **bandwork** and **arabesques** were used in the French formal garden, their ornamental exuberance was strictly contained within rectangular **parterres**. By contrast, the Rococo garden is characterized by irregularity, intimacy, and eclecticism. Serpentine paths, exotic plantings, and fantastic follies evince the playful nature of Rococo gardens and their shared intention to surprise and to delight the visitor.

For the most part, Rococo gardens crammed an impressive number of diversions into a relatively small space. It was not uncommon for visitors to follow a short, meandering path that took the wanderer past a pyramid, a pagoda, a grotto, a classical temple, a rock formation, a lake, and a wilderness in rapid succession. Despite the number and variety of attractions, an hour or two was all that was needed to take in the sights. Today, an impression of this type of experience can be gained at Parc Monceau in **Paris** or **Kew**

Gardens in London, although the features of both Rococo gardens have been considerably altered since the 18th century. By contrast, it takes the better part of a day to walk the gardens of **Versailles** or Stourhead. While the Rococo garden did not specifically oppose the rural naturalism of the English picturesque garden, of which Stourhead is an example, it generally rejected the grandeur of its scale.

A taste for Rococo gardens flourished in **England**, Ireland, **France**, and **Germany** between 1740 and 1780. At Kew (1757–63), in England, the Scottish-born architect **William Chambers** created for Princess Augusta, the widow of **Frederick, Prince of Wales**, the most royal and impressive of all English Rococo gardens. It included a monumental Chinese pagoda, a House of Confucius, a Gothic cathedral, a Mosque, an Alhambra, a Roman ruin, and a number of classical temples. Kew, in its original design, is the prototypical example of the Rococo garden's incorporation of cosmopolitan borrowings from different times and places, as if playing with the cultural achievements of the past. Such play was not exclusively erudite either. What mattered was the stimulation of experiential fantasies. At Parc Monceau, designed by Louis Carrogis Carmontelle for the duc de Chartres between 1774 and 1779, replicas of features from Hadrian's Villa were juxtaposed with a miniature farm and windmill. Visitors could just as easily fantasize upon the simple pleasures of a pastoral existence as the more imposing leisure pursuits of a Roman emperor. While Rococo gardens were mostly connected with the private residences of aristocratic patrons, the wider public gained exposure to such spaces at **Vauxhall Gardens** near London. A number of visual and aural surprises were scattered throughout the gardens, as were an eclectic mix of **architectural** styles, which included motifs borrowed from **chinoiserie**, *turquerie*, and the **Gothic**.

The Rococo spirit of cosmopolitan cultural variety was taken to an imperial level in **Russian** garden design at Tsarskoe Selo (1771–89). Designed for Catherine the Great, Tsarskoe Selo included, among other architectural features, an Egyptian pyramid that served as a monument to Catherine's deceased dogs, a Turkish bath, a Gothic admiralty, and a Chinese village, the latter a complex of more than a dozen buildings that is the most expansive example of chinoiserie built during the 18th century. While the artificial lakes and curvilinear paths emphasized the requisite playful exchange between art and nature, what defines the garden as Rococo is the mix of architectural forms from all over the world that defy consistency of time or place. In this, the Russian empress was influenced by Chambers's publications, particularly his *Designs of Chinese Buildings* (1757), which she translated into Russian in 1771. Chambers's book had stressed the merits of "variety" and "novelty," which are the founding elements of this Russian garden.

Rococo garden design thus sought to generate visual pleasure and imaginative play and is rightly perceived as anticipating the 20th-century amusement park. Indeed, Rococo gardens were dedicated spaces of liminal play. They created a space apart from everyday life where visitors, normally constrained by expectations of refined social behavior and physical deportment, could escape into exotic, rustic, and antique fantasies. With this relative freedom from the requirements of courtly and civilized behavior came, however, a certain element of risk. Would the visitor let his or her guard down and display indecorous excitement in response to the novelty of the place? The very excitement caused by that potential risk was an essential part of the pleasure to which the Rococo garden gave rise.

**GARRICK, DAVID (1717–79).** An English actor and the manager of Drury Lane theater for nearly 30 years, Garrick was portrayed by some of the most famous painters of his day, many of whom were personal friends: **Joshua Reynolds**, **William Hogarth**, **Francis Hayman**, Benjamin Wilson, and Johann Zoffany. Garrick is associated with the rise of the "theatrical conversation piece," a subcategory of **painting** that combines elements of the **conversation piece** proper with representations of scenes from contemporary theater, as in Hogarth's *Beggar's Opera* (1728–29, Tate Collections, London). It is likely that Garrick provided the impetus for the development of this genre, if not many of the ideas that went into its invention, through his active **patronage** of Wilson and Zoffany. Garrick appears to have immediately recognized the genre's potential for publicity through exhibition and circulation via engraving, which he began to manipulate shortly after the exhibition of Zoffany's *Farmer's Return from London* (1762, Yale Center for British Art, New Haven) at the Society of Artists in 1762. The theatrical conversation piece coincides with the social rise of the actor, which is also recognized in Reynolds's *Garrick between Tragedy and Comedy* (1762, private collection), a modern variation on the mythological subject of Hercules between Virtue and Vice. Garrick was also a patron of some note, commissioning works of art from **Angelica Kaufmann** and **Pompeo Batoni** while on the **grand tour** in 1763 and hiring **Robert Adam** to renovate his newly purchased Fuller House and Lancelot "Capability" Brown to lay out its gardens after 1755. *See also* ENGLAND AND THE ENGLISH ROCOCO; PORTRAITS.

**GENRE.** The term *genre* was first used to refer to scenes of everyday life by the French critic Quatremère de Quincy in 1791, although it is likely that it carried this connotation from at least the middle of the 18th century onward. **Jean-Baptiste Greuze**, for example, was accepted into the **Académie Royale de Peinture et de Sculpture** in 1769 as a "peintre de genre particu-

lier." In earlier usage, "history painting" recorded the noble deeds of men (religious, mythological, historical), while *les genres* referred generally to other subjects, including landscapes, still lifes, and animal pictures. Although scenes of everyday life date back to antiquity, it was not until the 17th century that artists, Dutch and Flemish in particular, began to treat such subjects with sustained attention. A taste for these scenes continued to develop in tandem with a growing middle class interest in the arts. Such subjects were often seen as inherently "modern," in that they dealt with subjects taken directly from contemporary life. *See also* CHARDIN, JEAN-BAPTISTE-SIMÉON; CHODOWIECKI, DANIEL NIKOLAUS; CRESPI, GIUSEPPE MARIA; FRAGONARD, JEAN-HONORÉ; GÉRARD, MARGUERITE; GILLOT, CLAUDE; GREUZE, JEAN-BAPTISTE; HOUASSE, MICHEL-ANGE; LANCRET, NICOLAS; LONGHI, PIETRO; PAINTING; PATER, JEAN-BAPTISTE; TROY, JEAN-FRANÇOIS DE; WATTEAU, ANTOINE.

***GENRE PITTORESQUE.*** The *genre pittoresque* appeared as a loose set of stylistic features in French **interior decorations, paintings**, prints, and decorative objects after 1730, superseding the *style régence*. In 1734, the term was first used in a review, published in the *Mercure de France* of a suite of engravings by **Juste-Aurèle Meissonier**, to describe forms that "often do not respond to each other," referring to a lack of symmetry within compositional structure. In this same review, other features of the *genre pittoresque* are discerned, such as **rocailles**, *coquillages*, and *effets bizarres*, which are typically associated with the Rococo. Later in the century, landscape painting drew on the *pittoresque* compositional principles of complement and contrast, as seen in works by **Hubert Robert** and **Jean-Honoré Fragonard**. Indeed, these principles were often extended to theme as well as form through the creation of decorative series or pendant pairs of paintings. An example of this *pittoresque* treatment of form and subject in pendants is Fragonard's *The Game of La Main Chaude* and *The Game of Horse and Rider* (c. 1775, National Gallery of Art, Washington DC), where the paintings complement each other through theme and palette but also establish contrasts through the treatment of distinctly different groups of figures, types of play, and settings. *See also* ASYMMETRY.

**GEOFFRIN, MARIE-THÉRÈSE (1699–1777).** The wife of a wealthy bourgeois, Madame Geoffrin hosted two of the most significant literary and artistic salons of the 18th century at a *hôtel particulier* on the Rue Saint-Honoré in **Paris**. Guests of her Wednesday literary salon included such prominent men of the **Enlightenment** as **Denis Diderot, Baron von Grimm**, Voltaire, **Jean Le Rond d'Alembert**, and others, while her Monday salons were at-

tended by artists, architects, connoisseurs, and collectors, including **François Boucher, Hubert Robert, Jean-Baptiste Greuze, Edme Bouchardon, Claude-Henri Watelet,** the **comte de Caylus,** and **La Live de Jully.** Her salons fostered the exchange of ideas concerning the arts and led to interesting collaborations, such as Boucher's and Robert's designs for Watelet's gardens at Moulin Joli. Geoffrin also owned a modest collection of works by contemporary artists, mostly the works of her friends. *See also* PATRONS AND PATRONAGE; WOMEN.

**GÉRARD, MARGUERITE (1761–1837).** From Grasse, Gérard moved to **Paris** after the death of her mother to live with her elder sister, a miniature painter, and her sister's husband, the painter **Jean-Honoré Fragonard.** She trained with Fragonard, collaborating with him on works that are now attributed to both artists, rather than to master and pupil. Technical examination of *The First Steps of Childhood* (c. 1780–83, Fogg Museum of Art, Cambridge, Massachusetts), for example, suggests that the two worked side by side, often in the same areas of the canvas, contributing equally to the invention of the composition as it evolved. By the late 1780s, Gérard began to enjoy an independent reputation as a leading woman artist who specialized in **genre** scenes and **portraiture,** which she continued to develop after the Revolution. She exhibited in the **Salons** from 1799, when **women** artists were more openly included, winning a *Prix d'Encouragement* in 1801 and a *Médaille d'Or* in 1803. Gérard's works are marked by a meticulous attention to surface textures and a sentimental approach to subject matter, much of which revolved around an ideal of womanhood and maternal tenderness. *See also* CHILDREN AND CHILDHOOD.

**GERMANY.** The Rococo in Germany centered on the princely courts at Dresden, Würzburg, Munich, Berlin, and Potsdam. Influenced by the grandeur of **Versailles,** prince-electors, archbishops, and the newly crowned kings of Prussia and **Poland** sought to emulate the magnificence of **Louis XIV.** Prominent **patrons,** such as Maximilian II Emanuel (Wittelsbach), were exiled to **France** in the first decade of the century. Upon return to his family seat, Maximilian II and other members of his family drew upon their knowledge of contemporary French models for major building projects in Western and Southern Germany. This appropriation of the latest stylistic trends in French **architecture,** interiors, and landscape gardening led to the introduction of Rococo modes of decoration into expansive palace designs. The masterful garden pavilion at **Amalienburg** outside of Munich, designed by **François de Cuvilliés,** is perhaps the first architectural project to translate the design principles of Rococo **ornamentation** into built form.

In general, however, the intimacy and delicacy of the French Rococo was subsumed by the ecstatic splendor of the **Bavarian Rococo**, which is characterized by a flamboyant and exuberant use of **rocaille** ornamentation that effectively eroded architectonic structure. Drawing on at least two centuries of workshop traditions that developed superior techniques in woodcarving and **stuccowork**, German artisans had the necessary skills to execute in three-dimensional form the decorative fantasies proposed by French ornamental engravings. Architectural projects involving the **Zimmermann brothers**, the **Asam brothers**, and **Balthasar Neumann** extended Rococo decorative forms throughout the sculptural interiors of both secular and ecclesiastical architecture. **Giambattista Tiepolo**'s fresco decorations at Würzburg combined with Neumann's architecture to create one of the most impressive examples of Rococo **interior decoration** involving theatricality, illusionism, and molded space. Closer to the original French model is the **Frederican Rococo**, which explored the tensions inherent to the Rococo concept of "artful" naturalness. It flourished at **Frederick the Great**'s **Sanssouci** in Potsdam, where teams of artists, such as **Georg Wenzeslaus von Knobelsdorff**, the **Hoppenhaupt brothers**, and **Johann August Nahl**, worked under the direction of the king of Prussia himself. In all instances, German princely patrons and the artists who worked for them developed the Rococo in novel and highly inventive ways. *See also* BRÜHL, SCHLOSS, AUGUSTUSBURG AND FALKENLUST; FEUCHTMAYER, JOSEPH ANTON; GARDEN DESIGN; MEISSEN PORCELAIN; MERCIER, PHILIP; NYMPHENBURG; PESNE, ANTOINE; VIERZEHNHEILIGEN; WÜRZBURG RESIDENZ; ZWINGER.

**GERSAINT, EDME-FRANÇOIS (1694–1750).** A *marchand mercier* and art dealer, Gersaint had a head for business and a flair for clever marketing devices. In 1718, he married the daughter of Pierre Sirois, a dealer who gave **Antoine Watteau** his first commission. Gersaint became a friend and protector of Watteau, who painted *Gersaint's Shopsign* (1720, Schloss Charlottenburg, Berlin) to hang outside Gersaint's shop, *Au Grand Monarque*. The work brought considerable attention to Gersaint's business and presented an image of the art dealer's shop as space of fashionable sociability rather than commerce. After the artist's death, Gersaint sold off Watteau's drawings that had been bequeathed to him, which he first had engraved. He also wrote a biography of the artist, *Abrégé de la vie d'Antoine Watteau*, which was published as part of a sale catalog to the Lorangere collection in 1744.

From the 1730s onward, Gersaint began to develop the sale catalog into a source of reference and pedagogy, and as such, his catalogs represent a significant departure from the usual simplistic description of objects. He was also the first art dealer to publicize his business in the *Mercure de France*. In

1740, he changed the name of his shop to *La Pagode* and increasingly traded in luxury goods and curiosities, which he acquired on purchasing trips to the **Netherlands** in the 1730s. **François Boucher** designed the frontispiece to Gersaint's first catalog of shells in 1736 and also a new **trade card** for his shop, which he treated in a characteristic Rococo style, providing an **aesthetic** link between the appearance and display of such curiosities and matters of taste in the visual arts. *See also* PARIS; PATRONS AND PATRONAGE.

**GIAQUINTO, CORRADO (1703–66).** A leading Roman painter of the Rococo who was favored by the Spanish **Bourbons**, Giaquinto first trained in Naples before moving to **Rome** in 1727. During the 1730s, he developed a reputation within international court circles, working for French **patrons** in Rome and traveling to Turin to carry out commissions for the Savoy court, where he also executed works at the request of **Filippo Juvarra** for the decoration of **La Granja de San Ildefonso** in **Spain**. Giaquinto perfected a refined and elegant style that reflected the classicizing Rococo tastes of the Roman school, which is exemplified by his *Baptism of Christ* (1750, Santa Maria dell'Orto, Rome). During the early 1740s, Giaquinto was admitted into the **Accademia di San Luca** and opened his own studio, where young Spanish artists were sent to train. In 1753, he was selected to assume the position of first painter to King Fernando VI and moved to Spain. Shortly after his arrival at the Bourbon court in Madrid, he became the first director of the newly created **Real Academia de Bellas Artes de San Fernando**. Through these two positions, Giaquinto had an immediate and long-lasting influence on the development of a Bourbon "court style" that delighted in all forms of Rococo decoration. His Rococo stylistic tendencies were particularly displayed in the principal project under his direction, a fresco interior scheme for the Palacio Nuevo. Giaquinto was a consummate court artist and administrator, capable of managing multiple projects and large teams of painters and craftsmen, and worked successfully for two Bourbon kings of Spain. He received leave from court in 1762 to travel to the spa town of Ischia, south of Naples, for his health, which continued to deteriorate and prevented his return to Spain. He continued to work for the Bourbons in Naples, however, retaining his title and stipend as first painter until his death in 1766.

**GILLOT, CLAUDE (1673–1722).** A pivotal figure in the development of the *goût moderne*, Gillot was highly inventive in his choice of subject matter and handling of decorative form. It is likely that he developed an artistic interest in the free play of decoration through his father, who was an embroiderer and painter of ornament. Gillot's drawings from the first decade of the 18th century firmly situate his artistic talents in the fields of **arabesque ornamentation** and scenes of modern life, particularly those connected with popular

theater. He simultaneously pursued an academic career, training in the studio of Jean-Baptiste Corneille before he was accepted into the **Académie Royale de Peinture et de Sculpture** in 1710. Despite the fact that he was received as a history painter upon submission of *Christ dans le temps qu'il va être attaché à la croix* (1715, parish church of Noailles, Corrèze), Gillot continued to specialize in **genre** subjects, particularly those involving characters from the **commedia dell'arte**. His best known **painting**, *Les deux carrosses* (1710, Musée du Louvre, Paris), is an example of his dramatic treatment of comic scenes from contemporary theater. Gillot was among a group of artists who revived an interest in **arabesques** as panel decorations for interiors, and it is in his studio that **Antoine Watteau** first trained in this ornamental manner, although Gillot's interest in scenes and characters from the commedia dell'arte had a more lasting impact on Watteau's development of the *fête galante*, which would also be taken up by another pupil, **Nicolas Lancret**. In addition to Gillot's drawings for **ceilings** and **paneling**, several of which are held in the Musée du Louvre, his ornamental designs were engraved and published after his death by **Gabriel Huquier** in the *Nouveau livre de principes d'ornements* (1732). *See also* PARIS.

**GOBELINS.** The Manufacture Royale des Meubles de la Couronne was established in 1662 on the premises of the Hôtel des Gobelins, which had been a family-run tapestry workshop since the beginning of the 17th century. Its purpose was to provide **tapestries**, furnishings, and decorative works for the royal palaces. Additionally, **Louis XIV** and **Jean-Baptiste Colbert** intended the Gobelins to serve as a training ground for craftsmen and artists, which would allow **France** to maintain an industry in luxury goods that surpassed foreign imports in quality. Appointed in 1663 as its first director, Charles Le Brun supplied designs for **tapestry** cartoons, many of which featured **arabesques**. From the late 1690s onward, architects directed the factory through the offices of the **Bâtiments du Roi**, and designs for cartoons were commissioned from leading Rococo painters, such as **Claude III Audran, Charles-Antoine Coypel, François Boucher**, Charles Parrocel, and **Jean-Baptiste Oudry**.

**GOLDONI, CARLO (1707–93).** Goldoni was a successful Venetian playwright who transformed Italian theater by representing actual situations and manners, rather than simply perpetuating the improvisational conventions of the **commedia dell'arte**. He provided an image of modern life that paralleled the works of his friends Alessandro and **Pietro Longhi**, and there may be specific connections between Pietro's **genre** paintings and Goldoni's plays that are not yet fully understood. Alessandro's **portrait** of Goldoni (1770, Civico Museo Correr, Venice) reveals a shared interest in human nature by

artist and sitter, with emphasis placed on capturing intellectual character rather than enhancing status or position. After disputes with Carlo Gozzi, another playwright, Goldoni moved to **Paris** in 1761. He was welcomed by the French court and put in charge of the Comédie Italienne. Goldoni spent the last 30 years of his life in **France**, writing plays and his memoirs in French. *See also* VENICE.

**GONCOURT BROTHERS.** Avid admirers of 18th-century art and initiators of the 19th-century **Rococo Revival**, Edmond de Goncourt (1822–96) and Jules de Goncourt (1830–70) were writers, collectors, critics, and artists. Their collection of 18th-century French prints was extensive and contributed to their understanding of the evolution of the Rococo style, which they surveyed in *L'Art du XVIIIe siècle* (1859–75), illustrated with etchings by Jules. Although at times inventing biographic details to create a more engaging idea of the 18th-century artist, the brothers made an important contribution to the history of Rococo art by providing enduring descriptions of the working methods and artistic accomplishments of the period. *See also* FRANCE.

**GONZÁLEZ VELÁZQUEZ, ANTONIO (1723–94).** A painter and draftsman from Madrid, Antonio González Velázquez trained in the workshop of **Corrado Giaquinto** in **Rome** between 1746 and 1752. Upon his return to **Spain**, he worked as a fresco painter and designer of **tapestries** and was appointed court painter in 1757. Antonio often worked with his brother Luis, and their experience with fresco techniques, rare for Spanish artists at the time, secured their involvement in the decoration of the Palacio Nuevo that included a series of **ceiling** frescoes by **Giambattista Tiepolo** and Giaquinto, who directed the project. Antonio contributed his **painting** *Christopher Columbus Being Received in Barcelona by the Catholic Kings after the Discovery of America* (1763, in situ) to the palace. He became director of painting at the **Real Academia de Bellas Artes de San Fernando** in 1785 and trained several of the younger Spanish painters who worked in the Rococo style, including **Francisco Bayeu** and **Luis Paret**.

**GOTHIC AND GOTHIC REVIVAL.** The Gothic was an improvisational style that often coexisted with the Rococo in English houses during the 18th century. It expanded upon the formal vocabulary of Gothic medieval motifs and followed the geometric ordering of **Classicism**, by which it can be distinguished from the more scholarly Gothic Revival. In contrast to the Gothic, Gothic Revival forms were more faithful in their replication of details from medieval examples, as seen at Horace Walpole's Strawberry Hill (1748–53). Esher Place in Surrey is the first important Gothic building in **England**, de-

signed by William Kent for Henry Pelham between 1729 and 1733, which is surrounded by Rococo gardens also laid out by Kent. The Gothic was consolidated as a style of design in **Batty Langley**'s *Ancient Architecture Restored and Improved* (1741–42). While most of the plates in this book provide suggestions for blending medieval forms into a classical architectural vocabulary, others link Gothic (which Langley called the "Saxon" style) with Rococo details in designs for windows and garden structures. Other examples of the Rococo-Gothic hybrid are found in **William Halfpenny**'s designs for Stouts Hill in the Gloucestershire Cotswolds (begun in 1743), which drew on Langley's plates to develop a delicate language of decorative forms from medieval sources of inspiration. Eventually, the inventiveness of the Gothic gave way to the authenticity of the Gothic Revival. *See also* ARCHITECTURE; CHIPPENDALE, THOMAS; GARDEN DESIGN.

***GOÛT GREC.*** *See* À LA GRECQUE.

**GOYA Y LUCIENTES, FRANCISCO JOSÉ DE (1746–1828).** The most well-known images of the Spanish Rococo are Goya's early **tapestry** cartoons painted for the **Real Fábrica de Tapices de San Bárbara** between 1775 and 1780, which represent **genre** subjects such as **children**'s games, scenes from the Madrid fair, hunts, and other portrayals of urban or pastoral life. These cartoons were the first royal commissions extended to this young artist from Saragossa, and they served to establish his reputation at court. He received this work through his brother-in-law, **Francisco de Bayeu**, who was rapidly becoming the most important senior artist at the **Bourbon** court in Madrid and was artistic director at the royal tapestry manufactory at the time. Both artists had initially trained in the workshop of José Luzán Martínez in Saragossa, where Goya learned to draw by copying prints. He went to **Rome** at his own expense after failing to win the competitions at the **Real Academia de Bellas Artes de San Fernando** in 1764 and 1766. By 1771, he was back in Saragossa and primarily occupied with commissions for religious **painting**, including his series representing the *Life of the Virgin* for the church of Aula Dei (1774, in situ). The work reveals a mix of stylistic influences, suggesting his knowledge of French, Italian, and Spanish art of the 17th and 18th centuries.

In 1774, Goya was called to Madrid to design tapestries. He was paid by the piece, rather than on salary, and, therefore, supplied detailed annotated lists along with the cartoons, which specified subject matter and dimensions. The first work that he specifically noted to be of "his own invention" was *The Picnic* (1776, Museo del Prado, Madrid). Although the subject is clearly inspired by French *fêtes galantes* and Rococo scenes of sociability,

Goya's treatment of the figures is distinctive. They are characters from Madrid society, with varied details of costume and gestures that allow them to be considered individually, rather than as part of a decorative composition. Moreover, they are Spanish types, lower class *majos* depicted at leisure on the banks of the Manzanares River. These images show that Goya had successfully translated French prototypes into images of contemporary Spanish life. Similar scenes juxtapose upper-class observers of lower-class activities taking place at the Madrid fair, such as *The Crockery Vendor* (1777, Museo del Prado, Madrid), in which a Valencian vendor haggles with his customers while an elegant woman of the court watches through her carriage window. These types of images were enormously successful with the royal family, who decorated their residences with the tapestries, particularly the Palacio del Pardo. The status of a painter of tapestry cartoons was limited, however, and Goya had higher ambitions. Nevertheless, it was a lucrative exploit, and drew the attention of the royal family and high-ranking **patrons** within court circles. In total, between 1775 and 1792, he supplied over 60 cartoons.

The royal tapestry factory closed for several years between 1780 and 1786, as crown funds were diverted to the war with **England**. Goya also fell out with Bayeu in 1781 over work that they were both involved in at the Cathedral of Nuestra Señora del Pilar in Saragossa. Despite this major shift in circumstances, Goya successfully established his career as an independent painter. He was elected as a member of the Real Academia de Bellas Artes in 1780 and started to receive a number of ecclesiastic and private commissions. As the decoration of religious institutions was largely a matter of royal patronage, participation in these projects was both an honor and an opportunity for advancement at court. Goya received this chance in the early 1780s with the altarpiece he painted for the Madrid church of San Francisco el Grande, *Saint Bernardino of Siena Preaching before Alfonso V of Aragon* (1781–83), a work that reflects his adoption of stylistic modes that had been popular at court since the time of **Philip V**. The influence of **Michel-Ange Houasse** can be seen in Goya's use of **color** and compositional arrangements of form. At the same time, Goya began to paint **portraits** of members of court. His sitters included the king's brother and his family, the minister of state, the aristocratic directors of the National Bank of San Carlos, and the Duke and **Duchess of Osuna**. By the end of the 1780s, he was the leading portraitist of Madrid society and had been appointed *pintor del rey*. His **portrait** of *Charles III Dressed as a Hunter* (1786–88, Del Arco Collection, Madrid), demonstrates the extent to which Goya was able to adapt Spanish portraiture traditions to the Francophile tastes of his patrons, while at the same time blending these demands with the naturalism of his own style.

When Charles IV and his wife Maria-Luisa ascended the throne in 1789, Goya was promoted to *primer pintor de cámera*. Goya's tapestry cartoons had charmed the king and queen 10 years earlier, and he was soon put to work on a series to decorate the apartments in **El Escorial**, which are among his last works to take up Rococo subject matter, coloring, and painterly handling of forms. The subjects requested by the king were to be "rural and jocose," and the resulting compositions took on a new satirical note, as can be seen in *The Straw Manikin* and *Playing at Giants* (1791–92, Museo del Prado, Madrid). In the former, four **women** toss a straw manikin in a blanket, implying what strong women can do to a weak man. The humor of the work would not have been lost on his **patrons** or their friends, who included the **Duchess of Alba**, for whom Goya began to work in the 1790s. This particular strong woman commissioned numerous paintings from Goya and became his most important patron after the king. By 1800, the taste for Rococo art had waned at the court of **Spain**. Goya's portrait of *The Family of Charles IV* (Museo del Prado, Madrid) is more consistent with ideas of truthfulness and respect for nature championed by **Enlightenment** writers on art. In style, it continues to reflect on Spanish traditions, namely through an intentional reference to *Las meñinas* by Diego Velázquez, although the work is endowed with a greater informality that claims a new "modern" look for the art of Spain and the court of Charles IV, entirely up to date with empire fashions. *See also* CHARLES III OF SPAIN.

**GRAND TOUR.** The grand tour generally refers to an extended journey for pleasure undertaken by British travelers through **France** and **Italy**. It was intended to augment the gentleman's education by providing young men with the opportunity to view the remains of classical antiquity and to collect works of art, whether ancient artifacts, Old Master paintings and sculptures, or pieces by contemporary artists. During the 18th century, the number of travelers went up dramatically, more **women** began to make the journey, and itineraries were expanded to include cities in Central Europe and the Low Countries. As such, part of the aim was to acquire knowledge, not just of the classical world but also the art, languages, politics, and manners of other European countries. Artists and scholars often accompanied young noblemen as tutors, although on occasion and as finances allowed, they made the journey on their own. **Robert Adam** is one example of a British architect who made the grand tour. Noblemen and aspiring aristocrats from other parts of Northern Europe also followed a similar itinerary, again often accompanied by artists, who recorded sites and art works along the way. Travelers often sat for **portraits** in **Paris**, **Venice**, and **Rome** by artists such as Maurice Quentin de La Tour, **Rosalba Carriera**, and **Pompeo Batoni**, who were

accomplished in conveying the idea of the cultured gentleman as connoisseur through a heightened sense of style and the inclusion of relevant motifs. Venetian *vedute* by **Canaletto** and Roman *capriccios* by **Giovanni Paolo Panini** also sold well. Archaeological discoveries at Pompeii and Herculaneum drew grand tourists farther south and reignited a passionate admiration of the classical past, which became increasingly informed by an interest in scholarly accuracy and is linked to the rise of **Neoclassicism**. *See also* CLASSICISM.

**GRAVELOT, HUBERT-FRANÇOIS BOURGUIGNON, KNOWN AS (1699–1773).** Gravelot trained as an artist in the studios of Jean Restout and **François Boucher** before moving to London in 1732 at the invitation of Claude du Bosc, who asked him to assist with engravings for an English translation of Bernard Picart's *Cérémonies et coutumes religieuses de tous les peuples et de tous les temps* (1725–43). Gravelot's elegant style of drawing and his familiarity with the latest designs for luxury goods in **Paris** worked to his advantage within this London setting. He was soon in demand to produce book illustrations and engravings for goldsmiths and **furniture** makers. Gravelot was part of the gathering of artists at Slaughter's Coffee House, where he became friends with **William Hogarth** and **Francis Hayman**. He collaborated with Hayman on projects such as the decoration of supper-boxes at **Vauxhall Gardens,** which included playful subjects represented in the Rococo style. Gravelot also taught drawing at **Saint Martin's Lane Academy** with **Thomas Gainsborough** as his pupil. Through these activities, he helped to introduce the French Rococo style into English art. Anti-French sentiment broke out in **England** after the Battle of Fontenoy in 1745, and Gravelot returned to Paris, where he continued to enjoy a career as a successful illustrator. His book illustrations for such works as Jean-Jacques Rousseau's *La nouvelle Héloïse* (1761), Voltaire's *Collection complete des œuvres* (1768–74), and Tasso's *Gerusalemme liberata* (1771) are characterized by their delicacy of line and meticulous rendering of contemporary **dress** and interiors.

**GREAT BRITAIN.** *See* ENGLAND AND THE ENGLISH ROCOCO.

**GREUZE, JEAN-BAPTISTE (1725–1805).** **Paintings** by Greuze are difficult to classify stylistically as either Rococo or **Neoclassical,** yet once he is considered as a "modern" painter, his works appear in step with major developments in 18th-century art. Like many of his contemporaries, his technique was influenced by his study of the minute detail of 17th-century Dutch *cabinet* pictures, which were popular with collectors in 18th-century **France**. He combined this technique with an academic approach to painting that was based on drawing. Where he differs is in his treatment of **genre** subjects in

the elevated manner of a history painter, a revolutionary approach that was celebrated by critics such as **Denis Diderot** and impressed some of the most important collectors of contemporary art.

From the provincial French town of Tournus, Greuze trained briefly with a **portrait** painter in Lyon before moving to **Paris** around 1750. Soon thereafter, he entered the **Académie Royale de Peinture et de Sculpture** as a student, where he learned academic drawing techniques from **Charles-Joseph Natoire**. Greuze was accepted as an associate member of the Académie Royale in 1755, the same year that he began to exhibit in the **Salons** and embarked upon a trip to **Italy** in the company of Louis Gougenot, Abbé de Chezal-Benoît. Greuze remained in **Rome** after the abbé returned to **Paris** and received lodging at the Académie de France on the order of the **marquis de Marigny**. When Greuze returned to Paris in 1757, he exhibited a group of paintings that set his work apart from those of his contemporaries, including *The Broken Eggs* (1756, Metropolitan Museum of Art, New York) and *The Neapolitan Gesture* (1757, Worcester Art Museum, Massachusetts). Both works are highly theatrical and legible, based on the decoding of disguised symbols, a similar tactic to that which had been used in Rococo pastorals by **François Boucher**. The compositions of these works and the emphasis on dramatic gestures and expressions clearly demonstrate Greuze's assimilation of academic rules, reworked as they are to convey ideas, not about the noble and historic deeds of man but the simple moral dilemmas experienced everyday by members of the lower classes.

Greuze exhibited a number of works in the 1759 Salon, including genre scenes and portraits of aristocrats. This was the first year that the critic Diderot discussed Greuze's art as part of his Salon reviews for **Baron von Grimm**'s *Correspondance littéraire*. Greuze's great moment of triumph, however, came at the Salon of 1761 when he exhibited *L'accordée de village* (Musée du Louvre, Paris). The work was an enormous success, leading Diderot to declare that Greuze had invented "moral painting," which he set in contrast to the decadent artificialities of the dominant style of painting practiced by Boucher and others. For the next several years, Greuze continued to exhibit moralizing genre scenes, such as *Girl Mourning over Her Dead Bird* (1765, National Galleries of Scotland, Edinburgh) and portraits of prominent collectors, artists, and friends.

In 1767, however, he was informed of his need to present a reception piece for full membership as an academician. For the next two years, he turned his attention to history painting and, in 1769, submitted *Septimius Severus Reproaching Caracalla* (Musée du Louvre, Paris) a work that demonstrates his close study of 17th-century French **Classicism**, particularly works by Nicolas Poussin. Although he was fully received into the Académie Royale, members

of the institution and critics at the Salons regarded the work as a complete failure. To his chagrin, Greuze was admitted into the Académie Royale as a genre painter, rather than a history painter, and, so enraged by this apparent insult, he did not exhibit at the Salons again until after the Revolution. Instead, he exhibited at alternative venues, such as the Salon de la Correspondance and in his own studio at the Louvre.

Greuze, however, continued to develop his particular brand of genre painting with works such as *The Father's Curse* pendants: *The Ungrateful Son* and *The Punished Son* (1777–78, Musée du Louvre, Paris), which became known as "bourgeois dramas." His fame within international circles of collectors remained such that Catherine the Great's son visited his studio in 1782, while traveling incognito as the comte du Nord, and commissioned *The Widow and Her Priest* (1784, Hermitage Museum, Saint Petersburg). Sentimentalized images of adolescent girls based on the format of academic *tête d'expression*, often described as "Greuze girls," were his bread and butter during the last decades of his life. While a painter of striking talent, Greuze was also a masterful draftsman and worked with remarkable facility in both chalk and ink.

**GRIMM, FRIEDERICH MELCHIOR, BARON VON (1723–1807).** Grimm was a German writer and diplomat who edited a bimonthly newsletter, the *Correspondance littéraire, philosophique et critique*, with an impressive list of subscribers from the different courts of Europe, particularly those in the north. Its circulation was prohibited in **France**, but Parisian artistic and literary circles were well aware of its content, which included reviews of the biennial **Salons**. The *Correspondance* was a principal source of anti-Rococo criticism in response to the Salons, due largely to the writings of Grimm and **Denis Diderot**. Grimm was interested in contemporary art, which he discussed in his personal correspondence with Madame d'Epinay, Diderot, and Catherine the Great, among others. He contributed writings on the Salons in the *Correspondance* prior to Diderot's reviews, which began in 1759. Grimm exerted a considerable amount of influence over matters of artistic taste in the **Russian** and **German** courts, using his personal contacts and the *Correspondance* to advance the careers of artists that he preferred, such as **Jean-Baptiste Greuze**, Jean-Antoine Houdon, and Jean Huber, a little-known Swiss artist that Grimm promoted to Catherine the Great. *See also* PARIS.

**GRIMOD DE LA REYNIÈRE, LAURENT (1734–93).** A third generation *fermier-général*, Grimod de La Reynière began collecting art at the age of 19. His father, Antoine-Gaspard (1690–1754), was a minor collector and had commissioned **portraits** from Maurice-Quentin de La Tour. Laurent's

purchases from the 1750s and 1760s were largely conventional: works by Old Master painters of the Italian, Flemish, and French schools. In the late 1770s, however, his activities as a **patron** and collector of contemporary French art became more substantial in connection with the building of his own townhouse in **Paris**, the Hôtel Grimod de La Reynière. Inspired by excavations at Pompeii, he engaged **Charles-Louis Clérisseau** to paint the interiors of the main salons with a scheme of **grotesque paneling** that incorporated historical and allegorical vignettes in styles that looked back to the Rococo and forward to **Neoclassicism**. Clérisseau's decorations provided an appropriate setting for the discrete display of works by the French school, which Grimod de La Reynière began to assemble for this purpose. The design of the *hôtel particulier* included a picture gallery in the west wing specifically devoted to the display of large-scale history **paintings** and **genre** scenes by French artists, like **François Lemoyne, François Boucher, Charles-Joseph Natoire, Jean-Honoré Fragonard**, and **Jean-Baptiste Greuze**. During the 1780s, Grimod de La Reynière and his wife hosted a celebrated salon, where artists, musicians, and writers mingled with members of the nobility, regular events that secured his reputation as an *amateur* of some distinction. *See also* CLASSICISM.

**GROTESQUES.** This form of surface decoration was derived from ancient Roman sources and reintroduced into European art during the Renaissance. The term was coined around 1480 when excavations of the Domus Aurea uncovered decorated rooms that the Romans called *grotte*, or grottoes. From these *grotte*, artists working under Raphael on the loggias of the Vatican developed a coherent system of **ornamentation** that filled rectangular panels and invited invention and play with classical forms. Grotesques include small, interconnected motifs and figural forms, whether human, animal, or creatures of pure fantasy. European printmakers, such as Jacques Androuet Ducerceau and Hans Vredeman de Vries, continued to adapt ancient Roman originals into increasingly refined systems contained within an upright framework for the use of painters and carvers. De Vries, in particular, incorporated strapwork into his grotesque fantasies, creating a lighter type of grotesque, which influenced **Jean Bérain**, one of the first Rococo artists to take up this interplay of decorative motifs in his designs for interior **paneling**. During the 18th century, the terms *grotesque* and *arabesque* were often used interchangeably. Excavations at Pompeii and Herculaneum fueled a revival of interest in grotesques, which artists such as **Charles-Louis Clérisseau** developed with a stronger sense of their classical origins. *See also* CLASSICISM; NEOCLASSICISM.

**GUARDI, FRANCESCO (1712–93).** A Venetian painter known for his *vedute* and *capricci*, Francesco began his career as an artist working in the family studio started by his father, Domenico (1678–1716), but headed by his older brother, Gianantonio (1699–1760), and in which his younger brother, Nicoló, also worked. Between 1730 and 1760, the brothers collaborated on religious and history **paintings**, without distinguishing individual contributions, a common practice in Venetian family workshops. The *Tobias* series in the Chiesa dell'Angelo Raffaele (c. 1750) demonstrates the highly decorative qualities of works produced by the Guardi brothers, which is characterized by a luminous use of **color** animated by the energetic application of paint. Around the time of Gianantonio's death, Francesco began to concentrate on views of **Venice**. In taking up *vedute*, Francesco continued his earlier studio practice of borrowing compositions from other artists.

He appears to have entered **Canaletto**'s studio in the late 1750s, an unusual move for an artist in his 40s, but he may have hoped to capitalize on the increasing market for this type of work and felt the need to become familiar with new compositional modes. According to a 19th-century source, Francesco was given the tasks of executing works that Canaletto had laid out and adding finishing touches to some of Canaletto's paintings, which suggests that the master recognized Francesco's extraordinary talents with the brush. *Gondola in a Lagoon* (c. 1765, Museo Poldi Pezzoli, Milan), which is unanimously agreed to have been painted solely by Francesco, is a remarkable work in which atmosphere is created through the dissolution of form and the sensitive blending of color. In the 1770s and 1780s, Francesco painted views of Venice during fairs and ceremonies, such as the *Piazza di San Marco* (1777, Museu Calouste Gulbenkian, Lisbon), a painting that delights in the detailing of decorative surfaces. A work that carries this interest over into a rare interior scene of contemporary sociability is *Ladies' Concert at the Philharmonic Hall* (1782, Alte Pinacoteca, Munich). This painting is quintessentially Rococo in its subjugation of independent figural and architectural form to a unified scheme of pictorial **ornamentation**.

**GÜNTHER, IGNAZ (1725–75).** The son of a German cabinetmaker, Ignaz Günther was apprenticed to Johann Baptist Straub, who was a leading sculptor in Munich. In the early 1750s, he trained as a journeyman in the workshops of Paul Egell in Mannheim and Joseph Zahner in Moravia, and subsequently studied at the Kunstakademie in Vienna. Günther returned to Munich and was appointed court sculptor to the elector of Bavaria in 1754. The majority of Günther's work was ecclesiastical rather than secular, producing **sculptures** for the monasteries and churches at Rott am Inn, Weyarn, Kircheiselfing, Mallersdorf, Munich, and elsewhere. His sculptural works

should be understood within the theatrical context of **Bavarian Rococo** interiors. Günther was primarily a wood-carver, and other artists completed the polychrome on his sculptures. His virtuoso carving technique achieved heightened forms of **ornamentation** through sharp repetitive cuts, which are often seen in the folds of draperies. For the Augustinian Church in Weyarn, he completed an Annunciation, a *Pietá*, and figures of saints (1763–64), which are characterized by harmonious lines, graceful gestures, and mystical affect. *See also* GERMANY.

# H

**HALFPENNY, WILLIAM (ACTIVE 1723–55).** A carpenter by trade, most likely from Yorkshire, Halfpenny worked as a provincial architect and was a prolific author of do-it-yourself pattern books. He wrote at least 23 of these, which covered a range of styles and were widely circulated both within and beyond the borders of **England**. His first publication was *Practical Architecture* (1724), a pattern book of the English Palladian movement intended for journeymen architects, which was followed by several other books that argued for the importance of accurate proportions, such as *The Art of Sound Building, Demonstrated in Geometrical Problems* (1725). In the 1740s, however, Halfpenny began to experiment with a new **architectural** vocabulary that was liberated from the rules of Palladianism. He was commissioned first by Timothy Gyde to reconstruct Stouts Hill at Uley (1743) and then by his friend, Richard Clutterbuck, to design the Orangery at Frampton-on-Severn (1750), both in Gloucestershire. Halfpenny's designs play with **classical** and Gothic forms, which he combined to produce a style that is curiously connected to the Rococo. Halfpenny's pattern books from this period similarly reveal a fashionable shift in taste toward **chinoiserie**, the **Gothic**, and Rococo **ornamentation**. These publications include *New Designs for Chinese Temples* (1750) and *Chinese and Gothic Architecture Properly Ornamented* (1752), which he wrote with his son, John Halfpenny.

**HAMEAU DE LA REINE, VERSAILLES (1783–86).** The Hameau de la Reine is a farm folly that was introduced into the gardens of Versailles for the enjoyment of **Marie-Antoinette**, who used to dress as a shepherdess and tend sheep at her rustic village. The collection of buildings included a dairy, a mill, a barn, and a tower from which to view the entire complex, which was built around an artificial lake. It was designed by **Richard Mique**, and it responded to the popularity of Rousseauist ideas at court and in **Paris**. *Hameaux* and *laiteries* (dairies) had been fashionable inclusions in gardens since the time of **Louis XV** and **Madame de Pompadour**, although they were not on the scale of a complete mock village. The charming *hameau* at **Chantilly** built for Louis-Joseph, Prince de Condé, in his new *jardin anglais* contained a

similar collection of thatched rustic buildings with elegant interiors, predating Marie-Antoinette's hamlet by a decade. *See also* GARDEN DESIGN.

**HAYMAN, FRANCIS (C. 1708–76).** Hayman trained as a decorative painter in London, where he initially worked as a painter of stage scenery at the Goodman's Fields and Drury Lane Theaters in the 1730s, making connections that would serve him well later in his career. In the 1740s, for example, **David Garrick** advised Hayman on appropriate gestures and expressions for Shakespearean characters, which the artist incorporated into his designs for book illustrations and the scheme of Shakespeare pictures for **Frederick, Prince of Wales**'s Pavilion at **Vauxhall Gardens**. Hayman was active as a painter of **portraits** and **conversation pieces** from the middle of the 1730s, demonstrating considerable originality, if not technical skill, as a portraitist. *David Garrick and Mrs. Pritchard in "The Suspicious Husband"* (c. 1747, Yale Centre for British Art, New Haven) is one of the earliest theatrical conversation pieces produced in English art, a genre that was closely connected with the performances of Garrick. With *Samuel Richardson and His Family* (1740–41, Tate Collection, London), Hayman introduced a new formula for outdoor portraiture, informally grouping figures in front of an imaginary landscape backdrop, and borrowing elements from the French *fête galante* but adapting them to English tastes in portraiture. This format particularly influenced **Thomas Gainsborough**, who studied with Hayman as a young artist.

Hayman's greatest contribution to the **English Rococo** was the supper-box pictures that he painted for Vauxhall Gardens, commissioned by the proprietor, Jonathan Tyers. Executed in the early 1740s by Hayman and a team of assistants, these large canvases represent themes of play, rural leisure, and scenes from the theater, all painted in the French Rococo style. One of the few surviving examples is the *See-saw* (c. 1742, Tate Collection, London). The supper-box pictures were thoroughly modern works of art, not only in terms of their subjects and style but also due to the nature of their intended context, as they were designed to be exhibited in a public space, one of the few venues in Europe that gave access to contemporary art.

Throughout his career, Hayman was an active proponent of a public academy of art with a strong educational program and regular exhibitions through which to promote British history painting. He was a friend of **William Hogarth**, who started the **Saint Martin's Lane Academy**, of which Hayman was an early member. As chairman of the artist's committee, he aided in the establishment of the Society of Artists in 1759, which sponsored the first formal exhibitions of art in London. Hayman was also a founder member of the Royal Academy of Arts when it received its royal charter in 1768.

**HOGARTH, WILLIAM (1697–1764).** The example of Hogarth frustrates any attempt to view the **English Rococo** in a definitive or simplistic way. His early training with an **ornamental** engraver, his **aesthetic** writings, which advocate a concept of beauty based on the sinuous line, and his association with artists such as the Frenchman **Hubert Gravelot** and the painter of playful supper-box pictures, **Francis Hayman,** suggest that he was firmly situated within a group of avant-garde painters responding to contemporary French art in London during the 1730s and 1740s. His group **portraits** seem to affirm this stylistic assessment. *The Wollaston Family* (1730, H. C. Wollaston Trust) and *The Cholmondeley Family* (1732, private collection) depict informal groupings of figures in elegant interiors, finely painted with a distinct interest in modernizing the conventions of portraiture. *Children Playing "The Indian Emperor" before an Audience* (1731–32, private collection) is a painting that demonstrates a thematic interest in the vitality of contemporary theater and fashionable scenes of daily life, executed with an **asymmetrical** compositional arrangement, small-scale figures, and a lightness of touch that parallels painting of this kind in France by artists like **Antoine Watteau, Carle van Loo,** and **Nicolas Lancret.**

At the same time, however, Hogarth painted works of an entirely different nature, which he called "modern moral subjects" and with which his fame as an artist is most closely connected. The first series in this vein was *A Harlot's Progress*, which was painted in 1731 and engraved in 1732 (original paintings destroyed in 1755). His contemporaries were captivated by these images, which appealed to viewers from different classes. This mocking pictorial narrative was followed by *A Rake's Progress* (1732–33, Sir John Soane's Museum, London) and *Marriage à-la-mode* (1743–44, National Gallery, London), cycles that make a scathing critique of the moral degradation of refined society. In this, his works depart significantly from their French counterparts, the closest of which are **Jean-Baptiste Greuze**'s bourgeois dramas, which address the moral dilemmas of the middle classes, rather than providing a social critique of the ruling elite.

In addition to his novel approaches to portraiture, **conversation pieces,** theatrical subjects, and moralizing satires of daily life, Hogarth made considerable efforts to elevate the training and status of the artist in England through the creation of academies and provision of exhibition spaces in which the public could view contemporary art. In 1735, he set up a nonhierarchical academy in **Saint Martin's Lane,** which provided classes in life drawing. Members included Hayman and Gravelot, with **Thomas Gainsborough** among the students. He worked with Jonathan Tyers, the proprietor of **Vauxhall Gardens,** in the orchestration of decorated spaces in which contemporary art would be presented to the public. His efforts gave rise to the creation

of the Society of Artists, which provided the first formal exhibition space for artists in London, and he was elected to the committee in 1761, although he only exhibited there once.

Hogarth's most enduring impact on a historical understanding of the Rococo aesthetic is through his theoretical treatise, *The Analysis of Beauty* (1753). In this text, he provides an extended defense of what is understood as the foundation of Rococo stylistic forms: C and S scrollwork and sinuous and serpentine lines that lead "the eye to a wanton kind of chase" and give the greatest pleasure to the mind. Yet Hogarth's art often stood in contrast to these aesthetic principles in its attempt to shape public opinion through a novel and satirical treatment of contemporary social issues. *See also* AESTHETICS; GENRE; PAINTING.

**HOLLAND.** *See* THE NETHERLANDS.

*HONNÊTETÉ.* This secular ideal of polite behavior was elaborated by the French nobility during the 17th century. The first important work on *honnêteté* was Nicolas Faret's *L'honnête homme ou l'art de plaire à la cour* (1630), although it can be traced back to the Italian Renaissance through Baldassare Castiglione's *Book of the Courtier* (1528). It is closely related to the cult of *préciosité*, which was perceived more negatively. *Honnêteté* has been linked to matters of good taste and subjective judgment, which gave rise to the Rococo. The *honnête* ideal of sociability has similarly been connected with the visual world of the *fête galante*, specifically through the art of **Antoine Watteau**. *See also* FRANCE.

**HOPPENHAUPT BROTHERS.** Johann Michael Hoppenhaupt II (1709–78/86) and Johann Christian Hoppenhaupt (active 1742–c. 1778/86) both worked in Prussia for **Frederick the Great** as ornamental **sculptors** and decorators on his palaces in Potsdam and Berlin. They were part of the team of architects and decorators responsible for the creation of the **Frederican Rococo**, which included **Johann August Nahl** and **Georg Wenzeslaus von Knobelsdorff**. An example of their collaborative efforts is the circular library at **Schloss Sanssouci**, Potsdam (1745–47). These artists worked under the careful supervision of the ruler, who often supplied them with sketches, and it can be difficult to differentiate the specific contributions of individual hands and minds. It is known, for instance, that Frederick provided Johann Christian with sketched ideas for the Voltaire Room (1752–53), which the artist then elaborated and executed. The decoration of this room is among the most remarkable at Sanssouci, with richly colored woodcarvings of monkeys, birds, fruits, flowers, and garlands attached to yellow lacquered wall panels.

Far more naturalistic than French precedents, the **boiseries** in this room indicate the originality of designers working within the Frederican Rococo. Between 1751 and 1755, Johann Michael collaborated with the engraver Johann Wilhelm Meil, possibly with the assistance of Johann Christian, to produce some 70 prints of designs for decorative objects, **furniture**, wall **ornamentation**, and carriages. The brothers were well-known designers of decorative cabriolets, carriages, and coaches featuring fantastic **rocaille** and **arabesque** ornamentation, an example of which is the ornate carriage given by Frederick the Great to the Empress Elizabeth of Russia (1746, Kremlin Armory, Moscow). *See also* GERMANY; INTERIOR DECORATION; PATRONS AND PATRONAGE.

**HÔTEL DE SOUBISE.** In 1700, François de Rohan, Prince de Soubise, purchased the Hôtel de Guise on the Rue des Paradis (today the Rue des Francs-Bourgeois). He hired the architect **Pierre-Alexis Delamair** to carry out transformative renovations, which began in 1704. Delamair completed the exteriors, but his designs for a central enfilade scheme for the interiors was considered to be old fashioned. The Soubise family replaced Delamair with **Germain Boffrand**, who built a two-story oval pavilion at one end of the garden facade, which attached to the suite of rooms at right angles, further emphasizing the novel **asymmetry** of his design. The Salon Ovale de la Prince employs a delicate **color** scheme of light blue-grey **paneling** with white **rocaille boiseries** and eight allegorical bas-reliefs attributed to the sculptors Lambert-Sigisbert Adam and Jean-Baptiste II Lemoine. It is the Salon Ovale de la Princesse, however, that is celebrated as the height of Rococo **interior decoration. Mirrors** alternate with smaller rounded panels topped by eight canvases set into curvilinear frames depicting the story of Psyche by **Charles-Joseph Natoire** (1737–39). The entire room is engulfed by gilt boiseries that invade all decorative elements and erode divisions between walls, **doors**, and **ceilings**. The painters **François Boucher, Carle van Loo**, Jean Restout, and Trémolières were engaged in 1736 to complete four mythological overdoors with light erotic themes to decorate the Chambre de Prince, whereas the Chambre de la Princesse was decorated with gilt boiseries set against white paneling with sculpted medallions depicting the loves of Jupiter. *See also* ARCHITECTURE; *HÔTEL PARTICULIER*; PARIS.

*HÔTEL PARTICULIER.* This French term literally means "private townhouse." It was originally used in the 16th century to refer to the city houses of the nobility but, by the 18th century, included residences that belonged to wealthy members of the third estate. *Hôtel* design of the first decades of the 18th century was influenced by the curvilinear forms and the **ornamentation**

of Rococo interiors. At the same time, it was impacted by a desire of owners to live in grand residences with the space to incorporate elements from château **architecture**, such as attached gardens and service wings that were separate from the main *corps de logis*. One of the most celebrated examples of this suburban type was the Hôtel de Biron (1728–30) designed by **Jean Aubert**. *See also* ARCHITECTURE; DE COTTE, ROBERT; INTERIOR DECORATION; PARIS.

**HOUASSE, MICHEL-ANGE (1680–1730).** Michel-Ange Houasse was one of a number of French painters and architects who worked in the court of **Philip V of Spain**. The son of René-Antoine Houasse, a high-ranking academician who had studied under Charles Le Brun, Michel-Ange received conventional training as young artist, which included a stay in **Italy** between 1702 and 1706. There he met the Princess Orsini, *camarera mayor* to Philip V's first wife, who initiated his contact with members of the Spanish court. Back in **Paris** in 1706, he became a full academician in 1707 and *peintre ordinaire du roi* in 1710. Upon the recommendation of Count Jean Orry, Philip V's French finance minister, he was engaged as a **portrait** painter and moved to Madrid in 1715. The **paintings** he produced at court ranged far beyond portraiture to include allegorical and religious subjects. It was, however, as a chronicler of contemporary activities, whether work or play, that he was most original. His works in this mode include *The Drawing Academy* (1725, Palacio Real, Madrid) and *Children Playing Leap Frog* (1725, Palacio de la Granja, Segovia). His representations of games played outdoors appear to have influenced his students, such as Antonio Gonzalez Ruiz, who took up similar subjects in their paintings and **tapestry** cartoons. While the figures in these scenes are more "low life" than those that appeared in *fête galante* games painted by his French contemporaries **Antoine Watteau, Nicolas Lancret**, and **Jean-Baptiste Pater**, Houasse's drawings of figures playing, running, and sitting (Biblioteca Nacional, Madrid) are far closer in spirit to the French Rococo, particularly in their delicate treatment of line, suggesting that he modified his manner to appeal to Spanish tastes. *See also* SPAIN.

**HUET, CHRISTOPHE (1700–1759).** From a family of French painters, Huet was admitted into the **Académie de Saint-Luc** in 1734 and exhibited animal paintings at the French **Salons** throughout the 1750s. He is best known, however, not as a specialist in this genre, but as one of the most inspired **ornamental** painters of the 18th century. His reputation in this regard rests on the celebrated interiors he created for such important **patrons** as the duc de La Vallière, the duchesse du Maine, and the Bourbon-Condé family. Huet painted charming **boiseries** to decorate the interiors of the Château des

Champs, the Hôtel de Rohan, and the **Château de Chantilly**, which survive as complete rooms. Huet was a master of **chinoiseries** and *singeries*, **painting** scenes that mix Chinese figures together with monkeys who ape the pastimes enjoyed by the French nobility. The scenes are painted with a lightness of touch and considerable grace, which works with the content to express a witty, yet tasteful inversion of life in **Paris** and its satellite courts. His nephew, Jean-Baptiste Huet (1745–1811), also painted animal pictures, collaborating with **François Boucher** and **Jean-Honoré Fragonard** on a decorative scheme for the printmaker Gilles Demarteau's house in Paris (Musée Carnavalet, Paris). *See also HÔTEL PARTICULIER.*

**HUQUIER, GABRIEL (1695–1772).** Huquier was a French engraver and printmaker who contributed to the dissemination of Rococo designs throughout Europe with a series of publications in the 1730s and 1740s that included hundreds of plates reproducing the **ornamental** compositions of **Juste-Aurèle Meissonier**, **Jacques de Lajoüe**, and **Gilles-Marie Oppenord**. Huquier also collected prints and drawings by his contemporaries, including **Claude Gillot**, **Antoine Watteau**, and **François Boucher**, many of which he reproduced in etchings lightly reworked with a burin, a technique particularly suited to the Rococo drawings that were his models. *See also FRANCE.*

**I**

**INTERIOR DECORATION.** The Rococo emerged within French interior decoration around 1700 as a novel type of **ornamentation**. It spread quickly throughout Europe and to **Great Britain**, largely through the increased movement of artists, extensive travel of **patrons**, and the expanded circulation of ornamental prints. Decoration of Rococo interiors included, but was not limited to, **ceiling** and panel painting, carved wood **paneling** or **boiseries, stucco and plasterwork,** as well as the extensive use of **mirrors.** In paradigmatic examples, such as the Salon Ovale de la Princesse of the **Hôtel de Soubise** and the Spiegelsaal of **Amalienburg,** mirrors were used in combination with surface decorations that eroded distinctions between walls and ceilings, replaced defined corners with continuous curves, and masked architectonic features of the room.

Perhaps more than any other period, in the Rococo, the importance of interior decoration rivaled that of **architecture** itself. As Sébastien Mercier wrote toward the end of the 18th century, "When a house is built . . . nothing is done as yet . . . . Enter the joiner, the upholsterer, the painter, the gilder, the sculptor, the furniture-maker etc." Interior decoration was a major expense and preoccupation of Rococo building work. Painters, sculptors, and architects often worked in highly organized teams to achieve designs that treated Rococo interiors as a unified whole. This was particularly true in geographic regions with established workshop traditions, such as **France** and **Germany,** where expertise in woodcarving was passed down through generations of artists and craftsmen, who were able to work as one under a supervising architect. Since boiseries and **stuccowork** were of fundamental importance to Rococo interior decoration, such training was indispensable. The domestic and church interiors of the **Bavarian Rococo** are remarkable for this very reason. By contrast, the **English Rococo** was reliant upon the imported talents of Swiss-Italian stuccoists, who in turn influenced the designs of local artists working in plaster, which was cheaper and easier to handle.

**Louis XIV** himself has been credited with giving orders that contributed to the early formation of Rococo interior decoration at the **Ménagerie de Versailles**. Presented with plans for conventional mythological allegories

that would perpetuate the Grand Manner interiors found elsewhere at **Versailles**, the king rejected the proposal and ordered a scheme that would be appropriately "youthful." The resulting interior decoration was based around **arabesque** fantasies invented by **Claude III Audran**. Audran's studio and the rival workshop of **Jean I Bérain** were in high demand among the nobility for their ornamental **paintings** in the genre of arabesques and **grotesques** for the interior decoration of châteaux and *hôtels particuliers* in and around **Paris**. The new taste for ornamental painting was matched by the "luxury" of carved wood paneling, which, according to the architect **Jacques-François Blondel**, "introduced sculpture, gilding and mirrors into apartments" during the first decades of the 18th century.

During the regency of **Philippe II, duc d'Orléans**, and the personal reign of **Louis XV**, the increasing lavishness of Rococo interior decoration was attributed to the expanding consumer market in **Paris**. As the writer Germain Brice noted of a new gallery added to the Hôtel Thévenin in 1704, it was crammed with "everything singular and beautiful that the imagination can conjure up." Critics of Rococo decorative excess, such as Blondel, reacted against this "amassing of a prodigy of ornament" and called for a return to simplified interior decoration. The restrained **Neoclassicism** of interior decoration at the time of **Louis XVI** responded to this desire for ornament to be once again subjugated to construction design. Neoclassicism is characterized by straight lines of rectangular paneling painted in white and gilded.

Outside of France, well-informed patrons were closely involved with the planning of interior decoration that gave rise to regional variants on the French Rococo. In Southern **Germany**, the Wittelsbach family, after an extended period of exile in France, employed both French and German artists to work alongside one another on the interior decoration of **Schloss Nymphenburg** and their other residences. In so doing, they sponsored the creation of the **Bavarian Rococo**. **Frederick the Great** sent drawings back from the battlefield for ideas for the interiors of **Schloss Sanssouci**. Empress Maria Teresa of **Austria** acquired objects from Constantinople and East Asia that formed the basis of interiors at Schloss Schönbrunn, which merged the **aesthetics** of East and West. While Baroque exteriors maintained an outward expression of the Hapsburg's **absolutist** authority, the Empress's emphasis on interior decoration over new building projects allowed her to create an updated imperial visual idiom that became a defining characteristic of the Austrian Rococo.

**ITALY.** The Italian Rococo is often referred to as the Barocchetto to emphasize the strong links it maintained with the Baroque. Indeed, the persistence of the Baroque as the predominant style in most regions of Italy during the

first half of the 18th century hindered the enthusiastic uptake of the Rococo from **France** and **Venice** by local artists. It is worth noting that Italy was not a unified nation in this period but rather a collection of states with divergent political and economic interests pervaded by linguistic, artistic, and cultural regionalism. Foreigners, nevertheless, perceived a certain societal unity in Italy, which was defined in terms of its past achievements.

**Grand tourists** flocked to Italy during the 18th century, seeking to complete a gentleman's education through the acquisition of taste. Their motives were primarily **aesthetic**: as one English traveler noted at the time, "One comes to Italy to look at buildings, statues, pictures, people." Venice and **Rome** were not only the cities of most interest to grand tourists, but also they were important European centers of artistic activity. Venetian art of the 18th century is notable for its development of a formal vocabulary that paralleled the Rococo in France and is characterized by an emphasis on luminous **color**, technical virtuosity in fresco and pastel, and an informal handling of **portraiture** and **genre** scenes. While Venice remained largely separate from the rest of Italy, the international fame of celebrated painters, such as **Antonio Pellegrini**, **Rosalba Carriera**, and **Giambattista Tiepolo**, brought considerable attention to the artistic achievements and innovations of the Venetian Rococo.

In Rome, portraitists and view painters catered to the fashionable taste for the Rococo among grand tourists, as can be seen in the decorative flourishes in portraits by **Pompeo Batoni** and the emphasis on **ornamentation** in the architectural fantasies of **Giovanni Paolo Panini** and **Giovanni Battista Piranesi**. Beyond this, there was little development of the Rococo in Roman art and **architecture**. The Spanish Steps (1723–26) was the major building project of the early 18th century in Rome, yet whether or not this scheme can be considered Rococo is debatable. The most significant connection of the Spanish Steps to the Rococo is a creative spirit that rejected the need to follow established architectural rules. Far more significant to the development of the arts in 18th century Rome, however, was the archaeological fervor initiated by the discoveries at Pompeii and Herculaneum, which stimulated a pan-European interest in classical art and life. With its profusion of examples of ancient architecture and **sculpture**, Rome was at the epicenter of an artistic movement that stood in opposition to the decorative excesses of the late Baroque and Rococo styles and culminated in the stylistic dominance of **Neoclassicism** in the late 18th century.

The princely and ducal courts of northern Italy and the Kingdom of Naples and Sicily in the south exerted their political and cultural ambitions through lavish building projects and **patronage** programs that stimulated artistic production in the decorative arts. When the Duke of Savoy became the king of

Sardinia in 1720, Turin increased in importance as the capital of the newly founded kingdom of Piedmont-Sardinia. **Filippo Juvarra** became first architect to King Victor-Amadeus II of Savoy and was put in charge of an extensive building program intended to transform Turin with 16 new palaces and 8 new churches. Although exterior architecture remained largely a mixture of Classical uniformity and Baroque splendor in Piedmont, elaborate decorative systems were used by Juvarra to adorn surfaces in his ecclesiastical and palace interiors that approached the formal vocabulary of the Rococo. At the Palazzina di caccia di Stupinigi (1729–31), for example, Juvarra directed the work of teams of decorative painters from Venice and engaged local craftsmen to carve wood **paneling**, parquetry, and **furniture** in the Rococo style. The central *salon* indicates the extent to which the playfulness of the Rococo merged with Baroque decorative traditions in Juvarra's use of lavish illusionistic detailing in lurid **colors** to produce an entertaining sensibility of sham grandeur. In character, Rococo interiors in Piedmont have much in common with the **Bavarian Rococo**.

Like Victor-Amadeus II in Piedmont, **Charles VI**, the newly installed **Bourbon** king of Naples and Sardinia, was determined to leave a lasting cultural legacy for his kingdom. Charles's model was the French court at **Versailles**, and he ordered the construction of a number of palaces at **Caserta**, Capodimonte, Portici, and in Naples to emulate its Baroque grandeur. The style of these palaces is largely Classical but on a Baroque scale, with minimal incursions of the Rococo in private interior spaces. More significant to the development of the Rococo in southern Italy was the founding of the Capodimonte Porcelain Factory by the king in 1743, which trained local artists to produce painted designs inspired by French Rococo prints and the **porcelain** productions of **Meissen**. A Neapolitan style of Rococo design developed, characterized by fleshy figures and richly colored floral bouquets and landscapes. The factory was transferred to Buen Retiro in Madrid when Charles acceded to the Spanish throne in 1759, encouraging an increasingly international development of the Rococo in the decorative arts. *See also* ALGAROTTI, FRANCESCO; BELLA, STEFANO DELLA; BELLOTTO, BERNARDO; BERNINI, GIAN LORENZO; CANALE, GIOVANNI ANTONIO, CALLED CANALETTO; CASERTA; CRESPI, GIUSEPPE MARIA; GUARDI, FRANCESCO; LONGHI, PIETRO; *QUADRATURA*; TIEPOLO, GIOVANNI DOMENICO; ZUCCARELLI, FRANCESCO.

# J

**JUVARRA, FILIPPO (1678–1736).** Juvarra was a highly original architect who worked in Turin for 20 years after he became first architect to the king of Sicily, Victor-Amadeus II of Savoy, in 1714. His early training as a silversmith with his father and in the studio of the late Baroque architect Carlo Fontana gave rise to the divergent stylistic impulses of Juvarra's work, which is characterized by imaginative decorative systems and structural clarity. These elements are combined with great facility in such works as the Palazzo Madama (1718–21), the Chiesa del Carmine (1732–35), both in Turin, and Stupinigi Castle (1729–33). While the scale and grandeur of these buildings is certainly late Baroque, Juvarra's unique decorative style suggests an affinity with the development of Rococo **ornamentation** in **architecture** outside of **France**, particularly in Bavaria. Juvarra had an international reputation, not only as an architect but also as a draftsman and stage designer of great talent. He received commissions from Emperor Joseph II of Austria, King John V of Portugal, and Augustus the Strong of Saxony, among others. He died in Madrid, while working on a royal palace for **Philip V of Spain**. *See also* AUSTRIA; BAVARIAN ROCOCO; GERMANY; ITALY; LA GRANJA DE SAN ILDEFONSO; POLAND; PORTUGAL; SPAIN.

# K

**KAUFFMAN, ANGELICA (1741–1807).** Born in Switzerland but raised and educated in **Austria**, Kauffman's art has been described as **Neoclassical**, Rococo, and Grand Manner. In truth, she moved easily between all three styles. As a young girl, Angelica trained with her father, Joseph Johann Kauffman (1707–82), with whom she traveled to **Italy** in the early 1760s. While in **Rome**, the Kauffmans socialized with British and German artists and theorists. Partly under the influence of Johann Winckelmann but also through her association with **Giovanni Battista Piranesi** and **Charles-Louis Clérisseau**, she studied classical **sculpture**, which had a considerable impact on her treatment of human form. She was invited to London in 1766 by the wife of an English diplomat and remained there until 1781. As a **woman** artist working in **England**, Kaufmann's most lucrative category of subject matter was **portraiture**, although she was also well regarded as a history painter by her peers at the Royal Academy of Arts, of which she was a founding member. Her works *Hector and Andromache* (exhibited at the Royal Academy in 1769) and *Vortigern and Rowena* (exhibited at the Royal Academy in 1770, both Saltram House, Devon) demonstrate the iconographic breadth of her subjects, which addressed diverse themes from classical antiquity, English medieval history, and contemporary European literature. Kauffman also completed allegorical and mythological **paintings** as part of decorative schemes for the interiors of houses and public buildings by **Robert Adam** and **Sir William Chambers**, such as *Colour*, *Design*, *Composition*, and *Genius* (1778–80, Burlington House, London) for the Royal Academy at Somerset House.

After the death of her first husband, she married the artist Antonio Zucchi in 1781 and returned to Italy. She continued to work for British **patrons** and sent works back to London for exhibition at the Royal Academy, but her paintings were also highly sought by members of European courts in **Russia**, **Poland**, Naples, and **Austria**. For the last decades of the 18th century, her studio became a fashionable stop on the **grand tour**.

**KEW.** The **ornamental** gardens designed by **William Chambers** for **Frederick, Prince of Wales**, and Princess Augusta at Kew, 12 kilometers west of London, are among the most significant examples of English Rococo **garden design**. In 1750, Frederick purchased additional acreage to the south of his residence, the White House, with the intention of laying out gardens in a style suitable for exotic plantings. Finished by his wife after Frederick's death in 1751, Chambers designed the garden between 1757 and 1763 in a style distinctly different from the straightforward picturesque designs of William Kent and Lancelot "Capability" Brown. It included buildings that referred stylistically to civilizations past and present, familiar and exotic: a pagoda, classical temples, a ruined arch, a mosque, and an Alhambra. Although many of these buildings are known only through engravings and Chambers's own publication *Plans, Elevations, Sections and Perspective Views of the Gardens and Buildings at Kew, in Surrey* (1763), the Pagoda stands, in slightly altered appearance, as one of the most enduring examples of architectural **chinoiserie** from the period. *See also* ENGLAND AND THE ENGLISH ROCOCO.

**KNOBELSDORFF, GEORG WENZESLAUS VON (1699–1753).** A German architect, interior decorator, and painter, Knobelsdorff entered the Prussian court of the crown prince, the future **Frederick the Great**, at Schloss Rheinsberg in the early 1730s. He trained with **Antoine Pesne**, who was the leading painter at court working in a Rococo manner derived from French examples. The two artists collaborated on **paintings**, such as the *Crown Prince's Residence at Schloss Rheinsberg* (1737, Berlin, Schloss Charlottenburg), in which Knobelsdorff painted the view and garden foreground and Pesne added aristocratic figures at leisure. Knobelsdorff painted numerous **portraits** of Frederick, including a small pastel (1737, Berlin, Schloss Charlottenburg). The likeness of this work was considered such that it was used as a pattern for medals and coins. In Knobelsdorff's paintings and drawings, the influence of **Antoine Watteau** and his followers is evident. Knobelsdorff would have been familiar with prime examples of the French Rococo through Frederick's personal collection.

After a trip to **Italy** in 1736, Knobelsdorff took over the direction of building and **interior decoration** at Schloss Rheinsberg. He was appointed superintendent of royal palaces and gardens when Frederick ascended the throne. Knobelsdorff designed several buildings in Berlin and Potsdam with celebrated interiors associated with the **Frederican Rococo**. At Schloss Charlottenburg, the Berlin residence of the king, Knobelsdorff built a new wing that included the Golden Gallery (1740–46). The most significant project of this period was the building of **Schloss Sanssouci** in Potsdam, an intimate garden retreat above terraced vineyards that the king intended as a

*maison de plaisance*. Frederick worked closely with his architect, supplying sketches that Knobelsdorff interpreted in his subsequent designs. The single-story building is a procession of glazed enclosures on the garden facade, with a round central space, crowned by a cupola. The interiors were richly decorated by a team of artists associated with the Frederican Rococo, which included **Johann August Nahl** and the **Hoppenhaupt brothers**, overseen by Knobelsdorff. In keeping with the spirit of the king's version of enlightened **absolutism**, he commissioned Knobelsdorff to redesign the Berlin Tiergarten as a public park, one of the first of its kind in Europe. *See also* ARCHITEC-TURE; GERMANY.

# L

**LABILLE-GUIARD, ADÉLAÏDE (1749–1803).** A French painter best known for her **portraits** of **Louis XVI**'s aunts, Labille-Guiard was one of the most prominent **women** artists of her generation. She trained in miniature, pastel with **Maurice-Quentin de La Tour**, and oil painting with François-André Vincent. During the late 1770s, she painted a number of portraits of leading academicians to extend her contacts within the **Académie Royale de Peinture et de Sculpture**, with the aim of gaining membership. She first began to exhibit portraits in miniature and pastel at the **Académie de Saint-Luc** in the 1770s and later at the Salon de la Correspondance in the early 1780s. In 1783, she became a full member of the Académie Royale and exhibited for the first time at the **Salon**. By this time, she already had her own studio and was training nine women students. Her *Self-Portrait with Two Pupils* (Salon of 1785, Metropolitan Museum of Art, New York) is a striking image that asserts the artist's professional achievements and, at the same time, carefully negotiates societal expectations of femininity.

During the late 1780s, when Labille-Guiard was regularly exhibiting at the Salons, critics compared her works favorably to those of **Élisabeth Vigée Le Brun**. These two female artists were often pitted against one another as rivals, not only by critics and academicians but also by their respective **patrons** at court. Labille-Guiard became *peintre des mesdames* in 1787 and, in this capacity, produced several portraits of Madame Adélaïde and Madame Victoire, examples of which are in the collection of the Château de **Versailles**. She also received an important commission from the comte de Provence for a history **painting** depicting the *Reception of a Knight of Saint Lazare by Monsieur, Grand Master of the Order* (painted 1788–91 and destroyed during the Revolution). *See also* FRANCE.

**LA FONT DE SAINT-YENNE, ÉTIENNE (1688–1771).** The first important art critic in **France**, La Font de Saint-Yenne had no official relationship to the **Salons** or the **Académie Royale de Peinture et de Sculpture**, which set his writing apart from that of previous *amateurs*. From a family of bourgeois origins, he was employed at **Versailles** as *Gentilhomme de la reine*

to the queen of France, Marie Leczinska, between 1729 and 1737. His first work of art criticism, *Réflexions sur quelques causes de l'état présent de la peinture en France*, published anonymously in 1747, did not appear until 10 years later. In this text, and purportedly as a response to the most recent Parisian Salon, La Font discussed what he perceived as the decline of French **painting** since the death of **Louis XIV**. More specifically, he blamed the dearth of serious history painting on the overabundance of works designed for decorative interiors. La Font's Salon criticism predates that of **Denis Diderot** by a decade and acts as an important precedent to the philosophe's work, particularly its anti-Rococo sentiment. Along with other anonymous critics, La Font's writings claimed to speak on behalf of the Salon-going public and initiated a significant reaction to Rococo styles and subjects in French art discourse. *See also* AESTHETICS.

**LA GRANJA DE SAN ILDEFONSO.** The palace La Granja de San Ildefonso was built near Segovia for **Philip V**, the first Bourbon king of **Spain**. Begun in 1719, it was modeled on the palace and gardens of the Château de **Versailles**. Although planned by the Spanish architect Teodoro Ardemans as a modest summer retreat, the garden facade was designed by **Filippo Juvarra** with the assistance of **Giovanni Battista Sacchetti**, both of whom were at work on the **Palacio Real** in Madrid. Several significant Rococo artists contributed to the decorations of La Granja, including **Giambattista Tiepolo**, **Francisco Bayeu**, and **Gilles-Marie Oppenord**, the latter sending his designs for **ornamental** garden vases from **Paris**. *See also* GIAQUINTO, CORRADO.

**LAJOÜE, JACQUES DE (1686–1761).** Lajoüe appears to have spent his early career working as an ornamental craftsman. By 1721, however, he had sufficiently developed his skills as a painter to be accepted into the **Académie Royale de Peinture et de Sculpture** on the basis of two architectural capriccios. He continued to specialize in this type of work throughout his career, producing architectural fantasies as easel paintings, overdoors, and for other decorative purposes. At the same time, he remained active as an ornamental designer. His work appears in numerous publications containing suites of engravings after his designs for **cartouches**, decorative objects, **furniture**, and **sculpture**. His "fantasy pieces" do not fit into any of these categories, but they are among the most fanciful visions of the Rococo period. Lajoüe's striking compositions distort pictorial conventions and intentionally thwart expectations of visual legibility. In works such as *Scene in a Park* (1740s, Hermitage Museum, Saint Petersburg), a monumental fountain dominates half of the foreground, while figures are displaced into the middle ground, off

to one side. Gestures and expressions cannot be discerned: backs are turned to the viewer, and the slight turn of a figure's head serves as a visual directive to move even further into the background where a natural cascade falls. In effect, the **asymmetry** of Rococo **ornamentation** has been successfully translated into a figural **painting**, resulting in a nonnarrative image that forsakes legibility for the experience of visual fantasy.

Lajoüe's most significant commissions were received in the 1730s and included perspectival overdoors for **Joseph Bonnier de La Mosson**, a major collector of curiosities and an *amateur* of science. One of these works is *The Cabinet of Physical Sciences* (1734, Sir Alfred Beit Foundation, Russborough) that represents, in high detail, a display of scientific apparatuses set within a fantastical interior space opening at the back to a scene of masonry construction that dissolves into the atmosphere. The painting alternates between tangible naturalism and illusionistic fantasy. Lajoüe continued to exhibit at the **Salons** during the 1730s and 1740s, and his ornamental designs were well known through the pamphlets of engravings after his work that circulated throughout Europe. *See also* FRANCE.

**LA LIVE DE JULLY, ANGE-LAURENT DE (1725–79).** The son of a wealthy tax-farmer, La Live de Jully was an important **patron** and collector of contemporary French art. He owned works by the painters Nicolas de Largillière, **Jean-Baptiste-Siméon Chardin, Jean-Baptiste Oudry, Hubert Robert**, and **Jean-Baptiste Greuze**, as well as sculptural works by **Étienne-Maurice Falconet, Jean-Baptiste Pigalle**, and Pierre Puget. He also began to collect **furniture** designed by Louis-Joseph Le Lorrain in the *goût grec*. While this shift has been viewed as part of the anti-Rococo reaction that took place in the second half of the 18th century, it can also be understood as part of a cohesive attempt on the part of La Live to encourage the creativity of living French artists, who worked in a variety of stylistic modes that could all be described as "modern." In his preface to the catalog of his collection, published in 1764, La Live expressed his desire to promote modern artists and the achievements of the French school. The **Académie Royale de Peinture et de Sculpture** officially recognized his status as a collector in 1754, when he was elected as an honorary member at the age of 28. His **portrait** by Greuze, *La Live de Jully Playing the Harp* (1759, National Gallery of Art, Washington DC) pictures the patron as a sensitive man of the **Enlightenment** who, in moments of private relaxation, pursued an *amateur*'s interest in the arts and music. *See also* FRANCE.

**LANCRET, NICOLAS (1690–1743).** Lancret specialized in scenes of everyday life and was the favorite **genre** painter of **Louis XV**. Dézallier

d'Argenville noted in the 1760s that the king "liked his style," which explains the several commissions Louis XV extended to Lancret between 1727 and 1743 for the decoration of rooms at **Versailles**, La Muette, and **Fontainebleau**. Lancret stands out among his contemporaries for the sustained attention he received from the king as a **genre** painter. His subjects for the crown include *The Luncheon with Ham* (1735, Musée Condé, Chantilly), *The Tiger Hunt* (1736, Musée de Picardie, Amiens), *The Four Seasons* (1736, Musée du Louvre, Paris), and works more generally described as *fêtes galantes* and pastorals. Lancret received commissions from other European monarchs, aristocratic **patrons**, and major collectors of contemporary French art, including **La Live de Jully** and **Frederick the Great**, who owned at least 26 of his paintings.

Lancret originally trained as a history painter alongside **François Lemoyne** at the **Académie Royale de Peinture et de Sculpture** (the two were expelled together for their verbal mistreatment of colleagues in 1708), and he entered the competition for the *Prix de Rome* in 1711, although he lost to his friend Lemoyne. It was around this time that Lancret began to shift the direction of his career, possibly owing to the stir created by **Antoine Watteau** when he exhibited a selection of his **paintings**, including *Les Jaloux* (untraced, known through an engraving), for approval at the Académie Royale in 1712. It may be at this point, or slightly earlier, that he entered the studio of **Claude Gillot**. Lancret's reception piece, *Conversation Galante* (Wallace Collection, London), earned him full membership at Académie Royale in 1719. His debt to Watteau in this period was obvious, so much so that he was soon after described as an "emulator" of Watteau in the *Mercure de France*. Lancret knew Watteau, but he did not work with him as a pupil, as did **Jean-Baptiste Pater**. Nevertheless, around 1720, there was such a correspondence between their works that when Lancret exhibited at the Exposition de la Jeunesse, people mistook his work for Watteau's, which led to the breakdown of their friendship.

After Watteau's death in 1721, Lancret's approach to *fête galante* imagery became more distinctive. The actions and facial expressions of his figures are increasingly descriptive, and while his genre scenes are nonnarrative, paintings such as *Blindman's Buff* (c. 1728, Nationalmuseum, Stockholm) and *The Cup of Hot Chocolate* (c. 1742, National Gallery, London), nevertheless, appear to tell pleasing stories of everyday life involving the social rituals and habits of well-heeled members of society. These works demonstrate Lancret's masterful handling of **color** and rhythmic composition. Among his varied genre subjects, a sustained interest in themes of **childhood** and play can be discerned. He was also an accomplished draftsman, often working in the *trois crayons* **technique**. *See also* PAINTING.

**LANGLEY, BATTY (1696–1751).** Batty Langley is important to the dissemination of the Rococo style through his publication of pattern books on **garden design** and **architecture**. He trained in the profession of his father, a landscape gardener from Twickenham, although his reputation as a garden designer rests not on practical experience but on his publications from the late 1720s: *Practical Geometry* (1726), *New Principles of Gardening* (1728), *A Sure Method of Improving Estates* (1728), and *Pomona, or the Fruit Garden Illustrated* (1729). In the first of these books, Langley provided directions for "arti-natural" design, which is an early promotion of irregular gardening. He expanded upon these ideas in his illustrations for *New Principles of Gardening*, which included writhing walks and serpentines ending in knotted **parterres**. In this text, Langley argued that the serpentine line is "exceeding beautiful," and recommended its use in "ceilings, parquetting, painting, paving." His promotion of the curvilinear **aesthetic** in **England** can be seen as an important precedent to **William Hogarth**'s Line of Beauty, which it predated by 25 years. His architectural books of the 1730s and 1740s plundered Rococo prints from **France** and **Germany**, appropriating multiple illustrations from **Nicolas Pineau**'s *Nouveaux desseins de pieds de tables*. Langley's patriotic case for **Gothic** architecture in *Ancient Architecture Restored, and Improved* (1741–42) is largely informed by his Rococo tastes, which embraced variety and surprise. As such, his work is more properly connected with the inventiveness of the Gothic than with the scholarly accuracy of Gothic Revival.

**LA TOUR, MAURICE-QUENTIN DE (1704–88).** Known for his penetrating **portraits** masterfully executed in pastel, Maurice-Quentin de La Tour pursued perfection in this relatively novel artistic technique. Most unusually, he did not paint in oils but was a prolific draftsman and pastel artist, producing over 1,200 works during his lifetime. Pastel portraits became popular in **Paris** and at **Versailles** following the visit of the pastelist **Rosalba Carriera** in the early 1720s. Although La Tour was only a student at the time, he was, nevertheless, profoundly influenced by the work of this celebrated **woman** artist from **Venice**. Like Carriera, La Tour aimed to produce portraits that conveyed a sense of the sitter's personality. The aesthetically refined naturalism of his portraits opposed both the traditional formality of stately portraits and the artificiality of portraits in mythological guise, such as those by **Jean-Marc Nattier**, which were enormously popular with women at court. La Tour, nevertheless, attracted **patrons** from the ranks of the high nobility. He executed bust portraits of **Louis XV** and Queen Marie Leczinska in the late 1740s, the success of which led to his appointment as *peintre du roi* in 1750. Four years earlier, he had achieved full membership at the **Académie Royale de Peinture et de Sculpture** and had been exhibiting regularly at the **Salons** since 1737.

La Tour's working methods were meticulous and time consuming. For his full-length portraits of elite members of society, such as the **marquise de Pompadour** (1748–55, Musée du Louvre, Paris), he executed the head from life and then pasted it to a large-scale support at the studio, on which the composition was laid out as a unified whole. Such an approach allowed La Tour to achieve a heightened sense of intimacy between the beholder and the sitter, at the same time that surface textures, **color** harmonies, pose, and setting could be carefully considered and rendered in detail. La Tour generally held to a narrow range of colors, as seen in the portrait of Pompadour, which is typically based around Rococo hues of blue, gold, pink, and white. In addition to his portraits of the nobility and prominent members of court, La Tour portrayed his fellow artists and prominent figures of the **Enlightenment**, such as Voltaire and Jean-Jacques Rousseau. His self-portraits, an example of which is *La Tour Wearing a Jabot* (c. 1751, Musée de Picardie, Amiens), evoke the creative energy of the Rococo artist primarily through subtle lighting effects, varied surface textures, and the pleasing effects of blended color.

**LEDOUX, CLAUDE-NICOLAS (1736–1806).** Ledoux was the most fashionable architect of his day. Not only was he employed by numerous wealthy clients to design their private townhouses in **Paris**, but also he had prominent connections at court and in the circles of *salonnières*. His style is predominantly **Neoclassical** and responds to the movement away from the Rococo supported by **Jacques-François Blondel**, with whom Ledoux studied at the newly formed École des Arts. Ledoux's most celebrated commissions were the Hôtel Guimard (1769–72) and a pavilion at **Louveciennes** (1770–71) built for **Louis XV**'s last official mistress, **Madame du Barry**. The Hôtel Guimard was built for Marie-Madeleine Guimard, a famous dancer of the Paris Opera, in the Chaussée d'Antin. Designed in the latest **Neoclassical** taste, it included a small private theater and was decorated with **paintings** by **Jean-Honoré Fragonard**, although the painter was dismissed after a dispute with the **patron**, and the work was finished by the young **Jacques-Louis David**. Fragonard was similarly commissioned by Du Barry to decorate the interiors of Ledoux's pavilions, but his paintings were ultimately rejected and replaced with a series by **Joseph-Marie Vien**. These two instances of patron dissatisfaction point to an inherent disjuncture between the Rococo style of Fragonard's paintings and the Neoclassical style of Ledoux's **architecture**, although it also suggests that the styles were once considered compatible, at least when the commissions were first extended. Enough historical evidence exists to indicate that the rejections had as much to do with the temperaments of the patrons as with a rejection of the Rococo. *See also HÔTEL PARTICULIER.*

**LEMOYNE, FRANÇOIS (1688–1737).** Lemoyne was a leading French history painter in the 1720s and 1730s, although his promising career was cut short when he committed suicide not long after he was appointed *premier peintre du roi* following the completion of his most important commission, *The Apotheosis of Hercules* (1733–36, in situ, ceiling of the Salon d'Hercules, Versailles). He had the usual training of an aspiring academician and won the *Premier prix* in 1711, without the scholarship to **Rome**. He was received as a full member of the **Académie Royale de Peinture et de Sculpture** in 1718, five years before he traveled to **Italy** in the company of the wealthy financier, François Berger. Having already completed major decorative schemes on commission, such as the **ceiling** of the Banque Royale, Lemoyne's style was fully formed prior to his departure for Rome. In fact, works that he made while in Italy, such as *Hercules and Omphale* (1724, Musée du Louvre, Paris), suggest the influence of Peter Paul Rubens over that of any Italian master. Back in **France**, Lemoyne participated in the 1727 competition between history painters organized by the **Bâtiments du Roi** under the **duc d'Antin**'s administration. His *Continence of Scipio* (Musée des Beaux-Arts, Nancy) was not an outright success, as Lemoyne was forced to share first prize with **Jean-François de Troy**, and contemporary critics preferred the work of **Nöel-Nicolas Coypel**. This competition did help to secure Lemoyne's reputation as a history painter, which led to commissions for major works at **Versailles**, such as *Louis XV Giving Peace to Europe* (1729) for the Salon de la Paix, a work that is predominantly Grand Manner in style to accord with Charles Le Brun's achievements in the adjoining Galerie des Glaces. **Charles-Joseph Natoire** and **François Boucher** both trained with Lemoyne and went on to become leading painters in the Rococo style during the 1740s. *See also* COLOR; PAINTING.

**LEMOYNE, JEAN-BAPTISTE (1704–78).** Lemoyne was one of the most prominent sculptors in 18th-century **France**. He completed monumental **sculptures** with allegorical, mythological, and religious themes, as well as notable decorative works and lively **portrait** busts made in terracotta and marble. Stylistically, he moved easily between the Rococo and **Classicism**, especially in his portrait busts. Lemoyne was from a family of artists and trained with Robert Le Lorrain in the early 1720s. Despite the fact that he won the *Prix de Rome* in 1725, he never studied at the Académie de France, remaining instead in **Paris**.

By 1735, he was at work on the **Hôtel de Soubise**, a major decorative project that involved a group of young architects and artists and represents the apogee of French Rococo interiors. Lemoyne contributed the sculpted allegorical scenes in **stucco** made for insertion into the pendentives of the Salon

Ovale. He was received into the **Académie Royale de Peinture et de Sculpture** in 1738, when he was already at work on *Oceanus with Sea Monsters*, a royal commission for the Basin of Neptune, completed in 1740. Lemoyne continued to receive royal commissions throughout his career, serving as portraitist to the king and, in 1768, was made rector of the Académie Royale.

Lemoyne created the official sculpted image of **Louis XV**, which was adapted and reproduced many times over during the king's lifetime. His marble *Louis XV* (1757, Metropolitan Museum of Art, New York) complements the nobility of pose with an **asymmetrical** and **ornamental** handling of drapery. The result is a portrayal that is both decorous and decorative, in keeping with the character and taste of his sitter. Lemoyne's *Vertumnus and Pomona* (1760, Musée du Louvre, Paris) is representative of Rococo sculpture at its best. The pastoral qualities of the theme, and the subtle eroticism of its conception, are legitimized by the allegorical status of the subject matter, while the potential theatricality of the grouping is offset through the ornamental handling of sculptural form and the rhythmic play of lines and gestures. The overall effect is one of a pleasing visual experience derived from form and figural interaction, to which subject matter is largely inconsequential.

**LENORMAND DE TOURNEHEM, CHARLES-FRANÇOIS (1684–1751).** A wealthy financier, Lenormand de Tournehem became *directeur des bâtiments du roi* in 1745. He was uncle by marriage to the **marquise de Pompadour**, who had been installed by **Louis XV** as official royal favorite earlier that year. At the time of his appointment, it was determined that the post would pass to Pompadour's younger brother, the future **marquis de Marigny**, upon Tournehem's death. Under the direction of Tournehem and Marigny, the **Bâtiments du Roi** revived the interventionist role in artistic policy that it had played under **Jean-Baptiste Colbert** during the early years of **Louis XIV**'s reign. Tournehem appointed **Charles-Antoine Coypel** to *premier peintre du roi*, a post that had been left vacant for nearly a decade, and took advice from *amateur* members of the **Académie Royale de Peinture et de Sculpture**, such as **Louis-Petit de Bachaumont** and the **comte de Caylus**. He was also responsive to the independent voice of the art critic, namely **La Font de Saint-Yenne**'s, who began to publish his anonymous pamphlets in response to the **Salons** in 1747, lamenting the lack of support for serious history **painting** and calling for a museum to be established in the Louvre.

Soon after this publication appeared, although not solely in reaction to it, Tournehem initiated a number of reforms at the Académie Royale and increased the number of royal commissions. He instituted a new competition and increased the prizes for history painting. For winners of the *Prix de*

*Rome*, he opened the École Royale des Élèves Protégés, which was intended to provide adequate preparation for study at the Académie de France in **Rome**. To improve standards at the Salons, he created the first Salon jury, which was charged with regularizing selection processes. At the Palais du Luxembourg, Tournehem put part of the royal collection on public display for two days per week and improved access for young artists to the Medici cycle by Peter Paul Rubens. Tournehem's reformist arts administration continued under his successor Marigny and was undoubtedly related to the larger ambitions of the Lenormand family, which included Pompadour's ascendancy at court and the wider perception of her influence on matters of taste. *See also* FRANCE; PATRONS AND PATRONAGE.

**LONGHI, PIETRO (1702–85).** The Italian painter Pietro Longhi created some of the most memorable scenes of Venetian life during the 18th century. While his earliest known works addressed mythological and religious themes, he gave up narrative **painting** to concentrate on **genre** scenes. His interest in scenes of everyday life developed through his study of **Giuseppe Maria Crespi**'s works. According to some early biographers, he entered Crespi's studio in Bologna as an assistant sometime after 1718. He also became familiar with the art of **Antoine Watteau** through the volumes of engravings that had been sent to **Rosalba Carriera** in **Venice** by the *amateur* Jean de Julienne. Longhi's affinity with French Rococo artists, such as Watteau and **Nicolas Lancret**, is most evident in his drawings, an example of which is his *Young Man Sprawled in a Chair* (c. 1760, Staatliche Museen, Berlin).

Many of his early genre subjects are also close to those of his French contemporaries, two examples of which are *The Married Couple's Breakfast* and *Blindman's Buff* (both 1744, Windsor Castle, Windsor), which were both owned by **Joseph Smith**, the British consul in Venice, and later entered the collection of George III. Other paintings by Longhi were more unusual and uniquely tied to life in contemporary Venice. *The Rhinoceros* (1751, Ca'Rezzonico, Venice) depicts the viewing of an exotic animal on display during Carnival in 1751. Longhi incorporated a number of recognizable **portraits** into the group of onlookers seen admiring the animal, including the owner of the rhinoceros and the **patron** who commissioned the work, Giovanni Grimani. This individualization of figures combines with the meticulous handling of still-life elements and natural lighting to convey a sense of truthfulness and vitality.

During Longhi's lifetime, the innovative quality of his work was compared to that of **Carlo Goldoni** in the theater, who had dismissed the artificial conventions of the **commedia dell'arte** in favor of plots based on his observations of daily life. Goldoni made this claim himself in a sonnet of 1750: "Longhi,

you summon my sibling muse; your pen like mine is seeking truth." As with Goldoni's, Longhi's work was popular with prominent Venetian families and well known in European court circles. *See also* FRANCE; ITALY.

**LOUIS XIV BOURBON (1638–1715), KING OF FRANCE (1643–1715).** Louis XIV valued the propagandistic value of the arts and asserted that their principal role was to glorify the king. His lavish expenditure on building projects achieved a level of incomparable magnificence, which distinguished his **patronage** from other European rulers and French princes of blood. Under the direction of Jules Hardouin-Mansart, Charles Le Brun, and André Le Nôtre, the arts were unified into a *tout ensemble* of **architecture, interior decoration**, and **garden design** and put in the service of the king. The Rococo is often framed as a stylistic reaction to this imposing use of the arts as it countered the stately splendor of Grand Manner forms, as well as the academicism and didactic qualities of 17th-century French **Classicism**, which also emerged under Louis XIV.

Nonetheless, the so-called genesis of Rococo forms occurred during the final two decades of his rule and in the workshops of artists such as **Jean Bérain** and **Claude III Audran**, which were attached to the **Bâtiments du Roi** through the **Menus Plaisirs**. Early uses of Rococo decorative forms occurred at the Château de Marly and the **Ménagerie** at **Versailles**, both spaces of relaxed pleasure and relative privacy intended for the use of intimate friends and close relatives of the king. Louis XIV's adoption of early Rococo forms of decoration did not constitute a paradigmatic shift in the king's taste but was simply used as an **ornamental** mode appropriate for private spaces of leisure and respite. The king's most lasting impact on matters related to the arts was the establishment of institutions, offices, and flourishing manufactories under the guidance of his minister, **Jean-Baptiste Colbert**. These included the **Académie Royale de Peinture et de Sculpture**, the **Académie d'Architecture**, the Académie de France in **Rome**, the **Bâtiments du Roi**, and the royal **tapestry** factory of **Beauvais**. *See also* ABSOLUTISM; FRANCE.

**LOUIS XV BOURBON (1710–74), KING OF FRANCE (1715–74).** The Rococo period is most closely aligned with the reign of Louis XV. He was the great-grandson of **Louis XIV** and ascended the throne at the age of five. During his minority, the regent **Philippe II, duc d'Orléans**, governed **France** from 1715 to 1723. The Regency is often considered to mark the beginning of the Rococo as a period style, particularly in **interior decoration**, and is contrasted with the Grand Manner of Louis XIV's reign. In part, this shift in style was due to the building boom in **Paris**, which occurred almost imme-

diately after the regent moved the court from **Versailles** back to the city. It resulted in a number of new interior refurbishments that were carried out in a style distinctly different from that of Louis XIV. During the Regency, Louis XV was installed in the Tuileries.

When his personal rule began in 1723, he returned the court to Versailles and made relatively minor, but nonetheless significant, changes to the private spaces of the château. The suite known as the Petits Appartements was transformed into a series of smaller rooms during the 1730s by the *premier architecte* **Anges-Jacques Gabriel** and decorated with carved **paneling** by **Jacques Verberckt**. Special **furniture** was also designed for the space, including the famous *cabinet intérieur* desk crafted by Jean-François Oeben and **Jean-Henri Riesener**. To maintain a uniformity of stylistic traditions that connected the reigns of Louis XIV and Louis XV, the principal **architectural** projects at Versailles, the building of the Petit Trianon (1760–64) and the Opera House (1763–70), are classical in style. The projects are, nevertheless, marked by an intimacy of scale (in the case of the Petit Trianon) and **ornamental** decoration that is entirely Rococo in spirit. Louis XV extended further commissions to Gabriel for urban projects in Paris, including the École Militaire and the Place de Louis XV (now the Place de la Concorde). Once again, these are mostly classical in style, establishing a visual continuity with architectural design under the reign of Louis XIV and his principal architect Jules Hardouin-Mansart.

Louis XV maintained the administrative structures developed for the arts under Louis XIV, specifically those connected with the **Académie Royale de Peinture et de Sculpture** and the **Bâtiments du Roi**, which he put under the direction of **Philibert Orry** (from 1730), **Lenormand de Tournehem** (from 1745), and the **marquis de Marigny** (from 1751). Funds for the arts, however, were often constrained. In spite of these limitations, significant institutional reforms were enacted, including the establishment of regular biennial **Salons**. Louis XV apparently had little interest in history **painting**. Early on in his reign, he favored the *fête galante* genre, extending numerous commissions to **Nicolas Lancret** from the late 1720s to the early 1740s. Subjects related to the hunt also gained in popularity during his reign, largely because of the king's personal interest in the theme. He commissioned numerous animal and hunt pictures from **Alexandre-François Desportes** and **Jean-Baptiste Oudry**. One of the major decorative schemes commissioned for the dining room of the king's *appartements* at Versailles was dedicated to exotic hunts and included works by Nicolas Lancret, **Jean-Baptiste Pater**, **François Boucher**, and **Carle van Loo**.

The decorative arts flourished under Louis XV, and his personal influence was particularly felt in connection with the **porcelain** manufactories

established by the king, first at Vincennes (1745, sole ownership from 1759) and later at **Sèvres**. Louis XV's official mistress, the **marquise de Pompadour**, also exerted a great deal of influence over the decorative arts, specifically at Sèvres, and her taste in painting and **sculpture**, as well as garden pavilions, dominated at court. *See also* ABSOLUTISM; PATRONS AND PATRONAGE.

**LOUIS XVI BOURBON (1754–93), KING OF FRANCE (1774–91), KING OF THE FRENCH (1791–92).** Louis XVI, grandson of **Louis XV**, did not take an active interest in the arts. Nevertheless, he supported the efforts of his chief administrator of artistic affairs, the **comte d'Angiviller**, in promoting serious history **painting** focused on patriotism and the great deeds of men. These efforts responded to the anti-Rococo reaction that had begun around 1750 and expressed a desire to return to what was celebrated as the Golden Age of French art under **Louis XIV**. The style associated with the reign of Louis XVI is largely **Neoclassical**, although many artists continued to work in a mode that is more closely connected with the decorative tastes that dominated the Regency and early years of Louis XV's reign. Louis XVI's personal taste was neither ambitious nor distinguished by any particular focus other than pleasing decoration. He enjoyed the views of **Hubert Robert**, the military paintings of **Louis-Nicolas van Blarenberghe**, and the animal paintings of **Alexandre-François Desportes**. He commissioned some redecorations at **Versailles**, including the library (1774), the queen's private suite (1783), and his own dressing room (1788), as well as ordering a dairy to be built at Rambouillet as a surprise for **Marie-Antoinette**. From the **porcelain** manufactory at **Sèvres**, he commissioned the most expensive dinner service of the 18th century, which was composed of 362 pieces, although it was only half completed at the time of the king's death (1783–92, Royal Collection, Windsor Castle). Louis XVI was tried for treason during the First Republic and guillotined in 1793. *See also* ABSOLUTISM; FRANCE.

**LOUVECIENNES.** In 1769, Louis XV presented his new favorite, the **comtesse du Barry**, with the Château de Louveciennes, located outside **Paris** near the royal Château de Marly. **Architectural** upgrades for the 17th-century château commenced immediately. **Anges-Jacques Gabriel**, the king's first architect, was put in charge of its expansion and redecoration. However, determined to demonstrate her authority as a fashionable patron of trend-setting taste, Du Barry turned to the rising young architect **Claude-Nicolas Ledoux** to design a new pavilion in the **gardens** of the estate, a private retreat where Du Barry would be able to entertain the king. Completed in 1771, this architectural project was celebrated for its classical purity.

Somewhat at odds with the **Neoclassical** style of the exterior, Du Barry commissioned a series of decorative **paintings** from the Rococo painter **Jean-Honoré Fragonard**. Known erroneously as the *Progress of Love* (1771–73, Frick Collection, New York), the paintings were sent back to the artist shortly after their installation at Louveciennes, and a replacement series was commissioned from **Joseph-Marie Vien**. These paintings were far more in keeping with Ledoux's Neoclassical building and epitomized the *goût grec*, then at the height of fashion. *See also* HAMEAU DE LA REINE.

**LUNÉVILLE.** Father-in-law to **Louis XV** and the deposed King of **Poland**, the Grand Duke Stanislas Leszczynski installed himself and his court at Lunéville, outside of Nancy, in 1737. The imposing château, designed in the manner of French **Classicism**, had been built by **Germain Boffrand** under Leopold, the Duke of Lorraine, after 1702. Leszczynski turned his attention to the **gardens**, where he commissioned his architect Emmanuel Héré (1705–63) to build a number of garden pavilions, assisted by **Richard Mique**, who later worked for **Louis XVI** and **Marie-Antoinette** at **Versailles**. Héré had trained with Boffrand while the more famous architect was at work on the **Hôtel de Soubise**. One of the first additions Héré designed for the gardens was the Trefoil Pavilion (1737), or Trèfle, which was used as an outdoor gaming salon. It employed oriental forms in its double-flaring roof and **chinoiserie** wallpaper. The Trèfle became an important source of influence at the court of **Frederick the Great**, who hired Johann Büring to build a similar Chinese Pavilion at **Sanssouci** between 1754 and 1756. An equally exotic building with more Turkish roots at Lunéville was the Kiosk, used as a dining pavilion on at least one occasion. More jocular features were also introduced to entertain and amuse visitors, such as *The Perspective*, a trompe l'oeil Palladian villa, painted life-size in grisaille and placed at the end of the Grand Canal with real staircases leading up to it. Behind *The Perspective* was a pavilion with walls entirely covered by Lunéville faience in pink and green, which was used as a music room. The most fantastic feature of all was *Le Rocher* (1742), a miniature mountain village with working figures animated by waterpower that could be viewed from a terrace on one side. All of these garden decorations are known only through descriptions and suites of engravings, the most important of which is *Recueil des châteaux, jardins et dépendances que le roy de Pologne occupe en Lorraine* (1750). *See also* PLACE STANISLAS, NANCY.

**MARIE-ANTOINETTE (1755–93).** A Habsburg princess from **Austria**, Marie-Antoinette arrived at the court of **France** in 1770 to marry the future **Louis XVI**. She became queen of France in 1774, when her husband ascended to the throne. Numerous **paintings** of Marie-Antoinette exist and range from full-length, formal court **portraits** to more informal, half-length portrayals in the latest fashions. Many of her **dresses** in these portraits were designed by the celebrated *marchande de mode*, Rose Bertin. In her letters to her mother, Marie-Antoinette noted that she had great difficulty finding a painter who could properly capture her likeness. The artist that pleased her above all others was **Élisabeth Vigée Le Brun**, who portrayed the queen first and foremost as a fashionable **woman**. The most remarkable of her many portraits include *Marie-Antoinette en chemise* (1783, private collection) and *Marie-Antoinette with Her Children* (1787, Musée National du Château de Versailles, Paris). Both pictures were the subject of critical attacks at the **Salons** and contributed to her unpopularity with the public.

Marie-Antoinette helped advance the careers of **women** artists, including Vigée Le Brun and **Anne Vallayer-Coster**, intervening on their behalf with the **Académie Royale de Peinture et de Sculpture**. She took an active interest in the remodeling and extension of her private spaces at **Versailles**, most of which followed the latest tastes in interior and **garden design**. Her principal architect was **Richard Mique**, who worked in a delicate form of early **Neoclassicism**. The most famous result of her architectural **patronage**, however, is strongly connected to the playful spirit of the Rococo—the **Hameau de la Reine** in the gardens of the Petit Trianon. In many ways, this artificial rustic village is a three-dimensional realization of earlier Rococo pastorals by artists like **François Boucher**, inhabited by the queen as the principal figure. The *hameau* was part of a larger project involving the redesign and extension of the gardens of the Petit Trianon. **Hubert Robert** was brought in as the landscape advisor to Mique, the queen's official architect. From 1774, the gardens were replanted in the *anglo-chinois* style, complete with serpentine paths, a variety of *fabriques*, a grotto, and a hamlet, which included a dairy. Looked at individually, the pavilions are Neoclassical and

the layout of the gardens is English, while the hamlet continues French traditions that date back to the time of **Louis XV** and **Madame de Pompadour**. The overall result, however, is a space that combines a variety of fashions for the diversion of the queen and her intimates in a decidedly Rococo spirit of eclecticism, exclusivity, and pleasure.

**MARIETTE, PIERRE-JEAN (1694–1774).** Mariette was a prominent *amateur* and historian of art. His collection of drawings, which amounted to over 9,000 at the time of his death, included works by contemporary French artists, although the majority was by Italian masters. He came from a family of print dealers and engravers, and his father was the most revered print connoisseur of his day. Mariette developed friendships with artists and collectors, including **Rosalba Carriera, Carl Gustav Tessin**, and the **comte de Caylus**. He made copious notes on artists and had a particular interest in provenance, which was unusual at the time. It was his intention to use his personal notes to write a dictionary of artists and a history of engraving, although he did not complete these projects. He did, however, write the informative sale catalogs for **Pierre Crozat**'s collections. His notes were eventually published in six volumes as the *Abécédario de P.-J. Mariette* (1851–62). It is one of the most significant primary sources for the study of 18th-century art. *See also* FRANCE; PATRONS AND PATRONAGE; PORTUGAL.

**MARIGNY, MARQUIS DE (1727–81).** Abel-François Poisson de Vandières, the marquis de Marigny, was the brother of **Louis XV**'s official mistress, the **marquise de Pompadour**. At the tender age of 24, he became the *directeur général des bâtiments*, after the death of his sister's uncle by marriage, **Charles-François Lenormand de Tournehem**. During the period of Tournehem's administration, Marigny was well prepared for the post that he was set to inherit. His education included sessions at the **Académie Royale de Peinture et de Sculpture**, the study of art theory with **Charles-Antoine Coypel**, and a **grand tour** of **Italy** in 1749, accompanied by the Abbé Le Blanc, the architect **Jacques-Germain Soufflot**, and the engraver **Charles-Nicolas Cochin**. His companions were meant to instruct their young charge on matters related to culture, **architecture**, history, and the visual arts. On this trip, which lasted nearly two years, he developed an interest in antiquity, partly in response to the remarkable discoveries at Herculaneum, which captivated artistic circles in **Rome** at the time.

When Marigny took up the post of *directeur de bâtiments* in 1751, he was determined to continue the spirit of reform initiated by Tounehem's arts administration, although many of his plans were curtailed by the shortness of funds during the Seven Years War (1756–63). He had envisioned, for example,

a project whereby the Palais du Louvre would become the cultural center of **France**, housing a royal library, the royal art collection, and the academies. This idea was an important forerunner to the public museum that was finally realized at the Louvre during the French Revolution. Marigny did, however, oversee the completion of the Cour Carrée of the Louvre, which had been left unfinished since the time of **Jean-Baptiste Colbert**. Among the major architectural commissions extended by the **Bâtiments du Roi** under Marigny were Soufflot's designs for the church of Saint Geneviève (commenced in 1758, now the Panthéon) and **Ange-Jacques Gabriel**'s Place Louis XV (now the Place de la Concorde), both of which continue the classicizing tendency of public architecture in **Paris** since the time of Jules Hardouin-Mansart, albeit with a new **Neoclassical** emphasis. In **painting**, Marigny commissioned a series of topographical views of the *Ports of France* from **Joseph Vernet**. He also installed Cochin in a leadership role in the Académie Royale and continued to promote history painting through the rhetoric and administration of the institution.

As a private collector, Marigny patronized avant-garde artists, such as **Jean-Baptiste Greuze**, from whom he commissioned *L'accordée de village* (Musée du Louvre, Paris), which became a triumphant success at the Salon of 1761. In his own collecting practices and as *directeur des bâtiments*, he also promoted established artists who were strongly associated with the Rococo, namely **François Boucher**, whom he promoted to the positions of *premier peintre du roi* and director of the Académie Royale. Marigny retired from office in 1773 and was briefly succeeded by Joseph-Marie Terray, before the **comte d'Angiviller** took over as *directeur des bâtiments* under **Louis XVI**. *See also* PATRONS AND PATRONAGE.

**MEISSEN PORCELAIN.** The first European **porcelain** factory was founded in 1710 by Augustus the Strong, King of Poland and Elector of Saxony, in the German town of Meissen, northwest of Dresden. It was housed in the unused palace of Albrechtsburg, which provided an ideal site in which to guard the secret process of creating hard-paste, or "true" porcelain that had, up until this time, only been made in East Asia. The importation of luxury goods by the East India Company in the 17th century brought porcelain into European markets and introduced new tastes and habits related to the drinking of tea, coffee, and cocoa that stimulated demand for new objects, such as pots, cups, and bowls. Almost all the courts of Europe joined in the race to discover methods that would replicate, or even surpass, the quality of fine white porcelain from East Asia. Success came at last to the court of Augustus the Strong through the efforts of Johann Friedrich Böttger, a German chemist and inventor, who collaborated with natural scientists, mining experts, and craftsmen to produce Meissen hard-paste porcelain.

Goldsmiths, sculptors, and wood-carvers were employed at the factory to produce designs for the modeling of objects, while painters worked on the development of porcelain decoration involving special enamel colors. Although East Asian forms were copied, European tastes were accommodated through the adaptation of models taken from Rococo art. Flowers and other natural motifs were popular, and increasingly, elements from **paintings** by Rococo artists, such as **Antoine Watteau** and **François Boucher**, were incorporated into designs. The German sculptor **Balthasar Permoser** provided models for **commedia dell'arte** figures around 1710, an indication of the pan-European popularity of Rococo themes. Notwithstanding the artistic and decorative innovations of **Sèvres porcelain** in the third quarter of the 18th century, Meissen continued to be highly sought after by the most discerning of European collectors. *See also* GERMANY.

**MEISSONIER, JUSTE-AURÈLE (1675–1750).** According to 18th-century sources, Meissonier was one of the principal innovators of Rococo decorative forms during the reign of **Louis XV**. Looking back from 1774, the architect **Jacques-François Blondel** credited him, along with **Nicolas Pineau** and **Jacques de Lajoüe**, with the invention of the *genre pittoresque*, some 20 years after Cochin the Younger had attacked the style in the *Mercure de France*, blaming Meissonier for banishing symmetry and inventing "les contrastes." Meissonier initially worked as a goldsmith or silversmith, although none of his works of this type survives. It is known that he was employed by the **Gobelins** and became *dessinateur de la chambre et du cabinet du roi* in 1726, a position once held by **Jean Bérain**. In this post, he designed domestic objects and festival decorations for the crown. A candlestick designed by Meissonier and known through an engraving published in 1728 illustrates the central stylistic elements of his novel approach, which is based on variation, rather than likeness, with an insistence upon unbalanced and **asymmetrical** forms. For private clients, Meissonier executed projects for interiors; a famous example of which is the Cabinet Bielenski (1734, engraved c. 1742), exhibited at the Tuileries before it was dispatched to its patron, a grand marshal of **Poland**. The **interior decoration** of this room successfully blended **architecture, sculpture,** and **painting** to create a heightened sense of illusionism combined with visual distortion. **Ornamental** asymmetries dominate the framework, and **mirrors** fragment architectural features to emphasize their decorative qualities. During the artist's lifetime, his designs were circulated widely in the form of prints, many of which were published in folios by **Gabriel Huquier**. *See also* FRANCE.

**MELÉNDEZ, LUIS (1716–80).** Luis Meléndez is known for his magnificent still-life **paintings**. He was nephew to the court portraitist **Miguel Jacinto Meléndez** and son of Francisco Antonio, a miniature painter also attached to **Philip V of Spain**. His father, one of the founders of the Madrid academy, had a falling out with other members. On behalf of his father, Luis delivered a public denunciation of the school in 1748, which led to his exclusion from many royal circles of **patronage**. He did manage to study in **Italy** for five years, returning to Madrid in 1753, where he painted still lifes for the open market. *See also* SPAIN.

**MELÉNDEZ, MIGUEL JACINTO (1679–1734).** The son of a tailor from Oviedo, Miguel Jacinto was the oldest member of a family of artists working at the Spanish court during the 18th century. With his brother Francisco, who later specialized in miniature painting, he became an apprentice in the workshop of José Garía Hidalgo. At 33, after painting **portraits** of **Philip V**, his wife and his son, Miguel Jacinto, became attached to the court on an honorary basis, assuming the title of court painter but not the income attached to the position. It was not until 1727, nearly 15 years later, that he received the official court painter's salary. Miguel Jacinto painted over 20 portraits of Philip V, the first dating from 1707. In his early portraits of the king, he emphasized his characteristic Hapsburg traits (a prognathous jaw, aquiline nose, and large mouth), no doubt to portray the continuity between the **Bourbon** line and the previous dynasty. Later portraits were more balanced, although Hapsburg jowls seem to be a consistent facial feature. Miguel Jacinto's style synthesized Baroque and Rococo portrait traditions: his compositional arrangements of pose and drapery were inherited from Anthony van Dyck, while a lightness of touch, delicacy of line, and decorative detailing clearly suggest the influence of French artists, such as Jean Ranc, working at the Madrid court. His religious **paintings**, and some of his portraits of sitters outside court circles, reveal the perseverance of Spanish pictorial traditions from the 17th century, exhibiting a preference for austere **color** and formal simplicity, in spite of the influence of the French Rococo tastes at court. *See also* SPAIN.

**MÉNAGERIE DE VERSAILLES. Louis XIV** took a personal interest in the decorations of the Ménagerie, which he determined should be suitable for the young duchesse de Bourgogne, who had arrived at court in 1697, at the age of 12, to marry the king's grandson. The remodeling of the Ménagerie began in 1699, with the architect and current director of the **Bâtiments du Roi**, Jules Hardouin-Mansart, proposing painted decorations that included

figures representing female gods. Louis XIV, however, considered these subjects to be "too serious," proposing instead the incorporation of "some youthfulness" into the design. The king's command was that "Childhood should spread throughout." In response, **Claude III Audran**, assisted by **Alexandre-François Desportes** and working out of the **Menus Plaisirs du Roi**, developed **arabesques** with animal scenes. Although an early instance of the introduction of Rococo designs at **Versailles**, this is not evidence of a comprehensive shift in taste at the court of Louis XIV. Rather, the contemporary forms of **ornamental** decoration struck an appropriate relationship between the associations of the space and the tender age of its intended occupant. *See also* ARCHITECTURE; INTERIOR DECORATION; PATRONS AND PATRONAGE.

**MENUS PLAISIRS DU ROI.** The French Menus Plaisirs was an administrative department within the Maison du Roi that was responsible for organizing decorative programs for all court entertainments and ceremonies. There were as many as three intendants at any one time administering the Menus Plaisirs, who served the four *premiers gentilshommes de la chambre du roi*, all high-ranking noblemen, in rotation. The most well-known intendant was **Denis-Pierre-Jean Papillon de La Ferté**, who kept a journal detailing his activities during the second half of the 18th century. Painters, sculptors, architects, draftsmen, and set designers held official posts within the Menus Plaisirs, the most important of which was *dessinateur de la chambre et du cabinet du roi*, created in 1660. Significant decorative artists held this post in the 17th and 18th centuries, including Henry de Gissey, **Jean Bérain I**, Jean Bérain II, **Juste-Aurèle Meissonier**, and René-Michel Slodtz. Their innovations in **ornamentation** are credited with the genesis of forms associated with the Rococo style. *See also* FRANCE.

**MERCIER, PHILIP (C. 1689–1760).** A French painter active in London from 1720, Mercier introduced the **conversation piece** to English art with his *Party on a Terrace* (1725, Tate Collections, London), which was an informal group **portrait** of the Schutz family. He also developed some of the first **"fancy pictures"** in **England** while he was working in York during the 1740s. These paintings translated the **genre** subjects of **Jean-Baptiste-Siméon Chardin** and 17th-century Dutch painters into a local idiom. As with his other works, they were frequently engraved and proved influential in creating a taste for Rococo art in England. Mercier was principal painter to **Frederick, Prince of Wales**, between 1729 and 1736, the most significant **patron** associated with the English Rococo. In this role, he completed the *Music Party* (1733, National Portrait Gallery, London), a fashionable

**portrait** and **conversation piece** picturing the prince and his sisters with the Dutch House at **Kew** in the background. Mercier's impact on English art began as early as 1720, when he etched plates after his own designs and those of **Antoine Watteau** and David Teniers. Little is known about his early life, although it is likely that he was born in **Germany**, the son of a Huguenot tapestry-worker, and that he trained in Berlin under **Antoine Pesne.**

**MIQUE, RICHARD (1728–94).** The son of an architect who worked at the court of Stanislas Leszczynski, the deposed king of Poland and Grand Duke of Lorraine, Mique trained in **Paris** with **Jacques-François Blondel.** Upon his return to Lorraine, he became *architecte-ingénieur* under Emmanuel Héré and developed a close familiarity with the playful spirit of entertainment in the gardens at the Château de **Lunéville**, which included fanciful pavilions and a mechanical village. Mique's most notable work from his time in Lorraine, however, is the series of classicized *portes* of Saint Stanislas and Saint Catherine (1761) completed as part of the urbanizing schemes in Nancy. The Rococo ethos and Neoclassical forms coexisted easily in Mique's work. This is most evident in the many projects he completed for **Marie-Antoinette**, whom he served as principal architect from 1770. His work at the Château de **Versailles** included the redesign of the Queen's Apartments, the Théâtre de la Reine (1779–80), and the gardens and temples surrounding the Petit Trianon. Perhaps his most memorable achievement is the **Hameau de la Reine**, an **ornamental** farm and village that were designed for the amusement of Marie-Antoinette and her favorites. It became a symbol of the perceived frivolity of the French court at the end of the Old Regime. Mique created another hamlet at **Bellevue** (destroyed) for the aunts of **Louis XVI.** *See also* ARCHITECTURE; GARDEN DESIGN; POLAND.

**MIRRORS.** From the 16th century onward, mirrors set within **paneling** to create "mirror-rooms" faced with glass were a mark of distinction among elite **patrons** due to the high cost of this material. The Galerie des Glaces at **Versailles** is an elaborate example of such a room, meant to extend the grandeur of the **interior decoration** and to reflect the landscape gardens seen through the opposite windows. In contrast to this Baroque style, the use of mirrors in the Salon de la Princesse at the **Hôtel de Soubise** is more intimate in function. Due to the room's oval shape, the mirrors endlessly reflect the interior, enhancing views of the inhabitants' elegant gestures, bodies, and **dress**. Throughout most of the 1600s, **Venice** and the island of Murano monopolized export of mirror-glass throughout Europe, but the migration of Venetian glassworkers spread the secrets of glass-making techniques. In the second half of the century, the production of mirror-glass in **England** and

France was accelerated through the **patronage** of the Duke of Buckingham and **Louis XIV** respectively. Mirror-frames were also an integral part of decorative schemes in 18th-century interiors and in the 17th- and 18th-century Europe were generally made of wood and **ornamented** with carving, painting, or gilding. In addition to their decorative function, mirrors had a social value as well, something that was understood by contemporaries. The architect Charles-Antoine Daviler noted that mirrors enabled the viewer to check his appearance while at the same time observing others as they entered and exited the apartment.

**MONDON, JEAN (ACTIVE 1736–45).** Little is known about this French ornamental engraver. He produced several suites of engravings in 1736, the year that he is first mentioned in the *Mercure de France* as a "young man" and "sculptor of jewelry and precious metals." His *Premier livre de forme rocquaille et cartel* (1736) includes an early, if not the first, description of a formal category as "**rocaille**-like" and "**cartouche**-like." In *L'homme du monde éclairé par les arts* (1774), the architect **Jacques-François Blondel** included Mondon within a list of designers that he blamed for introducing a "bad taste in **ornamentation** and consequently in **architecture**," which clarifies the extent to which his suites of ornamental engravings influenced the stylistic direction of architecture during the Rococo period. *See also* FRANCE; HUET, CHRISTOPHE; HUQUIER, GABRIEL; OPPENORD, GILLES-MARIE.

# N

NAHL, JOHANN AUGUST (1710–81). Alongside **Georg Wenzeslaus von Knobelsdorff,** Nahl created the interiors and furnishings that define the **Frederican Rococo.** He trained as a sculptor with his father, Johann Samuel Nahl, who worked at the court of Frederick I in Berlin. At 18, he became a journeyman artist, traveling first to Berne and Strasbourg, then on to **Paris** in 1731 and to **Rome** in 1735. In Paris, he studied **ornament,** perhaps because he perceived the new importance of ornamental **sculpture** within contemporary interiors. His skills in this area were recognized by **Frederick the Great, King of Prussia,** who summoned Nahl to Berlin from Strasbourg where the artist had settled as a citizen and had been working for Cardinal Armand-Gaston de Rohan Soubise on the Palais Rohan. Nahl became *directeur des ornements* to Frederick and joined the decorative team that included Knobelsdorff and the **Hoppenhaupt brothers.** Nahl worked on interiors at Schloss Charlottenburg, the Berliner Schloss (destroyed), and, in Potsdam, at the Stadtschloss and **Schloss Sanssouci.** Nahl's designs for the Concert Room at Sanssouci are rich in their references to nature and garden pleasures, including trellises that form fantastic C-curves growing up from the corners of the ceiling. Nahl apparently found the working conditions at the court of Frederick the Great to be oppressive, and he returned to Strasbourg in 1746. For the next decade, Nahl worked in Berne on public and private commissions. As was somewhat typical of German Rococo artists, he turned his skills with ease from sculptural work and **interior decoration** to decorative objects and **architecture.** He created garden sculptures for Schloss Hindelbank (1748–52) and tombs for the church at Hindelbank (1750–52), produced models for ornamental gun decorations (1750) and a ceremonial goblet for the guild of carpenters (1752). Nahl also sketched designs for garden pavilions at Frischingshaus. In 1755, he moved to Kassel and entered the service of Landgrave William VIII, for whom he completed designs for the interior decoration of Schloss Wilhelmsthal (1755–61). In 1777, Nahl became the director of the Kassel Academy. *See also* GERMANY.

**NATOIRE, CHARLES-JOSEPH (1700–1777).** Natoire was one of the most successful French painters of his generation. In style and handling of subject matter, his paintings from the 1730s are paradigmatic Rococo images. He trained initially with his father, a sculptor, before entering the studios of academic history painters as an apprentice, first to Louis Galloche (1670–1761) and then to **François Lemoyne** (1688–1737). He won the *Prix de Rome* in 1721 with *Manoah Offering a Sacrifice to the Lord* (École Nationale Supérieure des Beaux Arts, Paris), which paid for his travel to the Académie de France in **Rome** two years later. Back in **Paris** by 1730, his career began to prosper. He received an important commission from **Philibert Orry**, the new *contrôleur général des finances* and soon-to-be *directeur général des bâtiments* and *vice protecteur* of the **Académie Royale de Peinture et de Sculpture**. Between 1731 and 1740, Natoire painted four series of paintings intended to decorate Orry's Château de La Chapelle-Godefroy in Saint-Aubin: nine canvases of the History of the Gods, the Four Seasons, six canvases of the Story of Clovis (Musée des Beaux Arts, Troyes), and six more of the Story of Telemachus. The themes of the latter two series were unusual for this period in taking subjects from French national history and literature, demonstrating the sophisticated taste of the **patron** and the artist's capacity for invention.

In 1734, Natoire was received as a full member of the Académie Royale with his *Venus Demanding Arms from Vulcan for Aeneas* (c. 1732–34, Musée Fabre, Montpellier), a painting that epitomizes the Rococo at this particular moment in its history. Natoire's choice of mythological subject matter focuses on the power of love and seduction, rather than on valor or the heroic deeds of men. In style, the painting refuses the representational logic of three-dimensional space, instead displaying the figures in vertical orientation, with compositional lines generated through limbs, gestures, and expressions. The eye is led by these lines around the surface of the canvas to enjoy the painterly handling of flesh and the visual seduction of **color** and brushwork. Natoire received numerous commissions during the 1730s and 1740s for works to decorate the royal châteaux of **Versailles**, Marly, and **Fontainebleau**, as well as designs for **tapestry** cartoons at the **Gobelins** and **Beauvais** manufactories, including a series of scenes from *Don Quixote* by Cervantes (Château de Compiègne), once again taking subject matter from a 17th-century "modern" novel, rather than a classical text. Perhaps the best indication of Natoire's status at this moment as the leading French history painter working within *le goût moderne* was the commission he received to supply eight canvases to fill the spandrels of the Salon Ovale de la Princesse at the **Hôtel de Soubise** (1737–39). His rivals **François Boucher** and **Carle van Loo** also received commissions from the Prince de Soubise for his new *hôtel particulier*, which

was being transformed in the latest style by the architect **Germain Boffrand**, but Natoire was asked to decorate the most significant room with scenes from the *Story of Psyche*. Natoire collaborated with Boffrand to design compositions that would echo the curves created by their sculpted frames. The result is a seamless correspondence between the components of **interior decoration**, which flow into one and undulate around the oval room.

Natoire spent the last 25 years of his career as the director of the Académie de France in Rome, a position to which he was appointed in 1751. He was influential in this role, encouraging young artists, such as **Jean-Honoré Fragonard** and **Hubert Robert**, to draw in nature and to develop a taste for picturesque landscapes. His own masterful drawings in this genre were often highly finished works, such as *Gardens of the Villa d'Este at Tivoli* (1760, Metropolitan Museum of Art, New York), and composed with a combination of pen and brown ink, brown and gray wash, watercolor, and heightened with white, black, and red chalk. Such drawings signaled a new direction for the development of landscapes and garden scenes in the hands of third-generation Rococo artists.

**NATTIER, JEAN-MARC (1685–1766).** Nattier was a fashionable **portrait** painter, popular at court for his idealized manner of portraying **women** with mythological attributes that enhanced their femininity and beauty. He trained with his godfather, Jean Jouvenet, and attended drawing classes at the **Académie Royale de Peinture et de Sculpture**, where he excelled as a draftsman. Although offered a place at the Académie de France in **Rome**, Nattier decided to remain in **Paris** and build his career as a portraitist. In 1717, he was received into the Académie Royale as a history painter, but he continued to specialize in portraiture. That same year, Nattier traveled to **Holland**, where he painted portraits of Peter I the Great of Russia and the Empress Catherine (Hermitage Museum, Saint Petersburg). These conventional portraits pleased the tsar so much that he offered Nattier a position at the **Russian** court, which the artist declined. It was not until 15 years later that he began to develop a reputation within French court society. In 1733, he painted *Mademoiselle de Clermont "en sultane"* (Wallace Collection, London), a portrait that broke with Baroque portraiture formats to present the sitter as a fashionable woman of taste through contemporary references to exotic *turquerie* and a Rococo treatment of space. The use of guise, whether exotic or mythological, allowed Nattier to present his noble sitters in various stages of undress without violating decorum. While the face resembled the sitter, the body was regarded allegorically.

Nattier continued to develop this idealized treatment of female sitters, which reached a climax of popularity in the 1740s, when he was

commissioned to paint the daughters of **Louis XV** to decorate the queen's apartments at **Versailles**: *Henriette of France as Flora* and *Marie Adélaïde of France as Diana* (1743 and 1745, both Galleria degli Uffizi, Florence). Nattier's success with these paintings brought him further commissions on behalf of the queen, including a relaxed portrait of *Marie Leczinska* (1748, Musée National du Château de Versailles, Paris) where she is represented elegantly dressed reading the bible, as if surprised by the viewer in a private, contemplative moment. Such a treatment was innovative in its informal, almost personal representation of the queen of France. Nattier continued to enjoy favor with the royal family during the 1750s, when he completed a series of large state portraits of the Daughters of France in which Louis XV's children are shown pursuing leisure activities, such as music, in *Madame Henriette*, once again adapting formal portraiture conventions inherited from the Baroque to the growing taste for naturalistic modes of portrayal that revealed something of the character of the sitter. *See also* PAINTING.

**NEOCLASSICISM.** Around 1750, critics of the decorative and sensual qualities of Rococo art and architectural **ornamentation** called for a return to classical forms and themes. Recent excavations at Herculaneum and Pompeii, which began in 1738, brought increased attention to ancient art forms. Antiquarian scholars like the **comte de Caylus** took a more rigorous approach to understanding and documenting the past. In addition to the production of prints that systematically recorded the archeological findings at excavation sites in **Italy** and beyond, increased exposure to ancient art through collecting practices and **grand tour** itineraries that extended to Greece awakened interest in the artistic principles of ancient cultures. Distinctions were made between ancient Greek and Roman art that gave rise to new theoretical debates concerning issues of imitation and emulation.

The most influential Neoclassical theorist was Johann Joachim Winckelmann, a German antiquarian, who argued in his *Reflections on the Painting and Sculpture of the Greeks* (1765) that the art of the ancients should be studied to grasp its core **aesthetic** features but not slavishly copied. Winckelmann's association with the German painter Anton Raphael Mengs in **Rome** inspired a visual manifesto of Neoclassical ideals in the ceiling fresco of *Parnassus with Apollo and the Muses* (1761), which Mengs painted for the Villa Albani. British and **American** painters, such as Benjamin West, revived interest in classical history and literature as themes for contemporary painting, while French artists studying at the Académie de France were increasingly urged by administrative officials and their teachers to study the antique. For the international gathering of artists and connoisseurs studying in Rome, the solemnity and purity of classical forms observed in antique **sculpture** and

buildings represented an alternative to the extravagances of the Baroque and the **ornamental** approach of the Rococo.

In France, during the third quarter of the 18th century, three successive directors of the **Bâtiments du Roi**—Lenormand de Tournehem, the **marquis de Marigny**, and the **comte d'Angiviller**—encouraged a return to classical models through the institutional structures of the **Académie Royale de Peinture et de Sculpture**. Artists who competed for the *Prix de Rome* trained at the École Royale des Élèves Protégés, studied at the Académie de France in Rome, and were pushed toward previous models of **Classicism** found in ancient, Renaissance, and 17th-century art. The artistic output of Nicolas Poussin was once again celebrated as an example to follow.

**Joseph-Marie Vien** was one of the first French painters to respond directly to the classical revival. His painting *The Cupid Seller* (1763, Fontainebleau) was derived from an engraving of a recently excavated Roman wall painting at Herculaneum. Vien gained a reputation for works that satisfied both scholarly and fashionable interests in antiquity and attracted the **patronage** of the comte de Caylus and the king's mistress, **Madame du Barry**. In the 1770s, Vien's paintings replaced a series of canvases that Du Barry had commissioned from **Jean-Honoré Fragonard** to decorate her garden pavilion at **Louveciennes**. This infamous rejection of Fragonard's major decorative cycle is often considered to mark the ultimate demise of the Rococo. Vien's delicate handling of the classical revival, however, was far more in keeping with the geometric purity of the building designed by the Neoclassical architect **Claude-Nicolas Ledoux**. Whether or not the rejection is indicative of a full and complete dismissal of the Rococo as a style in court circles or something of a fashionable whim on the part of a powerful patron, it is clear that Neoclassicism was on the rise.

Far more significant to the official and public perception of Neoclassicism as the predominant artistic style of the late 18th century was the enthusiastic reaction of critics and **Salon** audiences to the works exhibited by **Jacques-Louis David** in the 1780s. The classical revival had been embraced and promoted by **Louis XVI**'s arts administration. Under the direction of d'Angiviller, Neoclassicism became part of a reformist agenda aimed at reestablishing royal authority in matters of taste, not only in court circles but also in the public realm. Neoclassicism is, however, less commonly associated with the reign of Louis XVI than it is with the French Revolution of 1789 and the decades that followed. David's studio became the primary training ground for young French artists well into the 19th century, and it was there that the term *Rococo* is said to have been first coined as a derogation of court art and **architecture** under **Louis XV**. *See also* ADAM, ROBERT; DIDEROT, DENIS; FRANCE; INTERIOR DECORATION; PAINTING.

**THE NETHERLANDS.** In the late 17th century, following the revocation of the Edict of Nantes in **France**, many Huguenot craftsmen immigrated to Holland, where they were welcomed by the Stadholder Willliam of Orange. These French Protestant refugees brought with them superior skills in the decorative arts, especially in carving and chasing, and knowledge of the latest French designs. The presence of these immigrant artisans in the Netherlands contributed to the development of Rococo design during the first half of the 18th century, particularly at the court of William IV and Anne of Hanover at the Hague. Both William and Anne had connections with two major **patrons** of Rococo art, **Frederick the Great** (William's cousin), and **Frederick, Prince of Wales** (Anne's brother). These relationships may have contributed to their interest in the Rococo as an expression of royal status and political allegiance. In Amsterdam, which was culturally distinct from The Hague, wealthy merchants and burghers were attracted to the high-quality craftsmanship of Rococo design in decorative objects and **furniture**. **Jacob de Wit** was the most important Dutch painter to embrace the Rococo. Working in Antwerp and Amsterdam, he became known for his painted imitations of **stucco** reliefs that were enjoyed for their visual trickery. *See also* GERSAINT, EDME-FRANÇOIS; NYMPHENBURG; PELLEGRINI, GIOVANNI ANTONIO.

**NEUMANN, BALTHASAR (1687–1753).** Arguably the most creative architect of the Rococo period, Neumann's achievements have been accurately described as experiments in molding space. His preferred forms were ovals and curves, and he had a flair for orchestrating spatial progressions through which visitors were led from darkness into light. He was based in Würzburg, where he maintained a drawing office and taught at the university (from 1732), with practical sessions held in his workshop. His primary **patrons** were members of the Schönborn family, which included a number of German prince-bishops who used building as an expression of their magnificence. Neumann designed both churches and palaces and was engaged by the city of Würzburg to develop building regulations largely aimed at improving the visual appeal and architectural coherence of the town. He later became the superintendent of all civic and ecclesiastical building for Würzburg, Bamberg, and Trier.

Neumann was the son of clothiers from Eger. He trained in canon and bell founding with his uncle, moving to Würzburg in 1712, where he joined the Franconian artillery and continued his studies, which eventually led him into civil engineering and **architecture**, with commissions coming from the Schönborn family as early as 1715. When Johann Philipp Franz von Schönborn was elected prince-bishop of Würzburg in 1719, he commissioned Neumann to rebuild a palace inside the city that would serve as his administrative

and ceremonial headquarters, transferred from the Marienberg fortress on the outskirts of town as an assertion of absolutist authority. Neumann advised that the palace, which was so badly constructed that it had never been occupied, be razed and a vast new complex be constructed in its place.

**Würzburg Residenz** occupied Neumann as supervising architect for most of his career. The exterior shell was completed by 1744, while work on the interiors began in the late 1730s and continued for over a decade. The Residenz was a collaborative project, typical of the German Rococo, with many architects, painters, sculptors, and **stuccoists** contributing to the overall design. In addition to acting as project supervisor and coordinating the efforts of various artists, Neumann was responsible for the major interiors, which include the Hofkirche (1740–43), the Treppenhaus (1737–50), and the Kaisersaal (completed 1753) with vaulted frescoes by **Giambattista Tiepolo** and his son.

The play of geometric forms and the orchestration of movement in these spaces are characteristic of Neumann's approach to architecture, with a continual variation of effects on the visitor. The monumental staircase, for example, turns and returns, revealing different aspects of the building and creating alternating spatial sensations as one moves upward into the vaulted space of the stairwell, which is surrounded by a gallery from which to view Tiepolo's frescoed allegory of the four continents paying homage to the prince-bishop. Moving into the Kaisersaal, the decorative effects are almost overwhelming in their opulence but balanced and enhanced by the arched windows and circular lunettes that bring light into the room and highlight the curvilinear treatment of space.

Neumann had a remarkable talent for inventively solving complex architectural problems. At Schloss Brüchsal (destroyed 1945, reconstructed in the 1960s), he worked for Damian Hugo von Schönborn, Prince-Bishop of Speyer, replacing Anselm F. Ritter zu Groenesteyn during the late 1720s as architect in charge of the project, after the patron decided to insert a mezzanine level between the main and ground floors. Ritter zu Groenesteyn had already laid the foundations for a circular staircase and was unable to modify his designs to accommodate the extra height needed for the mezzanine. Neumann developed an ingenious solution, which involved a complex sequence of spaces extending from the vestibule with three openings along the far side. The visitor was thus presented with options: to progress through the central opening, which led to a dim oval-shaped vaulted room painted to resemble a grotto with trompe l'oeil rocks, and then out onto gardens; or through either of the side openings into the Treppenhaus, seeing the arms of the circular staircase rising between curved walls that included a series of arcades and circular openings on the inside. This curvilinear play with space is one of great masterpieces of Rococo interior design.

In addition to his work on various palaces for the Schönborns, Neumann was prolific in his designs for altars and churches, the most famous of which is **Vierzehnheiligen** (begun 1742), a pilgrimage church dedicated to 14 helper saints near Banz in Franconia. As with many of Neumann's buildings, the design was not completely his own. Although the prince-bishop accepted Neumann's design, the abbot insisted that another architect, Johann Jakob Michael Küchel, remain involved in the construction. Neumann's final design placed a curvilinear interior within a rectilinear outer shell, with a series of ovals and circles linking together to make up a modified Latin cross floor plan. As with many of Neumann's buildings, masses and walls are cut into and reduced to a shell, which provides multiple surfaces for decoration. *See also* AMALIENBURG PAVILION; BAVARIAN ROCOCO; CUVILLIÉS, FRANÇOIS DE, I; GERMANY; INTERIOR DECORATION; ZIMMERMANN BROTHERS.

**NYMPHENBURG.** Schloss Nymphenburg, west of Munich, was the summer residence of the Bavarian electors and is most closely associated with the architectural **patronage** of the Wittelsbach family. Built in the mid-17th century as an Italianate villa, the main palace was expanded in 1701 under the elector Maximilian II Emanuel, whose artistic tastes and patronage reflected his political aspirations. As governor of the Spanish **Netherlands** from 1691, Netherlandish architectural influences, particularly the hunting lodge at Het Loo, directed his initial stylistic choices at Schloss Nymphenburg. Building work, however, was interrupted by the War of Spanish Succession, which forced Maximilian II Emanuel into exile between 1704 and 1715. For most of this period, he remained in **France**, where he became increasingly captivated by the splendor of **Versailles**.

When Maximilian II Emanuel was restored as elector of Bavaria and returned to Munich, he once again turned his attention to the enlargement of Schloss Nymphenburg, which he placed under the direction of his chief architect, **Joseph Effner**. The most significant Rococo features of the palace are located in the **gardens**, which were modified in 1715 by the Parisian landscape architect Dominique Girard. Four pavilions were constructed for leisure activities. Effner designed the "Chinese"-style Pagodenburg, the Badenburg, which was inspired by Turkish bathhouses, and the artificial ruins of the Magdalenenklause, while **François de Cuvilliés** created **Amalienburg**, one of the earliest and most important Rococo buildings in Europe. The decoration of these pavilions was driven by the elector's desire to follow the latest fashions, which included Dutch tiles, imported **porcelain**, and lacquerware from East Asia and the innovative elaboration of **rocaille** designs as three-dimensional **stuccowork** by artists such as **Johann Baptist Zimmermann**.

A porcelain factory was established at Nymphenburg in the middle of the 18th century and encouraged by the patronage of the elector Maximilian III Joseph. It became one of the most important German manufactories of Rococo porcelain, second only to **Meissen** and known for its productions of lively figures modeled by Franz Anton Bustelli (c. 1723–63). Bustelli, who was trained as a wood-carver, successfully translated the sculptural innovations of the **Bavarian Rococo** into porcelain form. His paired **commedia dell'arte** figures (1759–60) are endowed with a sense of vitality and movement, which was matched in his cycles of Chinese and Turkish figurines produced as table designs. *See also* ARCHITECTURE; CHINOISERIE; GERMANY; INTERIOR DECORATION.

# O

**OPPENORD, GILLES-MARIE (1672–1742).** The leading architect and interior designer of the Regency period (1715–23), Oppenord exerted an enormous influence over the development of the Rococo style. His early years were spent in **Italy**, under the protection of the *surintendant des bâtiments*, the marquis de Villacerf, who funded Oppenord's travel to **Rome** in 1692 and arranged for a two-year attachment to the Académie de France. Oppenord then became a *pensionnaire* at the academy and remained in Rome until 1699, where he immersed himself in the study of High Renaissance and Baroque buildings and **architectural** details. When he returned to **Paris**, his protector Villacerf had been replaced in his post by Jules Hardouin-Mansart, who did not offer Oppenord a position within the **Bâtiments du Roi**. Oppenord consequently remained excluded from official court **patronage** for 15 years.

By 1714, however, he was employed by wealthy financiers and received his first known commission for an interior at the Hôtel de Pomponne from the *reçeveur général*, Michel Bonnier. It seems likely that he was already working for the regent, **Philippe II, duc d'Orléans**, at this point, as he was appointed to the post of *premier architecte* prior to the beginning of the Regency in 1715. Oppenord's designs for chimney panels (Cooper-Hewitt, National Design Museum, New York) and surviving portions of the **paneling** for the dining room of the Hôtel de Pomponne (Musée des Arts Décoratifs, Paris) demonstrate the extent to which the bourgeoisie emulated the stylistic modes and thematic conventions of the nobility. Oppenord's debts to **Claude III Audran**, **Jean Bérain**, and **Alexandre-François Desportes** are evident in the **trophies** of the chase on the paneling, which merge innovative decorative schemes with Desportes' naturalistic **paintings** of animals.

In 1715, when the seat of the Regency was installed at the **Palais Royal** in Paris, Oppenord became involved in the building's numerous renovations. These alterations aimed to maintain suitable traditions of grandeur within ceremonial spaces, while at the same time introducing new curvilinear forms and **arabesques**. Although the exterior of the Palais Royal remained unchanged, the interiors were significantly transformed. One dramatic change

was Oppenord's reconstruction of the end wall of the Galerie d'Enée, which had been initially completed by Mansart in 1692 and decorated by **Antoine Coypel**. Oppenord altered the room to terminate in an oval hemicycle heavily **ornamented** with paneling, with Corinthian pilasters, and sculpted decoration framing a central fireplace and a mirrored mantel, which breaks through the entablature (1716, reproduced in **Jacques-François Blondel**'s *Cours d'architecture*, 1771–77). The Salon d'Angle (1719–20) was equally dramatic, although here Oppenord accomplished a greater fluidity of form by giving the room an elliptical shape cantilevered over the street below (preliminary design, Cooper Hewitt, National Design Museum, New York). The delicacy of the Rococo is found in Oppenord's designs for the Grands Appartements (1720), in which arabesque paneling and **asymmetrical** frameworks dominate in the mantels.

In addition to his work for the regent and the Orléans family, Oppenord received a number of commissions from private patrons who employed him to renovate their châteaux and *hôtels particuliers*. For the collector **Pierre Crozat** he remodeled a gallery in the Hôtel Crozat and designed an orangery at the Château de Montmorency during the 1720s and 1730s. Outside of **France**, he worked for the Elector Clemens Augustus at **Brühl** and Bonn (c. 1715–17), as well as providing designs for garden urns to **Philip V of Spain** for the palace of **La Granja de San Ildefonso**. At the end of Oppenord's life and after his death, the engraver **Gabriel Huquier** published his ornamental drawings and architectural designs. As many of Oppenord's interiors are lost, these prints provide important visual evidence of the *style régence* at its peak. *See also* INTERIOR DECORATION.

## ORLÉANS, PHILIPPE II, DUC DE CHARTRES ET D' (1674–1723).

Nephew of **Louis XIV** and son of the king's brother Philippe I and his second wife Elisabeth-Charlotte, Philippe II was an avid **patron** of the arts with extensive collections of **paintings**, medals, and gems. He contributed significantly to the urban development of **Paris** by swiftly moving the court from **Versailles** back to the city upon his installation as regent to the five-year-old **Louis XV** in 1715, and initiating substantial refurbishments of the **Palais Royal**. With a royal presence once again in the capital, a building boom ensued, focused on the construction of grand *hôtels particuliers* — the **Hôtel de Soubise** being just one prominent example. While still the duc de Chartres, Philippe II became protector of the artist **Antoine Coypel** and may have arranged his access to the works by Peter Paul Rubens in the collection of the duc de Richelieu in the 1690s. Coypel's exposure to Rubens's Medici cycle promoted a reconsideration of the Flemish artist within the context of the **color**/line debates. It is likely that Philippe II studied **painting** and

drawing with Coypel and developed, during this time, an *amateur* interest in decoration. After the death of his father in 1701, Philippe II became the duc d'Orléans. Soon thereafter, he commissioned Coypel to paint the Galerie d'Enée in the Palais Royal (1703–5; destroyed 1781). The young **Germain Boffrand** also worked for the duc d'Orléans during this period, as did **Gilles-Marie Oppenord**, who became his chief architect and designer. Oppenord's interior renovations of the Palais Royal, which extended to the design of furnishings and wall decorations, represent the culmination of a set of stylistic concerns that would become known as the *style régence*.

**ORNAMENTATION AND ORNAMENTALISTS.** Ornamentation refers to nonstructural forms of surface decoration used to embellish objects and interiors. Rococo ornamentation involved elaborate **grotesque** and **arabesque** patterns, which were first developed around 1700 as designs for **ceilings, paneling,** and **chimneypieces** used in **interior decoration** at the satellite of courts surrounding **Versailles**. From its beginnings, Rococo ornamentation blended artificial and naturalistic forms. Interlacing patterns of scrolling C- and S-curves, **bandwork,** and **palmettes** were strung together with caryatids and *espagnolettes* to form a framework that was occupied by putti, mythological, and exotic figures. As the *genre pittoresque* developed around 1730, Rococo ornamentation expanded its repertory to include asymmetrical **rocaille cartouches,** pastoral figures and motifs, and identifiable flowers and birds known in Europe and East Asia. *Singeries*, **chinoiseries,** and *turqueries* were invented as specific thematic variants. Rococo ornamentation was applied to all types of surfaces, not only in interiors, where it was used in delicately carved **boiseries, stucco and plasterwork,** and painting on walls and ceilings, but also in the decorative arts, for use on **furniture, tapestries,** and other luxury objects.

The Rococo artists who specialized in the design and execution of surface decoration for architectural interiors are often referred to as **ornamentalists.** These painters and sculptors took a leading role in the creation of the Rococo in **France** during the last decade of the 17th century and the first decades of the 18th century. **Claude III Audran, Jean Bérain,** Pierre Lepautre, and **François-Antoine Vassé** were among the most innovative ornamentalists and developed reputations for their novel forms of grotesque and arabesque ornamentation. Their **patrons** came from the highest ranks of the nobility, a fact that has led art historians to draw connections between the emergence of the Rococo and the distinctive aristocratic tastes of princes of the blood. It is also notable that none of these artists studied in **Italy**. As a result, their works were liberated in some respects from the dominance of Italian decorative models inherited from the Renaissance, which appeared in the Grand Manner interiors associated with Charles Le Brun.

A second generation of Rococo ornamentalists followed, which included **Nicolas Pineau, Juste-Aurèle Meissonier,** and **Jacques de Lajoüe.** These artists contributed to development of the *genre pittoresque*, which evolved from earlier arabesque surface decorations but is characterized by even more fanciful forms, a richness and variety of motifs, and **asymmetry** of design. Suites of their ornaments were engraved and published, publicized in the *Mercure de France*, and circulated throughout Europe. The ornamentalist's approach to surface decoration sought to fuse architectural elements with ornament, treating walls, **doors**, windows, chimneypieces, and ceilings as an organic whole. This was achieved to great effect in the **Bavarian Rococo,** which materialized in three-dimensional form the fantasies of French ornamental prints.

**ORRY, PHILIBERT (1689–1747).** A noble of the robe of bourgeois family origins, Orry became *contrôleur-général des finances* of **France** under **Louis XV** in 1730. He was appointed *directeur des bâtiments* and *vice protecteur* of the **Académie Royale de Peinture et de Sculpture** in 1737, posts that he held until 1745. While funds for arts expenditure were limited under Orry's directorship of the **Bâtiments du Roi**, he succeeded in establishing the biennial **Salons** in which members of the Académie Royale exhibited their works. His personal taste was expressed by his commission of the painter **Charles-Joseph Natoire** to decorate his Château de La Chapelle-Godefroy in 1730. *See also* PATRONS AND PATRONAGE.

**OSUNA, MARÍA JOSEFA DE LA SOLEDAD ALONSO PIMENTAL, DUQUESA DE (1752–1834).** The Duchess of Osuna and her husband, the ninth Duke of Osuna (1755–1807) were prominent noble collectors at the Spanish court of **Charles III**, known for their enlightened tastes. As with the **Albas**, the couple's **patronage** seems to have been largely driven by the interests of the duchess, who modeled herself as an enlightened woman after the example of Parisian *salonnières*, such as **Marie-Thérèse Geoffrin**, and as a fashionable **woman** after **Marie-Antoinette**, and was captured by **Francisco de Goya** in this way in his **portraits** of the duchess. The Osunas were patrons to a number of contemporary Spanish artists, including **Antonio Carnicero**, but their favorite painter was Goya, from whom they began to commission works in 1785 and continued to support for the next three decades. In addition to numerous portraits, including *The Duke and Duchess of Osuna with Their Children* (c. 1788, Museo del Prado, Madrid), Goya painted more unusual works depicting folkish scenes of witchcraft, such as the *Witches' Sabbath* (1789, Museo Lázaro Galdiano, Madrid) to decorate their Palacio de Alameda near Madrid. In the late 1790s, the Osunas purchased first edi-

tions of Goya's *Caprichios*, an example of their continued openness to more subversive forms of imagery emerging from social, political, and religious critiques of **Enlightenment** thought. *See also* SPAIN.

**OUDRY, JEAN-BAPTISTE (1686–1755).** Oudry is best known as an animal painter, although he initially trained as a portraitist in the studio of Nicolas de Largillière. This training facilitated Oudry's sophisticated translation of formal conventions used in figure **painting**, such as dramatic pose and gestures, into his treatment of animal subjects, particularly those of hunting dogs and exotic prey. He was received into the **Académie Royale de Peinture et de Sculpture** as a history painter in 1719, but he did not pursue this genre. Instead, he began to specialize in still lifes and hunting scenes, which became an increasingly popular subgenre during the second quarter of the 18th century, not only because **Louis XV** was an avid hunter but also because the chase was encoded with associations linked to the feudal rights of the nobility, attracting financiers and those recently ennobled to the theme.

Oudry began to receive royal commissions in the mid-1720s and was given lodgings and use of a studio in the Tuileries. The subjects were primarily **portraits** of royal dogs, which formed a series of overdoors for Louis XV's apartments at **Compiègne**. During a period when the **Salons** were irregular events, Oudry's protector, Louis Fagon, the *intendant des finances*, arranged exhibitions of his works at **Versailles**. Oudry had worked for Fagon in the early 1720s, completing decorative panels for the Château de Voré that featured **arabesques**, *singeries*, **commedia dell'arte** characters, and *fête galante* themes (1720–23, Musée du Louvre, Paris). In 1728, Oudry was commissioned by the king to paint *Louis XV Hunting the Stag in the Forest of Saint-Germain* (Musée des Augustins, Toulouse), which became famous in court circles during the 18th century as it was continuously on view in the Cabinet du Roi at Marly.

Oudry became director of the royal **tapestry** works at **Beauvais** in 1734, again owing to Fagon's interventions. He had been active as a designer of tapestry cartoons since the 1720s, executing several successful designs for tapestry sets that featured the *Comedies of Molière*, *Ovid's Metamorphoses*, and the *Fables of La Fontaine*. He also supplied designs to the **Gobelins** during this period, receiving a commission in 1733 for a series of *Royal Hunts of Louis XV* (the final painting for this series was delivered in 1746). Oudry was also a prolific draftsman, completing 275 drawings for an illustrated edition of La Fontaine's Fables (1729–34, published in 1755). He regularly sketched exotic animals in the **Ménagerie de Versailles** and made over 100 drawings of the overgrown park at the Château d'Arcueil in the mid-1740s. These drawings are remarkable for their interest in the tensions between art

and nature, which contributed to the development of a picturesque landscape **aesthetic** during the Rococo period. Oudry exhibited regularly at the Salons and often received critical acclaim for his works, such as *The Bitch-Hound Nursing Her Pups* (exhibited at the Salon of 1753, Musée de la Chasse et de la Nature, Paris), a painting that successfully blends maternal sentiment with a scene of nature. *See also* FRANCE; PATRONS AND PATRONAGE.

# P

**PAINTING.** Rococo easel painting is primarily characterized by sinuous line, the decorative and **asymmetrical** ordering of compositional structure, and distortions of visual space. It typically employs a light palette and exploits the material properties of paint and the sensual nature of **color**. More than a set of stylistic criteria, however, Rococo painting significantly reinvented conventions of subject matter and forms of spectatorship. In its pursuit of light-hearted themes of love and sociability, it revised the role of art in society, promoting visual pleasure over public edification. Moreover, its major practitioners, such as **Antoine Watteau**, **François Boucher**, and **Jean-Honoré Fragonard**, deployed subject matter and painterly style to engage the viewer in an open-ended, imaginative, and playful form of spectatorship.

Rococo painting developed out of the idiom of **rocaille** decorative forms and **ornament** employed within **interior decoration**. The earliest instances of rocaille forms and motifs in painted decoration can be found in designs for **ceilings** and ornamental **paneling**, which incorporate **grotesques**, **arabesques**, and a diverse range of naturalistic and fanciful motifs. The ornamentalist **Claude III Audran** produced richly colored arabesque designs for ceilings of this type at a number of royal French châteaux that he redecorated during the last decades of **Louis XIV**'s reign. Ornamentalists belonged to the guild of artists and artisans known as the **Académie de Saint-Luc**, which was associated with the production of decorative objects and luxury goods, rather than the "high" art of painting, the more prestigious province of the **Académie Royale de Peinture et de Sculpture**.

Many artists of the early Rococo period, however, moved easily between easel painting and decorative work. Antoine Watteau, arguably the first and most important Rococo painter, assisted Audran with major decorative projects and appears to have only turned to the Académie Royale for membership when he found it difficult to break into circles of aristocratic **patronage** as an **ornamental** painter. In his easel paintings, Watteau applied the rhythms and motifs of rocaille decoration to his images of men and **women** socializing in park-like landscapes. De-emphasizing narrative meaning and highlighting the evocative effects of color, light, and sinuous line, his paintings transposed

ornamental form into figural painting. The *fête galante*, a subject Watteau is credited with inventing, largely developed out of his use of rocaille decorative elements and culminated in his reception piece for the Académie Royale, *Pilgrimage to the Island of Cythera* (1717, Musée du Louvre, Paris).

Audran also collaborated with **Nicolas Lancret**, another prominent *fête galante* painter, and trained a number of first-generation Rococo painters in his studio, including **François Desportes, Jean-Baptiste Oudry**, and **Christophe Huet**. All of these artists were innovators, pursuing novel subject categories that altered the direction of French painting toward contemporary scenes of sociability and courtship, **childhood** and play, hunt and animal pictures, among other themes. Moreover, the influence of arabesque decorative forms can be seen in the figural poses and compositional structures of early Rococo painting, not only those of Watteau and his generation but also in the work of artists who followed.

By the 1730s, Rococo forms and themes had thoroughly invaded academic history painting in **France**, presenting a significant challenge to the inherited traditions of biblical and mythological painting. Instead of didactic, allegorical subject matter treated in a style that promoted narrative clarity, the most prominent painters of the period took up mythological subjects that allowed for mildly erotic imagery enhanced through the painterly handling of brushwork and a seductive use of color. The theoretical justification for this shift away from the formal conventions of 17th-century **Classicism** can be found within the color/line debates of the 1670s.

Writing around 1700, the *amateur* academician **Roger de Piles** stressed that the affective qualities of painting stemmed from its unique properties as a visual medium originating in brushwork and color. Paintings by **François Boucher, Charles-Joseph Natoire**, and **Carle van Loo** are connected to de Piles' theories through their partial rejection of line and linear perspective and the associated Renaissance ideal that painting should be a window onto a more perfectly ordered world. By contrast, Rococo painting flattened pictorial space to emphasize the decorative handling of composition and form, sinuous line, and sensuous color and, thus, heightened visual pleasure. Fragonard, who belongs to the last generation of Rococo painters, took up this approach in his most successful paintings. His *Happy Hazards of the Swing* (1767, Wallace Collection, London) is an icon of the Rococo for its appeal to the senses and use of encoded motifs that delight through an interpretive play with meanings. In Fragonard's work, the process of viewing Rococo painting is made creative and open-ended, activating the spectator's imagination.

Subject matter was an equally important area of innovation within Rococo painting. Engaging directly with the experience of modern life, artists devised subjects that blended fantasy with reality. Among the new subcategories of

**genre**, **portraiture**, and landscape painting invented by Rococo painters were *fêtes galantes* in France, **fancy pictures** and **conversation pieces** in England, and *vedute* and *capricci* in **Venice** and **Rome**. **William Hogarth**'s "modern moral subjects" and **Jean-Baptiste Greuze**'s "bourgeois dramas" are difficult to classify except as genre scenes, which hardly does justice to their originality. More established subject categories were also reinvented during the Rococo period. **Giambattista Tiepolo** extended the allegorical fresco traditions of the Baroque to blend unprecedented naturalism into a heightened level of illusionism. In portraiture, contemporary ideas of fashionability and a growing interest in the portrayal of personal character and identity replaced the traditional emphasis on likeness, status, and social position. Leading portraitists of the day included **Rosalba Carriera, Jean-Marc Nattier, Thomas Gainsborough, Sir Joshua Reynolds**, and **Francisco de Goya**, although few of these artists restricted themselves to this genre. More experimental essays in this mode were the "fantasy" portraits by Fragonard and the portraits of children at play by **Jean-Baptiste-Siméon Chardin**, which explored the boundaries of portraiture as a category.

Landscape painting, although a relatively new genre in this period, was nonetheless informed by strong conventions inherited from the 16th and 17th centuries that promoted the compositional reordering of nature according to artistic ideals. Rococo pastorals, however, rejected these traditions to embrace a highly artificial conception of nature that owed little to the natural world. Boucher's pastorals, in fact, were more closely connected to contemporary theater productions than to earlier landscape painting. When Rococo artists did turn their attention to nature, they based their images on direct observation gained by drawing *en plein air*. This practice informed the picturesque landscapes of **Hubert Robert**, Fragonard, and Gainsborough, as well as the view pictures of **Canaletto, Bernardo Bellotto**, and **Francesco Guardi**. Ruins also captivated Rococo painters and stimulated the production of architectural fantasies by **Giovanni Paolo Panini** and **Giovanni Battista Piranesi**, among others. Clearly, Rococo painters and their audiences valued variation and novelty above adherence to traditional subject categories and conventions.

While most Rococo paintings were made on commission, artists were increasingly able to sell finished works on the open market. In **Paris**, artists were able to attract prospective patrons and collectors at the **Salons**. Other countries lacked these sorts of official public exhibitions until later in the century, but there were new opportunities for the wider public to experience contemporary art across Europe. Artists' studios were progressively opened to less established collectors and patrons, not only in **Venice** and **Rome**, where visitors on the **grand tour** sought out souvenirs of their travels in the form

of landscapes and portraits, but also in **Bath**, where it became fashionable to have one's portrait painted during the season. Gainsborough and **Pompeo Batoni**, in particular, capitalized on these markets.

Additional exposure to wider audiences, however, also subjected Rococo painters to the opinions of art critics who claimed to speak on behalf of the public. **La Font de Saint-Yenne** and **Denis Diderot** were among the men of letters who circulated their writings about art and **aesthetics** through pamphlets and subscribed newsletters. The anti-Rococo reaction was fueled by this type of writing, in which critics lamented the lack of serious history painting and called for a return to classical principles as the foundation of art making. Moreover, discoveries at Pompeii and Herculaneum encouraged the fashionableness of the antique. This shift in taste is marked by the infamous rejection of Fragonard's Pursuit of Love series delivered to **Madame du Barry** for her garden pavilion at **Louveciennes** and their quick replacement with **Joseph-Marie Vien**'s Progress of Love paintings in the *goût grec*. [AQ4]

By the mid 1770s, Rococo painting was in decline, and **Neoclassicism** was rapidly becoming the predominant style of the late 18th century. **Jacques-Louis David**'s revolutionary works, exhibited in the Salons of the 1780s, were everything the Rococo was not, from their grand historical narrative subjects to the geometric clarity of their compositions and precise handling of form. Yet it would take the political disruptions of the Revolution of 1789 to finally end the taste for Rococo painting in France. Vestiges of the Rococo can be seen to vie with stylistic tendencies of Neoclassicism for at least the next two decades in other parts of Europe, not only in the work of artists connected to courts in which the Rococo was still an official taste, as for **Francisco de Goya** in Madrid, but also for French artists in exile, such as **Élisabeth Vigée Le Brun**, who continued to prosper as a portraitist in **Italy** and **Russia** without dramatically changing her style. See also COYPEL, CHARLES-ANTOINE; GILLOT, CLAUDE; KAUFFMAN, ANGELICA; LABILLE-GUIARD, ADÉLAÏDE; LEMOYNE, FRANÇOIS; PATER, JEAN-BAPTISTE; PESNE, ANTOINE; REAL ACADEMIA DE BELLAS ARTES DE SAN FERNANDO; SAINT MARTIN'S LANE ACADEMY; TROY, JEAN-FRANÇOIS DE; VERNET, JOSEPH.

**PALACIO REAL DE MADRID.** Also known as the Alcázar, the Palacio Real became the official residence of the king of **Spain** once Philip II moved his court to Madrid in 1561. The Antiguo Alcázar, built in the late 16th century, was destroyed by a fire in 1734. On the orders of **Philip V**, the new Palacio Real was built in the same location in 1738, from initial designs provided by **Filippo Juvarra** in 1735, which were modified extensively by his suc-

cessor, Giovanni Battista Sacchetti, between 1736 and 1760 and finally completed by Francesco Sabatini, who was brought from Naples by **Charles III**. Originally conceived by Juvarra as a vast Baroque palace that would surpass **Versailles** in **architectural** grandeur and scale, Sacchetti provided **Neoclassical** designs with an emphasis on cubic volumes and harmonizing horizontal and vertical forms. Whereas Juvarra envisioned a three-story palace built around numerous courtyards with vertical emphasis provided on the garden facade by the rhythmic succession of 79 bays, Sacchetti retained the plan of the 16th-century Alcázar, which was conceived around a single courtyard. He raised the height of the design but tempered its verticality by reducing the facade to 21 bays. Nevertheless, the facade undulates in typically Baroque *a-b-a-b-a* fashion, with the center and two ends of the building projecting from flat recesses in between. To suit the grandeur of the royal family, Sacchetti extended the palace grounds by planning a further 25 buildings to the east and two massive courtyards to the south, closed in by a cathedral. Despite the splendor of the palace complex, the imposing site retained the impression of a military fortress and is far more in keeping with Castilian alcazars than **Bourbon** châteaux.

**PALAIS ROYAL.** The Palais Royal was the de facto seat of the French court under the regent, **Philippe II, duc d'Orléans**, between 1715 and 1723. Philippe I had initiated extensions to the Palais Royal, in the form of a new gallery, prior to his death in 1701. His son completed the decoration of the gallery by commissioning a scheme dedicated to the story of Aeneas from **Antoine Coypel**. The Galerie d'Enée was completed between 1702 and 1703, although it was destroyed late in the 18th century. In addition to the completion of the gallery, Philippe II continued to expand and refurbish the Palais Royal, largely under the direction of his first architect, **Gilles-Marie Oppenord**. The decorative forms of the interiors and the furnishings that he designed established the visual vocabulary of the *style régence*. Interiors from the Palais Royal were engraved and published by **Gabriel Huquier** in the *Grand Oppenord* (c. 1748), further disseminating the early Rococo style associated with the Regency period. As Oppenord's renovations have been dismantled or destroyed, these engravings provide the most significant visual record of his work at the Palais Royal. *See also* INTERIOR DECORATION; PARIS.

**PALMETTES AND PALMS.** These **ornamental** motifs were used in **architecture**, decorative arts, and other media within larger schemes of Rococo **interior decoration**. Stylized in form, they resemble palm leaves or fan-shaped flowers. While primarily employed as part of pleasing decoration,

palms and palmettes have ancient associations with ideas of creative power, regeneration, and the underlying order within natural forms.

**PANELING.** In French interiors, walls were characteristically paneled in wood, as opposed to the plaster and frescoes common in **Italy**. By the second half of the 17th century, paneling the whole height of the room, often in several tiers, came into favor. Typically, the panels were rectangular in shape and richly sculpted, painted, and gilded. Early examples were carefully ordered through geometry, such as those by Louis Le Vau and Charles Le Brun in the Salle à Manger at Vaux-le-Vicomte (1660). By the first decade of the 18th century, paneling became the principal decorative feature of Rococo interiors through the dominance of **ornamentation**, both sculpted and painted, which eroded a sense of classical order by breaking down, interrupting, or overlapping geometrical lines. The French word *boiserie* is often used to describe wood paneling from the period that is decorated with shallow relief carvings that employ foliage, **arabesques**, **grotesques**, and other ornamented compositions. *See also* INTERIOR DECORATION; PINEAU, NICOLAS.

**PANINI, GIOVANNI PAOLO (1691–1765).** The Italian painter Panini is best known for his Roman *vedute*, or view paintings, which were heavily in demand with **grand tourists**. Panini's *vedute* were inventive rather than strictly programmatic. He depicted a variety of subjects, including topographical views, architectural fantasies, ceremonies and festivals, imagined galleries, and ruined monuments. In certain images, his views of contemporary events treat spaces and their occupants as interrelated objects of **ornamentation**, as in *Musical Fête* (1747, Musée du Louvre, Paris). His imaginary museums, such as the pendants *Gallery Views of Ancient Rome* and *Gallery Views of Modern Rome* (1748–49, Musée du Louvre, Paris), feature *vedute* as a fertile source of artistic inspiration and provide a witty commentary on the idea of **Rome** as a living museum. In addition to his easel **paintings**, Panini was an accomplished painter of decorative frescos, which involved complex spatial illusionism and allegorical themes. The best surviving example is his decoration of the Villa Montalto Grazioli in Frascati (c. 1720–c.1730). Panini influenced a number of artists working in Rome, including **Giovanni Battista Piranesi** and **Hubert Robert**, who trained for a time in his workshop. *See also* PAINTING.

**PAPILLON DE LA FERTÉ, DENIS-PIERRE-JEAN (1727–94).** Papillon de La Ferté became one of three intendants of the **Menus Plaisirs du Roi** in 1756 and then sole intendant from 1763 onward. In this office, he administered the department responsible for organizing all court festivities

and ceremonies. This involved supervision of the design and production of works of art, pieces of **furniture**, stage sets, fireworks, ephemeral **architecture**, and prints, as well as the management of music and theatrical performances. During his administration, he also brought the Comédie Française and the **Comédie Italienne** more closely under the management of the Menus Plaisirs. He kept a journal documenting the workings of the Menus, which provides insight into the development of a modern arts administrator, capable of managing large budgets, actively engaging in design projects, and supporting artists. Papillon de La Ferté was also an amateur draftsman and engraver. He produced over 500 designs for costumes and entertainments and engraved landscapes after **François Boucher**. He also purchased art for his own collection. In his posthumous sale, 318 items were listed, most of which were works by French and Dutch painters. Although he survived the first few years of the Revolution, he was executed in 1793 during the Terror. *See also* FRANCE; PATRONS AND PATRONAGE.

**PARET Y ALCÁZAR, LUIS (1746–99).** The Spanish painter Paret combined native traditions with imported French tastes to create distinctive images of the Spanish Rococo. He studied with **Antonio González Velázquez** and Charles de La Traverse, before traveling to **Italy** to continue his training between 1763 and 1766, returning for a second stay between 1767 and 1771. Paret's principal **patron** in these years was don Luis de Borbón, the brother of **Charles III**, to whom he was appointed court painter in 1775. For don Luis, Paret painted some of his most successful scenes of everyday life, including *The Draper's Shop* (1773, Museo Lázaro, Madrid), which has been compared with *Gersaint's Shopsign* by **Antoine Watteau** (1720, Schloss Charlottenburg, Berlin). In this work, Paret's painterly approach is evident in his treatment of luxurious silks and his delight in the play of curvilinear line. His figures, however, lack the refined elegance of those by Watteau and suggest a closer connection with those of **Pietro Longhi** in **Venice**. Paret was exiled to Puerto Rico for four years in the late 1770s, as the result of amorous court intrigues involving don Luis. Upon his return, he settled in Bilbao between 1779 and 1787, where he received a royal commission to paint the ports of the Cantabrian coast. This series is comparable to **Joseph Vernet**'s paintings of the ports of **France** commissioned under **Louis XV**. Paret's ports are decidedly less meticulous and descriptive than those by Vernet, demonstrating instead the virtuosity of his brushwork in the landscape backgrounds and buildings. Paret's paintings are among the finest examples of Spanish Rococo painting in their masterful handling of **color** and brushwork and are considerably darker in palette when compared to French Rococo works. *See also* SPAIN.

**PARIS.** The development of Rococo art and **architecture** contributed to the perception of Paris as a city of taste and refinement, which it maintains in the present day. While **Louis XIV** showed little interest in the city, concerning himself instead with the building of **Versailles** as his seat of government and an enduring symbol of his magnificence, the production of art, decorative objects, and other luxury goods took place in and around Paris. From the beginning of the 17th century, new manufactories were sponsored by the crown to serve the purposes of mercantile policies that sought to offset the need for foreign imports. Under Louis XIV and his chief minister of finance and cultural policy, **Jean-Baptiste Colbert**, royal support of arts manufactories and institutions increasingly centralized artistic production within the city of Paris, all with the aim of better serving the king's immediate needs and perpetual glory. Artists and artisans from the provinces were drawn to the city for the opportunities it presented in terms of training, **patronage**, and professional advancement. Acting on behalf of the king, the office of the **Bâtiments du Roi** administered all public building in Paris. As director of the Bâtiments at the turn of the century, Jules Hardouin-Mansart actively sought to maintain the uniformity of classical exteriors, not only in Paris but also in the building of the king's châteaux. It has been proposed that this external stylistic control contributed to the Rococo's initial development as an interior mode of architectural decoration, rather than an exterior architectural style.

Upon Louis XIV's death, his nephew, **Philippe II, duc d'Orléans**, became regent during the minority of **Louis XV** and moved the court back to Paris. As a result, a building boom ensued in the capital city, as the nobility and other high-ranking officials set up residence to be near the new center of government and social life at the **Palais Royal**. Louis XV's court was installed at the nearby Tuileries Palace. The regent appointed **Gilles-Marie Oppenord** as his *premier architecte*, signaling an official shift of taste to the *goût moderne*. Many existing *hôtels particuliers* were remodeled and refurbished in the latest decorative style, which embraced emerging forms of Rococo **ornamentation**. The Hôtels de l'**Arsenal** and de Soubise were expanded and redesigned by **Germain Boffrand**, while **Robert de Cotte** was at work on the Hôtels du Lude, d'Éstrees, and du Maine. The **Hôtel de Soubise** is a quintessential example of the new taste, with a magnificent two-story pavilion designed by Boffrand and decoration supplied by **Charles-Joseph Natoire, François Boucher**, and **Carle van Loo**, the leading Rococo painters and sculptors of the day.

Louis XV returned his court to Versailles when he reached the age of his majority in 1723. Nevertheless, Paris continued to thrive as the principal city of **France** and received the crown's attention as an important space in which

to assert the king's presence. A number of urbanization projects were initiated under Louis XV, including the Place Louis XV (from 1748, now the Place de La Concorde), clearing the front of the Louvre Colonnade (from 1759), the École Militaire (1751–68), and the churches of Saint-Sulpice (facade from 1726) and Sainte-Geneviève (from 1757). **Ange-Jacques Gabriel** and **Jacques-Germain Soufflot** were among the architects directing these projects. Boffrand, the other leading architect of the era, was occupied with urban design projects for the square around Notre-Dame and Les Halles. As public buildings, the exterior architecture of these spaces maintained continuity with the past through the predominance of classical form.

Between the reigns of Louis XIV and **Louis XVI**, the population of Paris doubled to over 800,000 and was accommodated by urban expansion to the north and east. Private development was prompted by a rise in property values, providing new investment opportunities that were seized by speculators, who included members of the nobility, wealthy financiers, and leading architects. Paris became a thriving city of commerce, as well as a cosmopolitan center of artistic culture and intellectual life. Discussions of art, beauty, and **aesthetics** became a focus of conversations at the literary and artistic salons held in the private homes of elite Parisians, including **Pierre Crozat** and **Madame Geoffrin**, where artists mixed with patrons, *amateurs*, and men of letters.

Trade in luxury goods and fashion was taken up as an elite diversion, perhaps best pictured in **Antoine Watteau**'s *Gersaint's Shopsign*. Men like **Edme-François Gersaint** and **Pierre-Jean Mariette** assumed important roles as mediators between collectors and contemporary artists. They were followed by increasingly professional expert art dealers, who emerged with the creation of international art markets that focused on the expansion of auction sales and public exhibitions in Paris. Sale catalogs became new sources of detailed information for local and foreign collectors alike, as did reviews of the **Salons** and other exhibitions written by critics and published in pamphlets, newsletters circulated by subscription, and notices in the *Mercure de France*.

The official Salons of the **Académie Royale de Peinture et de Sculpture** were the first regular and publicly accessible exhibitions of art in Europe, and as such, they garnered a great deal of international attention. These biennial events lasted about a month and took place in the Salon Carré of the Louvre, where the Académie Royale was housed and many members were granted studio space. It was common for patrons to visit artists in these studios and to view works that were both finished and in progress. **Women** artists were prohibited from holding these workshops, something that **Adélaïde Labille-Guiard** petitioned against in the late 1780s.

Alternative exhibition venues existed for much of the 18th century. Art works of varying quality was displayed for sale at the **Foire de Saint-Germain and the Foire de Saint-Laurent**, held on the outskirts of Paris. The lively environment of these fairs, which included performances by acrobats and **commedia dell'arte** actors, provided inspiration for motifs and figures that were included in *fêtes galantes* and early Rococo decorative **panels**. The Exposition de la Jeunesse was an annual exhibition for young artists. It was held outdoors during the feast of Corpus Christi in the Place Dauphine and on the Pont Neuf. Before the Salons became regular in 1737, members of the Académie Royale also exhibited there, including **Nicolas Lancret, Jean-Baptiste Oudry, Jean-Baptiste-Siméon Chardin, Jean-Marc Nattier**, and **François Boucher**. As the number of places for women artists in the Académie Royale was limited to four members at any one time, the Exposition de la Jeunesse was the primary venue for the display of works by women. **Élisabeth Vigée Le Brun, Anne Vallayer-Coster**, and Labille-Guiard all exhibited there prior to their approval as members. The guild, which became known as the **Académie de Saint-Luc**, had its own exhibitions from 1751 until it was suppressed in 1776. In 1779, the Salon de la Correspondance was opened by Pahin Champlain de La Blancherie, specifically as a rival exhibition to the official Salons at the Louvre. It was welcomed by artists who, for one reason or another, no longer wanted to participate in the activities of the Académie Royale: **Jean-Honoré Fragonard** and **Jean-Baptiste Greuze**. This venture was short lived, however, and disbanded in 1783. Following on the success of these various exhibitions, plans were laid for a public art museum to be located in the Louvre and sponsored by the king, although the Revolution of 1789 interrupted the execution of these plans. *See also* INTERIOR DECORATION; MENUS PLAISIRS DU ROI; PAINTING; SAINT-AUBIN, GABRIEL DE; SCULPTURE.

**PARTERRES.** In **garden design**, this term of French origin refers to formal terraces evenly planted into **ornamental** patterns, often using varieties of *Buxus*, or box hedge. Early examples of parterres incorporating both **bandwork** and natural motifs are found in Claude Mollet's *Théâtre des plans et jardinages* (1652) and **Jacques Boyceau**'s *Traité du jardinage* (1638). Often described as *parterres en broderie*, a strong formal connection exists between French designs for garden parterres and embroideries during this period, the general manner of which prefigures the **arabesques** of Rococo art.

**PATER, JEAN-BAPTISTE (1695–1736).** The only student of **Antoine Watteau**, Pater specialized in the painting of *fêtes galantes*. Like his master, Pater came from Valenciennes, where Watteau may have trained briefly with

his father, the sculptor Antoine Pater. Although Watteau did not maintain a workshop with apprentices, it was natural for Pater to seek him out upon his arrival in **Paris** around 1710. Watteau did not take easily to the master-student relationship, however, and Pater was soon dismissed. It is likely, however, that Watteau maintained contact with Pater, providing introductions to dealers and collectors for whom Pater began to work in 1718, including **Edme-François Gersaint** and Jean de Julienne. In the last few months of his life, Watteau recalled Pater to work with him at Nogent, outside of Paris. According to Pater, these weeks provided him with formative training in Watteau's style.

When Pater was received into the **Académie Royale de Peinture et de Sculpture** in 1728, it was as a painter of *fêtes galantes*, the genre established for Watteau. Pater's repertoire of **genre** subjects included village fairs and gatherings of elegant figures in parks, often accompanied by musicians and actors. *Fair at Bezons* (c. 1733, Metropolitan Museum of Art, New York) is one of his most sophisticated works, with complex figural groups set within a picturesque landscape. Pater used **color** along with subtleties of gesture and pose to guide the visual experience. His paintings were well represented in the collection of **Frederick the Great of Prussia**, who owned at least 40. Pater also worked for **Louis XV** and painted a *Chinese Hunt* (Musée Picardie, Amiens) as part of a series of exotic hunt scenes hanging in the Petits Appartements at **Versailles** alongside works by **François Boucher, Nicolas Lancret**, and **Carle van Loo**. *See also* PAINTING.

**PATRONS AND PATRONAGE.** The processes of patronage contributed as much to the development of Rococo art and design as the artists, architects, and craftsmen responsible for its production. At the beginning of the 18th century, artists worked almost entirely on commission, at court or in the permanent employ of high-ranking noblemen. There were few opportunities to exhibit works of art for sale on the open market. Academy exhibitions in **Italy** and **France** during the 17th and first half of the 18th century mostly included works that were already owned by individual collectors and patrons. In addition to promoting the interests of the academic institutions, these exhibitions were largely directed at attracting future patrons. Sketches for decorative projects were often included for this purpose, as well as to flatter the patron and promote the reputation of grand projects.

From the later 16th century onward, in **Venice**, there were important public displays of paintings in the Piazza San Marco on Ascension Day. By the 18th century, these were more commercial in purpose and exhibited works for sale. This practice was paralleled in **Paris** by the annual display of works at the **Foire de Saint-Laurent and the Foire de Saint-Germain**, commercial

events lasting several months with boutiques selling valuable art objects. Works were also displayed for sale in the permanent shops of art dealers, such as that of **Edme-François Gersaint**, depicted by **Antoine Watteau** in his famous *Gersaint's Shopsign* (1720, Schloss Charlottenburg, Berlin). During the second half of the 18th century, artists were increasingly able to work outside of traditional patronage systems. Nevertheless, patrons exerted enormous influence over the development of Rococo decoration around 1700, and later in the century, sophisticated *amateurs* continued to promote the careers of Rococo artists by focusing their collecting practices on contemporary art.

In **France**, the genesis of Rococo decoration can be dated to the last decades of **Louis XIV**'s reign, when **grotesques** and **arabesques** were embraced by high-ranking members of the nobility as unconventional forms of **ornamentation**, distinguishing their tastes as avant-garde, although much of it was produced by artists working within the king's administrative offices of the **Bâtiments du Roi** and the **Menus Plaisirs**. Nevertheless, the evolution of the French Rococo is strongly associated with patrons who sought out novelty, in opposition to the inherited artistic conventions of academic **Classicism** associated with the authority of Louis XIV and the **Académie Royale de Peinture et de Sculpture**. Upon the death of Louis XIV, his nephew, **Philippe II, duc d'Orléans**, became regent during the minority of **Louis XV**. His appointment of **Gilles-Marie Oppenord** as *premier architecte* at the start of the Regency marked an official change of taste that encouraged the further development of the Rococo in **architecture** and **interior decoration**.

During the Regency period, art became a matter of social discourse. Patrons, artists, and connoisseurs gathered together in private residences, forming unofficial academies in which debates about art theory took place and important contacts were formed. The most famous of these gatherings in the first decades of the 18th century were held at the Parisian *hôtel particulier* and country house of **Pierre Crozat**, a wealthy financier, avid collector, and friend to major artists of the early Rococo period, including **Antoine Watteau**. Crozat also played host to foreign artists and collectors passing through Paris, such as **Rosalba Carriera** and **Antonio Pellegrini**. His patronage of contemporary artists encouraged the spread of the Rococo as an international rather than purely French style among private collectors and connoisseurs.

The French Rococo reached its apogee under the patronage of Louis XV, although as a style, it is more strongly associated with the tastes of his official mistress, the **marquise de Pompadour**. While Pompadour's personal patronage was somewhat limited, all official commissions at court and in Paris were conducted through the office of the Bâtiments, which was directed sequentially by her uncle, **Lenormand de Tournehem**, and her brother, the **marquis de Marigny**. This allowed Pompadour and her family to exert an

enormous amount of influence on matters of taste. Officially, however, the Bâtiments responded to the growing anti-Rococo reaction, but in their private patronage, this family of bourgeois origins embraced the Rococo as a sign of aristocratic status and their positions at court. In addition to royal support, the most sophisticated private patrons of the period were *amateurs*, many of whom began to form collections of contemporary French art. **La Live de Jully**, **Grimod de La Reynière**, and the **comte d'Artois** are among the collectors who actively promoted the careers of contemporary French artists in this way and contributed to the perception of the Rococo as an unofficial style of the French school, much lamented by art critics at the time.

In the wider context of European art, national variations on the French Rococo are also associated with the tastes of individual rulers and ruling families. In Southern **Germany** and Central Europe, the rise of the **Bavarian Rococo** is directly linked to commissions from members of the Wittelsbach and Schönborn families, while the **Frederican Rococo** is the product of the personal preferences of **Frederick the Great**, who often executed sketches for designs that he passed onto his architects and decorative teams for development and realization. The existence of a "Spanish" Rococo is debatable, but the preference for Rococo art in **Spain** is intimately linked to the patronage of the newly installed **Bourbon** kings, who brought French tastes to Spanish courts. **Philip V** imported French artists and craftsmen working in the latest Rococo style to his court in Madrid, which significantly impacted upon local traditions. By the time **Charles III** assumed the throne, Rococo forms and themes had become part of the official style at court. **Francisco de Goya** consciously adopted elements of the Rococo to please his patrons, both in the **tapestry** cartoons he designed to decorate royal palaces and in his works for private patrons, such as the **Duchess of Alba** and the **Duchess of Osuna**. While **Venice** lacked the same level of direct patronage of Rococo art, prominent Venetians, such as **Francesco Algarotti**, encouraged the spread of the Rococo through his circles of international contacts and his service to rulers as artistic agent and advisor. **England**, too, had a royal patron of the Rococo in **Frederick, Prince of Wales**, who some consider to have embraced the style as a sign of political opposition to the rule of his father, George II.

**PELLEGRINI, GIOVANNI ANTONIO (1675–1741).** Pellegrini was a Venetian decorative painter who traveled widely and worked for a number of foreign **patrons** and courts. He was one of the first artists working in a Rococo manner in **England**, where he moved in 1708 with Marco Ricci to work as a scene painter for operas sponsored by Charles Montagu, the future Duke of Manchester. He remained in London until 1713 and was employed

by different members of the Whig nobility to decorate their houses, including Kimbolton Castle—the Duke of Manchester's country seat—and Castle Howard in Yorkshire for the third Earl of Carlisle. Most of Pellegrini's English interiors have been altered and the paintings destroyed, but George Vertue, one of Pellegrini's contemporaries who knew these decorations, noted both the quickness of his brush and the fruitfulness of his invention. The delightful trompe l'oeil effects and exotic figures on the staircase decorations at Kimbolton Castle survive and suggest the extent to which Pellegrini's work anticipated that of **Giambattista Tiepolo**. Pellegrini also sold easel paintings while in England and became one of the directors of Sir Godfrey Kneller's Queen Street Academy, which was an important forerunner of **William Hogarth**'s **Saint Martin's Lane Academy** and the Royal Academy of Arts.

When he left England, Pellegrini traveled widely. He worked for the Elector Palatine Johann Wilhelm in Düsseldorf, painting a decorative cycle in the Bensberg Castle (1713–14, reinstalled in a gallery of Castle Schleissheim), before moving to Flanders and later, **Holland**. He returned briefly to London in 1719 before going to **Paris**, where he painted a **ceiling** for the Banque Royale. While in Paris, he was hosted by **Pierre Crozat**, as was his sister-in-law, **Rosalba Carriera**. The Venetian colorists were widely celebrated in the artistic circle of Crozat, which included the *amateur* **Pierre-Jean Mariette**, the **comte de Caylus**, and **Antoine Watteau**. Pellegrini returned to Venice in 1721, but by 1722, he was at work in the courts of **Würzburg**, Vienna, Dresden, Prague, and Mannheim. Pellegrini was the most widely traveled of all Venetian painters during the 18th century and was influential in the international development of Rococo modes of decoration. *See also* VENICE.

**PERMOSER, BALTHASAR (1651–1732).** Permoser was a German **sculptor** working in a style that transitioned between the late Baroque and early Rococo periods. He spent his early career in the sculptural workshops serving the Medici grand dukes in Florence, before accepting an invitation to work at the elector of Saxony's court in Dresden. His most significant and memorable sculptures are connected with the **Zwinger** built for Augustus the Strong. Permoser completed all the sculptural designs, which were executed by the master and his workshop assistants. The satyr herms of the central Wallpavilion are by Permoser's own hand and are exceptional for their superlative carving of individualized expressions and **ornamental grotesques**. He worked closely with the architect in charge of the project, Mattahäus Daniel Pöppelmann, to achieve one of the wittiest spaces of the early 18th century. Permoser also collaborated with the court jeweler, Johann Melchior Dinglinger, to create small-scale decorative pieces with exotic themes, such as the *Moor with Emerald Plate* (1724, Grünes Gewöble, Dresden). An ex-

ample of his interest in themes taken up by contemporary Rococo artists is the series of models for **commedia dell'arte** figures (c. 1710) that he supplied to Augustus's **porcelain** manufactory at **Meissen**. *See also* GERMANY.

**PERRAULT, CHARLES (1628–1703).** Perrault was a historian and writer on the arts, serving **Louis XIV** in this capacity, initially as a protégé of **Jean-Baptiste Colbert**. He was a member of the Académie Française and held administrative positions in the **Bâtiments du Roi** and the Petite Académie, a council charged with overseeing royal propaganda. Perrault's significance in relation to the development of Rococo art stems from his promotion of the French school of **painting** and his role in the **quarrel of the ancients and the moderns**. In arguing for the "modern" side of the debate, Perrault celebrated the achievements of contemporary French artists over those of Italian masters and the artists of antiquity. He put forward this position in several texts, the most significant for the plastic arts appearing in the first volume of the *Parallèles des anciens et des modernes en ce qui concerne les arts et les sciences* (1688-97) and *Le cabinet des beaux-arts* (1690). In relation to the parallel **color**/line debates in the **Académie Royale de Peinture et de Sculpture**, Perrault's celebration of the French school included praise for several contemporary "colorists," including **Antoine Coypel**, yet was not at the expense of prominent artists from the previous generation, such as Charles Le Brun. His primary aim was to glorify French civilization and the reign of **Louis XIV**, rather than to assert stylistic criteria. *See also* FRANCE.

**PESNE, ANTOINE (1683–1757).** The French-born painter Antoine Pesne served at the Prussian court of **Frederick the Great**, and his work represents a significant link between the French and **Frederican Rococo**. The great-nephew of the academician Charles de La Fosse, Pesne studied at the **Académie Royale de Peinture et de Sculpture** and the Académie de France in **Rome** during the first decade of the 18th century. He attracted the attention of the then king of Prussia, Frederick I, with a **portrait** he painted of a German nobleman while in **Venice** and was invited to work at the Prussian court in Berlin. After the king's death in 1713, he worked at the courts of Dresden and Dessau, later visiting London and **Paris**, where he was received into the Académie Royale as a full member in 1720. While in Paris, Pesne painted the portrait of the prominent collector and print connoisseur **Pierre-Jean Mariette** (1723, Musée Carnavalet, Paris), who had significant international connections with artists and **patrons**.

Pesne's French credentials and his previous service at the Prussian court in Berlin would have piqued the interest of Frederick II, recently returned from exile and reinstated as crown-prince at the Prussian seat of Rheinsberg,

the cradle of the Frederican Rococo. As the future Frederick the Great was already collecting works by *fête galante* painters, such as **Antoine Watteau** and **Nicolas Lancret,** Pesne began to assimilate this style into his own work after he returned to the Prussian court. The figures he contributed to a collaborative **painting** made with **Georg Wenzeslaus von Knobelsdorff** of the *Schloss Rheinsberg* (1737, Schloss Charlottenburg, Berlin) are in this manner. Most of his decorative work at Rheinsberg and later at Berlin and Potsdam, however, took up allegorical and mythological themes, an example of which is the **ceiling** he painted for the audience room at **Sanssouci** with the subject *Zephyr Crowns Flora* (1747, in situ).

Although his talents were not as distinguished as those of Watteau or Lancret, Pesne was not a slavish imitator. Many of his portraits adapt French modes of portrayal with pleasing results, such as *The Dancer Barbara Campanini* (c. 1745, Schloss Charlottenburg, Berlin), which employs principles of complement and contrast in the pose and architectural setting to accentuate the charms of his sitter, a famous dancer from **Venice**. It was originally installed behind Frederick's desk in his study at Schloss Charlottenburg, a fitting expression of the enlightened monarch's refined tastes in the arts. *See also* GERMANY.

**PETERHOF.** The summer residence of the Russian tsar was initially built under Peter the Great and expanded by Empress Elizabeth. Both **patrons** were heavily influenced by French models in their building preferences. Although largely Baroque in style, with its monumental château and vast formal gardens, Rococo elements exist in the decoration of the interiors and intimate scale of the garden pavilions. The overall result is a combination of **architectural** forms that signal the imperial status of the principal inhabitant and its private function as a space of intimate retreat. The French architect Alexandre-Jean-Baptiste Le Blond, who had trained with Jean Lepautre in **Paris** and was known for his decorative interiors, supplied the initial designs (1714–23) for the main palace, the gardens, and the pavilion of Monplaisir, situated in the Lower Garden for the tsar's exclusive use. Le Blond had been brought by Peter the Great to serve as general architect in Saint Petersburg. When Le Blond traveled to **Russia**, he was accompanied by the **ornamentalist, Nicolas Pineau,** who was responsible for many of the interiors at Peterhof. Pineau designed oak **paneling** in an early Rococo style for the tsar's study (in situ). Other pavilions in the Lower Park were also given French names, the Marly Palace (1721–24) and the Ermitage (1721–26).

**PHILIP V (1683–1746).** The grandson of **Louis XIV,** Philippe d'Anjou became the first **Bourbon** king of **Spain,** acceding to the throne in 1700

as Philip V. He brought French court tastes with him to Madrid when he arrived in 1701. His **patronage**, however, was not exclusively directed to French artists. Italian architects and decorative painters were equally favored, as were the young Spanish artists working under the influence of foreign decorative teams. Early in his reign, Philip V created new opportunities for French painters, sculptors, and workmen that he brought to Spain to work on the refurbishment of his favorite royal palace, **La Granja de San Ildefonso** (1719–21), which was modeled on the Château de **Versailles** and decorated with Rococo **ornamentation**. Royal **portraiture** was also dominated by the importation of French academic artists to the court of Madrid, including **Michel-Ange Houasse**, Jean Ranc, and **Louis-Michel van Loo**. In turn, their French Rococo style impacted upon that of local Spanish painters, such as **Miguel Jacinto Meléndez** and Antonio González Ruiz, who also worked at court. The **Real Academia de Bellas Artes de San Fernando** (1744) was established under Philip V, as was the **Real Fábrica de Tapices y Alfombras de Santa Bárbara** (after 1721).

**PIGALLE, JEAN-BAPTISTE (1714–85).** Pigalle was a leading French **sculptor** during the reign of **Louis XV**. Like Falconet, he studied in **Rome** between 1736 and 1740 and was allowed to use the facilities at the Académie de France, although he had not won a scholarship. On his return, he stopped for a brief period to work in Lyon, where it is believed that he completed the terracotta *bozetto* of Mercury (c. 1739–42, Metropolitan Museum of Art, New York), later executed as a full-scale marble **sculpture**. The graceful movement of this work secured his reputation. He was received as a full member of the **Académie Royale de Peinture et de Sculpture** with the small marble version of this work (1744, Musée du Louvre, Paris), while a life-scale version was commissioned by the **Bâtiments du Roi** and given as a gift from **Louis XV** to **Frederick the Great** in 1748. Pigalle also began to work for the **marquise de Pompadour** and members of her circle, including the financier Jean Pâris de Montmartel. For the latter **patron**, he executed a portrait of his infant son as *Child with a Bird Cage* (Musée du Louvre, Paris), which proved a popular success at the **Salon** of 1750. The work combines sentimentality and naturalism in its treatment of the sitter, at the same time that it revives an ancient Roman prototype. Pigalle subsequently completed variations on this work as designs for biscuit **porcelain** figures produced at **Sèvres**. Among the works completed for Madame de Pompadour is her **portrait** as *Friendship* (1753), which asserted the continued importance of the official mistress as a confidant of the king, despite the fact that their sexual relationship had ended.

Pigalle's masterpiece is his Mausoleum of the Maréchal de Saxe in Strasbourg, which he worked on for 25 years (1753–76, church of Saint Tomas,

Strasbourg). It represents the culmination of a tradition of funerary monuments, with allegorical figures and symbols of power surrounding the central figure of the heroic marshal, who descends a flight of stairs. Toward the end of his career, Pigalle's work became strikingly naturalistic and eschewed idealization, indeed some of his works can be seen as practical experiments in **Enlightenment** thought. His *Voltaire Nude* (1776, Musée du Louvre, Paris) was the first statue of a living writer erected in **France** and paid for by public subscription. In order to study his model, Pigalle traveled to Ferney, where Voltaire spent the last years of his life. The nude portrayal of an old man was controversial and widely criticized.

**PILES, ROGER DE (1635–1709).** De Piles was a diplomat, celebrated connoisseur, and prominent writer of art history, theory, and criticism. He took part in the **color**/line debates that commenced in 1670s at the **Académie Royale de Peinture et de Sculpture**, arguing forcefully for the visual, rather than purely intellectual, effects of **painting** in his *Dialogue sur le coloris* (1673). In his subsequent writings and in the advice he gave to prominent collectors, de Piles championed the art of the Venetians and, more importantly, Peter Paul Rubens. When the duc de Richelieu lost his collection of paintings to **Louis XIV** as the result of a tennis match wager, de Piles recommended that he replace his Poussins with works by Rubens. He became an honorary member of the Académie Royale in 1699.

At the end of his life, he published his *Cours de peinture par principes* (1708), which represented a final summation of his ideas on the unified visual effect of **painting**, which must make its impact at a glance. Aspects of his argument can be understood in relation to the rise of the Rococo, specifically its emphasis on the role that color plays in the creation of visual unity. More generally, de Piles put forward a theory of pictorial composition that was based on form and visual perception, rather than rules that derive from subject matter. In this, he approaches a more modern understanding of visual **aesthetics** that similarly informs Rococo art. *See also* FRANCE; QUARREL OF THE ANCIENTS AND THE MODERNS.

**PINEAU, NICOLAS (1684–1754).** Pineau worked as an **ornamental** panel sculptor for the Russian court and in numerous elite residences in **Paris**. His mature style is defined by a delicacy of line and principles of contrast. **Jacques-François Blondel** credited Pineau, along with **Jacques de Lajoüe** and **Juste-Aurèle Meissonier**, with the creation of the *genre pittoresque* in interior decorative schemes during the 1730s and 1740s. His early career was spent in **Russia**, where he traveled with Alexandre-Jean-Baptiste Le Blond as part of the team of architects, sculptors, and painters brought by Peter the

Great to work at Saint Petersburg. His Russian contract designated that he was to make "**doors**, **chimneypieces**, frames, table frames, and other ornaments and designs." Pineau was responsible for the sculpted wood panels in the Tsar's Cabinet at **Peterhof**, which employ military **trophies**, **cartouches** with medallions representing the arts and sciences, and elaborate **arabesque** ornamentation.

Pineau was back in Paris in 1728, where he attempted to establish himself as an architect, as he had begun to do in Saint Petersburg after the death of Le Blond. According to Blondel, he found this difficult, although it seems equally likely that his experience with interior design at the court of Peter the Great situated him as an innovative ornamentalist with skills as a sculptor and designer that were in greater demand. He formed partnerships with architects who were engaged in the renovation and construction of *hôtels particuliers* throughout Paris. Pineau is known to have provided decorative schemes at the Hôtel de Rouillé (c. 1732) and the Hôtel de Mazarin (1735), as well as for the gallery of the Hôtel de Villars (1731–32) and decorations for the Hôtel de Roquelaure (1733) and the Hôtel de Marcilly (1738). As most of these interiors were dismantled or destroyed, Pineau's style is largely known through his surviving drawings and the prints after his schemes published during his lifetime in Blondel's *De la distribution des maisons de plaisance* (1737–38) and Jean Mariette's *Architecture françois* (1727). Pineau was one of the primary targets of **Charles-Nicolas Cochin**'s attack on the Rococo published in the *Mercure de France* in mid-1750s. *See also* ASYMMETRY; PANELING.

**PIRANESI, GIOVANNI BATTISTA (1720–78).** Piranesi was one of the most improvisational and idiosyncratic artists of the 18th century. His works are primarily etched or engraved topographical views, or *vedute*, and architectural fantasies, or *capricci*. Although he primarily worked in **Rome**, his interpretation of the *vedute* and *capricci* traditions was equally informed by his Venetian heritage. At times, this connection was direct. His Grotteschi series (c. 1747–50), for instance, was inspired by **Giambattista Tiepolo**'s *Scherzi* and *Capricci*, blending ruins and more macabre motifs, such as skeletons and piles of bones, into the typical Rococo decorative vocabulary of shells, flowing water, scrolling curves, and **asymmetrical** compositional arrangements. In Rome, and also in response to the excavations at Herculaneum, Piranesi found inspiration in the forms of antiquity.

Yet Piranesi's views were not strictly classical. He manipulated scale, perspective, and lighting to produce dream images of the past. Many of his designs are eclectic in their borrowings and inspirational sources. In addition to ancient Rome, he drew on Greek, Egyptian, Etruscan, Baroque, and Rococo models, providing visual evidence for his assertion that artists and

architects should be free to draw inspiration from every time and place for their own inventions. Such a mindset is inherently modern in its insistence upon creative freedom. As such, it is closely linked to the approach taken by early Rococo **ornamentalists**. *See also* VENICE.

*PITTORESQUE. See GENRE PITTORESQUE.*

**PLACE STANISLAS, NANCY.** For much of the 18th century, Nancy was the capital of Lorraine and ruled by Stanislas Leszczynski (1677–1766) as titular grand duke from 1736. As the deposed king of **Poland** and son-in-law of **Louis XV**, Stanislas determined to transform this regional town into an urban city displaying cultural splendor suitably reflective of his status as a regal **patron**. Around 1750, Stanislas initiated the building of a new Place Royale (now known as the Place Stanislas) to hold a number of public buildings, including the Hôtel de Ville, designed by Emmanuel Héré (1705–63). Spectacular gilded iron gates by Jean Lamour (d. 1771) form the curving corners of the royal square and employ a rich profusion of sculpted Rococo decoration on the grills that frame the three openings. The result is a highly creative and fanciful reinterpretation of the classical triumphal arch, formally establishing the modern perimeter of a newly urbanized space. *See also* LUNÉVILLE.

**PLASTERWORK.** *See* STUCCO AND PLASTERWORK.

**POLAND.** The 18th century was a period of political destabilization for the kingdom of Poland, which resulted in the division of its territories between **Russia**, Prussia, and **Austria**. Nevertheless, under the **patronage** of **King Augustus III** (ruled 1733–63), the Rococo filtered into the arts and **architecture** of Poland around 1750 as an updated expression of absolute power and authority. A member of the Wettin family, who were electors of Saxony, Augustus III's court in Warsaw stimulated activity in the decorative arts by establishing faience factories, textile plants, and glassworks to produce luxury goods for the embellishment of royal residences. Major sculptors working in Lwów developed Rococo forms in their work during the 1760s and were patronized by aristocratic families, such as the Potockis. In architecture, Rococo stylistic influences can be observed in both ecclesiastical and palace construction in Warsaw and Kraków. Several churches in Kraków exhibit *contrecourbe* C- and S-curves on facades, and the complex **ornamentation** of the interiors is achieved through expertly handled **stuccowork** and woodcarving that demonstrates strong connections with Rococo decoration in the churches of Southern **Germany**.

The Polish-born painter and printmaker **Daniel Nikolaus Chodowiecki** popularized bourgeois scenes of everyday life, which he developed as variations on the elite imagery of French *fêtes galantes*. Although he worked primarily in Berlin, Chodowiecki made repeated trips back to his native Danzig. In addition to the paintings he produced for aristocratic collectors, his prints were bought by educated members of the middle classes in Poland. The last king of Poland, Stanislaw August Poniatowski (ruled from 1764), took an active interest in the arts. Informed by **Enlightenment** ideals, his tastes were distinctly classical and encouraged a stylistic shift toward **Neoclassicism** in Polish art and architecture until the partitioning of the 1790s erased Poland from the maps of Europe.

**POMPADOUR, JEANNE ANTOINETTE POISSON, MARQUISE DE (1721–64).** Originally of bourgeois origins, Jeanne Antoinette Poisson became the official mistress of **Louis XV** in 1745. The king arranged her title, the marquise de Pompadour, upon her introduction at court. In this position, she exerted considerable influence over the arts in **France** during the middle of the 18th century, although it is perhaps due to the catchphrase "Van Loo, Pompadour, Rococo," coined by young artists working in the studio of **Jacques-Louis David** after the Revolution, that her name has become inextricably linked to the Rococo. As confidant of the king, she encouraged his interest in **architecture** and the royal **porcelain** manufactory at **Sèvres**. For members of her family, she obtained the most prominent administrative positions at court dealing with artistic matters. Her uncle by marriage, **Lenormand de Tournehem**, became *directeur général des bâtiments* in 1745, and her younger brother, the future **marquis de Marigny**, was designated as his successor.

Madame de Pompadour's personal **patronage** is most closely associated with her favorite painter, **François Boucher**, who was commissioned to paint her portrait several times, carefully negotiating the need to present his sitter as a **woman** of beauty and taste, as in *Madame de Pompadour* (1756, Alte Pinakothek, Munich). Boucher also gave Pompadour lessons in art, as did the gem-engraver Jacques Guay and the antiquarian engraver **Charles-Nicolas Cochin**. Under their supervision, she made etchings of reasonable quality. As an amateur artist, Pompadour experimented with **decoupage**, creating a trend at court. She was an avid patron of modern French **painting** and the decorative arts, which adorned her residences, especially the châteaux of Crécy and **Bellevue**. For her entertainment and pleasure, hermitages were built at **Fontainebleau**, Compiégne, Choisy, and **Versailles** by **Ange-Jacques Gabriel**, the king's architect, some with **ornamental** carvings by **Jacques Verberckt**. These were important forerunners to the dairies and **Hameau de la Reine** built for **Marie-Antoinette** at Rambouillet and Versailles.

**PORCELAIN.** Rococo porcelain is the product of the birth of a consumer society in early modern Europe and the expansion of trade networks by the East India Companies. Porcelain first came to European courts from East Asia and circulated with other commodities in transnational luxury markets. A symbiotic relationship developed between the consumption of exotic beverages and the types of objects that were created in porcelain. For example, tea, coffee, and chocolate pots, cups, and bowls were designed to meet the needs of new social rituals.

The Chinese began to make porcelain as early as the 7th or 8th century, but Europeans did not discover the techniques for making hard-paste, or true porcelain, until the early 18th century. True porcelain is made from a mixture of kaolin (china clay) and *petuntse* (china stone), which is fired at high temperatures in a kiln to produce a hard, translucent body that is milky white in color. Earlier European attempts at manufacturing this type of ceramic produced soft-paste, or artificial porcelain, which used ground glass mixed with white clays in an attempt to achieve a comparable degree of translucency. By 1700, a number of European princes were sponsoring experiments in the production of porcelain, many of whom were also avid collectors of East Asian porcelain.

The Prince de Condé in **France** and Augustus the Strong in Saxony held vast collections of Japanese porcelain and funded experiments at factories in Chantilly and **Meissen** respectively, which were motivated by economic and aesthetic interests. While Chantilly produced soft-paste porcelain of a high quality and trained artisans who later worked at the king's factories in Vincennes (later transferred to **Sèvres**), it was at Meissen in 1709 that the first European hard-paste porcelain was made through the successful collaboration of an alchemist, Johann Friedrich Böttger, with a group of mining officials, smelting experts, and natural scientists. As knowledge of the secret formula spread and local supplies of kaolin were discovered in many parts of Europe, new factories opened in Vienna, **Nymphenburg**, Berlin, and Capodimonte (which was later moved to Buen Retiro). The chief rival manufactories of Rococo porcelain, however, were Meissen and Sèvres.

Rococo porcelain is typically glazed and decorated with cobalt or rich enamel **colors**. When left unglazed, it is referred to as biscuit, which was favored for small-scale **sculptures** in imitation of marble. Leading sculptors and painters, such as **Étienne-Maurice Falconet** and **François Boucher**, were employed at Sèvres to produce designs for objects and their decorations. Not only did Falconet and Boucher provide images for painted porcelain, but prints after works by **Antoine Watteau** and other *fête galante* artists were also adopted as sources for designs outside of France. The popularity of these

designs contributed significantly to the spread of Rococo forms and themes throughout the decorative arts. *See also* CASERTA; POLAND; SPAIN.

**PORTRAITS AND PORTRAITURE.** Rococo portraits are notable for their reformulation of established traditions and development of new modes of representation that emphasized informality, personal character, and the value of **aesthetic** experience over resemblance. Since the Renaissance, conventions of portraiture had guided artistic choices toward the creation of an accurate likeness, which was broadly conceived to incorporate physical appearance and social status. Court portraitists were often referred to as counterfeiters who made copies of the original sitters, often high-ranking members of court. In the early 18th century, however, an increasing number of **patrons** from the lower nobility and wealthier levels of the bourgeoisie led to a demand for more informal portraits. Highly original approaches to portraiture resulted, which led to the development of works that eroded the boundaries of the genre, such as the **conversation piece** and **fancy picture** in **England** and, in **France**, fantasy portraits by **Jean-Honoré Fragonard** and child portraits that appear to be scenes of everyday life by **Jean-Baptiste-Siméon Chardin**.

Portraiture was one of the most common categories of **painting** at the start of the 18th century: half of the entries in the Paris **Salon** of 1704 were portraits. One quarter of the members of the **Académie Royale de Peinture et de Sculpture** in the same period were listed as portraitists, and many history painters also worked in the genre. Across the Channel in England, portraiture was in greater demand than any other genre, a situation much lamented by artists like **Joshua Reynolds** who hoped to raise the reputation of the British school through the production of serious history painting. Englishmen on the **grand tour** further influenced the market for portraits in **Italy**, as leading painters in **Venice** and **Rome**, such as **Rosalba Carriera** and **Pompeo Batoni**, were flooded with commissions for paintings that would serve as mementos of a journey focused on cultural and aesthetic edification. Batoni's portraits often included antique statuary and portfolios of prints or drawings as attributes of a cultured gentleman on the grand tour. Carriera took a slightly different approach that conveyed the artful refinement of sitters through an informality of pose and her effortless handling of the pastel medium.

As a guest of the French *amateur* Pierre Crozat, Carriera spent a year in **Paris** in 1720, where she came into contact with prominent portraitists. Carriera's pastel technique and relaxed mode of portrayal appealed to developing Rococo tastes that were concerned with the pleasing qualities of the portrait as a work of art. Her fame in working with pastels encouraged others to experiment with the medium, which was subsequently exploited to greatest

effect by **Maurice-Quentin de La Tour** in his full-length portraits of sitters such as the **marquise de Pompadour** (1748–55, Musée du Louvre, Paris). In scale, La Tour's pastels perpetuated the conventions of official court portraits; however, the very medium of pastel, which stands midway between preparatory drawing and finished oil painting, evoked informality, intimacy, and immediacy. **Thomas Gainsborough** similarly excelled in portraiture that combined a degree of personal familiarity with a sense of appropriate etiquette, which appealed to fashionable members of society in London and **Bath**. As a spa retreat, Bath attracted a tourist market for portraits much like that of the grand tour.

Novel reconceptualizations of the genre were not exclusively carried out by painters. Rococo **sculptors** also began to experiment with modes of portrayal that avoided conventional forms of idealization and enabled deeper insight into the character of their sitters. As early as 1730, **Louis-François Roubiliac** endowed his portrait busts with a heightened sense of individualism. His sculpted monuments were also revolutionary in portraying people known for their artistic achievements, rather than acts of heroism, such as the composer Handel and the playwright Shakespeare. Even portraits of heroes were treated more naturalistically. **Étienne-Maurice Falconet**'s bronze equestrian monument of *Peter the Great* (1782, Saint Petersburg) avoided allegorical trappings in an effort to update the image of the modern ruler. More confronting was **Jean-Baptiste Pigalle**'s naturalistic portrayal of *Voltaire Nude* (1776, Musée du Louvre, Paris). Although this portrait is a product of **Enlightenment** thought, it represents the culmination of attempts by Rococo artists and **patrons** to avoid traditional forms of idealization in portraiture and to achieve a greater sense of personal identity through new pictorial means. *See also* GOYA Y LUCIENTES, FRANCISCO JOSÉ DE; HOGARTH, WILLIAM; LABILLE-GUIARD, ADÉLAÏDE; NATTIER, JEAN-MARC; VIGÉE LE BRUN, ÉLISABETH-LOUISE.

**PORTUGAL.** The impact of Rococo art and **architecture** was limited in Portugal, largely owing to the distinctly Roman Baroque tastes of the Braganza King John V, who ruled between 1706 and 1750. Like other European monarchs and princes of the 18th century, John V intended not only to use the arts as an expression of his personal power and magnificence in emulation of **Louis XIV** but also to raise the prestige of Portugal and the Braganza dynasty. Discoveries of gold and diamonds in colonial Brazil funded his extensive building program, which was accompanied by an expansion of artistic **patronage** and collecting by the crown.

The enormous palace-convent of Mafra (1717–35), located 40 kilometers from Lisbon, is characteristic of John V's tastes. It was built under the

direction of the German-born architect João Frederico Ludovice, who had trained in **Rome** and was familiar with the Baroque forms of Francesco Borromini's buildings and the architecture of Saint Peter's. Many foreign artists were brought to work at the court of John V, including several minor Italian **sculptors** working in a Baroque manner who supplied works for Mafra. **Filippo Juvarra** was brought from Turin to Lisbon in 1719 to design a church and palace, but the project was never realized. Italian painters who followed Roman Baroque models were John V's preference, although he did invite some French artists to Lisbon. Jean Ranc, for example, moved from the Spanish court to the Portuguese court in the late 1720s and brought with him an international Rococo style of **portraiture**. The king's tastes never encouraged its further development, despite the fact that his agent, the French dealer and *amateur* **Pierre-Jean Mariette**, had significant connections with emerging Rococo artists in **Paris**. Instead, Mariette bought mostly 17th-century **paintings** by French, Flemish, and Dutch artists for the king and helped him build an extensive collection of engravings by leading European artists intended for the library of the royal palace in Lisbon. **English Rococo furniture** was more influential, as John V preferred Chippendale-style furniture, which later became popular with the merchant classes through the publication of **Thomas Chippendale**'s pattern book, *The Gentleman and Cabinet-maker's Director*, in 1762. Portuguese trade with England was an important aspect of the economy during the 18th century, which led to the importation of furniture, ceramics, and textiles from England rather than **France**.

The most Rococo of all 18th-century royal buildings is the Palácio Nacional de Queluz, which was intended as a summer retreat for dom Pedro of Braganza, brother of Joseph I. Building commenced in 1747 under the direction of the architect Mateus Vicente de Oliveira. Although of minor architectural importance, the palace blends Baroque grandeur with Rococo **ornamentation** and **interior decoration** in a way typical of international responses to the French Rococo in the princely courts of continental Europe. The predominant use of azulejos, or polychrome glazed tiles, throughout the interiors and **gardens** is, however, uniquely Portuguese. Azulejos tiles decorate the walls of the canal with Rococo themes of love and leisure and provide an example of the way in which local traditions were brought up-to-date with international court tastes. French artists and artisans were also involved in the design of the palace gardens and interiors, including Jean-Baptiste Pillement.

In 1755, the Lisbon earthquake destroyed much of the city, leading to a vast program of urban planning and reform during the reign of Joseph I (ruled 1750–77). Most of the rebuilding was organized by the king's minister, the

marquês de Pombal, who encouraged policies that can be characterized as enlightened despotism. As at the court of Catherine the Great of **Russia**, the aesthetic forms of **Neoclassicism** best served to express the new political and philosophical directions of government. *See also* ARCHITECTURE; INTERIOR DECORATION.

**Q**

*QUADRATURA.* This term is used in art history to describe painting techniques that create architectural illusions derived from theories of perspective. With *quadratura*, painted walls or **ceilings** appear to disappear, so that the **architecture** of a room extends into the sky. *Quadratura* blurs the boundaries between real space and the fictitious space of a painting to create dizzying feats of illusion. While this technique is generally associated with Baroque ceiling painting in 17th-century **Rome, Giambattista Tiepolo** employed it in many of his frescoes from the 18th century to contrast stable geometric structures with **asymmetrical** figural groupings in which billowing draperies, curvilinear forms, and rhythmic movement dominate. In spaces such as the Kaisersaal in the **Würzburg Residenz,** this principle of stylistic dichotomy is extended further into the three-dimensional space of the room, where **rocaille ornament** is heavily employed in the **stucco** framework both to emphasize the notion of artifice and to lighten the effects of illusionism and **Classicism** usually associated with *quadratura.*

**QUARREL OF THE ANCIENTS AND THE MODERNS (*QUERELLE DES ANCIENS ET DES MODERNES*).** The *querelle des Anciens et des Modernes* was a debate that erupted in French literary circles during the late 17th century, eventually moving into the formal arena of the Académie Française. It concerned the authority of classical antiquity and questioned the unassailable perfection reached by the Greeks and Romans, coinciding with the parallel **color**/line debates of the **Académie Royale de Peinture et Sculpture**. These literary and artistic debates had significant theoretical ramifications for the development of a *le goût moderne* in art, literature, and theater during the early 18th century. *See also* FRANCE; PERRAULT, CHARLES; PILES, ROGER DE.

# R

**REAL ACADEMIA DE BELLAS ARTES DE SAN FERNANDO.** The first royal academy in **Spain**, the Real Academia de Bellas Artes de San Fernando, was established in 1752. It was open to all artists and provided scholarships, often through competitions related to history **painting**, for selected students to spend six years in **Rome** to study the works of Italian masters. The founding of the academy was the result of two decades of efforts by French and Spanish artists, several of whom assembled as the Junta Preparatoria de la Academia de Bellas Artes from 1744 to solicit royal support for an academic institution and to provide classes in painting, **sculpture**, and **architecture**. Initially, foreign artists were appointed as directors, including **Louis-Michel van Loo** in 1752 and **Corrado Giaquinto** in 1753, most likely due to their experience with the institutional structures of academies in **France** and **Italy**. Later in the century, however, Spaniards, like **Francisco Bayeu** and **Francisco de Goya**, became directors, a shift which marks the academy's role as training ground for young Spanish artists.

**REAL FÁBRICA DE TAPICES Y ALFOMBRAS DE SANTA BÁRBARA, MADRID.** King **Philip V of Spain** founded this royal **tapestry** factory in 1720, after the Treaty of Utrecht and the loss of Flemish provinces, which had previously supplied the crown with tapestry works. He brought skilled weavers from Antwerp to establish production in **Spain** and commissioned court painters to supply original tapestry cartoons. Initially, the subjects were conventional, examples of which are the mythological subjects supplied by **Michel-Ange Houasse** in 1730: *Telemachus and Mentor Arriving at the Island of Calypso* and the *Banquet Held by Calypso in Honour of Telemachus and Mentor* (Museo del Prado, Madrid). In 1777, however, **Francisco Bayeu** was appointed artistic director and began to produce compositions that featured popular **genre** themes and scenes of contemporary Madrid, such as *Paseo de las delicias, Madrid* (1785, Museo del Prado, Madrid), which were turned into cartoons by his younger brother Raymon. Bayeu's productions in this vein were most likely inspired by the work of his brother-in-law, **Francisco de Goya**, who began supplying large-scale designs

to the factory in 1775. Paid by the piece in these years, Goya painted more than 60 tapestry cartoons for the Real Fábrica between 1775 and 1792, which were intended to decorate rooms in the palaces occupied by the **Bourbon** monarchy. Goya's compositions, depicting **children**'s games, popular entertainments, and elite pastimes, are among the most Rococo works to be produced by a Spanish artist (a large number of these are held by the Museo del Prado in Madrid). The factory was closed in 1780, when the royal budget was constrained by the war between Spain and **England**. See also BEAUVAIS, MANUFACTORY OF TAPESTRIES.

**REYNOLDS, SIR JOSHUA (1723–92).** The most famous British portrait painter of his day and first president of the Royal Academy of Arts in London, Reynolds painted over 2,000 works in a wide variety of genres, including history **painting, fancy pictures**, and landscapes. He was also active as a collector and art theorist, delivering his influential *Discourses on Art* to the Academy between 1769 and 1790. These annual lectures outlined a pedagogical approach for the institution and described the pursuit of beauty in art as an intellectual ideal. Reynolds worked throughout his life to raise the status of the artist and the arts in 18th-century **England**. He was knighted by George III in 1769.

Reynolds's earliest **portraits** from the 1740s are heavily influenced by his study of the 17th-century artists, Rembrandt van Rijn and Anthony van Dyck. By the end of the decade, however, he began to look more closely at contemporary **sculpture**, such as the portrait busts of **Louis-François Roubiliac**, which were endowed with a greater sense of character and individualism. Reynolds's portrait of the *Man in a Brown Coat* (1748, Marble Hill House, Twickenham) reveals the influence of Rembrandt in the choice of palette and use of *chiaroscuro*, but the weightiness of the figure and his careful attention to individual features aligns it with an 18th-century sculptural treatment of form. By 1750, Reynolds was on his way to **Rome**, where he remained for two years before traveling through **Italy** and **Paris** on his return home.

Back in London, he set up his studio at Saint Martin's Lane in 1753. Considering his interest in founding a public academy of art, it is likely that he attended the nearby **Saint Martin's Lane Academy**. Although the English Rococo style associated with the teachers at this institution in the 1740s and 1750s is rarely discussed in relation to Reynolds, many of his works from this period suggest his interest in updating the conventions of Georgian portraiture, which he achieved through a greater informality of pose, fashionability of **dress**, and individuality of expression, as in *Catherine, Lady Chambers* (1756, Kenwood House, London) and *Mrs. Francis Beckford* (1756, Tate Collections, London).

It was also in these years that Reynolds began to respond to a modern interest in the state of **childhood**, which is revealed in the affectionate relationships he depicted between parents and children. He also developed affective portrayals of motherhood in early **portraits** such as *Mrs. Richard Hoare and Child* (1763, Wallace Collection, London), which builds to the animated play between mother and child in the *Duchess of Devonshire and Her Daughter* (1786, Devonshire Collection, Chatsworth). The 18th-century interest in the child was not limited to portraiture. The theme of children at play was popular with continental Rococo artists, such as **Jean-Baptiste-Siméon Chardin, Jean-Honoré Fragonard**, and **Jean-Baptiste Greuze**. Reynolds, however, pursued a more sentimental image of childhood in his fancy portraits, the most notable of which are the *Strawberry Girl* (1773, Wallace Collection, London) and *Cupid as a Link Boy* (c. 1773, Albright-Know Gallery, Buffalo).

The first public exhibition of **painting** in England was held in 1760 at the Society of Artists. Reynolds exhibited four portraits, including a full-length painting of *Elizabeth, Duchess of Hamilton* (1758–59, Lady Lever Art Gallery, Port Sunlight), which combines a curvilinear treatment of pose with a statuesque handling of the body to communicate the sitter's beauty in the visual language of both contemporary and classical **aesthetics**. Two years later, Reynolds exhibited *Garrick between Tragedy and Comedy* (1761, private collection), a work that draws on the pictorial conventions of a mythological theme, Hercules torn between virtue and vice, to inform a witty portrayal of a well-known living actor, **David Garrick**. With these two paintings, Reynolds explored the relationship between artistic tradition and modernity. Although he retained strong classicizing tendencies through his career, when he turned to history painting, he was often drawn to unusual subjects. He experimented with the sublime, as theorized by his friend Edmund Burke, in *Ugolino* (c. 1773, Knole House, Kent) and subjects taken from Shakespeare.

Reynolds began to form a collection of paintings, drawings, and **sculpture** after 1752, buying in London, Paris, and **the Netherlands**. He owned more than 400 paintings and 6,000 drawings, with all the major European schools from the Renaissance to the early 18th century represented. His tastes were closely connected to the pedagogical goals and ideals he laid out in the *Discourses*, and at some point, if not from the beginning, he intended it to serve as a study collection for the Royal Academy. He also may have envisioned that his collection would educate the London public through exhibition. He held one such exhibition of his Old Master paintings in the Haymarket in 1791, to which he charged admission. Although Reynolds offered his collection to the Royal Academy at a low price on the condition that an exhibition space would be provided, the proposal was rejected. The collection was dispersed after Reynolds's death, primarily through public sales between 1794 and 1798.

**RIESENER, JEAN-HENRI (1734–1806).** Riesener was the favorite cabinetmaker of **Marie-Antoinette**. He was apprenticed to Jean-François Oeben and later married his daughter. Oeben became *ébéniste du roi* in 1774 and was inundated with commissions to provide **furniture** for royal palaces and Parisian *hôtels particuliers*. His furniture is characterized by rich decoration featuring floral marquetry, gilt bronze mounts, and mahogany veneers. After Oeben's death in 1763, Riesener took over the direction of his father-in-law's workshop and produced the most famous piece of French 18th-century furniture, the *Bureau du roi*, an elaborate roll-top secretary with mechanical fittings that allowed it to be opened and closed with the touch of a single button. The desk was commissioned by **Louis XV** and used by the king in the Cabinet Intérieur du Petit Appartement at **Versailles**.

**RISAMBURGH, BERNARD VAN (C. 1696–1766).** From a family of French cabinetmakers of Dutch origin, Risamburgh learned the trade from his father. He opened his own workshop in 1730 and stamped his work B.V.R.B., although in 18th-century sale catalogs he is often referred to as Bernard. Risamburgh produced all types of **furniture**, working directly with **patrons** and through *marchands merciers*. He was highly innovative in developing new forms of furniture, and his decorative blending of materials led to strong demand within the French court and internationally. He worked not only on commission, producing works for the apartments of **Louis XV**, Marie Leczinska, and **Madame de Pompadour**, but also supplied pieces to *marchands merciers*. Risamburgh's furniture is characterized by a high quality of lacquer work, floral marquetry, and gilt-bronze mounts, several examples of which are held in the Getty Museum in Los Angeles. In the late 1750s, he became the first artist to use **porcelain** on a commode, a design innovation that characterizes Rococo pieces of this type. *See also* FRANCE.

**ROBERT, HUBERT (1733–1808).** Early in his career, Robert showed an affinity for landscapes and **architecture**. He traveled with the comte de Stainville (the future duc de Choiseul) to **Rome** in 1754. His protector soon arranged for Robert to participate in the activities of the Académie de France in Rome, which was then under the directorship of **Charles-Joseph Natoire**. Rather than making copies of Italian art, Natoire encouraged students to draw in nature, and Robert's own interests led him to landscapes that included ruins. In the company of the Abbé de Saint-Non and **Jean-Honoré Fragonard**, Robert spent a great deal of time making sketches in the overgrown gardens of the Villa d'Este at Tivoli. Fragonard and Robert worked side-by-side during the late 1750s, and their landscape drawings and **paintings** from this period remain close in subject and style, both artists rendering remarkable natural effects in their fluid handling of red chalk.

In 1765, Robert returned to **Paris** and was accepted and received into the **Académie Royale de Peinture et de Sculpture** the next year. He began to actively participate in the **Salons** and was soon known as Robert des Ruines, a nickname apparently coined by **Denis Diderot** in response to his paintings of ancient Roman remains and contemporary Parisian buildings in ruins, the latter as fantasy views often pictured as the result of fires. At the Salon of 1777, Robert exhibited views of the replanting of the gardens of **Versailles**, one of which included **Louis XVI** and his family walking in the gardens while workmen play on a seesaw (Musée National du Château de Versailles, Paris). The propagandistic aim of such a scene was to represent the new king as an enlightened monarch. Robert was able to merge such ideological meanings into a scene that updates the playful motifs of *fêtes galantes* through the picturesque contrasts established by the comparison of upper- and lower-class figures.

Robert was appointed *dessinateur des jardins du roi* in 1778, an unusual post for a painter. Although he was not a landscape architect, Robert served as a design advisor, collaborating with the leading **patrons** and landscape architects of picturesque gardens at Ermenonville, Méréville, Moulin Joli, the Petit Trianon, and the **Hameau de la Reine** at Versailles. Robert also created decorative ensembles for interiors, many of which were for spaces that communicated directly onto gardens. His six landscapes for the **comte d'Artois'** *petite maison* at **Bagatelle** covered an entire room, and the windows out onto the *jardin anglais* urged comparisons between the different forms of landscape in painting and in **garden design**. From this series, *The Swing* (1777–79, Metropolitan Museum of Art, New York) merges *fête galante* subject matter with the conventions of the *genre pittoresque* and marginal references to antiquity.

A capable arts administrator, Robert became *garde des tableaux* of the Musée Royal installed at the Palais du Louvre in the 1780s, a post he effectively maintained after the French Revolution as one of the first curators of the reformed public museum, following a brief period of imprisonment in 1793–94. He devised a number of plans to convert the Grande Galerie of the Louvre for the public display of confiscated collections, completing numerous painted designs of his schemes between 1789 and 1796, including the *Imaginary View of the Grande Galerie in the Louvre in Ruins* (1797, Musée du Louvre, Paris). *See also* GEOFFRIN, MARIE-THÉRÈSE; WATELET, CLAUDE-HENRI.

**ROBINS, THOMAS, THE ELDER (1716–70).** The gouache and watercolor views of country estates produced by this English painter provide rare information about the appearance of **English Rococo** gardens created during the 1740s and 1750s in the region of **Bath**. His sketchbooks record the

delightful details of some of these gardens, which have long since disappeared, such as the rustic hermit's cell on the grounds of Jeremiah Peirce's Lilliput Castle (1759–60, Victoria and Albert Museum, London). These are not strictly topographical images, however, as Robins exaggerated the serpentine lines of paths and water features, as well as the curvilinear features of hillsides, and manipulated perspective to enhance the **ornamental** appearance of the view. Many of his watercolors are framed with decorative borders that feature birds, butterflies, fruit, leaves, flowers, and shells, such as in *Pan's Lodge, Coldbourne Grove, Gloucestershire* (private collection). He often included staffage for visual interest. His views of the garden at Woodside, Old Windsor in Berkshire, show well-heeled figures at leisure in the greenhouse gardens and workers maintaining the grounds in front of a **chinoiserie** kiosk. *See also* GARDEN DESIGN.

**ROCAILLE.** Literally meaning "rockwork," rocaille forms include shells, scrolling, and *contrecourbe* C- and S-curves, flowing water, batwings, and **palmettes.** In the early 18th century, the word was used in the titles of suites of **ornamental** prints by **Jacques de Lajoüe** and **François Boucher** (examples include *Tableaux d'ornements et rocailles; Livre de formes rocailles et cartels, Livre de formes ornées de rocaille*) and also to describe the colorful rocks, shells, corals, and stones that decorated grottoes, fountains, decorative objects, and **furniture.** The related term *coquillage*, or shellwork, often appeared in conjunction with rocaille, as in an article in the *Mercure de France* from March 1734, in which a suite of engravings by **Juste-Aurèle Meissonier** and other artists was described as containing "cascades, ruins, *rocailles* and *coquillages*, pieces of **architecture** that make bizarre and picturesque effects." By the third quarter of the 18th century, rocaille was employed more generally in critical writing to refer to forms of architecture and **painting.** In his *Cours d'architecture* (1772), **Jacques-François Blondel** noted, "Several years ago it seemed that everything within our century was that of the *Rocailles* . . . now, without knowing why, it is otherwise." The etymological origins of the word Rococo most likely derive from a derogatory adaptation of rocaille by students working within **Jacques-Louis David**'s studio in the early 19th century.

**ROCOCO REVIVAL.** In the mid-1830s, travelers to **France** began to remark on the use of the epithet *rococo* to refer to "young and innovating" Parisians who valued old-fashioned tastes in art, literature, dress, manners, and politics. These attitudes signaled the beginning of the Rococo Revival, which culminated in the art writing and collecting activities of the **Goncourt brothers** in the 1870s and 80s. The Empress Eugénie, wife of Napoleon III,

was an avid **patron** of Revival **furniture, sculpture,** and **painting.** The fashionable court portraitist Franz Xaver Winterhalter, for example, painted the *Empress Eugénie Surrounded by Her Ladies in Waiting* (Château de Compiègne, 1855) in a compositional arrangement that recalled the *fêtes galantes* of **Antoine Watteau** and the *tableaux des modes* of **Jean-François de Troy.** The impact of the Revival on 19th-century artists was widespread and ranged from the Romantics to the Impressionists, who were variously attracted to the sensuality, grace, and **color** harmonies found in Rococo art. Although the Rococo Revival was centered in **France,** it extended throughout continental Europe, **Great Britain,** and North America. *See also* AMERICAN ROCOCO.

**ROME.** During the 18th century, Rome was the principal destination of men and women on the **grand tour.** An extended stay in Rome to study the **architecture** and **sculpture** of antiquity, as well as the **paintings** of Italian Renaissance masters, was considered to be essential training for young artists and architects hailing from countries and principalities throughout Europe. The French maintained the Académie de France in Rome specifically for this purpose and established the *Prix de Rome* to send its most outstanding pupils in art and architecture to study there. There was also a significant and influential community of British expatriates and travelers in Rome, many of whom desired **portraits** by **Pompeo Batoni** and **Angelica Kauffman.** Many foreign artists participated in the activities of the **Accademia di San Luca,** and several, such as **Giaquinto Corrado** and **Élisabeth Vigée Le Brun,** were made members. **Giovanni Paolo Panini** was the best-known Roman artist of the period, celebrated for his inventive *vedute,* which influenced **Giovanni Battista Piranesi** and **Hubert Robert,** among others. The ruins at Tivoli and other sites in and around Rome stimulated the development of a taste for the picturesque in the late Rococo period, which can be seen in the numerous drawings made by Robert and **Jean-Honoré Fragonard.** A strong shift toward **Neoclassicism** occurred midcentury, provoked by the discoveries at Herculaneum and Pompeii and coinciding with the anti-Rococo reaction that called for a return to serious history painting. *See also* ADAM, ROBERT; BARRY, JAMES; CLASSICISM; DAVID, JACQUES-LOUIS.

**ROUBILIAC, LOUIS FRANÇOIS (1702–62).** A sculptor of French birth, Roubiliac studied at the **Académie Royale de Peinture et de Sculpture** in **Paris** before leaving for **England** in 1730 as part of the Huguenot exodus from **France.** He frequented Slaughter's Coffee House in London, a meeting place for writers and artists, such as **William Hogarth, Hubert Gravelot,** and **Francis Hayman.** Roubiliac received his first major London commission from Jonathan Tyers, the proprietor of **Vauxhall Gardens,** for a

full-length marble statue of *George Frederick Handel* (Victoria and Albert Museum, London) that was completed in 1738. Emphatically modern in its depiction of a living composer, the contemporary sensibility of the work is enhanced through the informality of pose and the pleasing contrasts of compositional lines, which are **ornamental** rather than classically informed. During this same period, Roubiliac completed **portrait** busts of friends and acquaintances, including Hogarth and the author Alexander Pope, matching the choice of costume and dress to the sitter's character, which the artist vividly portrayed through his naturalistic handling of facial features. In 1745, he began to teach **sculpture** at the **Saint Martin's Lane Academy**, which scholars have described as the nursery of the English Rococo. Roubiliac made a number of sculptural monuments, including *William Shakespeare* (1758, British Museum, London), which was commissioned by the actor **David Garrick**. Such networks of contacts, between Tyers, Garrick, Hogarth, and Roubiliac, who each fostered connections between art and contemporary life through fashionable themes and forms, suggest that the Rococo in England is more about staking a claim for modernity rather than the close following of continental models.

**RUSSIA.** In 1703, Tsar Peter the Great founded the city of Saint Petersburg by the Baltic Sea. Situated physically at Russia's opening to the West in a position secured by victories in the Great Northern War against the Swedes, Saint Petersburg stood as a symbol of Peter's authority, military might, and ambitions for an expansive empire. As the city was built on lands recently gained, Saint Petersburg presented an opportunity to signal Peter's dramatic cultural reorientation of Russia toward the West by embracing Western forms in **architecture**, **painting**, **sculpture**, and **interior decoration**. At first, Peter was inspired by the palaces and cities he had seen on his first European tour in 1697–98, which took in much of the Baltic region, Central Europe, **Germany**, **Holland**, and **England**. He imported Swiss-Italian, Italian, German, and French architects and artists to work on the design, construction, and decoration of building work in Saint Petersburg and the palace and grounds of **Peterhof** to the west of the city. The example of **Versailles** also loomed large in the Tsar's imagination as a result of a second Western tour of 1716–17 that included **France**. While his stylistic choices revealed an international mix of influences, the main source of inspiration was clearly France, as is evidenced not only by his employment of a French team of architects, sculptors, and painters led by Alexandre-Jean-Baptiste Le Blond but also by the French names given to the pavilions constructed on the grounds of Peterhof in the 1720s: Mon Plaisir, Marly, and Ermitage. The **ornamentalist Nicolas Pineau** was also part of Le Blond's team and was responsible for the delicate

carvings that are among the most Rococo aspects of the Tsar's private spaces at Peterhof.

Later in the century, Peter the Great's successors were attracted by the more lighthearted aspects of the Rococo, particularly its playfulness and artful naturalness. Following an incognito **grand tour** in 1781–82, which included lavish entertainments in the **gardens** of **Chantilly** and other royal châteaux, Grand Duke Paul and his wife, Maria Fedorovna, brought back volumes of architectural drawings and visual mementos of their visits. In addition, the grand duke ordered the transformation of sections of the grounds of Pavlovsk into a Rococo garden.

The complex of "Chinese" buildings at Catherine the Great's Tsarskoe Selo, which included a Chinese village, was similarly inspired by the exotic fantasies of the Rococo and stands as the most extensive elaboration of **chinoiserie** in 18th-century Europe. Catherine also patronized a number of Rococo artists, including **Étienne-Maurice Falconet**, whom she brought to the Russian court on the advice of **Denis Diderot** to produce a monumental bronze equestrian statue of *Peter the Great* (unveiled 1782, Saint Petersburg). Catherine the Great and other Russian aristocrats were also avid collectors of **Sèvres** porcelain. Prince Nikolai Borisovich Yusupov had a collection admired for its quality and variety that he acquired on purchasing trips to **Paris** in the 1780s and through gifts from **Louis XVI** and **Marie-Antoinette**. Catherine the Great is less known for her Rococo tastes than for her architectural **patronage**, which significantly contributed to the development of **Neoclassicism** in Russia. Her classicizing tastes were encouraged through her correspondence with major figures of the **Enlightenment**, including Diderot, **Baron Melchior von Grimm**, and Voltaire. *See also* ABSOLUTISM.

# S

**SACCHETTI, GIOVANNI BATTISTA (1690–1764).** *See* PALACIO REAL DE MADRID.

**SAINT-AUBIN, GABRIEL DE (1724–80).** From an artistic family of royal embroiderers, draftsmen, engravers, painters, and **ornamentalists**, Saint-Aubin chronicled the artistic life of **Paris** in his sketchbooks (Musée du Louvre, Paris, and Nationalmuseum, Stockholm) and drawings on the margins of sale catalogs and **Salon** *livrets* (examples from the 1760s and 1770s are held at the Bibliothèque Nationale de France in Paris). These sketches and marginalia provide important visual records of how art was hung and experienced by viewers in 18th-century Paris. He also recorded the pleasures and entertainments of Paris and its surrounds in his **paintings**, watercolors, and engravings, such as *A Street Show in Paris* (1760, National Gallery, London), *The Tuileries* (1760, Bibliothèque Nationale de France, Paris), and *Company Taking a Promenade* (1760–61, Hermitage Museum, Saint Petersburg). Although many of his drawings and sketches have not survived, his brother, Charles-Germain, estimated Gabriel's artistic output at over 100,000 works. Of considerable recent interest to scholars is the Saint-Aubin private family albums, the *Livre des Saint-Aubin* (Musée du Louvre, Paris) and the *Livre de caricatures tant bonnes que mauvaises* (Waddesdon Manor, Buckinghamshire), which appear to be creative, pictorial amusements shared between the siblings from the early 1740s until the mid-1770s.

**SAINT MARTIN'S LANE ACADEMY.** In 1735, **William Hogarth** revived the Academy of Painting and Sculpture founded by Sir Godfrey Kneller in 1711, which had ceased to function in the early 1720s while under the direction of Louis Chéron and John Vanderbank. Meetings and classes at the Saint Martin's Lane Academy were primarily dedicated to the study of life drawing, taught by artists now associated with the **English Rococo**, including Hogarth, **Francis Hayman**, **Hubert Gravelot**, **Louis François Roubiliac**, Richard Yeo, and George Michael Moser. These artists frequented the cosmopolitan gathering place of Slaughter's Coffee House in London, described

by George Vertue in 1739 as "a rendezvous of persons of all languages and nations Gentry artists and others," and were all involved in Jonathan Tyers's venture at **Vauxhall Gardens**. Saint Martin's Lane Academy was distinguished from its continental counterparts by its nonhierarchical structure and remained in operation until the Royal Academy of Arts was founded in 1768.

**SALONS, PARIS.** The Salons were public exhibitions of art held regularly in **Paris** from 1737 onward. During the second half of the 17th century, the **Académie Royale de Peinture et de Sculpture** began to display the **paintings** of its members, first in its meeting rooms, which were cramped, and then in the open arcades of the **Palais Royal**, which were too exposed to inclement weather. By 1699, under the direction of Jules Hardouin-Mansart, the newly installed *surintendant des bâtiments*, the Académie Royale moved its exhibitions into the Palais du Louvre, eventually settling in the Salon Carré, from which the Salons derive their name. The Salons were initially irregular, with only one exhibition occurring between 1704 and 1737, when the new *directeur général des bâtiments*, **Philibert Orry**, established the biennial events (for a short time, they were annual). Participation was restricted to academicians, whose works were listed in the accompanying catalog, the *livret*, according to their status within the Académie Royale, thereby reinforcing internal hierarchies. The Salons gave rise to art critics, such as **Étienne La Font de Saint-Yenne** and **Denis Diderot**, as well as art theorists who wrote in response to the exhibitions and took it upon themselves to enlighten and instruct a wider literate public. This was a shift away from the literary practices of earlier *amateurs*, who wrote primarily for an inner circle of artists and **patrons**. Art criticism of works displayed at the Salons gave a voice to the anti-Rococo reaction that developed from the middle of the 18th century onward. *See also* BÂTIMENTS DU ROI; GRIMM, FRIEDERICH MELCHIOR.

**SANSSOUCI, SCHLOSS, POTSDAM.** Schloss Sanssouci is the apogee of the **Frederican Rococo**, expressing through its placement and design an enthusiasm for nature and a dedication to the related purposes of leisure and pleasure. It was built between 1745 and 1747, in part according to plans supplied by **Frederick the Great** to his favorite architect, **Georg Wenzeslaus von Knobelsdorff**. The king's idea was for a garden retreat based on the design of a *maison de plaisance*, following patterns set by the Grand Trianon at **Versailles** and **Amalienburg** at **Nymphenburg**. As Sanssouci would also serve as the principal residence of the king during the summer, some imperial resonance was required in its architectural form. The result is a unique combination of visual associations. Certain elements of the building employ the **ar-**

**chitectural** conventions of the orangery, such as the suite of arched windows and doors along the main facade that communicates directly with the garden terraces planted with vines. Other elements are more imposing, such as the colonnade of Corinthian columns and the rounded cupola that have both imperial and celestial overtones. These ideas are also evoked by the shape and location of the building, which sits crown-like atop a rise of terraces. In this, Sanssouci possesses a certain degree of regal architectural wit, which it shares with the **Zwinger** in Dresden. The interior likewise mixes areas of royal grandeur with spaces of intimate retreat and includes a concert room in which the king himself performed with some of the most famous musicians of the age. Frederick was actively involved in the design of the exterior, and the interiors are the result of close collaboration between the king and his teams of court architects, painters, and **ornamentalists**, including Knobelsdorff, **Johann August Nahl**, **Antoine Pesne**, and the **Hoppenhaupt brothers**. *See also* GERMANY; PATRONS AND PATRONAGE.

**SCULPTURE.** As with **architecture**, Rococo sculpture struggles to differentiate itself as a distinct style, independent from the traditions of the Italian Baroque and classical antiquity. The influence of **Gian Lorenzo Bernini**'s sculptural spirit—its theatricality, emotional intensity, and dynamic movement—was strongly felt by sculptors working in the first half of the century, until discoveries at Pompeii and Herculaneum stimulated a renewed enthusiasm for the purified forms of **Classicism** around the middle of the century. Nevertheless, a set of stylistic criteria can be used to identify Rococo sculptural works: **asymmetry** of pose and composition, sensual charm and grace, delicacy of movement, and a preference for curvilinear forms and ornamental contrasts. Such forms can be found in the works of the major sculptors of the Rococo period, including **Edme Bouchardon**, the **Coustou brothers**, **Antoine Coysevox**, **Étienne-Maurice Falconet**, **Jean-Baptiste Lemoyne**, **Jean-Baptiste Pigalle**, and **Louis-François Roubiliac**. These characteristics link the forms of Rococo sculpture to other types of Rococo art and architecture. In addition, Rococo sculpture subtly challenged the authority of sculptural traditions through variation, play with convention, and the reinterpretation of inherited schemas.

Sculpture, perhaps more than any other artistic medium, was grounded in the canon of antique statuary from the 15th century onward. The majority of 18th-century sculptors worked to commission, primarily owing to the expense of materials and the length of time required to produce large-scale pieces. Experimentation and freedom of expression was, therefore, relatively limited when compared to the other plastic arts. Increasingly, however, private collectors began to acquire small-scale models in bronze, terracotta,

and **porcelain**. During the first half of the century, these works were rarely commissioned from the point of creative inception; rather, they tended to be reductions of large-scale, semi-public works that adhered to the familiar formats and conventions of specific sculptural types (equestrian, allegorical, monumental, and commemorative, as well as the **portrait** bust). In **France**, sculptors exhibited their major commissions at the **Salons**, which often led to a demand for further versions if the original was a success. Even so, this type of **patronage** relied more on replication than innovation. Perhaps more than anything else, what stimulated change around midcentury was the increased popularity of the statuette in *biscuit de Sèvres*, the production of which was encouraged through the patronage of the **marquise de Pompadour** and the artistic direction of Falconet at the porcelain factory at **Sèvres**. Other small-scale statuettes in bronze, marble, and terracotta followed suit, depicting putti, **children**, and **women**, mostly in the nude. This is a significant contribution of the Rococo period to the history of sculpture, which effectively created a new genre within the medium.

Much Rococo sculpture is inextricably linked to **architecture**, where it performed the role of decoration, and to garden spaces, where it contributed central features to the layout and design. In **Germany** and Central Europe, where the Rococo developed in connection with palatial and ecclesiastical building projects, sculpture assumed a pivotal role in creating a cohesive relationship between architecture and **ornamentation**. **Johann Baptist Zimmerman**'s **stuccowork** in the Mirror Room of **Amalienburg** (1734–39) near Munich presents loosely narrative scenes of the hunt, defining itself as sculpture at the same time that the elaborate ornamentation of its forms dissolves mass and erodes architectonic structure. The high achievement of **Bavarian Rococo** sculpted stuccowork is the result of international tendencies and local traditions. The superior craftsmanship of artisans, trained for generations in the art of limewood carving, enabled the three-dimensional realization of complex designs proposed by French ornamental engravings, as well as the development of original Rococo sculptural forms, as seen in the work of **Ignaz Günther** and **Joseph Anton Feuchtmayer**. Similarly, in **France**, dynasties of sculptors and woodcarvers had the necessary training to achieve such seamless relationships between architecture, sculpture, and ornamental **paneling** as that found in the Salon Ovale du Prince at the **Hôtel de Soubise** in **Paris** (1735–40). **England**, however, lacked a native tradition of craftsmanship and this dynastic tendency in sculpture and sculptural carving. Therefore, English Rococo interior ornamentation was largely limited to **plasterwork**, which was easier to work with and required less training.

While there were significant pressures on European sculpture during the Rococo period to serve as ornamentation, the status of sculptors increased

in association with academic practice. Aspiring 18th-century sculptors were taught to draw as the foundation of their art, and leading Rococo sculptors were their teachers. Roubiliac, at the **Saint Martin's Lane Academy**, and **Jean-Baptiste Lemoyne**, at the **Académie Royale de Peinture et de Sculpture**, were influential in this regard. Contemporary art criticism also contributed to the revitalization of sculpture as a highly respected medium by reflecting on the sculptural achievements of antiquity. **Denis Diderot** argued for the significance of sculpture in his *Salons* of 1765, proclaiming that it was a medium uniquely suited to transmit to posterity the progress of the arts of any nation. *See also* GARDEN DESIGN; PERMOSER, BALTHASAR.

**SÈVRES PORCELAIN.** During the 17th and 18th centuries, there was fierce competition among the princely courts of Europe to establish **porcelain** manufactories and to find a formula for the production of true porcelain, which was first developed in western Europe by **Meissen** in Saxony around 1710. Meissen was the chief rival of Sèvres, which was the Manufacture Royale de Porcelaine in France. Initially, the manufactory was located in the Château de Vincennes, but by 1756, it had moved into a purpose-built complex on the outskirts of **Paris**, largely as a sign of official support from the king.

Sèvres produced a range of objects in hard- and soft-paste porcelain, including small sculptural pieces, **ornamental** vases, plaques, and tableware in innovative shapes. Most typical are those featuring vivid paintings on enamel set against deeply colored backgrounds with gilded ornamentation. By 1759, **Louis XV** had assumed complete ownership of Sèvres, putting the resources and authority of the French crown behind the factory, which became a distinctly royal enterprise. As with other French royal manufactories of luxury goods, prominent artists and designers worked at Sèvres, establishing close links between fashions in **painting**, the decorative arts, and porcelain. For much of the 18th century, **Jean-Jacques Bachelier** was the artistic director at Sèvres. The **marquise de Pompadour**, Louis XV's titled mistress, took a keen interest in the manufactory, involving artists whom she patronized, such as **François Boucher** and **Étienne-Maurice Falconet**, in the creation of designs. An example of the relationship struck between Pompadour, her **patronage** of leading artists, and their subsequent involvement at Sèvres is the bisque *L'amour Falconet* (1766–73, Huntington Library and Art Collection, San Marino), a miniature version of Falconet's marble *Cupid* commissioned by Pompadour and exhibited at the **Salon** of 1757, the same year the artist was appointed head of the sculpture studio at the porcelain factory. *See also* SCULPTURE.

**SINGERIES.** The term *singeries* derives from the French word *singe*, meaning "ape" or "monkey." It refers to a mode of decoration figured with monkeys, often wearing clothing and "aping" the actions or occupations of human beings. **Claude III Audran** was one of the first artists to employ *singeries* as part of his decorations for the Château de Marly. **Antoine Watteau** and **Jean-Baptiste-Siméon Chardin** both painted representations of monkeys in the guise of artists. **Christophe Huet** developed *singeries* to fill the decorative schemes of entire rooms at the **Château de Chantilly** (c. 1735) and the Hôtel de Rohan (1745), where *singeries* are merged with **chinoiseries**, and monkeys ape the habits and airs of both the European noble and the Chinese mandarin. The popularity of this mode of **interior decoration** extended across Europe, with one of the finest examples remaining in situ at Kirtlington House in the Monkey Room, painted by **Andien Clermont** (1745). A more naturalistic treatment of *singeries*, characteristic of the **Frederican Rococo**, appears in the sculpted **ornamentation** of the Voltaire Room at **Sanssouci**.

**SMITH, JOSEPH (1674–1770).** Along with **Francesco Algarotti**, Joseph Smith was the most significant art **patron** in 18th-century **Venice**. He moved to **Italy** from his native London sometime around 1700, initially to pursue a career as a businessman and merchant. His friendships with contemporary Venetian artists, such as Anton Maria Zanetti, Marco and Sebastiano Ricci, **Rosalba Carriera**, and **Canaletto**, as well as his growing networks of contacts with British men on the **grand tour**, opened up a new profession for Smith, who acted as an agent for artists and collectors. Venice was known as a center for decorative painters and a place to purchase fashionable *vedute* and *capriccios*, and Smith found his niche in this market. His considerable diplomatic skills, which served him well as an agent, led to his later appointment as the British consul in Venice in 1744. Smith had a remarkable collection of contemporary Venetian painting and drawings as well as Old Master works, most of which he sold to George III in 1762, when he experienced a financial crisis.

**SNUFFBOXES.** These airtight luxury boxes, called *tabatières* in French, were made to transport small amounts of grated tobacco, or snuff, which was inhaled to provoke a healthy sneeze. In size, the gold boxes were designed to fit comfortably in the hand or pocket. Rare and exquisite materials were used in their decoration: miniature **painting** on copper or enamel, **porcelain**, lacquer, diamonds, and precious stones. Goldsmiths drew on the fashionable designs of contemporary Rococo painters and **ornamentalists**. Examples at the Huntington Library and Art Collections in San Marino include painted enamels and **Sèvres** porcelain plaques after designs by **Nicolas Lancret** and

**François Boucher**. Some of the most exceptional snuffboxes provide rare visual documentation of *hôtel particulier* interiors, popular entertainments, fairs, and street life in **Paris**, such as the boxes produced by the **Van Blarenberghes**. *See also* CARRIERA, ROSALBA.

**SOUFFLOT, JACQUES-GERMAIN (1713–80).** Although Soufflot is remembered as the leading **Neoclassical** architect in **France** and often linked to the **Enlightenment** rather than the Rococo, he was a significant figure within the artistic culture of **Louis XV**'s reign. His formative architectural training began in **Rome**, where he was admitted to the Académie de France in 1734 and first began to investigate classical sites. When he returned to France in 1738, he settled in Lyon, which provided him with more opportunities as a young architect. He received public and private commissions, including work on the Hôtel Dieu, and he adapted his style according to the requirements of the commission. He also delivered papers at the Lyon Academy on topics ranging from an attack on modern **architecture** to a tentative defense of the **Gothic**. In Lyon, Soufflot was not, however, cut off from developments in **Paris**, as he formed important connections with **patrons** of influence and sent his designs back to Paris to be assessed by leading academicians, most notably drawings for a public square dedicated to Louis XV (1748, eventually leading to Gabriel's designs for what is now the Place de la Concorde).

Soufflot's reputation reached the king's new mistress, **Madame de Pompadour**, who was looking for companions to accompany her brother, the future **marquis de Marigny**, as cultural guides on an abbreviated **grand tour** through **Italy** that would complete his education in preparation for his advancement to the post of *surintendant des bâtiments* (from 1751 onward). Fluent in Italian, Soufflot became Marigny's instructor in architecture, traveling with him (alongside the engraver **Charles-Nicolas Cochin** and the writer Abbé Leblanc) to Rome in 1750. The journal kept by Cochin and later published indicates that the taste of this group of travelers was inclined toward the antique. Soufflot and Cochin journeyed farther south together, as both were interested in the Greek temples of Paestum and the excavations at Pompeii and Herculaneum.

This trip, taken by men who would assume positions of significant power and authority in the arts, signals the beginnings of the *goût grec*, which would take hold in Paris for the next 20 years and initiate the development of **Neoclassicism**. Marigny's patronage and support of Soufflot situated the architect, newly arrived in Paris, as the rival of **Ange-Jacques Gabriel**, the *premier architecte du roi*. In 1753, **Baron Grimm** wrote that Soufflot was the "only architect famous today in France." Two years later, Soufflot was appointed architect of Sainte-Geneviève (now the Pantheon), and in 1756,

Marigny put him in charge of the **Bâtiments du Roi**, the royal **tapestry** factory of **Gobelins**, and the carpet factory of Savonnerie. Numerous other honors and positions followed, culminating in his appointment by the **comte d'Angiviller**, Marigny's successor, as *intendant général des bâtiments du roi* in 1776, which made him the most powerful French architect of his generation. His friendship with the *encyclopédistes* and the evident **Classicism** of his style suggest Soufflot to be a proponent of the anti-Rococo reaction, yet his association with Marigny, brother to the woman who is most often connected to the height of the Rococo as a style, Madame de Pompadour, demonstrates the complexities of relationships in matters of taste that defy division along oppositional lines. *See also* À LA GRECQUE.

**SPAIN.** The relationship between the Rococo and Spain is an uneasy one. Many scholars question the existence of a true "Spanish" Rococo. The shift to Rococo forms and themes in Spain was largely the result of French tastes introduced by the newly installed **Bourbon** monarchy at the beginning of the 18th century. When **Philip V** moved from **Versailles** to Madrid in 1701, he began to import artists and craftsmen from his native **France**. Among the academic painters he recruited were **Michel-Ange Houasse**, Jean Ranc, and **Louis-Michel van Loo**. These artists were instrumental in the establishment of the first official academy of the arts in Spain, the **Real Academia de Bellas Artes de San Fernando**. The Rococo manner of their works influenced the Spanish painters who worked around them, such as **Miguel Jacinto Meléndez** and Antonio González Ruiz, as did the stylistic preferences of the Bourbons. **Charles III** maintained the Francophilic inclinations of his father but also favored the Italian Rococo artist **Giambattista Tiepolo**, who completed a number of decorative **ceilings** at the **Palacio Real de Madrid** and designed frescoes for the Church of the Holy Trinity at **La Granja de San Ildefonso**.

The dominance of Rococo tastes in official circles, whether derived from French or Italian models, merged with local traditions and impacted upon the early manner of **Francisco de Goya**. It is seen specifically in the original **genre** scenes he produced as **tapestry** cartoons, which introduced local Spanish figures, pastimes, and modes of **dress** into the visual language of the Rococo. Goya's alteration of Rococo motifs according to native customs influenced his brother-in-law, **Francisco de Bayeu**, who developed similar subjects. It also drew the attention of sophisticated female **patrons** of Madrid society, namely the **Duchess of Osuna** and the **Duchess of Alba**. The patronage of these **women** encouraged the production of images that incorporated the decorative fashions of French Rococo art but that are uniquely Spanish in their sobriety of **color** and composition.

The Spanish Rococo thrived in the decorative arts, not only in the tapestries produced at the **Real Fábrica de Tapices y Alfombras de Santa Bárbara** but also in the **porcelain** objects created at the Fábrica del Buen Retiro, which Charles III moved from Capodimonte shortly after his succession to the Spanish throne. As the refurbishment of royal palaces was a large part of the Bourbon cultural agenda in 18th-century Spain, the productions of these factories serviced major decorative projects at **El Escorial** and **Aranjuez.**

**STUCCO AND PLASTERWORK.** Rococo stucco and plasterwork is notable for its elaborate and complex combinations of figural and ornamental designs. As a material used in architectural **ornamentation**, stucco dates back to ancient Roman times. It is generally composed of dehydrated lime mixed with pulverized marble and differs from plaster, which uses gypsum as its base. The suitability of this pliable medium to **grotesque** ornamentation led to a renewed interest in stuccowork when Rococo forms began to emerge as part of interior decorative schemes at the court of **Versailles** and in **Paris**. The preference for **boiseries** in 18th-century **France**, however, led to the general perception of stuccowork as an inferior and cheaper alternative to woodcarving.

In **Great Britain**, local plaster firms dominated the market, although they were challenged in the first half of the 18th century by the talented teams of Swiss-Italian stuccoists brought from Ticino to work on country houses, such as Castle Howard. A spirit of competition encouraged plasterers to pursue Rococo designs, and remarkable achievements were made by Thomas Clayton in Scotland and the firm of Joseph Rose and Company in **England**. **Bavarian Rococo** artists, the best known of whom is **Domenikus Zimmermann**, produced the most masterful stuccowork. Like the Swiss-Italians, **German** artisans had become highly skilled in working in cooperative teams from the 17th century onward. Zimmermann, for example, often worked with his brother, a painter, and the architect **François de Cuvilliés** at the Bavarian court in Munich. Their execution of the stucco decoration of **Amalienburg** (1734–37) in the **gardens** of Schloss **Nymphenburg** realized in three dimensions what had only been depicted by French printmakers at the time. Moreover, German artists and craftsmen built on centuries of limewood sculpting traditions, which they translated into their handling of stucco as a medium for architectural ornamentation. Consequently, the most spectacular examples of Rococo stuccowork can be found in the interiors of Bavarian Rococo churches and palaces. Similarly, stucco was a fundamental material of the **Frederican Rococo.** *See also* ARCHITECTURE; FEUCHT-MAYER, JOSEPH ANTON; FISCHER, JOHANN MICHAEL; INTERIOR DECORATION.

**STYLE RÉGENCE.** The *style régence* refers to the **furniture** design and modes of **interior decoration** in the years 1715 to 1723, when **Philippe II, duc d'Orléans**, was regent of France during the minority of **Louis XV**. As this was a period when the nobility returned to **Paris** and attempted to reassert old hierarchies, the *style régence* is often associated with high-ranking members of the aristocracy, their behavioral codes and values. The style emerged around 1700 in the **grotesque** and **arabesque** decorations of **Jean Bérain** and **Claude III Audran**, whose designs and themes influenced the early work of **Antoine Watteau**. Consequently, the *style régence* is often a term used in connection with *fête galante* painters. More specifically, the style is directly associated with the decorative artists and **ornamentalists** who worked for the duc d'Orléans, such as **Gilles-Marie Oppenord**. *See also* ARCHITECTURE; FRANCE.

**SWEDEN.** Following the death of Karl II in 1719 and the conclusion of the Nordic war in 1721, Sweden experienced a period of economic crisis that inhibited the funding of major building projects and **patronage** programs of the type that had characterized the Golden Age of Gustav II Adolf and Queen Christina during the 17th century. Expansive patronage of the arts by the Swedish crown did not occur again until 1770s and 1780s, under Gustav III. A taste for the Rococo was, nevertheless, embraced by the monarchy and nobility for most of the 18th century, as Swedish patrons and collectors continued to be inspired by the example of the French court at **Versailles** and the growing fashionability of **Paris**.

Many French artists and craftsmen were brought to work in Sweden during the first two decades of the 18th century and took with them the latest Rococo forms of **ornamentation** from **France**. In 1728, **Carl Gustav Tessin** took over his father's position as superintendent of the royal residences. He later became the Swedish ambassador to France and lived for several years in Paris around 1740. Tessin traveled extensively throughout Europe, making his first **grand tour**, at the age of 19, through **Germany**, France, and **Italy**. During his travels and extended stay in Paris, Tessin's activities were focused on making contacts with dealers, artists, and collectors, as well purchasing works of art for the crown and extending the art collections of his own family, which were already substantial. His preference for works by Rococo artists was shared by Queen Lovisa Ulrica, for whom he purchased significant paintings by **Jean-Baptiste-Siméon Chardin** and **François Boucher**.

Under Tessin, practical supervision of royal building projects and their interior decoration was entrusted to Carl Hårleman, whose tastes were influenced by the designs of the French ornamentalists **François-Antoine Vassé** and **Nicolas Pineau**. The Swedish variation on their use of **rocaille**

sculptural forms in **paneling** involved a greater emphasis on subtle symmetries. A peculiar Swedish adoption of the French Rococo can be seen in local interpretations of works by Boucher, **Charles-Joseph Natoire**, and **Jean-Baptiste Oudry**, which were copied as wall decorations. Although a Swedish Royal Academy of Drawing was founded in 1735, with the French painter Guillaume-Thomas Taraval appointed as a teacher, many Swedish painters left for other parts of Europe to find work. The most significant Swedish Rococo portrait painters were Alexander Roslin and Gustaf Lundberg, both of whom trained in France. As in other parts of Europe, there was an enthusiasm for **chinoiserie** in Sweden during the 18th century, the most notable example of which is the Rococo Chinese village built by Carl Fredrik Adelcrantz for the royal family at Drottningholm. *See also* ARCHITECTURE; INTERIOR DECORATION; PAINTING.

# T

**TAPESTRIES.** Tapestry refers to weft-faced textile woven on a loom. It was used in figurative or patterned wall hangings and as upholstery on **furniture**. Weavers typically copied designs from painted cartoons, and the medium proved particularly suitable for the painterly effects and **colors** characteristic of the Rococo. New manufactories were opened in Saint Petersburg, Turin, Naples, Berlin, and Madrid under the **patronage** of imperial and princely courts, while older workshops and manufactories in Brussels, Antwerp, **Paris**, London, Munich, and **Rome** continued to thrive. In **France**, **Claude III Audran** and **Charles-Antoine Coypel** produced **arabesque** and **grotesque** designs that form the earliest Rococo decorative schemes. Shortly thereafter, a close alignment was struck between tapestry and **painting**, which was initially due to the fact that major artists produced designs for cartoons in the same style as their painted works. At **Gobelins**, **Jean-Baptiste Oudry** and **François Boucher** were successively in charge of artistic direction for nearly 50 years, and they both provided designs to the manufactories of **Beauvais** and Aubusson, as well. Among their most successful subjects were the hunting scenes produced by Oudry and the pastorals and **chinoiserie** designs produced by Boucher. In **Spain**, **Francisco de Goya** created memorable designs of courtly and popular games, which are his most Rococo works in theme and style. *See also* REAL FÁBRICA DE TAPICES Y ALFOMBRAS DE SANTA BÁRBARA, MADRID.

**TESSIN, COUNT CARL GUSTAV (1695–1770).** Born into a family of Swedish **patrons** and art collectors, Tessin was sent at the age of 19 on a **grand tour** through **Germany**, **France**, and **Italy**. On this trip, he made his first purchases of works on paper, some for his father and others to start his own collection. While in **Paris**, in 1715, he bought drawings from **Antoine Watteau** and met **Pierre-Jean Mariette**, a prominent French collector of drawings who would become a mentor to Tessin as he entered the elite world of *amateurs* specializing in the collection of drawings by contemporary artists. Back in **Sweden**, Tessin became superintendent of the royal residences in 1728, a post that put him in charge of the decoration of the Royal Palace.

To accomplish this task, he made trips to Paris and **Venice**, with the aim of inviting French and Italian artists to work at the Swedish court. On these trips, he also made important purchases for his own collection and that of the royal family, exhibiting a distinct preference for Rococo artists, such as **Giambattista Tiepolo**, **Francesco Zuccarelli**, Watteau, **Nicolas Lancret**, and **Jean-Baptiste Pater**, among others.

Between 1739 and 1742, Tessin served as the Swedish ambassador to France. He lived in Paris and held fashionable salons attended by artists, writers, musicians, and collectors. Tessin regularly visited the studios of artists, purchasing works directly from **Jean-Baptiste-Siméon Chardin** and **François Boucher**, as well as commissioning **portraits** from **Jean-Marc Nattier** and **Jean-Baptiste Oudry** (the latter painted his basset hound). On behalf of Lovisa Ulrica, Queen of Sweden, he commissioned Chardin's *Domestic Pleasures* (1747) and Boucher's *The Milliner* (1746, both Nationalmuseum, Stockholm). In 1741, Tessin purchased over 2,000 drawings from the sale of **Pierre Crozat**'s collection, which included works by Italian, French, and German artists from the Renaissance through to the 18th century. His aim was to create a collection that would serve as a history of drawing. He brought the vast collection that he had amassed back to Sweden, much of which later entered the collection of the royal family and is now in the Nationalmuseum in Stockholm.

**TIEPOLO, GIOVANNI BATTISTA (GIAMBATTISTA) (1696–1770).** Giovanni Battista, or Giambattista, Tiepolo was the most successful fresco painter in 18th-century Europe. Most of his decorative work remains in situ, adorning the walls and **ceilings** of palaces throughout Northern **Italy** and Southern **Germany**. He was also highly sought after as a painter in oil on canvas and a gifted draftsman and sent entire collections of his drawings abroad to avid **patrons**.

Tiepolo was not from a dynasty of artists, although he started one, working closely with his sons, **Giovanni Domenico (Giandomenico)** and Lorenzo. His father, Domenico Tiepolo, who was a tradesman and part owner of a commercial boat, died when Giambattista was only one year old. His mother, then, was responsible for securing an apprenticeship for her son with one of **Venice**'s leading artists and teachers, Gregorio Lazzarini. He augmented Tiepolo's training with study of Veronese's work, which influenced his choice of **color** and costuming in one of his first major decorative commissions. In 1726, the Patriarch Dionisio Dolfin commissioned the decoration of a gallery in the Archbishop's Palace at Udine from Tiepolo. This was the artist's first opportunity to carry a decorative scheme across an entire room. His themes were taken from the Book of Genesis, but despite the serious subject

matter, the treatment is distinctly lighthearted. Biblical figures are dressed in 16th-century costumes and set against luminous landscapes. The overall effect of the room comes from color, rather than design, with emphasis placed on shimmering fabrics and **ornamentation**, as seen in *The Angel Appearing to Sarah* (in situ, Archbishop's Palace, Udine).

Tiepolo's fame spread quickly through the princely courts of Europe. Working in Milan between 1730 and 1731, he frescoed walls and ceilings in the Palazzo Archinto and Palazzo Casati. By 1732, Tiepolo had secured enough of a reputation for his talents that Vincenzo de Canale, a Venetian noble who wrote on the arts, was led to remark that his manner was "resolute and rapid" and his nature, "all spirit and fire." He also began to command high fees for his work. In 1736, when **Count Tessin** was looking for painters to decorate the Royal Palace in **Sweden**, he was unable to meet the artist's asking price. Tessin did, however, acquire two works for his private collection: modellos of *Beheading of John the Baptist* (Nationalmuseum, Stockholm), and a mythological **painting**, *Danaë and Jupiter* (Stockholm University). In describing Tiepolo's working methods, Tessin noted that he could paint "a picture in less time than it would take another to mix his colors," an apt assessment of his rapidity of execution. During the late 1730s and early 1740s, Tiepolo took on a number of commissions from patrons in Southern **Germany** and Northern Italy, which he carried out with characteristic energy and speed. For the archbishop elector of Cologne, Clemens August von Wittelsbach, he painted an altarpiece of *The Vision of Saint Clement* (before 1739, Alte Pinacothek, Munich) for Our Lady at **Nymphenburg**.

Around the same time, he signed a contract with the Dominican Order in Venice to complete 40 frescoes (1738–39) for the church of the Gesuati, Santa Maria del Rosario, which he did in just 12 months. Following these commissions, he took on three more major decorative schemes for the Palazzo Clerici in Milan (*The Chariot of the Sun*, 1740), the Villa Cordellina in Montecchio Maggiore (*The Family of Darius before Alexander* and *The Magnanimity of Scipio*, 1743), and the Palazzo Labia in Venice, where he collaborated with the *quadratura* specialist Girolamo Mengozzi Colonna (*The Meeting of Anthony and Cleopatra* and the *Banquet of Anthony and Cleopatra*, 1746–47) and in which his mature style is evident. The illusionism and wit of the scheme conflates real and fictive space in a manner characteristic of Rococo painting. No other artist in this period matched Tiepolo's output in large-scale decorative painting.

The last two decades of Tiepolo's career were equally demanding, taking him to Franconia, back to Venice and the Veneto, and finally to **Spain**, where he died. Although he had sent many works outside of Italy, he made his first trip abroad in 1750 to work on the **Würzburg Residenz** for the reigning

Prince-Bishop Carl Philipp von Greiffenklau. There he collaborated with the architect **Balthasar Neumann** to create the most magnificent interiors of the German Rococo. Tiepolo was initially hired to paint ceiling frescoes in the Kaisersaal. The theme was drawn up by a local court-historian and intended to represent the imperial authority of the prince-bishop dating back to the 12th century. Tiepolo worked with Neumann's team of **stuccoists** to achieve remarkable feats of illusionism that move trompe l'oeil effects of painting into three-dimensional sculpted decoration. The prince-bishop was so pleased with the result that he commissioned Tiepolo to paint the enormous cove vault of the Treppenhaus, also designed by Neumann. The theme conflates allegory, mythology, and history in bringing together the gods of Olympus and the four continents of the world to pay homage to von Greiffenklau, whose portrait medallion is carried into the heavens by the personification of Europe. At Würzburg, Tiepolo was assisted by his son, Giandomenico Tiepolo, and their **portraits** are included in the ceiling.

Tiepolo continued to work on decorative schemes with his son in the 1750s, back in Venice and the Veneto, the most significant of which are at the Villa Valmarana outside of Vicenza (1757). While Giandomenico was engaged to decorate the adjoining guest quarters, or *foresteria*, Giambattista painted frescoes in the main villa with schemes from Greek, Roman, and Italian literature. Tiepolo's ability to move between biblical, allegorical, mythological, and literary themes demonstrated more a sense of theatrical versatility than studious learning, as the subjects are performed, often superficially, with paint rather than meticulously translated from a text into visual form. Around 1760, while working on the country villa of the Pisani family at Strà, Tiepolo was called to Spain by **Charles III** to paint rooms of the **Palacio Real** in Madrid, newly built according to the designs of **Filippo Juvarra**. Initially, Tiepolo was resistant, but the Spanish ambassador at Venice asked the Senate if his journey could be expedited, and the artist left in December 1761 with his two sons, Giandomenico and Lorenzo.

Although taking on less work during the last eight years of his life, he still was able to complete an impressive number of large frescoes and altarpieces in Madrid. His major project at the Palacio Real included ceilings depicting *The Glory of Spain* in the throne room, *The Apotheosis of Aeneas* in the Guard Room, and *The Apotheosis of the Spanish Monarchy* in the queen's antechamber. Tiepolo died in Spain while on another royal commission, designing frescoes for the Collegiate Church of the Holy Trinity at **La Granja da San Ildefonso**, which were completed by **Francisco Bayeu**. *See also* BAVARIAN ROCOCO.

**TIEPOLO, GIOVANNI DOMENICO (GIANDOMENICO) (1727–1804).** The son of **Giovanni Battista (Giambattista) Tiepolo**, Giovanni Domenico worked as the assistant to his father on many of the latter's decorative schemes. His first name is often shortened to Giandomenico or simply Domenico. Between 1750 and 1753, the two Tiepolos prepared and executed the fresco decorations of the **Würzburg Residenz**, but his independent work can be seen at the Villa Valmarana in Vicenza (1757). While his father decorated the main villa of Valmarana with episodes taken from heroic poetry, Giandomenico completed frescoes in the rooms of the guesthouse, or *foresteria*, with light-hearted **genre** scenes. He covered the walls with images of relaxed peasant life (*Peasants Reposing* and *Family Meal*), courtly promenades (*Summer Stroll*), and **chinoiserie** allegories (*Offering of Fruits to the Moon Goddess*). In works such as these, Giandomenico's style blends pastoral naturalism into the decorative spirit of the Rococo.

In the 1750s, Giandomenico produced delightful genre scenes, such as *The Minuet* and *The Tooth-Puller* (both 1754–55, Musée du Louvre, Paris), works that draw on the imagery of popular Venetian festivals involving the **commedia dell'arte** and the carnival figure of Punchinello. He took up subjects of this type again in the decorations he completed in the 1790s for the family villa Zianigo, which he initially began to work on with his father in 1759. The Pulcinella series produced some of the most witty and luminous images of the late Rococo period. Flashes of brushwork and swirling paint fill these works with a heightened sense of theatricality and a sensibility of pure pleasure. Giandomenico was also active as a draftsman in the 1790s, producing dozens of scenes of contemporary life, such as *At the Dressmaker* (Pierpont Morgan Library, New York) and a series of 104 sketches entitled *Entertainments for the Children* (an example of which is in the Nelson-Atkins Museum of Art, Kansas City), again involving the figure of Punchinello but in a more overtly satirical treatment that has been connected with the *Venerdì gnoccolare*, part of the Carnival celebrations in Verona. *See also* VENICE.

**TRADE CARDS.** Trade cards and other printed ephemera, such as invitation cards, advertisements, maps, and meal tickets, were a significant means through which the public was brought into contact with Rococo graphic design. In **Paris** and London, the number of trade cards produced and circulated increased substantially from 1730. Major artists of the period created designs for trade cards, such as **François Boucher** who produced a design for **Edme-François Gersaint**'s new shop, *La Pagode*, while **Thomas Chippendale** designed his own cards, as well as those for others. The majority,

however, were designed and produced by professional engravers. Many of the most ornate and fantastic **ornamental** designs of the Rococo period exist on trade cards, with substantial cross-pollination of motifs and forms between trade cards and decorative objects, such as silverwork and **porcelain**. *See also* ENGLAND AND THE ENGLISH ROCOCO.

*TROIS CRAYONS* **TECHNIQUE.** This term, used in the study of Rococo drawings, refers to the technique of using red, black, and white chalk to render form. It is closely associated with the working methods of **Antoine Watteau**, and the medium has become virtually synonymous with his drawing style. Watteau's technique was to use red chalk for the initial sketch of his subject, which he subsequently strengthened with black chalk and heightened with white chalk, although he varied this approach on occasion. The three-color technique was developed in French academic circles by the prominent *rubénistes*, Charles de La Fosse and **Antoine Coypel**. All three artists studied **Pierre Crozat**'s collection of Rubens's drawings in red, black, and white chalks. *See also* COLOR.

**TROPHIES.** In Rococo decorative interiors, trophies were commonly used as decorative motifs on panels, either carved or painted, or as elements incorporated into **ornamental** engravings. They represented a group of arms and armor and derived from ancient Greek and Roman usage in which real arms were taken in battle and set up as monuments of victory. In addition to standard military motifs and coats of arms, there were trophies of the church, of the chase, and of the sea. One of the earliest period uses of a fluted shell motif was in a trophy design by **François-Antoine Vassé** for the panels of the gallery of the Hôtel de Toulouse.

**TROY, FRANÇOIS DE (1645–1730).** A prominent history painter, François de Troy advanced steadily through the ranks of the **Académie Royale de Peinture et de Sculpture** from full membership in 1674 to assistant rector in 1722. Although he was initially taught to paint by his father, an artist from Toulouse, he studied with the portrait painter Claude Lefebvre when he moved to **Paris** after 1662. His friendship with **Roger de Piles** introduced him to Venetian and Flemish uses of **color**, which can be seen in his *Bacchus and Ariadne* (1717, Staatliche Museen, Berlin), a work that is indebted to Titian's bacchanals. This work reveals the extent to which themes of love and a seductive use of color dominated French history painting in the second decade of the 18th century. De Troy employed saturated blues, golds, and reds, while his use of bold chiaroscuro in the flesh tones and painterly brushwork serve both to establish form and dissolve line. Academic expressions and

gestures are present, but the continuous movement erodes legibility, which is only restored by the light coloration of the central figure.

While his mythological paintings, which explore the power of love in boldly sensual terms, place François de Troy at the forefront of stylistic developments in history **painting** around 1720, his **portraits** were equally innovative. By combining a sense of realism in the portrayal of facial features with a sensuality of paint and brushwork, Coypel enhanced the appearance of the sitter without a loss of likeness. A particularly effective example of his success with this combination is his portrait of *Jean de Jullienne* (1722, Musée des Beaux-Arts, Valenciennes). This approach was developed further by the next generation of Rococo portraitists, particularly **Jean-Marc Nattier** and Hubert Drouais. De Troy was widely sought as a portraitist by members of court and bourgeois Parisians. *See also* TROY, JEAN-FRANÇOIS DE.

**TROY, JEAN-FRANÇOIS DE (1679–1752).** The son of the successful French painter and academician, **François de Troy**, Jean-François trained with his father and also at the **Académie Royale de Peinture et de Sculpture**. He was received into the Académie Royale as a history painter in 1708, following an eight-year sojourn in **Italy**. Biblical, mythological, and historical subjects, such as *Lot with His Daughters* (1721, Hermitage Museum, Saint Petersburg) and *The Plague of Marseilles* (1722, Musée des Beaux-Arts, Marseilles), secured his reputation as a leading painter of his generation, but it is his *tableaux des modes* that are his most innovative and celebrated works. *Reading Molière* (c. 1730, private collection) and the *Declaration of Love* (1731, Schloss Charlottenburg, Berlin) are two examples of this genre in which the modes, manners, and fashions of elegant Parisians are made the subject matter of art. In these **paintings**, the viewer's attention is drawn as much to the meticulous rendering of garments, fabrics, **furniture**, and interior spaces as it is to the figural poses and gestures. Such an even-handed treatment of figures and decorative details suggests formal parallels between **rocaille** interior **ornamentation** and the physical bodies and deportment of the social elite. These works explore the artfulness of daily life within Parisian aristocratic culture as a theme worthy of painting.

De Troy painted similar decorative **genre** paintings at court for the Petits Appartements of the châteaux of **Versailles** and **Fontainebleau**, which included *The Oyster Lunch* (1735, Musée Condé, Chantilly) and *A Hunting Meal* (1737, Musée du Louvre, Paris). While distinctly different from the *tableaux des modes* in their treatment of courtly themes and settings, they are nevertheless connected, as both depict the pastimes and pleasures of modern life. *The Oyster Lunch*, for example, includes the first representation of sparkling champagne in the history of art. De Troy became the director

of the Académie de France in **Rome** in 1738 and spent the rest of his life there, although he was replaced as director in 1751. A popular teacher, he was responsible for the training of young artists in residence and, therefore, highly influential in the development of the French school of painting around midcentury. He continued to paint in Rome, and one of his final works was a portrait of the **marquis de Marigny** (1750, Musée National du Château de Versailles, Paris), while the latter was on the **grand tour**. *See also* PARIS.

# U

**UPPER BELVEDERE, VIENNA (1721–22).** This upper section of the garden palace in Vienna was built by Johann von Hildebrandt for Eugene, Prince of Savoy. It was designed to provide a view across to the Lower Belvedere (1714–16), which was built first. The term *belvedere* combines the Italian *bello* (beautiful) and *vedere* (to see) and was used in the 18th century to describe buildings set on hills specifically to provide views. Both buildings are located at opposite ends of a garden designed in the French style by Dominique Girard. The Upper Belvedere is predominantly Baroque in its architectural grandeur, although early Rococo elements can be found in Hildebrandt's emphasis on ornament that erodes mass. This characteristic **ornamentation** can be seen as one moves toward the center of the facade, as well as in the *sala terrena*, where atlantes struggle to hold up the richly decorative **stuccowork** proliferating on the roof vaults. *See also* AUSTRIA.

# V

**VALLAYER-COSTER, ANNE (1744–1818).** Vallayer-Coster was one of the most successful female artists of her generation, best known for her colorful flower paintings and still lifes. At a time when participation in the **Académie Royale de Peinture et de Sculpture** was limited for **women** artists, she was received as a member in 1770 with her *Attributes of Painting, Sculpture and Architecture* (Musée du Louvre, Paris). As an academician, she was able to exhibit at the **Salons**, which she began to do in 1771. Her flower **paintings** brought her the most attention, but she also painted **portraits** and trompe l'oeil bas-reliefs. Between 1778 and 1780, she made several portraits of important women at court, including Queen **Marie-Antoinette**, whom she depicted in pastel (Florence Bouchy-Picon) and the aunts of **Louis XVI** (Musée National du Château de Versailles, Paris). Marie-Antoinette owned one of Vallayer-Coster's *Vestal* pictures, which was possibly given to her by the artist as a token of gratitude. The queen appears to have taken a special interest in Vallayer-Coster around this time, arranging lodgings for her in the Louvre and signing her marriage contract. Networks of **patronage** created by prominent women who supported female artists are a peculiarity of the late 18th century, the culmination, perhaps, of **Madame de Pompadour**'s model of involvement in the arts. While critics favorably compared Vallayer-Coster's early still-life paintings with those of **Jean-Baptiste-Siméon Chardin**, her portraits fared less well when compared with those of **Élisabeth Vigée Le Brun** and **Adélaïde Labille-Guiard**. For the remainder of her career, she concentrated on still lifes. Vallayer-Coster's masterful studies of flowers in oil, gouache, and watercolor reveal a close observation of nature. *See also* FRANCE.

**VAN BLARENBERGHE.** The Van Blarenberghes, an artistic dynasty of miniature painters, are best known for their work on **snuffboxes**, which includes depictions of royal châteaux, interiors of Parisian townhouses, country *fêtes*, scenes of street life, games and performances, and historical events of interest, such as balloon flights around **Paris** and the marriage of Grand Duke Paul of **Russia** (1774, Hermitage Museum, Saint Petersburg).

Part of the social ritual that surrounded the sniffing of grated tobacco, these exquisite objects were trendy mementos of fashionable places and popular entertainments. There were at least three Van Blarenberghes active as artists in 18th-century Paris: Louis-Nicolas (1716–94), his brother, Henri-Désiré (1734–1812), and son, Henri-Joseph (1741–1826). Most of their **paintings** are in gouache on vellum, mounted under clear crystal and set into small gold snuffboxes. The most famous snuffbox by the Van Blarenberghes is the Choiseul Box (private collection), painted in 1770 for Étienne-François, duc de Choiseul. The top and sides of the box depict images of different rooms in the patron's Parisian *hôtel particulier* on the Rue de Richelieu. Designed to fit in the palm of the hand, the depiction of detail is remarkable, and the specifics of **furniture** and decorations, as well as the identity of individuals, are easily discernable despite their diminutive size.

**VAN LOO, CARLE (1705–65).** As with his friend, rival, and contemporary, **François Boucher,** Carle van Loo's name was once synonymous with the Rococo art and design produced during the reign of **Louis XV.** After the French Revolution, the young students working under **Jacques-Louis David** derided the artist through their rallying cry, "Van Loo, Pompadour, Rococo," yet at the height of his career, Van Loo was praised by **Baron von Grimm** as "the foremost painter in Europe." Van Loo's successes within the **Académie Royale de Peinture et de Sculpture** and his numerous court commissions support Grimm's assessment. As a student at the Académie Royale, he won both first prize for drawing and the *Prix de Rome* before the age of 20. By the time he was 45, he had been received into the Académie Royale, promoted to professor, and then made director of the École Royale des Élèves Protégés in 1749. He was appointed *premier peintre du roi* in 1762 and was made director of the Académie Royale in 1763, although he died only two years later.

Van Loo's style was the result of eclectic influences. The time he spent in **Rome,** first with his older brother, between 1714 and 1719, and then again as a student at the Académie de France, between 1728 and 1732, allowed him to study the refined **Classicism** of Raphael. The influence of the High Renaissance master appears mostly in Van Loo's religious **paintings,** such as *Saint Clotilda Praying at the Tomb of Saint Martin* (1752, Musée des Beaux-Arts de Brest), although the sweet sentiment of this work and the Gothic architectural background treated as a decorative stage set are decidedly Rococo in character. Van Loo also had an opportunity to study the mannerist paintings of the Galerie François I at the Château de **Fontainebleau,** when he assisted his brother in their restoration around 1720. The "stylish" style, as Mannerism is aptly described, with its contorted poses and decorative flourishes, provided an influential alternative model for Van Loo, which can be detected

in his mythological works, such as *Perseus and Andromeda* (1735–40, Hermitage Museum, Saint Petersburg).

Van Loo's reputation, however, did not rest on a particular stylistic idiom. Rather, he adapted his approach to the work at hand. Louis XV favored themes related to the hunt, and accordingly, Van Loo applied himself to this genre with celebrated results. For the king's Petits Appartements at **Versailles**, he painted *Bear Hunt* (1736) and *Ostrich Hunt* (1738) as part of a decorative series that included works by Boucher, **Jean-Baptiste Pater**, **Nicolas Lancret**, **Jean-François de Troy**, and Charles Parrocel. Van Loo also painted the social side of this royal diversion for the king in *Halt during the Hunt* (1737, Musée du Louvre, Paris), which hung as a pendant to another work by Parrocel in the Petits Appartements at Fontainebleau. During this period, he was commissioned to supply decorative history paintings for the **Hôtel de Soubise**, where Boucher and **Charles-Joseph Natoire** were also at work; *turqueries* for prominent private collectors; and fantasy scenes of sociability in "Spanish" dress for the *salonnière* **Marie-Thérèse Geoffrin** (*Spanish Conversation* of 1754 and *Spanish Lecture* of 1758, both Hermitage Museum, Saint Petersburg). He became associated with the **marquise de Pompadour** through the commission he completed for her château at Bellevue: four allegories in which **children** perform the arts of music, **painting**, **sculpture**, and **architecture** (Fine Arts Museum, San Francisco). The charm of these works lies in their lighthearted treatment of serious pursuits, which conveys the idea that artistic excellence should appear to be the result of effortless play, rather than rigorous toil.

**VAN LOO, LOUIS-MICHEL (1707–71).** Son of the painter Jean-Baptiste van Loo and nephew of **Carle van Loo**, Louis-Michel had a reputation as an academic history painter specializing in portraiture in **Paris** before the age of 30. He moved to Madrid in 1737 following a recommendation by Hyacinthe Rigaud, who had been asked by **Philip V of Spain** to suggest a new court painter to take the place of Jean Ranc, recently deceased. Van Loo's royal **portraits** were well received and often copied at the court of **Spain**. His most famous Spanish portrait is the *Family of Philip V* (1743, Museo del Prado, Madrid), which is largely Baroque and ceremonial in style, although the curvilinear handling of the draperies and **architecture** are more indicative of Rococo formal preferences. In 1744, Van Loo received the title of *primer pintor de camera* and became the director of studies at the Junta Preparatoria, an assembly of artists working to establish a royal academy in Spain. His pledge painting for the Junta, *Education of Love by Venus and Mercury* (1748, Museo de la Real Academia de Bellas Artes de San Fernando, Madrid) was a rare mythological work that included allegorical references to the

pedagogical mission of an academy that balanced the pursuits of learning, intelligence, beauty, and **aesthetics**, while the sinuous curves of Venus, the tilted architectural background, and veiled profiles of the central figures conform to Rococo stylistic formulas.

Van Loo had been both a student and a professor in an academic institution, which was unusual among his fellow artists, and once the **Real Academia de Bellas Artes de San Fernando** was founded in 1752, he quickly became both academician and director of **painting**, although his impact in these positions was minimal as he returned to Paris in the same year. Nevertheless, the example of his works at court influenced younger artists such as **Francisco de Goya** and **Luis Meléndez**. When Van Loo returned to **France**, he worked actively as a painter at court, executing formal portraits of **Louis XV** and other members of the royal family, but he also painted more intimate portraits that focus on the revelation of character, sometimes termed "bourgeois" portraits, including one of *Denis Diderot* (Musée du Louvre, Paris), which he exhibited at the **Salon** of 1767. He succeeded his uncle, Carle van Loo, as director of the École Royale des Élèves Protégés, the elite school of the Académie Royale.

**VASSÉ, FRANÇOIS-ANTOINE (1681–1736).** A French sculptor and **ornamentalist**, Vassé trained with his father at the Arsenal in Toulon, where he was introduced to the ornamental designs of **Jean Bérain**. In 1707, he won first prize as a student in the **Académie Royale de Peinture et de Sculpture**, and a year later, he was engaged as a decorative sculptor at **Versailles**. He became the favorite sculptor of **Robert de Cotte**, who employed him on a number of his projects, including notable *hôtels particuliers*. Vassé's most important work was the remodeling of the gallery at the Hôtel de Toulouse (built 1718–19), which belonged to Louis-Alexandre de Bourbon, comte de Toulouse (1678–1737), the legitimized son of **Louis XIV**. Vassé's initial designs provided new frames of varied outlines for the **ceiling** and completely transformed the walls, eliminating geometry and making **trophies** follow the surface of the curved panels (c. 1713–14, Cabinet des Estampes, Bibliothèque Nationale, Paris). Although the execution of the final designs modified this approach to give more weight to the frames, **cartouches**, and modeled fields on the **paneling**, Vassé's sculpted **ornamentation** had the distinctly plastic character of early Rococo decoration. *See also* FRANCE; SCULPTURE.

**VAUXHALL GARDENS.** Jonathan Tyers took out a 30-year lease on Vauxhall Gardens in London in 1728 with the aim of establishing a fashionable space for public entertainments that would eventually include musical performances, garden promenades, fireworks, and food and drink served

in "supper-boxes" adorned with painted decorations. **Frederick, Prince of Wales**, who was the landlord of the estate, took enough interest in the venture to erect a large pavilion within the pleasure gardens for his exclusive use in the company of his entourage. A royal presence elevated the status of Vauxhall Gardens to a destination for elite members of society, as well as for the wider public, who were able to buy single tickets or season passes. Initially, the decorations were classically inspired and ephemeral. A description of the Ridotto Al'Fresco in 1732 refers to "Temples, Obelisks, Triumphal Arches and Grotto Rooms." By the late 1730s, more permanent structures and decorations were erected by contemporary artists associated with the **Saint Martin's Lane Academy** and the **English Rococo**. It may have been at **William Hogarth**'s suggestion that the first Ridotto, or ball, was held, and early sources claim that he "assisted" with the decoration of the central orchestra building, which opened in 1735.

Tyers bought a marble statue of Handel from **Louis-François Roubiliac** to adorn the gardens in 1738, and by the early 1740s, at least 53 supper-box pictures by **Francis Hayman** and his assistants were installed, several of which copied earlier designs by Hogarth and **Hubert Gravelot**. The subjects of the supper-box pictures are distinctly Rococo in their representations of games and pastimes frequently depicted by French painters of the early 18th century, such as see-saws, blindman's buff, card parties, and stolen kisses. Exotic tastes also were introduced into Vauxhall Gardens to delight the fashionable clientele and provide additional shelters. In 1744, a Turkish tent was erected, followed by "Chinese" pavilions (actually a hybrid of **chinoiserie** and **Gothic** forms) around 1750, and finally a new Gothic orchestra in 1758. Although the works of art and structures at Vauxhall did not receive critical acclaim, they were enormously popular with the public and exposed visitors to modern trends in contemporary **architecture** and **painting**. *See also* GARDEN DESIGN.

**VENICE.** By the beginning of the 18th century, art making in Venice was closely connected to the international influx of **grand tourists** and the market they stimulated for *vedute*, or view pictures, and portraiture. Venetian scenes by **Antonio Canaletto**, **Bernardo Bellotto**, and **Francesco Guardi** were highly sought after mementos of travel to this increasingly cosmopolitan city. In addition to *vedute*, these artists also created *capricci*, fantastic distortions of real and imagined spaces that are characteristic of Rococo artists' decorative manipulation of the natural world. **Rosalba Carriera**'s **portraits**, often executed in pastel, were immensely popular, bringing her an extraordinary amount of fame in the first decades of the 18th century. The lightness of her style is considered to have ushered in a new mode of informal portraiture

associated with the Rococo period, and her pastels influenced a number of French artists, including **Antoine Watteau**.

The talents of Venetian decorative painters were equally celebrated across Europe. Artists such as **Giovanni Antonio Pellegrini**, Sebastiano Ricci, and **Giambattista Tiepolo** were in high demand for their technical skills as fresco painters and the playful illusionism of their works. The Swedish ambassador, **Count Tessin**, traveled to Venice in the 1730s specifically to hire decorative painters to take back with him to work on the Royal Palace in Stockholm. **Francesco Algarotti**, a diplomat and **patron**, also traveled widely, establishing relationships across Europe that proved advantageous for the Venetian artists that he favored. Other Venetian artists embarked upon expatriate careers in **Rome**, most famously **Giovanni Battista Piranesi**. The fact that so many prominent Venetian artists were employed outside of their native city implies a lack of significant local **patronage**. To a certain extent, this is valid; yet, decorative schemes created for patrician villas in the Veneto are among the most delightful interiors of the Rococo period. Venetian **genre painting**, particularly that of **Pietro Longhi** and **Giandomenico Tiepolo**, had its own local character and engaged with *carnivale*, festivals, and the theater.

**VERBERCKT, JACQUES (1704–71).** Originally from Antwerp, Verberckt was a panel carver who entered the Gabriels' **Paris** atelier in 1730. He became the leading artisan of ornamental **paneling** designed by **Ange-Jacques Gabriel** when the latter was *premier architecte* at the **Bâtiments du Roi**. Verberckt worked on the decorations for numerous royal châteaux, including the Chambre de la Reine (1730), the apartments of the Dauphine, the Petite Galerie of the king's apartments (1736), and the apartment of Madame Adélaïde (1752), all in situ at **Versailles**. He also worked at the châteaus of La Muette, Choisy, **Bellevue**, Rambouillet, and **Fontainebleau**. The style of his carved **ornamentation** at Versailles, which emphasized border moldings as much as the fields of panels, influenced the development of the **Bavarian Rococo** and the **Frederican Rococo**, particularly through the designs of **François de Cuvilliés** and **Georg Wenzeslaus von Knobelsdorff**.

**VERNET, JOSEPH (1714–89).** Vernet was one of the most successful landscape painters in 18th-century Europe. He was born in Avignon and accepted into the Académie de France in **Rome** without having studied in **Paris**. In Rome, he established a reputation with his imaginary landscapes and marine **paintings**. He worked for a wide circle of international **patrons** and became a full member of the **Académie Royale de Peinture et de Sculpture** before returning to **France** in 1753. The **marquis de Marigny** had visited Vernet's studio when he made his tour of **Italy** in 1750, and when he became *directeur*

*des bâtiments*, he extended to Vernet an important royal commission that was intended to glorify the reign of **Louis XV** through topographical representations of the ports of France. Vernet's paintings of the ports of Marseilles, Toulon, and Bordeaux, among others, include a wealth of detail and are carefully, at times minutely, rendered. Only 15 paintings were completed, slightly more than half of the planned series, as funds were diverted to the crown's involvement in the Seven Years War (1754–63). In the latter part of his career, Vernet increasingly painted seascapes and storm pictures, and works such as *Shipwreck* (1763, Hermitage Museum, Saint Petersburg) employ dramatic formal contrasts between the geometric lines of man-made structures and the irregular, natural forms of rocky cliffs, waves, and clouds. He exhibited regularly at the **Salons**, and in his Salon criticism, **Denis Diderot** repeatedly praised his landscapes for their truthfulness to nature.

**VERSAILLES.** The royal Château de Versailles was largely completed before the Rococo style emerged; however, early elements were introduced through **Claude Audran**'s **arabesques** for the redecoration of the **Ménagerie** under **Louis XIV**. When **Louis XV** returned the court to Versailles in 1722, he maintained the exterior of the château, in order to maintain a visual and architectural continuity between the two regimes. Most of the changes made to Versailles during the 18th century were to the interior spaces and pleasure pavilions in the gardens. In 1738, Louis XV ordered the alteration of the Petits Appartements under the direction of his *premier architecte*, **Anges-Jacques Gabriel**. The suite of rooms was transformed into a series of smaller, more intimate spaces decorated with white and gold **paneling** by **Jacques Verberckt**. Further interior changes necessitated the removal of the Escalier des Ambassadeurs (1752), where temporary auditoria had been set up for theatrical productions. A permanent performance space became a matter of urgency and resulted in Gabriel's designs for the Opéra. This became the major building project in the main château under Louis XV, completed in 1770.

Outside in the gardens, Gabriel altered the layout of the Basin of Neptune (inaugurated in 1741), adding new sculptures in the Rococo style by **Jean-Baptiste Lemoyne** and **Edme Bouchardon**, which joined the more Baroque *Triumph of Neptune and Amphitrite* (1735–40) by the brothers Lambert-Sigisbert and Nicolas Sébastien Adam. Gabriel also completed the Petit Trianon (1764–68). Built for gatherings hosted by **Madame de Pompadour** for the private entertainment of the king, the intimacy of its scale and intended purpose relate in spirit to the Rococo, but the style of the exterior is a purified form of **Classicism**. It represents a clear rejection of Rococo fashions that had been extending from the interiors onto the exteriors of building, and suggests

a visual continuity with the golden age of **architecture** under Louis XIV. The interior is equally austere. A more delicate use of classical forms appears on the earlier Pavillion Français (1749–50) in the gardens of the Trianon, an early hermitage built for Pompadour by Gabriel and decorated by Verberckt.

**Louis XVI** gave the Petit Trianon to Queen **Marie-Antoinette**, a gift of some significance as it signaled the king's intention not to take an official mistress, and placed property within the grounds of Versailles in the hands of the queen. Everything, including access, was by order of the queen, which caused considerable scandal and resentment among the members of the court who were excluded. Marie-Antoinette redecorated the interiors and ordered the construction of a private theater on its grounds from **Richard Mique**. In taste, the décor reflected the intended simplicity of the place and maintained the tenor of the Neoclassical exterior. The queen's apartment was furnished with pieces by **Jean-Henri Riesener**, cabinetmaker to Louis XV and Louis XVI. Her boudoir included mirrored **paneling** that could be raised and lowered by a crank to reveal the windows that looked out onto the garden, alternatively ensuring privacy and closeness to nature and responding to the Rousseauist sensibility of the 1770s and 1780s.

This sensibility was extended to the replanting of the gardens of the Petit Trianon in the *anglo-chinois* style, which was supervised by the landscape architect Mique, the garden designer **Hubert Robert**, and Antoine Richard, the curator of the botanic garden established under Louis XV. In addition to the laying of serpentine paths in this section of the gardens, Mique and Robert introduced a number of structures in a variety of styles and forms: the rustic grotto, to which the sculptures from the Basin of Apollo were transferred and rearranged in an irregular manner by Robert; the Neoclassical Temple of Love and the octagonal Belvedere; a Chinese *jeu de bague*; and a fictive village, called the **Hameau de la Reine** (from 1783), where Marie-Antoinette played shepherdess and blindman's buff. Extraordinary rumors about the extreme luxury of this space fueled revolutionary sentiment in the late 1780s. *See also* FRANCE; GARDEN DESIGN.

**VIEN, JOSEPH-MARIE (1716–1809).** Vien is an important transitional figure in the shift of artistic tastes from the Rococo to **Neoclassicism**. His own style is highly decorative and sentimental in character, while his handling of subject matter and attention to historical detail reveals a careful study of antiquity. Although he trained with **Charles-Joseph Natoire** in the 1740s, by 1750, he was closely associated with the **comte de Caylus**, who was an antiquarian scholar and encouraged Vien's interest in Greek and Roman art at a time when excavations were under way at Pompeii and Herculaneum. Under Caylus' influence, Vien experimented with the wax encaustic process, a method of painting with molten wax used by ancient Greek and Roman

artists, which he employed in six paintings exhibited at the **Salon** of 1755. During the early 1760s, Vien painted works that satisfied the *goût grec* of fashionable collectors, including *The Virtuous Athenian Girl* (Musée des Beaux-Arts, Strasbourg), painted for **Marie-Thérèse Geoffrin**, who hosted a celebrated **Enlightenment** salon in **Paris**.

Vien's works from this period are endowed with a sense of archaeological correctness in the treatment of **dress** and objects. Nevertheless, his figures are often engaged in superficial actions related to the theme of love, such as his *Cupid Sellers* (1763, Musée National du Château, Fontainebleau). In 1774, Vien delivered a series of four decorative pictures entitled *The Progress of Love in the Hearts of Young Girls* to **Madame du Barry**'s château at **Louveciennes** (two of the canvases are in the Musée du Louvre, Paris, while the others are in the Préfecture of Chambery). These paintings replaced **Jean-Honoré Fragonard**'s panels, erroneously known as the *Pursuit of Love* (1771–73, Frick Collection, New York), which the **patron** had rejected soon after they were hung. This moment is often considered by scholars to mark the official end of the Rococo and the rise of Neoclassicism, which had first taken hold as a modish interest in the antique to which Vien's art catered.

As a teacher, Vien held important posts within the **Académie Royale de Peinture et de Sculpture**, first as director of the École des Élèves Protégés (from 1771) and then as director of the Académie de France in **Rome** (from 1775). His greatest pupil was **Jacques-Louis David**, but he also trained other painters considered to be part of the first generation of Neoclassical artists in **France**, including Joseph-Benoît Suvée, Jean-Baptiste Regnault, and Jean-François-Pierre Peyron. *See also* À LA GRECQUE; CLASSICISM.

**VIERZEHNHEILIGEN.** A Franconian pilgrimage church at Bad Staffelstein near Bamberg, Vierzehnheiligen began as a small chapel on the site where a shepherd had several visions of 14 helper saints in the 1440s. By the 18th century, the chapel had become so popular that the abbot proposed a new building to accommodate the stream of pilgrims. Several architects submitted designs for the project, including Johann Jakob Michael Küchel and **Balthasar Neumann**. The Prince-Bishop of Würzburg and Bamberg, Friedrich Karl von Schönborn, accepted Neumann's design, but the abbot insisted that Küchel supervise construction, which began in 1742. Neumann's design is based on a modified Latin cross plan with three longitudinal ovals composing the entrance, nave, and choir. The vaults are supported by piers, open at the bottom, with light flowing in from windows on the side walls, creating a sense of space. The use of windows to open up the walls and curvilinear arcades to form the side aisles, appears to reduce the **architecture** to a decorative shell. **Stuccowork** by Johann Michael Feuchtmayer further erodes any remaining sense of mass in the ceiling. The central decorative element of

Vierzehnheiligen is the shrine (1762), a baldachin designed by Küchel and executed by Feuchtmayer from a series of interconnected *contrecourbe* C- and S-curves. *See also* BAVARIAN ROCOCO; GERMANY; WÜRZBURG RESIDENZ.

**VIGÉE LE BRUN, ÉLISABETH-LOUISE (1755–1842).** Vigée Le Brun is the portraitist most closely connected with **Marie-Antoinette**, Queen of France, of whom she painted more than 30 **portraits**. While Vigée Le Brun was a successful portraitist prior to the queen's **patronage** and interest in her career, she had been prohibited from membership to the **Académie Royale de Peinture et de Sculpture**, not simply because she was a **woman** (the rules allowed four female members at any one time), but because her husband, Jean-Baptiste-Pierre Le Brun, was an art dealer. The queen, however, intervened on Vigée Le Brun's behalf, and in 1783, she was admitted to the institution. For many years, Marie-Antoinette had complained to her mother, the Empress of **Austria**, that she could not find an artist who was able to capture her likeness. "Likeness," in 18th-century terms, extended beyond mere physical resemblance to include an idea of the person, although this was complicated in the case of Marie-Antoinette by the rules of decorum that surrounded her royal status. Vigée Le Brun had developed an approach to portraiture that accommodated fashionability through the suggestion of informality, which clearly appealed to the queen. She portrayed Marie-Antoinette *en gaulle*, attired in a simple and casual dress that was often worn in the garden. When exhibited in the **Salon** of 1783, critics complained that the queen had appeared in her underwear. The work was removed and replaced in the same Salon by a work of similar pose, but with the queen attired in a more formal gown.

In 1785, in an attempt to improve the queen's reputation with the wider public, Vigée Le Brun was commissioned to paint a **portrait** of *Marie-Antoinette and Her Children* (1787, Musée National de Château de Versailles, Paris). Drawing on imagery of the Madonna and a previous portrait of Marie Leczinska, wife of **Louis XV**, Vigée Le Brun represented the queen as a "good mother," ensconced within the royal residence of **Versailles** and surrounded by her **children**. Despite these references, the critics found Marie-Antoinette to be wooden and unnatural. Due to her close association with the queen, Vigée Le Brun was forced into 12 years exile after the French Revolution began in 1789, traveling with her daughter to **Italy**, Vienna, Prague, Dresden, Berlin, and Saint Petersburg, although she continued to prosper as an artist. Her self-portraits, some of which include her daughter, combine with her memoirs to provide an intriguing and informative picture of a woman artist in 18th-century **France**. *See also* ARTOIS, CHARLES-PHILIPPE DE FRANCE, COMTE D'; LOUIS XVI; VALLAYER-COSTER, ANNE.

# W

**WARE, ISAAC (1704–66).** An English architect who worked predominantly in the Neo-Palladian manner, Ware was nevertheless a prominent member of the **Saint Martin's Lane Academy** in London, which is known as the nursery of the **English Rococo**. He joined the Office of Works in 1728 and remained an architectural civil servant throughout his life. His finest private commission was for **Chesterfield House** (1747–52, destroyed) in Mayfair, London, for a **patron** with distinctly Rococo tastes. Lord Chesterfield had Ware working with the plasterer Joseph Thomas along with French craftsmen who specialized in **boiseries**. Notable compromises were made between the French Rococo **interior decoration** and the English Palladianism of the building. In Ware's own words, the license of Rococo **ornamentation** needed to be "naturally and necessarily circumscribed" in buildings that brought both Palladian proportions and fanciful decoration together. Ware wrote extensively on **architecture**, including a publication of the designs of Indigo Jones (1731), a new translation of Palladio (1738), and his own *Complete Body of Architecture* (1756).

**WATELET, CLAUDE-HENRI (1718–86).** Watelet was an amateur artist who wrote extensively about the arts and **garden design**. His writings contribute significantly to our historical understanding of **aesthetic** tastes during this period. The son of a *receveur général des finances* in Orléans, Watelet inherited his father's post and considerable fortune at the age of 22. This financial security allowed him to pursue his true interests in art and literature, and his country house at Moulin Joli, near **Paris**, drew artists, writers, and **patrons** from Paris to exchange ideas. He was elected an associate member of the **Académie Royale de Peinture et de Sculpture** in 1747, an honor that was followed by his election to many other learned and artistic societies across Europe, a sign of how well he was regarded within international circles as a man of considerable taste and knowledge.

Watelet's first major text on art, *L'art de peindre* (1760), was a didactic poem codifying the principles of **painting**. It was followed by entries related to the arts for **Denis Diderot** and **Jean Le Rond d'Alembert**'s *Encyclopédie*,

and this intellectual inquiry culminated in his own extensive *Dictionnaire des arts de peinture, de gravure et de sculpture* (1788–91), which was completed posthumously by Charles Lévesque. Of greater originality and importance to the history of garden design was his *Essay on Gardens* (1774). It reflected on his own garden, designed by Watelet with contributions from **Hubert Robert** and **François Boucher**, at Moulin Joli. From the surviving evidence, it appears that the views he created brought Rococo pastoral landscapes to life in the space of the garden. Watelet also owned a distinguished collection of works by contemporary French artists, including drawings and **paintings** by Robert, **Carle van Loo**, **Joseph Vernet**, and **Charles-Joseph Natoire**, and pastels by **Rosalba Carriera**.

**WATTEAU, ANTOINE (1684–1721).** Watteau is the most celebrated French artist of the Rococo period. A pivotal figure in the development of the *goût moderne*, he translated the habits and preferences of Parisian society into visual form. Whether taking on themes of sociability, love, conversation, dance, or the theater, Watteau created images that effectively express the artfulness of daily life in 18th-century **Paris**. He developed an approach to art-making that was highly individualistic and original yet remained closely connected to the world of his contemporaries. Consequently, his works appear to be broadly representative of French tastes in the first two decades of the century.

Little documentary evidence exists about Watteau's early life. Of Flemish birth, he trained initially in his native Valenciennes, either with the painter Jacques-Albert Gérin (c. 1640–1702) or the sculptor Antoine-Joseph Pater (1670–1747), before moving to Paris around 1702. His early years in Paris were spent in the workshop of **Claude Gillot**, who painted scenes of the theater and **grotesques**, and as an assistant to the successful **ornamental** painter **Claude III Audran**. These artists provided Watteau with useful introductions and access to decorative commissions. It was as an "assistant" to Audran that Watteau completed *singeries* for Marly (destroyed) and ornamental **arabesques** for the marquis de Nointel's *hôtel particulier* in Paris, which include two of his earliest surviving works, *The Cajoler* and *The Faun* (c. 1707–8, private collection). The former panel has an enigmatic quality that would become a definitive aspect of Watteau's approach to nonnarrative subjects, whereby interpretive significance is suggested through figural pose and gesture yet without readable meanings attached.

Watteau was provisionally accepted into the **Académie Royale de Peinture et de Sculpture** in 1712 with the submission of a number of works, some of which included theatrical figures. These included *Les jaloux* (original painting lost), a scene in which **commedia dell'arte** actors socialize in a

garden setting. Rather than engaging in dramatic action, the figures are shown at leisure, playing music and conversing. Significantly, the Académie Royale did not categorize his submissions according to accepted genres of painting and left open the choice of subject for his reception piece, through which he would gain full membership.

For the next few years, Watteau began to develop the genre of paintings for which he is best known—the *fêtes galantes*. These scenes of sociability blend elements of fantasy with reality. More often than not, they are set in gardens and mix men and **women** in contemporary **dress** with those wearing theatrical costumes. Figures often have their backs to the viewer, and expressions are often obscured through loose brushwork and lack of detail. Elegant gestures and the fluid fall of drapery combines with Watteau's characteristically painterly handling to achieve remarkable gracefulness. Watteau's sense of **color** and his depiction of shimmering fabrics were inspired by his close study of works by Peter Paul Rubens.

Through his association with Audran, Watteau gained access to the Palais du Luxembourg, which housed Rubens's Marie de' Medici cycle (1621–25, Musée du Louvre, Paris). In notable works, such as *Les fêtes vénitiennes* (1716–20, National Galleries of Scotland, Edinburgh), figural poses are taken directly from Rubens's cycle yet adapted to fit the circumstances of the scene. For example, the central dancing figure in *Les fêtes vénitiennes* borrows her pose from Marie de' Medici in one of Rubens's panels. More than a simple borrowing, however, Watteau transforms historical pose and gesture to serve a scene of sociability and contemporary life. Her body is no longer meant to be "read" through a Baroque symbolic language of power and glory but to be viewed as a sign of refined deportment. In a manner that epitomizes the relationship between the French Rococo and inherited traditions of monarchical representation, Watteau has appropriated signs of royal power and authority for decorative and pleasurable ends. This appropriation also suggests that one of the aesthetic ambitions of Watteau's art is to absorb the lessons of past art and to create from them something new, "modern," and connected to its own time and place.

Watteau finally submitted his acceptance piece, *The Pilgrimage to the Island of Cythera* (Musée du Louvre, Paris) in 1717. His most famous work, and a paradigm of the Rococo period, it represents courting couples on a voyage to Cythera, a mythological island dedicated to Venus, goddess of love. In theme, the **painting** has mythological connections, yet the figures themselves are the ladies and gentleman of Parisian society. Indeed, the phrase "voyage to Cythera" had contemporary connotations as it referred to the practice in 18th-century Paris of traveling down the Seine to suburban parklands where couples engaged in illicit love affairs. This blending of mythology with the

everyday defied the usual academic subject categories, and Watteau was listed in the minutes as a "peintre des festes galantes." As this is the first use of the term "feste galante," or *fête galante*, in documents of the Académie, it effectively credited Watteau with the creation of a new category of painting. At the same time, however, this appellation maintained academic subject hierarchies: since Watteau was not received as a history painter, he was unable to rise through the ranks to become a professor.

Sometime around this period, Watteau became an intimate member of the circle of the *amateur* **Pierre Crozat**, which included the artists **Antoine Coypel**, **Charles-Antoine Coypel**, and Charles de La Fosse, as well as prominent collectors and art theorists, such as the **comte de Caylus**, **Pierre-Jean Mariette**, and Jean de Julienne. By 1717, the artist was living at Crozat's house, although his association with this wealthy art lover appears to have begun several years earlier. It is known, for example, that Crozat introduced Watteau to the Italian pastel painter **Rosalba Carriera** in 1716. Moreover, Watteau's *The Perspective* (1714, Museum of Fine Arts, Boston) pictures Crozat's country residence at Montmorency. The weekly gatherings at this house, which brought together artists, collectors, and theorists to discuss **aesthetics**, became something of a "shadow academy" during the first two decades of the 18th century. Moreover, Crozat was artistic advisor to **Philippe II, duc d'Orléans**, and possessed significant authority over semiofficial matters of taste during the Regency period. For Watteau, the association was critical in linking his career to a group that was influential in shifting the direction of French art away from the Grand Manner style associated with **Louis XIV** and toward the lighter and more playful forms of the *style régence*.

Watteau made a brief trip to London in 1719, reportedly to consult with the doctor Richard Mead about his worsening tuberculosis. There, he painted the *Italian Comedians* (1719, National Gallery of Art, Washington, DC) for Mead, who was also a prominent collector. His direct influence on the development of the Rococo in **England** was minimal, although his work *Iris c'est de bonne heure* (c. 1719–20, Gemäldegalerie, Berlin) prefigures the **conversation piece**. More indirectly, Watteau's art was popularized in England by **Philip Mercier**, who produced prints and pastiches of his work. By 1721, Watteau was back in Paris and living with the dealer **Edme-François Gersaint**. His health continued to deteriorate; nevertheless, according to Gersaint, he suggested that he "flex his fingers" by painting a signboard for his friend's shop, which specialized in the buying and selling of paintings and other luxury goods. Known as *Gersaint's Shopsign* (1720, Schloss Charlottenberg, Berlin), the three-meter-long canvas advertized the dealer's shop as a site of aristocratic leisure. Although Gersaint claimed that it was made

from life, it is clear that the work blends fantasy with reality to comment upon the artful naturalness of an elite clientele. While it is arguably the men and women in the scene who are the principal subjects, the artworks on the wall are integral to the display of taste and elegance. At its core, the work is an exploration of the role that art plays in shaping the habits and pleasures of modern life.

Watteau's career was cut short by his early death from tuberculosis at the age of 37. Nevertheless, he played a central role in the adaptation of ornamental decorative forms and motifs to the "high" art of easel painting. He was a masterful draftsman, most well known for his manipulation of the *trois crayons* **technique**. While he executed an enormous quantity of figural studies, few were made as preparatory drawings for specific compositions. Instead, Watteau's drawings formed a repertoire of poses, gestures, and costumes that he extracted for use in his paintings. Watteau's influence on French art cannot be overestimated, despite the fact that he seems to have closely guarded his style and approach to art-making. During his career, he took only one student, **Jean-Baptiste Pater**, no doubt out of a sense of duty to Pater's father. He was initially on good terms with **Nicolas Lancret**, yet when their works were confused due to their closeness in subject and style, Watteau ended the friendship. The dissemination of Watteau's art was greatly assisted after his death by the volumes of engravings and etchings published by Jean de Jullienne, *Figures de différents caractères* (1726 and 1728) and the *Recueil Jullienne* (1735). **François Boucher** worked extensively on these publications and was influenced by Watteau's graceful handling of form.

**WIT, JACOB DE (1695–1754).** The leading Dutch painter of his generation, de Wit specialized in **ceiling** and room decoration. He was well known for his *witjes* (a pun on the Dutch word *Wit* meaning "white"), imitative **stucco** reliefs or *grisailles* that generally depicted allegorical and religious subjects or attributes represented by putti. One decorative cycle of this type is the *Allegory of the Four Seasons* (1751, Staatliche Museen, Kassel), in which putti cavort around the bases of the portrait busts representing the relevant gods. In their playful spirit, they are entirely Rococo. De Wit studied at the Koninklijke Academie in Antwerp from 1708 and, between 1709 and 1712, with the history painter Jacob van Hal (1672–1718). He became a member of the Antwerp Guild of Saint Luke in 1713, before moving to Amsterdam. De Wit was strongly influenced by the work of Peter Paul Rubens, which he knew intimately through the copies he made of 36 ceiling **paintings** by the Flemish artist in the Jesuit church in Antwerp. When the originals were lost in a fire, de Wit reproduced them many times over in different media. *See also* THE NETHERLANDS.

**WOMEN.** From the middle of the 18th century onward, Rococo art was denigrated as a taste formed through the influence of women. Critics like **Denis Diderot** associated the perceived loss of talent in the French school to the production of art works that were destined for the **boudoir**, a distinctly female space. Such attitudes no doubt gave rise to the rallying cry of **Jacques-Louis David**'s students, who coined the term *Rococo* and simultaneously linked it to prominent woman of court with the phrase "Van Loo, Pompadour, Rococo." With a strong emphasis on curvilinear forms, sinuous patterns, pastel **color** harmonies, and sensual surface textures, the formal vocabulary of the Rococo appears destined to be perceived as feminine. Nevertheless, revisionist studies have debunked the gender bias that has characterized the historical reception of the Rococo. What remains indisputable, however, is the significant role women played in the production of Rococo art as subjects, artists, and **patrons**.

The female body, clothed and nude, was of central importance to Rococo compositions, both formally and thematically. In *fêtes galantes*, both women and men were depicted in scenes of sociability. Even so, a much greater pictorial interest appears to have been bestowed on the female figures and particularly the forms and textures of the contemporary clothing in which they are attired. Mythological scenes of love and seduction, which were favorite subjects with Rococo artists, necessarily implicated the female nude. From the 1730s onward, mythological subjects involving scantily clad goddesses, especially Venus, became the preferred subjects for large-scale decorative works and were exhibited to the public at the **Salons**. Pastoral scenes of amorous shepherds and shepherdesses were also popular at the time and tended to bring the female figure to the fore in superficial allegories of the seasons that commonly incorporated coded sexual motifs. Even more provocative were boudoir scenes of nude women on beds, which were painted by major Rococo artists, such as **François Boucher** and **Jean-Honoré Fragonard**, and bought by high-ranking noblemen, including **Louis XV** and the **marquis de Marigny**, for display in their private cabinets. It was exactly these types of pictures that Diderot railed against, not only for picturing women in indecent poses but also for their overt eroticism, which, he argued, encouraged both artists and audiences to embrace triviality and degeneracy in art.

While a ubiquitous subject for Rococo art, women also achieved new levels of prominence as artists and patrons during this period. **Rosalba Carriera** was one of the first female artists in history to enjoy an international reputation in her own lifetime and received numerous invitations to work at a variety of different European courts. While women were routinely barred from official academic drawing classes in which the nude was studied, thereby limiting their training in the foundations of history painting, **Angelica Kauff-**

man was known not only for her work in the "lesser" genres of **portraiture** and landscape but also for her allegorical and mythological scenes. Having gained the respect of her peers as a history painter in **England**, Kauffman became a founding member of the Royal Academy of Arts. In **France**, involvement in the **Académie Royale de Peinture et de Sculpture** was essential for those artists who hoped to pursue an official career, yet membership was limited to four female members at any one time. Despite this hurdle, **Élisabeth Vigée Le Brun** became the most successful painter at the court of **Louis XVI**, and Queen **Marie-Antoinette** intervened on the painter's behalf to gain her admittance to the Académie Royale.

A peculiarity of the late 18th century, in fact, was the extent to which women patrons supported women artists. In addition to the favor that Marie-Antoinette bestowed upon Vigée Le Brun, she also encouraged the career of **Anne Vallayer-Coster**. Similarly, **Adélaïde Labille-Guiard** became *peintre des mesdames* in 1787 and was, thereby, appointed official painter to Louis XVI's aunts, the highest-ranking women at court after the queen. Consciously or not, these women were following the example of Louis XV's official mistress, **Madame de Pompadour**, who used art patronage as a political and social tool of self-fashioning at court. Although less successful as a patron of taste and authority, the king's subsequent mistress, **Madame du Barry**, likewise attempted to use arts patronage in support of her reputation as a woman of fashion.

Outside of **France**, women rulers exerted an even greater amount of influence on the rise and fall of the Rococo. The **Austrian** Rococo, for example, is largely the result of refurbishments of court residences ordered by Maria Theresa, which were carefully calculated to reflect her status as a ruler of an empire. Catherine the Great used her patronage of the arts to assert her ambitions, although her contact with men of the **Enlightenment** encouraged her tastes away from the Rococo and toward **Neoclassicism**. Other avid patrons of Rococo art included Lovisa-Ulrica of **Sweden**, who bought works by Boucher and **Jean-Baptiste-Siméon Chardin**, among others, and the **Duchesses of Alba** and **Osuna** in **Spain**, who encouraged the early career of **Francisco de Goya**. *See also* GEOFFRIN, MARIE-THÉRÈSE; GÉRARD, MARGUERITE; RUSSIA.

**WÜRZBURG RESIDENZ.** Rococo **interior decoration** was adapted to accommodate grandiose visual language at the prince-bishop's Residenz in Würzburg. The Rococo's stylistic associations with intimate spaces and graceful elegance was reoriented toward the expression of secular magnificence derived from ecclesiastical power. In 1719, the new Prince-Bishop Johann Philip Franz von Schönborn resolved to move the ceremonial and

administrative center of the See of Würzburg from Marienberg into the city. While the architects Johann Dientzenhofer and Johann Lukas von Hildebrandt were involved in the early design stage, it was **Balthasar Neumann** who coordinated the building project and remained in charge until his death in 1753, by which time the exterior and the most significant of the interiors were complete. French royal architects, **Robert de Cotte** and **Germain Boffrand**, were consulted by Neumann, indicating a certain deference to French architectural authority in the 18th century, while the decoration of the Treppenhaus and Kaisersaal, completed during the early 1750s by **Giambattista** and **Giandomenico Tiepolo**, suggests the undisputed preeminence of Italian fresco painters in Southern **Germany**. The overall impact of the design, however, is the result of well-coordinated teams of architects, sculptors, and painters, who created decorative ensembles under the direction of Neumann. *See also* ARCHITECTURE; BAVARIAN ROCOCO.

# Z

**ZIMMERMANN BROTHERS.** Johann Baptist (1680–1758) and Domenikus Zimmermann (1685–1766) were from a family of German artists from Wessobrunn and initially trained as stuccoists. The brothers frequently collaborated on architectural projects, and their unique ways of combining **architecture, painting**, and **plasterwork** had a strong impact on the development of the **Bavarian Rococo**. Domenikus worked primarily on ecclesiastical buildings and became well known for his artificial marble altars. He showed a propensity for turning architectural forms into decoration. Johann Baptist worked more in Bavarian court circles as a painter and plasterer and was appointed court stuccoist to the elector of Bavaria in the late 1720s. In these years, he collaborated with **Joseph Effner** and **François de Cuvilliés**, who introduced the forms and techniques of Rococo design into Bavarian interiors. Characteristic of his approach to **ceiling** design is his use of motifs from nature that culminate in reliefs of figures. His delicate blending of forms from art and nature and his extensive use of **color** is typical of the Bavarian Rococo. An example of his approach to decoration is found at the **Amalienburg Pavilion** (1734–37) on the grounds of Schloss **Nymphenburg** outside Munich, which brings together silver **stucco ornamentation** and delicately sculptured figures both set against soft pastel backgrounds. The brothers worked together on the Die Wies Pilgrimage Church (1744–54), which epitomizes the Bavarian Rococo in its ecstatic use of color and decoration. Here the illusionistic frescoes and **rocaille** framing elements erode the substance of architecture. *See also* GERMANY.

**ZUCCARELLI, FRANCESCO (1702–88).** Considered by many Englishmen of the 18th century to be the most important Italian artist of his day, Zuccarelli specialized in picturesque landscapes. Originally from Tuscany, he worked primarily in **Venice** and **England**. The esteem he enjoyed with his fellow artists is marked by his involvement in the Royal Academy of Arts in London, of which he became a founding member in 1768, and his election to president of the Venetian Academy four years later. In contrast to the

topographical views of his contemporary **Canaletto**, Zuccarelli took a decorative approach to painting, preferring idealized landscapes endowed with an **Arcadian** spirit. While he often adopted subjects from biblical, mythological, and historical sources, his treatment of subject matter is highly generalized, emphasizing instead the imaginative nature of the scenes. His paintings were popular with such important collectors as **Francesco Algarotti, Joseph Smith**, and George III.

**ZWINGER, DRESDEN (1711–28).** The crowning feature of Augustus the Strong's building projects in Dresden, the Zwinger was intended to serve as both the framing element of a festival square and the forecourt of a castle that was never built. Its architectural forms are a playful reminder of royal ambition and achievement. Designed by the architect Mattahäus Daniel Pöppelmann (1662–1736) and the sculptor **Balthasar Permoser** (1651–1732), the Zwinger translates a tradition of temporary festival structures into sizeable permanent stone **architecture** yet with a decorative lightness that serves to remind visitors of its ephemeral source. Though largely Baroque in its grandeur and theatricality, the curving movement of line, the witty play on forms, and the erosion of architectonic form through sculptural **ornamentation** look forward to the Rococo. *See also* GERMANY; POLAND.

# Bibliography

## CONTENTS

## 1. INTRODUCTION

Scholarship related to the Rococo extends across a vast range of disciplines. Art history addresses the Rococo in painting, drawing, sculpture, engraving, interior decoration, architecture, dress, decorative objects, and garden design. While most survey texts trace its stylistic development in specific countries and media during the 18th century, a few treat the Rococo as a matter of periodicity, subject to reproduction, repetition, and revival. Increasingly, monographic studies have explored the historical context of Rococo art and considered its forms and themes in relation to social, political, and aesthetic values. Some of these studies address patterns of patronage, collecting practices, and institutional structures, while others focus on individual artists,

themes, and the reception of art by particular audiences. Among the most provocative studies of the Rococo are those that have considered its specific visual properties in relation to issues of spectatorship and aesthetic pleasure. While this bibliography includes a number of sources that are primarily concerned with the stylistic development of Rococo art, architecture, and garden design within the context of art history, it emphasizes recent scholarship that critically engages with the social, historical, and cultural dimensions of the Rococo as a period style within the 18th century. Preference has been given to books written in English.

The first section comprises scholarly surveys and contextual studies of the Rococo. Art-historical investigations of Rococo art were initially dominated by issues of connoisseurship, with the aim of identifying and evaluating decorative objects and furniture for private collectors. While this approach provided a set of stylistic criteria with which to identify objects, ornamental decorations, and later paintings as "Rococo," it not only discounted the significance of artistic, social, philosophical, and political contexts but also avoided interpretation of the Rococo as a "modern" visual experience. Nevertheless, a number of these early studies provide the most comprehensive analyses of the development of stylistic forms within interior decoration, architecture, and the decorative arts and have, therefore, been included.

Exhibition catalogs have also contributed to a broader understanding of the Rococo by bringing together groups of works for reconsideration. Many of these catalogs include useful illustrations of lesser-known works and provide comprehensive factual information concerning individual objects. In general, however, this section focuses on studies that explore connections between the Rococo and wider issues within 18th-century European culture. Several of these employ new critical methodologies that challenge conventional notions of the Rococo as a formal category, exploring instead the deeper significance of stylistic choices through interdisciplinary and historical investigations of social, cultural, and thematic contexts. It is hoped that these sources will help the reader develop a nuanced critical perspective on the Rococo and its relationship to contemporary ideas and conditions of viewing.

Theoretical treatises and lectures written in the 18th century on art, artists, architecture, gardens, and ornament contributed significantly to the development and dissemination of the Rococo. These sources are grouped together in the next section along with artist's biographies, memoirs, and letters, as well as documents relating to the Académie Royale de Peinture et de Sculpture. Primary sources of this type allow scholars and students to cultivate a better understanding of how 18th-century artists, patrons, and writers thought about the nature and role of contemporary art and design and provide some indication of the reception of Rococo art by its various audiences. As the term *Rococo* only came into use during the 19th century, 18th-century theoretical treatises and critical writings address the qualities of what was known as *le style rocaille, le genre pittoresque*, and *le goût moderne*. Outside of France, particularly in pattern books and published suites of engravings, Rococo forms were described in similar terms. Some books, such as Blondel's *De la Distribution de la maison de plaisance*, Halfpenny's *Chinese and Gothic Architecture Properly Ornamented*, and Chambers' *Dissertation on Oriental Gardening* contain original plates illustrating Rococo architectural, ornamental, and garden designs.

Many of these primary sources have been used by scholars to explore the Rococo within the context of academic institutions, patronage and collecting practices, new markets in the trade of luxury goods, and the public display of art. Patrons and collectors with avant-garde tastes were instrumental in encouraging the production of Rococo art. Conversely, the voice of the critic, vehemently attacking its forms and themes, fueled an anti-Rococo reaction and contributed to the decline of the Rococo as a period style.

The next section of the bibliography focuses on secondary sources that have provided new information about academies and art training, the role of the patron, the development of collections focused on contemporary art, and the rise of the art critic. Pevsner's *Academies of Art* and Goldstein's *Teaching Art* provide readers with a useful introduction to the history of academies in this period, pedagogical practice, and the motives of artists and architects who hoped to raise the status of their professions through the creation of state-sponsored academic institutions. Patronage studies have expanded considerably in the past 30 years. In addition to those that focus on specific individuals, such as the Marquise de Pompadour, Bailey's *Patriotic Taste* presents an account of avant-garde collectors that focused their attention on contemporary French painting, much of which was Rococo. Adamson's *Princely Courts of Europe* gives a historical overview of court culture, which will help readers to understand the wider social and political contexts of the international Rococo.

Monographic studies and exhibition catalogs concerned with individual artists and architects provide more in-depth information about the practitioner and his or her work, as well as detailed biographies. These are listed in the final sections of the bibliography and categorized by region, beginning with France, then England, Ireland, and Wales, followed by Germany, Central Europe, Russia, Sweden, the Netherlands, and the Dutch Republic, and ending with Italy, Spain, and Portugal. Over the past 30 years, there has been a general historiographical pattern of scholarship related to individual artists, which can be observed in the example of Antoine Watteau. In the 1980s, the 300th anniversary of the artist's birth was marked by a blockbuster exhibition and the publication of a major monograph and an important exhibition catalog (Posner's *Antoine Watteau* and Grasselli and Rosenberg's *Watteau 1684–1721*), which stimulated significant scholarly interest in the artist and his work. Over the next two decades, studies that were more critically engaged with the interpretation of his images and their thematic context followed (Vidal's *Watteau's Painted Conversations*, Plax's *Watteau and the Cultural Politics of his Eighteenth-Century France*, Cohen's *Art, Dance, and the Body in the French Culture of the Ancien Régime*), culminating with a collection of essays by a group of interdisciplinary scholars (edited by Sheriff, *Antoine Watteau: Perspectives on the Artist and the Culture of His Time*).

While not all artists have been the subject of such progressive historical research, the field has benefited from the increased attention brought to 18th-century art through monographic exhibitions and critical inquiry. Bryson's *Word and Image* and Fried's *Absorption and Theatricality* encouraged a reconsideration of the role of the viewer in studying Rococo painting. Scott's *Rococo Interior* placed new emphasis on the social and historical contexts of the development of Rococo ornamentation in France, shifting interest away from the formal analyses provided by Fiske Kimball

in *The Creation of the Rococo*. Reading these two texts together, along with the sections related to arabesques, rocailles, and chinoiseries in Gruber's edited *History of the Decorative Arts*, provides a broad introduction to the genesis of Rococo forms in architecture, interior decoration, and the decorative arts from the different perspectives of connoisseurship and cultural history. While still primarily considered as a style of art and architecture, the introduction to Mowl and Earnshaw's *Insular Rococo* explains why it might be more fruitful to pursue the Rococo as a playful revolt against artistic conventions.

In addition to the texts listed in this bibliography, there are several useful Internet sites that provide biographical, stylistic, and historical information on Rococo art as well as scanned primary source materials and reproductions of images. Grove Art Online (www.oxfordartonline.com/public/) is a searchable scholarly art encyclopedia with bibliographies attached to individual entries, many of which are related to the Rococo. Libraries and archives are progressively digitizing their collections of 18th-century texts. A wide range of French materials held at the Bibliothèque Nationale de France is freely available on the Gallica website (http://gallica.bnf.fr). Accessible through many university and public libraries, ECCO, or Eighteenth-Century Collections Online, provides full electronic texts of books published in England between 1700 and 1800.

For images, there are a number of sites to search. Museum websites tend to illustrate and provide overviews of the history of art represented in their own collections. The Musée du Louvre and the J. Paul Getty Museum have strong collections of Rococo art and decorative objects, particularly by French artists, and offer high-resolution images and limited historical information through their searchable online databases (www.louvre.fr/llv/commun/home.jsp and www.getty.edu/). The Metropolitan Museum of Art maintains the Heilbrunn Timeline of Art History (www.metmuseum.org/toah/), which covers the Rococo within the time period 1600–1800. Virtual museums bring together reproductions of works held in separate locations and collections. The Web Gallery of Art (www.wga.hu/) reproduces paintings and sculptures by major and minor Rococo artists (some of which are referred to on the website as Baroque). Olga's Gallery (www.abcgallery.com) is similarly useful for its broad selection of works by individual artists. While the expansive collections of images on these two sites offer a wide variety of works to study and compare, the reader should be warned that information attached to the artworks is largely summary and not always reliable. Finally, Scholars Resource (www.scholarsresource.com) is a searchable database of quality images that brings together works from a number of different photographic archives and museum collections.

Further research can be carried out in European and American art museums, libraries, and archives, most of which maintain useful websites detailing their collections. Rich holdings of Rococo paintings and drawings can be found in the Frick Collection in New York, the Hermitage Museum in Saint Petersburg, and the Nationalmuseum in Stockholm. Important collections of Rococo furniture, porcelain, decorative arts, and paintings are in London at the Wallace Collection and the Victoria and Albert Museum and in Los Angeles at the J. Paul Getty Museum and the Huntington Library, Art Collections, and Botanical Gardens. Rococo period rooms give a sense of how the

arts contributed to a unified aesthetic experience within interior spaces. Significant examples are located within Schloss Sanssouci in Potsdam, the Metropolitan Museum of Art in New York, and the Musée National du Château de Versailles. A sense of the wider circulation of Rococo imagery can be gained by perusing the vast holdings of prints, cartouches, illustrated books, trade cards, and works on paper in the Bibliothèque Nationale de France in Paris. On a more limited scale, some extraordinary examples of Rococo art and ephemera can be viewed at Waddesdon Manor in Buckinghamshire, England.

## 2. SCHOLARLY SURVEYS AND CONTEXTUAL STUDIES OF THE ROCOCO

Baker, Malcolm. *Figured in Marble: The Making and Viewing of Eighteenth-Century Sculpture*. Los Angeles: J. Paul Getty Museum, 2000.

Baxter, Denise Amy, and Meredith Martin, eds. *Architectural Space in Eighteenth-Century Europe: Constructing Identities and Interiors*. Burlington, VT: Ashgate, 2010.

Beard, Geoffrey. *Stucco and Decorative Plasterwork in Europe*. London: Thames and Hudson, 1983.

Bermingham, Ann, and John Brewer. *The Consumption of Culture, 1600–1800: Image, Object, Text*. London: Routledge, 1995.

Blair, Claude, ed. *Pollard's History of Firearms*. London: Country Life Books, 1983.

Blunt, Anthony. *Baroque and Rococo Architecture and Decoration*. London: Elek, 1978.

———. *Some Uses and Misuses of the Terms* Baroque *and* Rococo *as Applied to Architecture*. London: Oxford University Press for the British Academy, 1973.

Boime, Albert. *Art in an Age of Revolution, 1750–1800*. Chicago: University of Chicago Press, 1987.

Brewer, John, and Roy Porter, eds. *Consumption and the World of Goods*. London: Routledge, 1993.

Bussagli, Marco, and Mattia Reiche. *Baroque and Rococo*. Translated by Patrick McKeown. New York: Sterling, 2009.

Carr, C. T. "Two Words in Art History II: Rococo." *Forum for Modern Language Studies* 1, no. 3 (1965): 266–81.

Cavanagh, Alden, and Michael E. Yonan. *The Cultural Aesthetics of Eighteenth-Century Porcelain*. Burlington, VT: Ashgate, 2009.

Clifford, Timothy. *Designs of Desire: Archictectural and Ornamental Prints and Drawings, 1500–1850*. Edinburgh: National Galleries of Scotland, 1999.

Coffin, Sarah D. *Rococo: The Continuing Curve, 1730–2008*. New York: Assouline, 2008.

Conner, Patrick. *Oriental Architecture in the West*. London: Thames and Hudson, 1979.

Crown, Patricia. "British Rococo as Social and Political Style." *Eighteenth-Century Studies* 23, no. 3 (1990): 269–82.

Denvir, Bernard. *The Eighteenth Century: Art, Design, and Society, 1689–1789*. London: Longman, 1983.

Duffy, Stephen, et al. *The Wallace Collection*. London: Scala, 2005.

Edwards, Clive. *Eighteenth-Century Furniture*. Manchester: Manchester University Press, 1996.

Fuhring, Peter. *Design into Art: Drawings for Architecture and Ornament: The Lodewijk Houthakker Collections*. 2 vols. London: Philip Wilson, 1989.

Girouard, Mark. *Cities and People: A Social and Architectural History*. New Haven, CT: Yale University Press, 1985.

Goodman, Dena, and Kathryn Norberg. *Furnishing the Eighteenth Century: What Furniture Can Tell Us about the European and American Past*. New York: Routledge, 2007.

Goodman, Elise, ed. *Art and Culture in the Eighteenth Century: New Dimensions and Multiple Perspectives*. Newark: University of Delaware Press, 2001.

Grimwade, Arthur. *Rococo Silver, 1727–1765*. London: Faber, 1974.

Gruber, Alain, ed. *The History of Decorative Arts*. Vol. 2, *Classicism and the Baroque in Europe*. Translated by John Goodman. New York: Abbeville, 1996.

Gusler, Wallace B., and James D. Lavin. *Decorated Firearms, 1540–1870: From the Collection of Clay P. Bedford*. Williamsburg, VA: Colonial Williamsburg Foundation, 1977.

Hart, Clive, and Kay Gilliland Stevenson. *Heaven and the Flesh: Imagery of Desire from the Renaissance to the Rococo*. Cambridge: Cambridge University Press, 1995.

Hauser, Arnold. *The Social History of Art*. Translated by Stanley Godman. 4 vols. New York: Vintage Books, 1958.

Hayward, J. F. *The Art of the Gunmaker*. 2 vols. London: Barrie and Rockcliff, 1962–63.

Heckscher, Morrison H., and Leslie Greene Bowman. *American Rococo, 1750–1775: Elegance in Ornament*. New York: Metropolitan Museum of Art, 1992.

Held, Julius S., and Donald Posner. *17th- and 18th-Century Art: Baroque Painting, Sculpture, Architecture*. New York: H. N. Abrams, 1971.

Honour, Hugh. *Chinoiserie: The Vision of Cathay*. London: J. Murray, 1973.

Howells, Robin. "Rococo and Carnival." *Studies on Voltaire and the Eighteenth Century* 308 (1993): 185–218.

Hyde, Melissa, and Jennifer Milam. *Women, Art and the Politics of Identity in Eighteenth-Century Europe*. Burlington, VT: Ashgate, 2003.

Impey, Oliver R. *Chinoiserie: The Impact of Oriental Styles on Western Art and Decoration*. London: Oxford University Press, 1977.

Ireland, Ken. *Cythera Regained? The Rococo Revival in European Literature and the Arts, 1830–1910*. Madison, NJ: Fairleigh Dickinson University Press, 2006.

Jacobson, Dawn. *Chinoiserie*. London: Phaidon, 1993.

Kimball, Fiske. *The Creation of the Rococo*. Philadelphia: Philadelphia Museum of Art, 1943.

Levey, Michael. *Rococo to Revolution: Major Trends in Eighteenth-Century Painting*. London: Thames and Hudson, 1966.

Lowengard, Sarah. *The Creation of Color in Eighteenth-Century Europe.* New York: Columbia University Press, Gutenberg-e Electronic Book, 2006.

Millon, Henry A., ed. *Circa 1700: Architecture in Europe and the Americas* Washington DC: National Gallery of Art, 2005.

Minor, Vernon Hyde. *Baroque and Rococo: Art and Culture.* New York: Harry N. Abrams, 1999.

Outram, Dorinda. *Panorama of the Enlightenment.* Los Angeles: J. Paul Getty Museum, 2006.

Park, William. *The Idea of Rococo.* Newark: University of Delaware Press, 1992.

Penny, Nicholas. *The Materials of Sculpture.* New Haven, CT: Yale University Press, 1993.

Praz, Mario. *Mnemosyne: The Parallel between Literature and the Visual Arts.* Princeton, NJ: Princeton University Press, 1970.

Ribeiro, Aileen. *The Art of Dress: Fashion in England and France 1750 to 1820.* New Haven, CT: Yale University Press, 1995.

——. *Dress in Eighteenth-Century Europe, 1715–1789.* New York: Holmes and Meier, 1985.

Saisselin, Rémy G. *The Enlightenment against the Baroque: Economics and Aesthetics in the Eighteenth Century.* Berkeley: University of California Press, 1992.

Sedlmayr, Hans, and Hermann Bauer. "Rococo." In Vol. 12, *Encyclopedia of World Art,* 258. New York: McGraw Hill, 1966.

Sheriff, Mary. "Rococo." In Vol. 3, *Encyclopedia of the Enlightenment.* Edited by Alan Charles Kors. Oxford: Oxford University Press, 2003. http://www.oxford reference.com.ezproxy2.library.usyd.edu.au/views/ENTRY.html?subview=Main &entry=t173.e622 (accessed July 7, 2010).

Snodin, Micheal, and Nigel Llewellyn. *Baroque, 1620–1800: Style in the Age of Magnificence.* London: V and A, 2009.

Tarabra, Daniela. *European Art of the Eighteenth Century.* Los Angeles: Getty, 2008.

Thornton, Peter. *Authentic Décor: The Domestic Interior, 1620–1920.* London: Wiedenfield and Nicolson, 1984.

——. *Baroque and Rococo Silks.* London: Faber and Faber, 1965.

——. *Seventeenth-Century Interior Decoration in England, France, and Holland.* New Haven, CT: Yale University Press, 1978.

Ward-Jackson, Peter. *Rococo Ornament: A History in Pictures.* Edited by Michael Snodin. London: Victoria and Albert Museum, 1984.

——. "Some Main Streams and Tributaries in European Ornament from 1500–1750." *Victoria and Albert Museum Bulletin* 3, nos. 2–4 (1967): 58–71; 90–104; 121–34.

Wiebenson, Dora, ed. *Architectural Theory and Practice from Alberti to Ledoux.* Chicago: University of Chicago Press, 1982.

Wong, James I. *Chinoiserie and Sinophilism in Seventeenth- and Eighteenth-Century Europe: Examples of Cultural Symbioses.* Stockton, CA: Koinonia Productions, 1984.

## 3. EIGHTEENTH-CENTURY TREATISES, ARTISTS' BIOGRAPHIES, LECTURES, CORRESPONDENCE, SALON CRITICISM, AND OTHER PRIMARY TEXTS OF RELEVANCE TO THE ROCOCO

Addison, Joseph, and Richard Steele. *Spectator*. Edited by Donald F. Bond. Oxford: Clarendon, 1965.

Algarotti, Francesco, conte. *Opere*. 8 vols. Livorno: Presso Marco Coltellini, 1764–65.

Bastide, Jean-François de. *The Little House: An Architectural Seduction*. Translated by Rodolphe el-Khoury. New York: Princeton Architectural Press, 1996.

Blondel, Jacques-François. *Cours d'architecture, ou traité de la décoration, distribution et construction des bâtiments*. Paris: Desaint, 1771–77.

———. *De la distribution des maisons de plaisance et de la décoration des édifices en general*. 2 vols. Paris: C.-A. Jombert, 1737–38.

———. *L'homme du monde éclairé par les arts*. Paris: chez Monory, 1774.

Boffrand, Germain. *Book of Architecture: Containing the General Principles of the Art and the Plans, Elevations, and Sections of Some of the Edifices Built in France and in Foreign Countries*. Edited by Caroline van Eck. Translated by David Britt. Burlington, VT: Ashgate, 2002.

Boyceau de La Baraudière, Jacques. *Traité du jardinage, selon les raisons de la nature et de l'art*. Paris: A. Courbé, 1640.

Brice, Germain. *Nouvelle description de la ville de Paris et de tout ce qu'elle contient de plus remarquable*. Paris: J. M. Gandouin, 1725.

Burlington, Richard Boyle, Earl of. *Fabbriche antiche disegnate da Andrea Palladio Vicentino e date in luce da Riccardo conte di Burlington*. London, 1730.

Canal, Vincenzo da. *Vita di Gregorio Lazzarini*. Edited by Giovanni Antonio Moschini. Venice, 1809.

Caylus, Anne Claude Philippe, comte de. "Discours du comte de Caylus sur les dessins." *Revue universelle des arts* 9 (1859): 316–23.

———. *Recueil d'antiquités égyptiennes, étrusques, grecques et romaines*. 7 vols. Paris: Desaint et Saillant, 1752–67.

Chambers, Sir William. *Designs of Chinese Buildings, Furniture, Dresses, Machines, and Utensils*. London: by the author, 1757.

———. *A Dissertation on Oriental Gardening*. London: W. Griffin, 1772.

———. *Plans, Elevations, Sections, and Perspective Views of the Gardens and Buildings at Kew, in Surrey*. London: by the Author, 1763.

———. *A Treatise on Civil Architecture*. London: by the Author, 1759.

Chantelou, Paul de Fréart, sieur de. *Journal du voyage du cavalier Bernin en France*. Paris: Stock, 1930.

Chippendale, Thomas. *The Chippendale Director: The Furniture Designs of Thomas Chippendale*. Edited by J. Munro Bell. Ware: Wordsworth Editions, 1990.

Cochin, Charles-Nicolas. *Observations sur les antiquités d'Herculanum, avec quelques réflexions sur la peinture & la sculpture des anciens*. Paris: C.-A. Jombert, 1755.

———. *"Le voyage d'Italie" de Charles-Nicolas Cochin, 1758*. Edited by Christian Michel. Rome: École française de Rome, 1991.

Courtonne, Jean. *Traité de la perspective pratique*. Paris: J. Vincent, 1725.

Daviler, Antoine-Charles. *Cours d'architecture qui comprend les ordres de Vignole, avec des commentaires, les figures et descriptions de ses plus beaux bâtimens, et de ceux de Michel-Ange*. 2 vols. Paris: J. Mariette, 1710.

De Piles, Roger. *Abrégé de la vie des peintres, avec des reflexions sur leurs ouvrages, et un traité du peintre parfait, de la connoissance des desseins, & de l'utilité des estampes*. Paris: François Muguet, 1699.

———. *Cours de peinture par principes. Avec une balance des peintres*. Paris: Jacques Estienne, 1708.

———. *Dialogue sur le coloris*. Paris: Nicolas Langlois, 1699.

———. *Dissertation sur les ouvrages des plus fameux peintres, Avec la vie de Rubens*. Paris: Nicolas Langlois, 1681. Reprint, Farnborough, UK: Gregg, 1968.

*A Description of Vaux-Hall Gardens. Being a Proper Companion and Guide for All Who Visit That Place*. London: S. Hooper, 1762.

Dézallier d'Argenville, Antoine-Nicolas. *Vies des fameux architectes et sculpteurs*. Paris: chez Debure l'aîné, 1787. Reprint, Geneva: Minkoff Reprints, 1972.

Diderot, Denis. *Diderot on Art*. Edited and translated by John Goodman. 2 vols. New Haven, CT: Yale University Press, 1995.

Diderot, Denis, and Jean Le Rond d'Alembert. *Encyclopédie ou dictionnaire raisonné des sciences, des arts et des metiers, par une société de gens de letters*. 28 vols. Paris, 1751–76.

Dubois de Saint-Gelais, Louis François. *Description des tableaux du Palais Royal*. Paris, D'Houry, 1727.

Dubos, Jean-Baptiste. *Réflexions critiques sur la poésie et sur la peinture*. Paris: Jean Mariette, 1719.

Enggass, Robert, and Jonathan Brown. *Italy and Spain, 1600–1750: Sources and Documents*. Englewood Cliffs, NJ: Prentice-Hall, 1970.

Eitner, Lorenz. *Neoclassicism and Romanticism, 1750–1850: Sources and Documents*. Englewood Cliffs, NJ: Prentice-Hall, 1970.

Falconet, Étienne-Maurice. *Oeuvres d'Étienne Falconet, . . . contenant plusieurs écrits relatifs aux beaux-arts, dont quelques-uns ont déjà paru mais fautifs, d'autres sont nouveaux*. 6 vols. Lausanne, Switzerland: Société typographique, 1781.

Faret, Nicolas. *L'Honnête homme, ou l'art de plaire à la court*. Paris: T. du Bray, 1630.

Félibien, Andre. *Conferences de l'Académie royale de peinture et de sculpture. Pendant année 1667*. Paris, 1669. Reprint, Portland, OR: Collegium Graphicum, 1972.

———. *Entretiens sur les vies et sur les ouvrages des plus excellens peintres anciens et modernes*. 10 vols. Paris: Denys Maritte, 1666–88.

Gainsborough, Thomas. *The Letters of Thomas Gainsborough*. Edited by John Hayes. New Haven, CT: Yale University Press, 2000.

Gersaint, Edme-François. *Catalogue raisonné des diverses curiosités du cabinet de feu M. Quentin Lorangere*. Paris: chez Jacques Barois, 1744.

——. *Catalogue raisonné d'une collection considérable de diverses curiosités en tous genres contenues dans les cabinets de feu Monsieur Bonnier de la Mosson.* Paris: J. Barois, 1744.

Gillot, Claude. *Nouveau livre de principes d'ornements d'après C. Gillot, gravé par G. Huquier.* Paris, 1732.

Goncourt, Edmond de, and Jules de Goncourt. *L'Art du XVIIIe siècle.* 3 vols. Paris: G. Charpentier, 1881–82. Reprint, Tusson, France: Du Lérot, 2007.

Halfpenny, William. *The Art of Sound Building, Demonstrated in Geometrical Problems.* London: by the Author, 1725.

——. *Chinese and Gothic Architecture Properly Ornamented.* London: R. Sayer, 1752.

——. *New Designs for Chinese Temples, Triumphal Arches, Garden Seats, Palings, etc.* London: R. Sayer, 1752.

——. *Practical Architecture . . . Representing the Five Orders, with Their Several Doors and Windows, Taken from Inigo Jones.* London: T. Bowles, 1724.

Harrison, Charles, Paul Wood, and Jason Gaiger, eds. *Art in Theory, 1648–1815: An Anthology of Changing Ideas.* Oxford: Blackwell, 2000.

Hirschfeld, Christian Cajus Lorenz. *Theory of Garden Art.* Edited and translated by Linda B. Parshall. Philadelphia: University of Pennsylvania Press, 2001.

Hogarth, William. *The Analysis of Beauty: Written with a View of Fixing the Fluctuating Ideas of Taste.* London: J. Reeves, 1753.

Holt, Elizabeth Gilmore. *A Documentary History of Art.* Vol. 2, *Michelangelo and the Mannerists, the Baroque and the Eighteenth Century.* Princeton, NJ: Princeton University Press, 1981–86.

Jouin, Henri. *Charles Le Brun et les arts sous Louis XIV. Le premier peintre, sa vie, son œuvre.* Paris: Nationale, 1889.

Jullienne, Jean de. "Abrégé de la vie de Watteau." In *Figures des différents caractères de paysages et d'études dessinées d'après nature par Antoine Watteau, tires des plus beaux cabinets de Paris.* Paris: chez Audran, 1726–28.

La Font de Saint-Yenne, Étienne. *Réflexions sur quelques causes de l'état present de la peinture en France.* Paris, 1747. Reprint, Geneva: Slatkine Reprints, 1970.

——. *Sentimens sur quelques ouvrages de peinture, de scuplture, et gravure.* The Hague: Jean Neaulme, 1754.

La Live de Jully, Ange-Laurent de. *Catalogue historique (1764); The catalogue raisonné des tableaux (March 5, 1770).* Introduction and concordance by Colin B. Bailey. Reprint, New York: Acanthus Books, 1988.

Langley, Batty. *Ancient Architecture, restored and improved by a great variety of grand and usefull designs, entirely new, in the Gothick mode, for the ornamenting of buildings and gardens.* 2 vols. London, 1742.

——. *Ancient Masonry, Both in the Theory and Practice.* London: by the Author, 1736.

——. *New Principles of Gardening.* London: A. Bettesworth and J. Batley, 1728.

——. *Practical Geometry Applied to the Useful Arts of Building.* London: W. and J. Innys, 1726.

Ledoux, Charles-Nicolas. *L'architecture: Edition Ramée.* Reprint, Princeton, NJ: Princeton Architectural Press, 1984.

Leroy, David. *Ruines des plus beaux monuments de la Grèce.* Paris: H. L. Guerin and L. F. Delatour, 1758.

Mariette, Jean. *Architecture françoise ou recueil des . . . maisons royalles, de quelques églises de Paris et de châteaux et maisons de plaisance . . . de France bâties nouvellement.* Paris: chez Jean Mariette, 1738.

Mariette, Pierre-Jean. *Abécédario de P.-J. Mariette et autres notes inédites de cet amateur sur les arts et les artistes.* Edited by Ph. Chennevières and A. Montaiglon. Paris: J.-B. Dumoulin, 1851–62.

Mézières, Nicolas Le Camus de. *The Genius of Architecture; or, the Analogy of That Art with Our Sensations.* Edited by Robin Middleton. Translated by David Britt. Santa Monica, CA: Getty Center for the History of Art and the Humanities,1992.

Mollet, Claude. *Théâtre des jardinages, contenant une méthode facile pour faire des pépinières . . . avec les fleurs qu'il faut mettre dans les parterres qui servent à l'embellissement des jardins.* Paris: C. de Sercy, 1678.

Montaiglon, Alain, ed. *Procès verbaux de l'Académie royale de peinture et de sculpture.* 4 vols. Paris: Charavay frères, 1881.

Montfaucon, Bernard de. *L'antiquité expliquée, et représentée en figures: Ouvrage françois et latin, contenant près de douze cent planches, divisé en cinq tomes.* Paris: la Compagnie des libraries, 1716.

Piranesi, Giambattista. *Le antichità romane.* Rome: Nella Stamperia Salomoni, 1784.

———. *Raccolta di varie vedute di Roma si anticha che moderna,* Rome, 1748.

Poussin, Nicolas. *Correspondance de Nicolas Poussin.* Edited by Ch. Jouanny. Paris: Archives de l'art français, 1911.

Reynolds, Sir Joshua. *Discourses on Art.* Edited by Robert Wark. New Haven, CT: Yale University Press, 1975.

Rosenberg, Pierre, ed. *Vies anciennes de Watteau.* Paris: Hermann, 1984.

Shaftesbury, Anthony Ashley Cooper, third Earl of. "A Notion of the Historical Draught or Tablature of the Judgment of Hercules." In *Characteristicks of Men, Manners, Opinions, Times.* 3 vols. London: John Darby, 1714.

Tourneux, Maurice, ed. *Correspondance littéraire, philosophique et critique par Grimm, Diderot, Raynal, Meister, etc.* Paris: Garnier Frères, 1877.

Vertue, George. "The Note-Books of George Vertue." *Walpole Society* 18 (1930); 20 (1932); 22 (1934); 24 (1936); 26 (1938); 29 (1942); 30 (1950).

Vigée Le Brun, Élisabeth. *The Memoirs of Elisabeth Vigée-Le Brun.* Translated by Siân Evans. London: Camden, 1989.

Walpole, Horace. *Anecdotes of Painting in England.* 4 vols. Twickenham, UK: Thomas Kirgate, 1762–71.

Ware, Isaac. *A Complete Body of Architecture.* London: T. Osborn and J. Shipton, 1756.

Watelet, Claude-Henri, and Pierre-Charles Levèsque. *Encyclopédie méthodique. Beaux-arts.* Paris: chez Panckoucke, 1788–91.

Winckelmann, Johann J. *Gedanken über die Nachahmung der griechischen Werke in der Malerei und Bildhauerkunst.* Dresden: Walther, 1756.

——. *Geschichte der Kunst des Altertums*. Dresden: In der Waltherischen Hof-Buchhandlung, 1764.

Zanetti, Anton Maria. *Della pittura veneziana e delle opere pubbliche de' veneziani maestri*. Venice: Nella Stamperia di G. Albrizzi, 1771.

——. *Descrizione di tutte le pubbliche pitture della Città di Venezia e isole circonvicine*. Venice: P. Bassaglia, 1733.

## 4. ACADEMIES, EXHIBITIONS, ART THEORY, AND CRITICISM

Berger, Robert W. *Public Access to Art in Paris: A Documentary History from the Middle Ages to 1800*. University Park: The Pennsylvania State University Press, 1999.

Brookner, Anita. *The Genius of the Future; Studies in French Art Criticism: Diderot, Stendhal, Baudelaire, Zola, the Brothers Goncourt, Huysmans*. London: Phaidon, 1971.

DeJean, Joan. *Ancients against Moderns: Culture Wars and the Making of a Fin de Siècle*. Chicago: University of Chicago Press, 1997.

*Diderot et l'art, de Boucher à David*. Paris: Éditions de la Réunion des musées nationaux, 1984.

Duro, Paul. *The Academy and the Limits of Painting in Seventeenth-Century France*. Cambridge: Cambridge University Press, 1997.

Goldstein, Carl. *Teaching Art: Academies and Schools from Vasari to Albers*. Cambridge: Cambridge University Press, 1996.

Harrington, Kevin. *Changing Ideas on Architecture in the* Encyclopédie, *1750–1776*. Ann Arbor, MI: UMI Research Press, 1985.

Haskell, Francis. *Patrons and Painters: A Study in the Relations between Italian Art and Society in the Age of the Baroque*. New York: Knopf, 1963.

Hobson, Marian. *The Object of Art: The Theory of Illusion in Eighteenth-Century France*. Cambridge: Cambridge University Press, 1982.

Holt, Elizabeth. *The Triumph of Art for the Public: The Emerging Role of Exhibitions and Critics*. New York: Anchor, 1979.

Hoock, Holger. *The King's Artists: The Royal Academy of Arts and the Politics of British Culture, 1760–1840*. Oxford: The Clarendon Press, 2007.

Hughes, Anthony. "'An Academy for Doing.' II: Academies, Status and Power in Early Modern Europe." *Oxford Art Journal* 9, no. 2 (1986): 50–62.

Ingrams, R. "Bachaumont: A Parisian Connoisseur of the Eighteenth Century." *Gazette des Beauz-Arts*, 75, no. 1 (1970): 11–28.

Lee, Rensselaer. *Ut Pictura Poesis: The Humanistic Theory of Painting*. New York: W. W. Norton, 1967.

Pevsner, Niklaus. *Academies of Art, Past and Present*. New York: Da Capo, 1973.

Puttfarken, Thomas. *Roger de Piles' Theory of Art*. New Haven, CT: Yale University Press, 1985.

Tate, Robert S., Jr. *Petit de Bachaumont: His Circle and the Mémoires Secrets*. Geneva: Institut et Musée Voltaire, 1968.

Vidler, Anthony. *The Writing of the Walls: Architectural Theory in the Late Enlightenment*. Princeton, NJ: Princeton Architectural Press, 1987.

Wrigley, Richard. *The Origin of French Art Criticism: From the Ancien Régime to the Restoration*. Oxford: Oxford University Press, 1993.

## 5. ART PATRONAGE, COLLECTING, MARKETS, AND DEALERS

Adamson, John, ed. *The Princely Courts of Europe: Ritual, Politics and Culture under the Ancien Régime, 1500–1750*. London: Wiedenfield and Nicolson, 1999.

Arminjon, Catherine. *Madame de Pompadour et la floraison des arts*. Montreal: Musée David M. Stewart, 1988.

Bailey, Colin. *Patriotic Taste: Collecting Modern Art in Pre-Revolutionary Paris*. New Haven, CT: Yale University Press, 2002.

Bignamini, Ilaria, and Clare Hornsby. *Digging and Dealing in Eighteenth-Century Rome*. New Haven, CT: Yale University Press, 2010.

Bjurström, Per. *Dessins du Nationalmuseum de Stockholm, Collection du comte Tessin, 1695–1770, ambassadeur de Suède près la cour de France*. Ghent, Belgium: Impr. E. Ledeberg, 1970.

Dauly, E., and E. Taillemite, eds. *Colbert*. Paris: Hôtel de la Monnaie, 1983.

Denis, Marie-Amynthe. *Madame du Barry: de Versailles à Louveciennes*. Paris: Flammarion, 1992.

Glorieux, Guillaume. *À l'enseigne de Gersaint: Edme-François Gersaint, marchand d'art sur le pont Notre-Dame (1694–1750)*. Seyssel, France: Champ Vallon, 2002.

Hunter-Stiebel, Penelope. *Louis XV and Madame de Pompadour: A Love Affair with Style*. New York: Rosenberg and Stiebel, 1990.

McClellan, Andrew. *Inventing the Louvre: Art, Politics, and the Origins of the Modern Museum in Eighteenth-Century Paris*. Cambridge: Cambridge University Press, 1994.

Menzhausen, J., et al. *The Splendor of Dresden: Five Centuries of Art Collecting*. Washington, DC: National Gallery of Art, 1978.

Pardhailé-Galabrun, Annik. *The Birth of Intimacy: Privacy and Domestic Life in Early Modern Paris*. Translated by Jocelyn Phelps. Philadelphia: University of Pennsylvania Press, 1991.

Pety, Dominique. *Les Goncourt et la collection. De l'objet d'art à l'art d'écrire*. Geneva: Droz, 2003.

Pomian, Krzysztof. *Collectors and Curiosities: Paris and Venice 1500–1800*. Translated by Elizabeth Wiles-Portier. Cambridge: Polity, 1990.

Posner, Donald. "Madame de Pompadour as a Patron of the Visual Arts." *Art Bulletin* 72 (1990): 74–105.

Redford, Bruce. *Dilettanti: The Antic and the Antique in Eighteenth-Century England*. Los Angeles: Getty Research Institute, 2008.

Rorschach, Kimerly. "Frederick Prince of Wales (1707–1751) as Collector and Patron." *Walpole Society* 55 (1989–90): 1–76.

Sargentson, Carolyn. "Markets for Boulle Furniture in Early Eighteenth-Century Paris." *Burlington Magazine* 134, no. 1071 (1992): 363–67.

——. *Merchants and Luxury Markets: The* Marchands Merciers *of Eighteenth-Century Paris.* Malibu, CA: Victoria and Albert Museum in association with the J. Paul Getty Museum, 1996.

Scott, Barbara. "The Collection of the Tessin Institut, Paris." *Connoisseur* 768 (1976): 87–96.

——. "Madame Geoffrin: A Patron and Friend of Artists." *Apollo* 85 (1967): 98–103.

——. "Mme du Barry: A Royal Favourite with Taste." *Apollo* 97 (1973): 60–71.

——. "Pierre Crozat: A Maecenas of the Régence." *Apollo* 97 (1973): 11–19.

——. "Pierre-Jean Mariette: Scholar and Connoisseur." *Apollo*, 97 (1973): 54–59.

Snodin, Michael, ed. *Horace Walpole's Strawberry Hill.* New Haven, CT: Yale University Press in association with the Yale Center for British Art, 2009.

Tite, Catherine. *Portraiture, Dynasty, and Power: Art Patronage in Hanoverian Britain, 1714–1759.* Amherst, NY: Cambria, 2010.

Warren, Jeremy, and Adriana Turpin, eds. *Auctions, Agents, and Dealers: The Mechanisms of the Art Market, 1660–1830.* Oxford: Beazley Archive, 2007.

## 6. FRANCE

### Painting, Sculpture, Prints, and Drawings

Ananoff, Alexandre. *L'oeuvre dessiné de François Boucher (1703–1770): Catalogue raisonné.* Paris: F. de Nobele, 1966.

Ashton, Dore. *Fragonard in the Universe of Painting.* Washington DC: Smithsonian Institution, 1988.

Auricchio, Laura. *Adélaïde Labille-Guiard: Artist in the Age of Revolution.* Los Angeles: J. Paul Getty Museum, 2009.

Bacou, Roseline. *French Landscape Drawings and Sketches of the Eighteenth Century.* London: British Museum, 1977.

Baetjer, Katharine, ed. *Watteau, Music, and Theater.* New York: Metropolitan Museum of Art, 2009.

Bailey, Colin, ed. *The Age of Watteau, Chardin, and Fragonard: Masterpieces of French Genre Painting.* New Haven, CT: Yale University Press, 2003.

——. *Gabriel De Saint-Aubin, 1724–1780.* New York: The Frick Collection in association with Musée du Louvre Éditions and Somogy Art Publishers, 2007.

——. *Jean-Baptiste Greuze: The Laundress.* Los Angeles: J. Paul Getty Museum, 2000.

——. *The Loves of the Gods: Mythological Painting from Watteau to David.* New York: Rizzoli, 1992.

Banks, Oliver T. "Watteau and the North: Studies in the Dutch and Flemish Baroque Influences on French Rococo Painting." PhD diss., Princeton University, 1975.

Barker, Emma. *Greuze and the Painting of Sentiment.* Cambridge: Cambridge University Press, 2005.

Baxandall, Michael. *Patterns of Intention: On the Historical Explanation of Pictures.* New Haven, CT: Yale University Press, 1985.

Bennett, Shelley, and Carolyn Sargentson. *French Eighteenth-Century Art at the Huntington.* New Haven, CT: Yale University Press, 2008.

Besnard, Paul Albert, and Georges Wildenstein. *La Tour: la vie et l'oeuvre de l'artiste.* Paris: Les Beaux-Arts: 1928.

Bjurström, Per. *French Drawings: Eighteenth Century.* Nationalmuseum, Stockholm: Liber Förlag, 1982.

Blunt, Anthony. *Art and Architecture in France, 1500–1700.* New Haven, CT: Yale University Press, 1999.

Bordeaux, Jean-Luc. *François Le Moyne and His Generation, 1688–1737.* Neuilly-sur-Seine, France: Arthena, 1984.

Brookner, Anita. *Greuze: The Rise and Fall of an Eighteenth-Century Phenomenon.* London: Elek, 1972.

———. *Jacques-Louis David.* London: Chatto and Windus, 1980.

Brugerolles, Emmanuelle, ed. *Boucher, Watteau and the Origin of the Rococo.* Paris: École nationale supérieure des beaux-arts, 2003.

Bryson, Norman. *Tradition and Desire: From David to Delacroix.* Cambridge: Cambridge University Press, 1984.

———. *Vision and Painting: The Logic of the Gaze.* London: Macmillan, 1983.

———. *Word and Image: French Painting of the Ancien Régime.* Cambridge: Cambridge University Press, 1981.

Cailleux, Jean. "Some Family and Group Portraits by François de Troy (1645–1730)." *Burlington Magazine* 113, no. 817 (1971): i–xviii.

Carey, Juliet. *Theatres of Life: Drawings from the Rothschild Collection at Waddesdon Manor.* London: Paul Holberton, 2007.

Carlson, Victor I., John W. Ittman, and David. D. Becker. *Regency to Empire: French Printmaking, 1715–1814.* Baltimore: Baltimore Museum of Art, 1984.

Cavanaugh, Alden, ed. *Performing the "Everyday": The Culture of Genre in the Eighteenth Century.* Newark: University of Delaware Press, 2007.

*Charles-Joseph Natoire: peintures, dessins, estampes et tapisseries des collections publiques françaises.* Troyes, Musée des beaux-arts, Nîmes, Nantes, France: Chiffoleau, 1977.

Chastel, André. *French Art.* Vol. 3, *The Ancien Régime, 1620–1775.* New York: Flammarion, 1996.

*Claude Gillot (1673–1722): Comédies, sabbats et autres subjects bizarres.* Musée de Langres, Paris: Éditions d'art Somogy, 1999.

Cohen, Sarah R. *Art, Dance, and the Body in French Culture of the Ancien Régime.* Cambridge: Cambridge University Press, 2000.

Conisbee, Philip. *Chardin.* Oxford: Phaidon, 1985.

———. *Claude-Joseph Vernet, 1714–1789.* London: The Greater London Council, 1976.

———, ed. *French Genre Painting in the Eighteenth Century.* New Haven, CT: Yale University Press, 2007.

———. *Painting in Eighteenth-Century France*. Oxford: Phaidon, 1981.

Crow, Thomas. *Emulation: Making Artists for Revolutionary France*. New Haven, CT: Yale University Press, 1995.

———. *Painters and Public Life in Eighteenth-Century Paris*. New Haven, CT: Yale University Press, 1985.

Cuzin, Pierre. *Jean-Honoré Fragonard*. New York: Abrams, 1988.

Démoris, Réné. *Chardin, la chair et l'objet*. Paris: A. Biro, 1991.

Dulau, Anne, ed. *Boucher and Chardin: Masters of Modern Manners*. London: Paul Holberton, 2008.

Duncan, Carol. *The Aesthetics of Power: Essays in Critical Art History*. Cambridge, Cambridge University Press: 1993.

———. *The Pursuit of Pleasure: The Rococo Revival in French Romantic Art*. New York: Garland, 1976.

Faÿ-Hallé, Antoinette, Marie-Noëlle Pinot de Villechenon, and Guilhem Scherf, et al. *Falconet à Sèvres, 1757–1766 ou L'art de plaire*. Musée national de la céramique, Sèvres, Paris: Réunion des musées nationaux, 2001.

Field, Richard, Ellen D'Oench, and Victor Carlson. *Prints and Drawings by Gabriel de Saint-Aubin, 1724–1780*. Middletown, CT: Davidson Art Center, 1975.

Fried, Michael. *Absorption and Theatricality: Painting and Beholder in the Age of Diderot*. Berkeley: University of California Press, 1980.

Friedlaender, Walter. *David to Delacroix*. Translated by Robert Goldwater. Cambridge, MA: Harvard University Press, 1952.

Fuhring, Peter. *Designing the Décor: French Drawings from the Eighteenth Century*. Lisbon: Calouste Gulbenkian Foundation, 2005.

Gareau, Michel. *Charles Le Brun: First Painter to King Louis XIV*. New York: H. N. Abrams, 1992.

Goodman, Elise. *The Portraits of Madame de Pompadour: Celebrating the Femme Savante*. Berkeley: University of California Press, 2000.

Grasselli, Margaret Morgan, and Pierre Rosenberg. *Watteau, 1684–1721*. Washington DC: National Gallery of Art, 1984.

Grate, Pontus. *French Paintings II: The Eighteenth Century*. Stockholm: Swedish National Art Museums, 1994.

Hedley, Jo. *François Boucher: Seductive Visions*. London: Wallace Collection, 2004.

Holloway, Owen E. *French Rococo Book Illustration*. London: Tiranti, 1969.

Holmes, Mary Tavener. *Nicolas Lancret: Dance before a Fountain*. Los Angeles: J. Paul Getty Museum, 2006.

———. *Nicolas Lancret, 1690–1743*. New York: H. N. Abrams in association with the Frick Collection, 1991.

Hyde, Melissa. *Making Up the Rococo: François Boucher and His Critics*. Los Angeles: Getty Publications, 2006.

Hyde, Melissa, and Mark Ledbury. *Rethinking Boucher*. Los Angeles: Getty Research Institute, 2006.

Ingersoll-Smouse, Florence. *Pater: biographie et catalogues critiques*. Paris: les Beaux-Arts, 1928.

Jacky, Pierre. *Alexandre-François Desportes: tableaux de chasse.* Paris: Mona Bismarck Foundation and Musée international de la chasse, 1998.

Jacoby, Beverly Schreiber. *François Boucher's Early Development as a Draughtsman, 1720–1734.* New York: Garland, 1986.

Johnson, Dorothy. *Jacques-Louis David: Art in Metamorphosis.* Princeton, NJ: Princeton University Press, 1993.

Kahng, Eik, and Marianne Roland Michel. *Anne Vallayer-Coster: Painter to the Court of Marie-Antoinette.* New Haven, CT; Yale University Press, 2002.

Kalnein, Wend Graf von, and Michael Levey. *Art and Architecture of the Eighteenth Century in France.* Harmondsworth: Penguin, 1972.

Kavanagh, Thomas. *Esthetics of the Moment: Literature and Art in the French Enlightenment.* Philadelphia: University of Pennsylvania Press, 1996.

Lajer-Burcharth, Ewa. *Necklines: The Art of Jacques-Louis David after the Terror.* New Haven, CT: Yale University Press, 1999.

Lang, Alistair. *The Drawings of François Boucher.* London: Scala, 2003.

———. *François Boucher: 1703–1770.* New York: Metropolitan Museum of Art, 1986.

Ledbury, Mark. *Sedaine, Greuze and the Boundaries of Genre.* Oxford: Voltaire Foundation, 2000.

Leith, James A. *The Idea of Art as Propaganda in France, 1750–1799: A Study in the History of Ideas.* Toronto: University of Toronto Press, 1965.

Levey, Michael. *Painting and Sculpture in France, 1700–1789.* New Haven, CT: Yale University Press, 1993.

Levitine, George. *The Sculpture of Falconet.* Greenwich, CT: New York Graphic Society, 1972.

Lochhead, Ian. *The Spectator and the Landscape in the Art Criticism of Diderot and His Contemporaries.* Ann Arbor, MI: UMI Research Press, 1982.

Maillet-Chassagne, Monique. *Une dynastie de peintres lillois: les Van Blarenberghe.* Paris: Bernard Giovanangeli, 2001.

*Marguerite Gérard: Artiste en 1789, dans l'atelier de Fragonard.* Musée Cognacq-Jay, Paris: Paris musées, 2009.

Mérot, Alain. *French Painting in the Seventeenth-Century.* New Haven, CT: Yale University Press, 1995.

Michel, Christian. *Charles-Nicolas Cochin et l'art des lumières.* Rome: École française de Rome, 1993.

———. *Charles-Nicolas Cochin et le livre illustré.* Geneva: Droz 1987.

Michel, Marianne Roland. *Chardin.* New York: Abrams, 1996.

Milam, Jennifer. *Fragonard's Playful Paintings: Visual Games in Rococo Art.* Manchester: Manchester University Press, 2006.

Morton, Mary, ed. *Oudry's Painted Menagerie: Portraits of Exotic Animals in Eighteenth-Century Europe.* Los Angeles: J. Paul Getty Museum, 2007.

Mouradian, Hélène ed. *Jean-Jacques Bachelier (1724–1806): Peintre du roi et de Madame de Pompadour.* Paris and Versailles: Somogy editions d'art and Musée Lambinet, 1999.

Munhall. Edgar. *Greuze the Draftsman*, London: Merrell, in association with the Frick Collection, 2002.

———. *Jean-Baptiste Greuze, 1725–1805.* Hartford, CT: Wadsworth Athenuem, 1977.

Opperman, Hal N. *J.-B. Oudry, 1686–1755.* Galeries nationales du Grand palais. Paris: Editions de la Réunion des musées nationaux, 1982.

Opperman, Hal N. *Jean-Baptiste Oudry.* 2 vols. New York: Garland, 1977.

Plax, Julie-Anne. *Watteau and the Cultural Politics of Eighteenth-Century France.* Cambridge: Cambridge University Press, 2000.

Posner, Donald. *Antoine Watteau.* London: Weidenfeld and Nicolson, 1984.

———. *Watteau—"A Lady at Her Toilet."* London: Allen Lane, 1973.

Rand, Richard. *Intimate Encounters: Love and Domesticity in Eighteenth-Century France.* Princeton, NJ: Princeton University Press, 1997.

Renard, Philippe. *Jean-Marc Nattier (1685–1766): Un artiste parisien à la cour de Louis XV.* Saint-Rémy-en-l'Eau, France: Monelle Hayot, 1999.

Robertson, S. W. "Marguerite Gérard." In *French Painting 1774–1830: The Age of Revolution,* 440–41. Detroit: Wayne State University Press, 1975.

———. "Marguerite Gérard." In *Women Artists, 1550–1950,* edited by Ann Sutherland Harris and Linda Nochlin, 197–98. Los Angeles: Los Angeles County Museum of Art, 1977

Roland-Michel, Marianne. *Anne Vallayer-Coster, 1744–1818.* Paris: C. I .L., 1970.

Rosenberg, Pierre. *The Age of Louis XV: French Painting 1710–1774.* Chicago: Art Institute of Chicago, 1975.

———. *Chardin.* Translated by Carolyn Beamish. London: Royal Academy of Art, 2000.

———. *Chardin, 1699–1779.* Cleveland, OH: Cleveland Museum of Art, 1979.

———. *Fragonard.* New York: Metropolitan Museum of Art, 1988.

———. *France in the Golden Age: Seventeenth-Century French Paintings in American Collections.* New York: Metropolitan Museum of Art, 1982.

———. *Le "Livre des Saint-Aubin."* Paris: Réunion des musées nationaux, 2002.

Rosenberg, Pierre, and Renaud Temperini. *Chardin.* New York: Prestel, 2000.

Rosenblum, Robert. *Transformations in Late 18th-Century Art.* Princeton NJ: Princeton University Press, 1967.

Rosenfeld, Myra Nan. *Largillière and the Eighteenth-Century Portrait.* Montreal: Montreal Musuem of Fine Arts, 1981.

Rosenthal, Donald A. *La Grande Manière: Historical and Religious Painting in France, 1700–1800.* Rochester, NY: Memorial Art Gallery of the University of Rochester, 1987.

Salmon, Xavier. *Jean-Marc Nattier, 1685–1766.* Paris: Réunion des musées nationaux, 1999.

Schnapper, Antoine. *David.* Translated by Helga Harrison. New York: Alpine Fine Arts Collection, 1982.

Sheriff, Mary, ed. *Antoine Watteau: Perspectives on the Artist and the Culture of His Time.* Newark: University of Delaware Press, 2006.

———. *The Exceptional Woman: Elisabeth Vigée-Lebrun and the Cultural Politics of Art.* Chicago: University of Chicago Press, 1996.

———. *Fragonard: Art and Eroticism.* Chicago: University of Chicago Press, 1990.

———. *Moved by Love: Inspired Artists and Deviant Women in Eighteenth-Century France.* Chicago: University of Chicago Press, 2004.

Snoep-Reitsma, Ella. "Chardin and the Bourgeois Ideals of His Time." *Nederlands Kunsthistorisch Jaarboek* 24 (1973): 147–243.

Souchal, François. *French Sculptors of the 17th and 18th Centuries: The Reign of Louis XIV.* 4 vols. Oxford: Cassirer: 1977–93.

———. *Les frères Coustou: Nicolas, 1658–1733, Guillaume, 1677–1746, et l'évolution de la sculpture française, du dôme des Invalides aux chevaux de Marly.* Paris: E. de Boccard, 1980.

Stafford, Barbara Maria. *Artful Science: Enlightenment, Entertainment, and the Eclipse of Visual Education.* Cambridge, MA: MIT Press, 1994.

———. *Body Criticism: Imaging the Unseen in Enlightenment Art and Medicine.* Cambridge, MA: MIT Press, 1991.

Stewart, Philip. *Engraven Desire: Eros, Image, and Text in the French Eighteenth Century.* Durham, NC: Duke University Press, 1992.

Tadgell, Christopher. *Ange-Jacques Gabriel.* London: A. Zwemmer, 1978.

Thuillier, Jacques, and Albert Chatelet. *French Painting from Le Nain to Fragonard.* Geneva: Skira, 1964.

Tonkovich, Jennifer. "Claude Gillot's Costume Designs for the Paris Opera: Some New Sources." *The Burlington Magazine* 147 (2005): 248–52.

Vidal, Mary. *Watteau's Painted Conversations: Art, Literature, and Talk in Seventeenth- and Eighteenth-Century France.* New Haven, CT: Yale University Press, 1992.

Wakefield, David. *French Eighteenth-Century Painting.* London: Gordon Fraser, 1984.

Wayne State University Press. *French Painting 1774–1830: The Age of Revolution.* Detroit: Wayne State University Press, 1975.

Wildenstein, Georges. *Chardin: Biographie et catalogue critiques l'œuvre complet de l'artiste reproduit en deux cent trent-huit héliogravures.* Paris: Les Beaux-Arts, 1933.

Wintermute, Alan, ed. *Claude to Corot: The Development of Landscape Painting in France.* New York: Colnaghi, 1990.

Wright, Christopher. *The French Painters of the Seventeenth Century.* London: Orbis, 1985.

## Architecture and Interior Decoration

Babelon, Jean-Pierre. "Les façades des palais Rohan-Soubise sur le jardin." *Revue de l'Art* 4 (1969): 66–73.

Bédard, Jean-François. "The Architect as *honnête homme*: The Domestic Architecture and Decoration of Gilles-Marie Oppenord (1672–1742)." PhD diss., Columbia University, 2003.

——. *Decorative Games: Ornament, Rhetoric, and Noble Culture in the Work of Gilles-Marie Oppenord (1672–1742)*. Newark: University of Delaware Press, 2010.

Boyer, Marie-France. *The Private Realm of Marie Antoinette*. Translated by Jennifer Wakelyn. London: Thames and Hudson, 1995.

Braham, Allan. *The Architecture of the French Enlightenment*. London: Thames and Hudson, 1980.

Dennis, Michael. *Court and Garden: From the French Hôtel to the City of Modern Architecture*. Cambridge, MA: MIT Press, 1986.

Etlin, Richard. *Symbolic Space: French Enlightenment Architecture and Its Legacy*. Chicago: Chicago University Press, 1994.

*Le faubourg Saint-Germain: La rue de Grenelle*. Galerie de la SEITA, Paris: Délégation à l'action artistique, 1985.

*Le faubourg Saint-Germain: La rue de Varenne*. Paris: Musée Rodin, 1981.

Fuhring, Peter. *Juste-Aurèle Meissonnier: Un genio del rococò: 1695–1750*. 2 vols. Torino: U. Allemandi, 1999.

Gallet, Michel. *Claude-Nicolas Ledoux (1736–1806)*. Paris: Picard, 1980.

——. *Paris Domestic Architecture of the Eighteenth Century*. Translated by James C. Palmes. London: Barrie and Jenkins, 1972.

Gallet, Michel, and J. Garms. *Germain Boffrand, 1667–1754: L'aventure d'un architecte indépendant*. Paris: Herscher, 1986.

Girouard, Mark. *Life in the French Country House*. London: Cassell, 2000.

Gorce, Jerome de la. *Bérain dessinateur du Roi Soleil*. Paris: Herscher, 1986.

Kemp, Gérald van der. *Versailles*. Translated by Bronia Fuchs. London: Philip Wilson: 1978.

Myers, Mary L. *French Architectural and Ornament Drawings of the Eighteenth Century*. New York: Metropolitan Museum of Art, 1991.

Neuman, Robert. *Robert de Cotte and the Perfection of Architecture in Eighteenth-Century France*. Chicago: University of Chicago Press, 1994.

Pelletier, Louise. *Architecture in Words: Theatre, Language and the Sensuous Spaces of Architecture*. London: Routledge, 2006.

Pons, Bruno. *De Paris à Versailles, 1699–1736: Les sculpteurs ornemanistes parisiens et l'art décoratif des bâtiments du roi*. Strasbourg, France: Association des publications près les Universités de Strasbourg, 1986.

——. *French Period Rooms, 1650–1800: Rebuilt in England, France, and the Americas*. Translated by Ann Sautier-Greening. Dijon, France: Éditions Faton, 1995.

——. *Grands décors français 1650–1800: Reconstitues en Angleterre, aux Etats-Unis, en Amerique du Sud et en France*. Dijon, France: Éditions Faton, 1995.

Scott, Katie. *The Rococo Interior: Decoration and Social Spaces in Early Eighteenth-Century Paris*. New Haven, CT: Yale University Press, 1995.

Sutcliffe, Anthony. *Paris: An Architectural History*. New Haven, CT: Yale University Press, 1993.

Verdier, Roger. *Le style régence: Ses ornemanistes, ses menuisiers, ses sculpteurs, ses sièges, ses tapissiers, ses lexiques.* Saint Martin de la Lieue, Lisieux, France: R. Verdier, 1989.

Vidler, Anthony. *Claude-Nicolas Ledoux: Architecture and Social Reform at the End of the Ancien Régime.* Cambridge, MA: MIT Press, 1990.

Walton, Guy. *Louis XIV's Versailles.* Chicago: University of Chicago Press, 1986.

Whitehead, John. *The French Interior in the Eighteenth Century.* London: Laurence King, 1992.

## Decorative Objects, Furniture, and Dress

Delpierre, Madeleine. *Dress in France in the Eighteenth Century.* Translated by Caroline Beamish. New Haven, CT: Yale University Press, 1997.

Fuhring, Peter. "Designs for and after Boulle Furniture." *The Burlington Magazine* 134, no. 1071 (1992): 350–62.

Koda, Harold. *Dangerous Liaisons: Fashion and Furniture in the Eighteenth Century.* New York: Metropolitan Museum of Art, 2006.

Pinot de Villechenon, Marie-Noëlle. *Sèvres: Porcelain from the Sèvres Museum, 1740 to the Present Day.* Translated by John Gilbert. London: Lund Humphries, 1993.

Pradère, Alexandre. *French Furniture Makers: The Art of the Ébéniste from Louis XIV to the Revolution.* Malibu, CA: J. Paul Getty Museum, 1989.

Roche, Daniel. *The Culture of Clothing: Dress and Fashion in the "Ancien Régime."* Translated by Jean Birrell. Cambridge: Cambridge University Press, 1994.

Roth, Linda H., and Clare Le Corbeiller. *French Eighteenth-Century Porcelain at the Wadsworth Atheneum: The J. Pierpont Morgan Collection.* Hartford, CT: Wadsworth Atheneum, 2000.

Sassoon, Adrian. *Vincennes and Sèvres Porcelain: Catalogue of the Collections.* Malibu, CA: J. Paul Getty Museum, 1991.

Scott, Katie, and Deborah Cherry, eds. *Between Luxury and the Everyday: Decorative Arts in Eighteenth-Century France.* Malden, MA: Blackwell, 2005.

Verlet, Pierre. *French Furniture of the Eighteenth Century.* Translated by Penelope Hunter-Stiebel. Charlottesville: University Press of Virginia, 1991.

Watson, Francis John Bagott. *The Choiseul Box.* London: Oxford University Press, 1963.

———. *Louis XVI Furniture.* London: A. Tiranti, 1960.

Watson, Francis John Bagott, and Carl Christian Dauterman. *The Wrightsman Collection Catalogue.* 5 vols. New York: Metropolitan Museum of Art, 1966-1973.

## Gardens and Garden Design

Adams, William Howard. *The French Garden, 1500–1800.* New York: George Braziller, 1979.

Baridon, Michel. *A History of the Gardens of Versailles.* Translated by Adrienne Mason. Philadelphia: University of Pennsylvania Press, 2008.

Berger, Robert W. *In the Garden of the Sun King: Studies on the Park of Versailles under Louis XIV.* Washington DC: Dumbarton Oaks Research Library and Collection, 1985.

DeLorme, Eleanor P. *Garden Pavilions and the Eighteenth-Century French Court.* Woodbridge, Suffolk, UK: Antique Collectors' Club, 1996.

Dubois, Jacques. *Versailles, a Garden in Four Seasons.* Translated by Daniel Wheeler. New York: Vendome, 1983.

Girard, Jacques. *Versailles Gardens: Sculpture and Mythology.* Translated by E. Rosenthal. New York: Vendome, 1985.

Hunt, John Dixon, and Michel Conan, eds. *Tradition and Innovation in French Garden Art: Chapters of a New History.* Philadelphia: University of Pennsylvania Press, 2002.

Ketcham, Diana. *Le Desert de Retz: A Late Eighteenth-Century French Folly Garden: The Artful Landscape of Monsieur de Monville.* Cambridge, MA: MIT Press, 1994.

Lablaude, Pierre-André. *The Gardens of Versailles.* Translated by Fiona Biddulph. London: Zwemmer, 1995.

McIntosh, Christopher. *Gardens of the Gods: Myth, Magic and Meaning.* New York: Palgrave Macmillan, 2005.

Mukerji, Chandra. *Territorial Ambitions and the Gardens of Versailles.* Cambridge: Cambridge University Press, 1997.

Woodbridge, Kenneth. *Princely Gardens: The Origins and Development of the French Formal Style.* New York: Rizzoli, 1986.

# 7. ENGLAND, IRELAND, AND WALES

## Painting, Sculpture, Prints, and Drawings

Allen, Brian. *Francis Hayman.* New Haven, CT: Yale University Press, 1987.

——, ed. *Towards a Modern Art World.* New Haven, CT: Yale University Press, 1995.

Asfour, Amal, and Paul Williamson, *Gainsborough's Vision.* Liverpool, UK: Liverpool University Press, 1999.

Asleson, Robyn, and Shelley M. Bennett. *British Painting at the Huntington.* New Haven, CT: Yale University Press, 2001.

Barrell, John. *The Dark Side of the Landscape: The Rural Poor in English Painting, 1730–1840.* Cambridge: Cambridge University Press, 1980.

——. "The Functions of Art in a Commercial Society: The Writings of James Barry." *Eighteenth-Century Theory and Interpretation* 25 (1984): 117–40.

——. *The Political Theory of Painting from Reynolds to Hazlitt: "The Body of the Public."* New Haven, CT: Yale University Press, 1986.

Belsey, Hugh. "A Visit to the Studios of Gainsborough and Hoare." *The Burlington Magazine* 129 (1987): 107–9.

Bermingham, Ann. *Landscape and Ideology: The English Rustic Tradition, 1740–1860.* Berkeley: University of California Press, 1986.

——. *Learning to Draw: Studies in the Cultural History of a Polite and Useful Art.* New Haven, CT: Yale University Press, 2000.

——, ed. *Sensation and Sensibility: Viewing Gainsborough's* Cottage Door. New Haven, CT: Yale University Press, 2005.

Bindman, David. *Hogarth.* London: Thames and Hudson, 1981.

Bindman, David, and Malcolm Baker. *Roubiliac and the Eighteenth-Century Monument: Sculpture as Theatre.* New Haven, CT: Yale University Press, 1995.

Fort, Bernadette, and Angela Rosenthal. *The Other Hogarth: Aesthetics of Difference.* Princeton, NJ: Princeton University Press, 2001.

Fryer, Edward, ed. *The Works of James Barry.* 2 vols. London: T. Cadell and W. Davies, 1809.

Girouard, Mark. "Coffee at Slaughter's: English Art and the Rococo." *Country Life* 13 and 27 January, 5 February (1966): 58–61; 188–90; 224–27.

Govier, Louise. *Hogarth to Turner: British Painting.* New Haven, CT: Yale University Press, 2010.

Gowing, Laurence. "Hogarth, Hayman, and the Vauxhall Decorations." *Burlington Magazine* 95 (1953): 4–19.

Harris, John. *The Artist and the Country House: A History of Country House and Garden View Painting in Britain, 1540–1870.* London: Sotheby Parke Bernet, 1979.

——. *Gardens of Delight: The Rococo English Landscape of Thomas Robins the Elder.* London: Basilisk, 1978.

Hayes, John. *The Landscape Paintings of Thomas Gainsborough.* 2 vols. London: Sotheby, 1982.

Hogarth, William. *The Analysis of Beauty.* Edited by Ronald Paulson. New Haven, CT: Yale University Press, 1995.

Holbrook, Mary. "Painters in Bath in the Eighteenth Century." *Apollo* 97 (1973): 375–84.

Ingamells, John, and Robert Raines. "A Catalogue of the Paintings, Drawings and Etchings of Philip Mercier." *The Walpole Society* 46 (1978): 1–10.

——. *Philip Mercier, 1689–1760: An Exhibition of Paintings and Engravings.* York, UK: City Art Gallery, 1969.

Johnson, E. D. H. *Paintings of the British Social Scene from Hogarth to Sickert.* New York: Rizzoli, 1986.

Lindsay, Jack. *Thomas Gainsborough: His Life and Art.* London: Granada, 1981.

Mannings. David. *Sir Joshua Reynolds: A Complete Catalogue of His Paintings; The Subject Pictures Catalogued by Martin Postle.* New Haven, CT: Yale University Press, 2000.

Myrone, Martin, and Michael Rosenthal. *Gainsborough.* London: Tate, 2002.

Paulson, Ronald. *Emblem and Expression: Meaning in English Art of the Eighteenth Century.* London: Thames and Hudson, 1975.

——. *Hogarth*. 2 vols. New Brunswick: Rutgers University Press, 1992.

Pears, Iain. *The Discovery of Painting: The Growth of Interest in the Arts in England, 1680–1768*. New Haven, CT: Yale University Press, 1988.

Postle, Martin. *Angels and Urchins: The Fancy Picture in Eighteenth-Century British Art*. London: Draig, 1998.

——. *Sir Joshua Reynolds: The Subject Pictures*. Cambridge: Cambridge University Press, 1995.

Pressly, William L. "A Chapel of Natural and Revealed Religion: James Barry's Series for the Society's Great Room Reinterpreted." *Journal of the Royal Society of Arts* 32, no. 5336 (1984): 543–46, 634–37, 693–95.

——. *James Barry: The Artist as Hero*. London: Tate Gallery, 1938.

——. *The Life and Art of James Barry*. New Haven, CT: Yale University Press, 1981.

Retford, Kate. *The Art of Domestic Life: Family Portraiture in Eighteenth-Century England*. New Haven, CT: Yale University Press, 2006.

Rosenthal, Michael. *The Art of Thomas Gainsborough: "A Little Business for the Eye."* New Haven, CT: Yale University Press, 1995.

Shawe-Taylor, Desmond. *The Georgians: Eighteenth-Century Portraiture and Society*. London: Barrie and Jenkins, 1990.

Simon, Robin. *Hogarth, France and British Art: The Rise of the Arts in Eighteenth-Century Britain*. London: Hogarth Arts, 2007.

Snodin, Michael, ed. *Rococo: Art and Design in Hogarth's England*. London: Victoria and Albert Museum, 1984.

Solkin, David, ed. *Art on the Line: The Royal Academy Exhibitions at Somerset House, 1780–1836*. New Haven, CT: Yale University Press, 2001.

——. *Painting for Money: The Visual Arts and the Public Sphere in Eighteenth-Century England*. New Haven, CT: Yale University Press, 1993.

Sumner, A., and P. Bishop. *Gainsborough in Bath: A Bicentenary Exhibition*. Bath: Holburne Museum, 1988.

Uglow, Jennifer S. *Hogarth: A Life and a World*. London: Faber and Faber, 1997.

Waterhouse, Ellis K. "Bath and Gainsborough." *Apollo* 97 (1973): 360–65.

——. *Gainsborough*. London: Spring Books, 1958.

Wendorf, Richard. *Sir Joshua Reynolds: The Painter in Society*. Cambridge, MA: Harvard University Press, 1996.

West, Shearer. *The Image of the Actor: Verbal and Visual Representation in the Age of Garrick and Kemble*. London: Pinter, 1991.

Whitley, William T. *Artists and Their Friends in England, 1700–1799*. 2 vols. New York: B. Blom, 1968.

## Architecture and Interior Decoration

Archer, John. *The Literature of British Domestic Architecture, 1715–1842*. Cambridge, MA: The MIT Press, 1985.

Arciszewska, Barbara, and Elizabeth McKellar, eds. *Articulating British Classicism: New Approaches to Eighteenth-Century Architecture*. Burlington, VT: Ashgate, 2004.

Arnold, Dana, ed. *The Georgian Villa*. Stroud, Gloucestershire, UK: Alan Sutton, 1996.

Ayres, James. *Building the Georgian City*. New Haven, CT: Yale University Press, 1998.

Barnard, Toby, and Jane Clark, eds. *Lord Burlington: Architecture, Art and Life*. London: Hambledon, 1995.

Beard, Geoffrey. *Craftsmen and Interior Decoration in England, 1660–1820*. Edinburgh, UK: Bartholemew, 1981.

——. *Decorative Plasterwork in Great Britain*. London: Phaidon, 1975.

——. *The National Trust Book of the English House Interior*. London: Viking, 1990.

——. *The Work of Robert Adam*. Edinburgh, UK: J. Bartholemew, 1978.

Binney, Marcus. *Sir Robert Taylor: From Rococo to Neo-Classicism*. London: Allen and Unwin, 1984.

Colvin, Howard. *A Biographical Dictionary of British Architects, 1600–1840*. New Haven, CT: published for the Paul Mellon Centre for Studies in British Art by Yale University Press, 1995.

Cruickshank, Dan, and Neil Burton. *Life in the Georgian City*. London: Viking, 1990.

Davis, Terence. *The Gothick Taste*. Newton Abbot: David and Charles, 1974.

Forsyth, Michael. *Bath*. New Haven, CT: Yale University Press, 2003.

Fowler, John, and John Cornforth. *English Decoration in the 18th Century*. London: Barrie and Jenkins, 1974.

Girouard, Mark. *Life in the English Country House: A Social and Architectural History*. New Haven, CT: Yale University Press, 1978.

Harris, Eileen. *British Architectural Books and Writers, 1556–1785*. Cambridge: Cambridge University Press, 1990.

——. *The Genius of Robert Adam: His Interiors*. New Haven, CT: Yale University Press, 2001.

Harris, John. *The Palladian Revival: Lord Burlington, His Villa and Garden at Chiswick*. New Haven, CT: Yale University Press, 1994.

——. *Sir William Chambers, Knight of the Polar Star*. London: A. Zwemmer, 1970.

Harris, John, and Michael Snodin, eds. *Sir William Chambers: Architect to George III*. New Haven, CT: Yale University Press, 1996.

Hind, Charles, ed. *New Light on English Palladianism*. London: Georgian Group, 1988.

——, ed. *The Rococo in England: A Symposium*. London: Victoria and Albert Museum, 1986.

Hussey, Christopher. *English Country Houses: Early Georgian, 1715–1760*. Woodbridge, UK: Antique Collector's Club, 1955.

McCarthy, Michael. *The Origins of the Gothic Revival*. New Haven, CT: Yale University Press, 1987.

Mowl, Timothy, and Brian Earnshaw. *An Insular Rococo: Architecture, Politics and Society in Ireland and England, 1710–1770*. London: Reaktion Books, 1999.

——. *John Wood: Architect of Obsession*. Bath, UK: Millstream Books, 1988.

Neale, R. S. *Bath, 1680–1850: A Social History, or, A Valley of Pleasure, Yet a Sink of Iniquity*. London: Routledge and Kegan Paul, 1981.

Pons, Bruno. *The James A. de Rothschild Bequest at Waddesdon Manor: Architecture and Panelling*. London: Philip Wilson, 1996.

Summerson, John. *Architecture in Britain, 1530 to 1830*. Harmondsworth, UK: Penguin, 1977.

Wilson, Michael I. *William Kent: Architect, Designer, Painter, Gardener, 1685–1748*. London: Routlege and Kegan Paul, 1984.

## Decorative Objects, Furniture, and Dress

Beard, Geoffrey, and Christopher Gilbert, eds. *Dictionary of English Furniture Makers, 1660–1840*. Leeds: Furniture History Society, 1986.

Gilbert, Christopher. *The Life and Work of Thomas Chippendale*. 2 vols. London: Christie's 1978.

Gilbert, Christopher, and A. Firth. *The Chippendale Society: Catalogue of the Collections*. Leeds, UK: Temple Newsham House, 2000.

Harris, Nathaniel. *Chippendale*. Secaucus, NJ: Chartwell Books, 1989.

Murdoch, Tessa, ed. *Noble Households: Eighteenth-Century Inventories of Great English Houses: A Tribute to John Cornforth*. Inventories transcribed by Candace Briggs and Laurie Lindey. Cambridge: J. Adamson, 2006.

Savill, Rosalind. *The Wallace Collection: Catalogue of Sèvres Porcelain*. London: Trustees of the Wallace Collection, 1988.

Sellars, Jane. *The Art of Thomas Chippendale: Master Furniture Maker*. Leeds, UK: Harewood, 2000.

Ward-Jackson, Peter. *English Furniture Designs of the Eighteenth Century*. London: H.M.S.O., 1958.

Young, Hillary. *English Porcelain, 1745–95*. London: V and A, 1999.

## Gardens and Garden Design

Bolla, Peter de. *The Education of the Eye: Painting, Landscape, and Architecture in the Eighteenth Century*. Stanford, CA: Stanford University Press, 2003.

Coffin, David. *The English Garden: Meditation and Memorial*. Princeton, NJ: University of Princeton Press, 1994.

Coke, David. *The Muse's Bower: Vauxhall Gardens 1728–1786*. Sudbury, UK: Gainsborough's House, 1978.

Harris, Eileen. "Batty Langley: A Tutor to Freemasons (1696–1751)." *The Burlington Magazine* 119, no. 890 (1977): 327–33, 35.

Harris, John, and Marin Rix. *Gardens of Delight: The Rococo English Landscape of Thomas Robins the Elder*. 2 vols. London: Basilisk, 1978.

Hunt, John Dixon. *William Kent, Landscape Garden Designer: An Assessment and Catalogue of His Designs*. London: A. Zwemmer, 1987.

Hunt, John Dixon, and Peter Willis, eds. *The Genius of the Place: The English Landscape Garden, 1620–1820*. London: Paul Elek, 1975.

Jackson-Stops, Gervase. *An English Arcadia, 1600–1900: Designs for Gardens and Garden Buildings in the Care of the National Trust*. Washington DC: American Institute of Architects Press, 1992.

Jacques, David. *Georgian Gardens: The Reign of Nature*. London: B. T. Batsford, 1983.

Laird, Mark. *The Flowering of the Landscape Garden: English Pleasure Grounds, 1720–1800*. Philadelphia: University of Pennsylvania Press, 1999.

Liu, Yu. *Seeds of a Different Eden: Chinese Gardening Ideas and a New English Aesthetic Ideal*. Columbia: University of South Carolina Press, 2008.

Symes, Michael. *The English Rococo Garden*. Princes Risborough, Buckinghamshire, UK: Shire, 1991.

Williamson, Tom. *Polite Landscapes: Gardens and Society in Eighteenth-Century England*. Baltimore: Johns Hopkins University Press, 1995.

White, Roger. *Georgian Arcadia: Architecture for the Park and Garden*. London: P. and D. Colnaghi, 1987.

## 8. GERMANY, CENTRAL EUROPE, RUSSIA, SWEDEN, AND THE NETHERLANDS

### Painting, Sculpture, Prints, and Drawings

Baarsen, Reinier. *Rococo in Nederland*. Amsterdam: Rijksmuseum, 2001.

Goodden, Angelica. *Miss Angel: The Art and World of Angelica Kauffman*. London: Pimlico, 2006.

Huisken, Jacobine, and Friso Lammertse. *Jacob de Wit: De Amsteltitiaan* [The titian of the Amstel]. Amsterdam: Royal Palace, 1986.

Mandle, Earl Roger. *Dutch Masterpieces from the Eighteenth Century: Paintings and Drawings, 1700–1800*. Minneapolis, MN: Minneapolis Institute of Arts, 1971.

Marx, Harald, and Gregor J. M. Weber. *Dresden in the Ages of Splendor and Enlightenment: Eighteenth-Century Paintings from the Old Masters Picture Gallery*. Translated by Russell Stockman. Columbus, OH: Columbus Museum of Art, 1999.

Rosenthal, Angela. *Angelica Kauffman: Art and Sensibility*. New Haven, CT: Yale University Press in association with the Paul Mellon Centre for Studies in British Art, 2006.

Roworth, Wendy Wassyng, ed. *Angelica Kauffman: A Continental Artist in Georgian England*. London: Reaktion Books, 1992.

Volk, Peter. *Ignaz Günther: Vollendung des Rokoko*. Regensburg: F. Pustet, 1991.

Yonan, Michael. *Empress Maria Theresa and the Politics of Habsburg Imperial Art*. University Park: Pennsylvania State University Press, 2011.

### Architecture, Interior Decoration, and the Decorative Arts

Cracraft, James. *The Petrine Revolution in Russian Architecture*. Chicago: University of Chicago Press, 1988.

Eggeling, Tilo. *Raum und Ornament: Georg Wenceslaus von Knobelsdorff und das friderizianische Rokoko*. Regensburg, Germany: Schnell and Steiner, 2003.

Fauchier-Magnan, Adrien. *The Small German Courts in the 18th Century*. Translated by Mervyn Savill. London: Methuen, 1958.

Harries, Karsten. *The Bavarian Rococo Church: Between Faith and Aestheticism*. New Haven, CT: Yale University Press, 1983.

Hitchcock, Henry-Russell. *German Rococo: The Zimmermann Brothers*. London: Allen Lane, 1968.

——. *Rococo Architecture in Southern Germany*. London: Phaidon, 1968.

Kaufmann, Thomas DaCosta. *Court, Cloister, and City: The Art and Culture of Central Europe, 1450-1800*. Chicago: University of Chicago Press, 1998.

Kristoffer, Neville. *Nicodemus Tessin the Elder: Architecture in Sweden in the Age of Greatness*. Turnhout, Belgium: Brepols, 2009.

Leben, Ulrich. "German Rococo: From Cuvilliés in Munich to Nahl in Potsdam." In *Rococo: The Continuing Curve, 1730–2008*, edited by Sarah D. Coffin, 136–149. New York: Assouline, 2008.

Otto, Christian F. *Space into Light: The Churches of Balthasar Neumann*. New York: Architectural History Foundation, 1979.

Pietsch, Ulrich. *Meissen for the Czars: Porcelain as a Means of Saxon-Russian Politics in the Eighteenth Century*. Munich, Germany: Hirmer, 2004.

Powell, Nicolas. *From Baroque to Rococo: An Introduction to Austrian and German Architecture from 1580 to 1790*. London: Faber and Faber, 1959.

Röntgen, Robert. *The Book of Meissen*. Atglen, PA: Schiffer, 1996.

Roosevelt, Priscilla. *Life on the Russian Country Estate: A Social and Cultural History*. New Haven, CT: Yale University Press, 1995.

Shvidkovsky, Dimitri. *The Empress and the Architect: British Architecture and Gardens at the Court of Catherine the Great*. New Haven, CT: Yale University Press, 1996.

Wittwer, Samuel. *A Royal Menagerie: Meissen Porcelain Animals*. Los Angeles: J. Paul Getty Museum, 2001.

## 9. ITALY, SPAIN, AND PORTUGAL

Alpers, Svetlana, and Michael Baxandall. *Tiepolo and the Pictorial Intelligence*. New Haven, CT: Yale University Press, 1996.

Bean, Jacob, and William Griswold. *Eighteenth-Century Italian Drawings in the Metropolitan Museum of Art*. New York: The Metropolitan Museum of Art, 1990.

Beddington, Charles, ed. *Canaletto in England: A Venetian Artist Abroad, 1746–1755*. New Haven, CT: Yale University Press, 2007.

Blunt, Anthony. *Neapolitan Baroque and Rococo Architecture*. London: A. Zwemmer, 1975.

Bottineau, Yves. *L'art de cour dans l'Espagne des lumières, 1746–1808*. Paris: De Boccard, 1986.

——. *L'art de cour dans l'Espagne de Philippe V, 1700–1746*. Bordeaux, France: Feret and Fils, 1962.

Bowron, Edgar Peters. *Pompeo Batoni and His British Patrons*. London: Greater British Council, 1982.

Bowron, Edgar Peters, and Peter Björn Kerber. *Pompeo Batoni: Prince of Painters in Eighteenth-Century Rome*. New Haven, CT: Yale University Press, 2007.

Bowron, Edgar Peters, and Joseph J. Rishel, eds. *Art in Rome in the Eighteenth Century*. Philadelphia: Philadelphia Museum of Art, 2000.

Brown, Jonathan, et al. *The Spanish Manner: Drawings from Ribera to Goya*. New York: Frick Collection, 2010.

Calasso, Roberto. *Tiepolo Pink*. Translated by Alastair McEwen. New York: Alfred A. Knopf, 2009.

Christiansen, Keith, ed. *Giambattista Tiepolo 1696–1770*. New York: The Metropolitan Museum of Art, 1996.

Clark, Anthony M. *Pompeo Batoni: A Complete Catalogue of his Works*. Oxford: Phaidon, 1985.

——. *Studies in Roman Eighteenth-Century Painting*. Edited by Edgar Peters Bowron. Washington, DC: Decatur House, 1981.

Collins, Jeffrey. *Papacy and Politics in Eighteenth-Century Rome*. Cambridge: Cambridge University Press, 2004.

Delaforce, Angela. *Art and Patronage in Eighteenth-Century Portugal*. Cambridge: Cambridge University Press, 2002.

Diez, José Luis. *Da Goya a Picasso: La pittura spagnola dell'Ottocento*. Milan: Mazzotta, 1991.

Findlen, Paula, Wendy Wassyng Roworth, and Catherine M. Sama, eds. *Italy's Eighteenth Century: Gender and Culture in the Age of the Grand Tour*. Stanford, CA: Stanford University Press, 2009.

Frothingham, Alice Wilson. *Capodimonte and Buen Retiro Porcelains, Period of Charles III*. New York: Hispanic Society of America, 1955.

Gealt, Adelheid M. *Domenico Tiepolo: The Punchinello Drawings*. New York: G. Braziller, 1986.

Gealt, Adelheid M., and George Knox. *Domenico Tiepolo: A New Testament*. Bloomington: Indiana University Press, 2006.

*The Golden Age of Naples: Art and Civilization under the Bourbons, 1734–1805*. Detroit: The Detroit Institute of Arts, 1981.

Helston, Michael, ed. *Painting in Spain during the Later Eighteenth Century*. London: National Gallery, 1989.

Hibbert, Christopher. *The Grand Tour*. London: Methuen, 1987.

Johns, Christopher M. S. *Papal Art and Cultural Politics: Rome in the Age of Clement XI*. Cambridge: University of Cambridge Press, 1993.

Kasl, Ronda, and Suzanne L. Stratton, eds. *Painting in Spain in the Age of Enlightenment: Goya and His Contemporaries*. Indianapolis Museum of Art and the Spanish Institute, New York, Seattle: University of Washington Press, 1997.

Knox, George. *Antonio Pellegrini, 1675–1741*. Oxford: Clarendon, 1995.

———. "Domenico Tiepolo's Punchinello Drawings: Satire, or Labor of Love?" In *Satire in the 18th Century*, edited by J. D. Browning, 124–46. New York: Garland, 1982.

———. *Giambattista and Domenico Tiepolo: A Study and Catalogue Raisonné of the Chalk Drawings*. 2 vols. Oxford: Clarendon, 1980.

Krückmann, Peter Oluf. *Heaven on Earth: Tiepolo: Masterpieces of the Würzburg Years*. Munich, Germany: Prestel, 1996.

Kubler, George, and Martin Soria. *Art and Architecture in Spain and Portugal and Their American Dominions, 1500 to 1800*. Harmondsworth, UK: Penguin, 1959.

Lees-Milno, James. *Baroque in Spain and Portugal and Its Antecedents*. London: Batsford, 1960.

Levey, Michael. *Giambattista Tiepolo: His Life and Art*. New Haven, CT: Yale University Press, 1986.

———. *Painting in Eighteenth-Century Venice*. Revised edition. Ithaca, NY: Cornell University Press, 1980.

Links, J. G. *Canaletto*. London: Phaidon, 1999.

Mahon, Denis. *Studies in Seicento Art and Theory*. London: Warburg Institute, 1947.

Mallory, Nina A. *Roman Rococo Architecture from Clement XI to Benedict XIV (1700–1758)*. New York: Garland, 1977.

Martineau, Jane, and Andrew Robison, eds. *The Glory of Venice: Art in the Eighteenth Century*. New Haven, CT: Yale University Press, 1994.

Maxon, John, and Joseph J. Rishel, eds. *Painting in Italy in the Eighteenth Century: Rococo to Romanticism*. Chicago: Art Institute of Chicago, 1970.

Morassi, Antonio. *A Complete Catalogue of the Paintings of G. B. Tiepolo*. London: Phaidon, 1962.

Pedrocco, Filipo, Massimo Favilla, and Ruggero Rugolo. *Frescoes of the Veneto: Venetian Palaces and Villas*. New York: Vendome, 2009.

Redford, Bruce. *Venice and the Grand Tour*. New Haven, CT: Yale University Press, 1996.

Rosenthal, Donald A. "Children's Games in a Tapestry Cartoon by Goya." *Philadelphia Museum of Art Bulletin* 78, no. 335 (1982): 14–24.

Sani, Bernardina, ed. *Rosalba Carriera: lettere, diari, frammenti*. Florence, Italy: L. S. Olschki, 1985.

Schulz, Andrew. *Goya's Caprichos: Aesthetics, Perception, and the Body*. New York: Cambridge University Press, 2005.

Smith, Robert C. *The Art of Portugal, 1500–1800*. London: Meredith, 1968.

Sohm, Philip L. "Pietro Longhi and Carlo Goldoni: Relations between Painting and Theater." *Zeitschrift für Kunstgeschichte* 45, no. 3 (1982): 256–73.

Spike, John T. *Giuseppe Maria Crespi and the Emergence of Genre Painting in Italy*. Fort Worth, TX: Kimbell Art Museum, 1986.

Steward, James Christen, ed. *The Mask of Venice: Masking, Theater and Identity in the Art of Tiepolo and His Time*. Berkeley: University of California, Berkeley Art Museum, 1996.

Sullivan, Edward J. *Goya and the Art of His Time*. Dallas, TX: Meadows Museum, Southern Methodist University, 1982.

Tavernor, Robert. *Palladio and Palladianism*. New York: Thames and Hudson, 1991.

Tomlinson, Janis. *Francisco Goya: The Tapestry Cartoons and Early Career at the Court of Madrid*. Cambridge: Cambridge University Press, 1989.

Tufts, Eleanor, and Juan J. Luna. *Luis Meléndez: Spanish Still-Life Painter of the Eighteenth Century*. Translated by Tomás Rodríguez and Patricia Zahniser. Dallas, TX: Meadows Museum, Southern Methodist University, 1985.

Varriano, John. *Italian Baroque and Rococo Architecture*. Oxford: Oxford University Press, 1986.

Wilton, Andrew, and Ilaria Bignamini, eds. *Grand Tour: The Lure of Italy in the Eighteenth Century*. London: Tate Gallery, 1996.

Wittkower, Rudolph. *Art and Architecture in Italy, 1600–1750*. Revised by Joseph Connors and Jennifer Montagu. 6th edition. New Haven, CT: Yale University Press, 1999.

———. *Palladio and Palladianism*. New York: G. Braziller, 1974.

# About the Author

Jennifer Milam is associate professor in the Department of Art History and Film Studies at the University of Sydney. She received her PhD in art history from Princeton University in 1996. Her field of specialization is 17th- and 18th-century European art and garden design, with particular emphasis on French painting, patronage issues, and aesthetic theory. She has published widely on 18th-century art in edited volumes and such journals as *Eighteenth-Century Studies*, *Art History*, and *Burlington Magazine*. Her books include *Fragonard's Playful Paintings: Visual Games in Rococo Art* (University of Manchester Press, 2006) and *Women, Art and the Politics of Identity in Eighteenth-Century Europe* (coedited with Melissa Hyde, Ashgate, 2003). She has received fellowships and awards from the Australian Research Council, the Yale Center for British Art, the Australian Academy of the Humanities, Columbia University's Institute for Scholars at Reid Hall, the Samuel H. Kress Foundation, and the National Endowment for the Humanities. She is working on two new books, one in the field of 18th-century studies addressing the playful aesthetic in Rococo visual culture, and the other in the related discipline of museum studies, analyzing corporate interventions into the production, display, and reception of the visual arts.